From Hogarth to Rowlandson

Medicine in Art
in Eighteenth-Century Britain

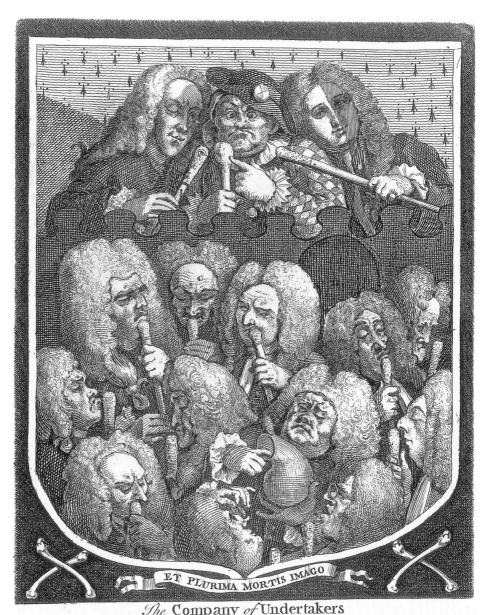

ET PLURIMA MORTIS IMAGO

The Company of Undertakers

Beareth Sable, an Urinal proper, between 12 Quack-Heads of the Second & 12 Cane Heads Or, Consul-
-tant. On a Chief Nebulæ, Ermine, One Compleat Doctor issuant, checkie Sustaining in his
Right Hand a Baton of the Second. On his Dexter & Sinister sides two Demi-Doctors, issuant
of the Second, & two Cane Heads issuant of the third: She first having One Eye conchant, to-
wards the Dexter Side of the Escocheon; the Second Faced per pale proper & Gules, Guardent. ——
With this Motto
Et Plurima Mortis Imago .

A Chief betoken eth a Senatour or Honourable Personage, borrowed from the Greeks &c a Head signifying a Head, & as the Head is the Chief Part in a Man, so the Chief in the Escocheon should
be Reward of such only, whose High Merites have procured them Chief Place, Esteem, or Love amongst Men. Guillim.
The bearing of Clouds in Armes (saith Upton) doth import some Excellencie.
Publish'd by W. Hogarth. March the 3.d 1736.

Price Six pence

WILLIAM HOGARTH: The Company of Undertakers

FROM HOGARTH TO ROWLANDSON

Medicine in Art in Eighteenth-Century Britain

FIONA HASLAM

LIVERPOOL UNIVERSITY PRESS

First published 1996 by
LIVERPOOL UNIVERSITY PRESS
Liverpool, L69 3BX

British Library Cataloguing-in-Publication Data
A British Library CIP record is available.

ISBN 0–85323–630–5 (cased)
ISBN 0–85323–640–2 (paper)

Designed and produced by Janet Allan
10 Dale Road, New Mills, High Peak SK22 4NW

Set in 11/13pt Sabon by Wilmaset Ltd, Birkenhead, Wirral
Printed and bound in the United Kingdom by
Alden Press Ltd, Oxford

Foreword by Professor Martin Kemp

BRITISH ACADEMY WOLFSON RESEARCH PROFESSOR
OXFORD UNIVERSITY

THE visual legacy of medicine is richer than from any other scientific or technical pursuit. This should not, perhaps, come as a surprise. The practice of medicine has been historically dominated by the physicians' visual inspections of the signs of the patient's condition, and the surgeons' physical interventions in the body, directed by sight. In the Western tradition, knowledge and skill has been transmitted not least through pictures and diagrams. The visual paraphernalia of medicine and the look of the spaces within which it has been conducted have become integral parts of its practice. We all know, for instance, what to expect of a clinical interior. Indeed, 'clinical' has become the label for a visual style. Visual images themselves have played a medicinal role. An image of a plague saint, to whom the sufferer prays, no less than the witch doctor's African charm, has been taken to possess the power to intervene alongside surgery and potions. There is also the huge body of imagery generated by those who have observed medicine from outside its professional institutions but who are inevitably subject to its ministrations. It is this last category of imagery that is largely the subject of Fiona Haslam's study.

Representations of medicine in action have been present in virtually every phase of Western art from classical antiquity. Until the Renaissance, the majority of the surviving images fall into the category of indicative rather than directly instructive – that is to say, they do enough to show the kind of activity, bloodletting or whatever, without being designed to provide the aspiring practitioner with precise instructions about procedures and instruments. With the growing illustrative power of picturing in the Renaissance, representations played a more integral role in the transmission of know-how. During the seventeenth century, the increasing use of illustration within the professional practice of medicine was complemented by an increasing range of representation of medical practice in a social context. Dutch genre paintings are the most conspicuous case in point, typically showing vernacular medicine in its most vulgar forms – the itinerant puller of teeth or the roving quack. Britain in the eighteenth century was direct heir to the

Dutch tradition. The great British picture books of anatomy, such as William Cheselden's *Osteographia* (1733) and William Hunter's *Gravid Uterus* (1774) stood alongside a burgeoning range of representations of medical practice in more public forms, particularly through the medium of the print. There were links: for instance, Hunter was one of Hogarth's subscribers when the painter marketed his print series. The visual and literary arts in Britain at this time are rich in medical matters – indeed, it sometimes seems as if it was a society obsessed with maladies, particularly the genteel affliction of 'nerves' which few sensitive people wished to gainsay. The treatment of madness, and the buildings designed to incarcerate the fevered mind, became prominent issues of public concern. Medicine in its turn supplied common metaphors for the state of the nation in satirical paintings and prints.

Fiona Haslam's study demonstrates the huge role played by engraved and painted images in the social discourse of medicine. All the images were designed to perform specific functions and belonged to particular genres of representation which obey their own rules. None of the images were designed to provide us with 'evidence' about contemporary medical practice, sites and paraphernalia. We need, as Fiona Haslam acknowledges, to recognise the modes of communication native to the images themselves, in relation to their generation, their diffusion and their intended and actual audiences. The images work within certain visual codes, conventions and types, and cannot be read as if they are documentary reportage, but they do not stand in an arbitrary relationship to the realities of medical practice. To make their impact, they had to 'ring true' – whether they were true to a partial perception of medicine or to more technical details of medical practice. The historian needs to set the imagery beside the 'controls' of related representations in art and other bodies of visual and written evidence within medicine itself – though none of the items to which we look for 'controls' can be taken as transparently 'given', since they are all cultural products in their own right. Faced with such complexity, the historian has to balance sober empiricism with intuitive juggling.

The apparent unreliability of 'art' as evidence, compared to the apparent directness of professional medical imagery and the written text, has made historians of medicine traditionally wary of pictures – other than as decorative adjuncts to their texts. This suspicion has been breaking down, both because the professional imagery is increasingly seen as culturally determined and because the subjective perceptions of art and literature have become increasingly recognised as integral parts of the story of medicine. Fiona Haslam, bringing together perceptions from her career in medicine and from the studies she undertook for her doctorate in Art History at the University of St Andrews, has produced a richly documented panorama of medical imagery which is placed to illuminate a vital chapter in our growing understanding of medicine as a human practice rather than simply as a progression of increasingly effective procedures.

Contents

❧❀❧

Illustrations

❧❀❧

[ix]

Acknowledgements

I SHOULD like to thank the staff of the following institutions who were indispensable to my research for this book: the Wellcome Institute for the History of Medicine in London and Manchester; the Library of the Royal College of Surgeons of London; the Royal Colleges of Physicians of London and Edinburgh; the Print and Drawing Room at the British Museum; the British Library; the Witt Library; the Courtauld Institute of Art, University of London; the Library of the Society of Medicine; the John Rylands University Library of Manchester; the Hunterian Library and Museum, University of Glasgow; the Thomas Coram Foundation for Children, London; the Guildhall, London; the Bethlem Royal Hospital, Beckenham, Kent; the Jenner Museum, Berkeley, Gloucestershire; St Bartholomew's Hospital Library and Archive Department; St Thomas's Hospital Library; Guy's Hospital Library; Soames Museum, London; Victoria Art Gallery, Bath; the Whitworth Art Gallery, Manchester; Yale Medical Library, New Haven, Conn., USA; the Huntington Library, San Marino, California, USA; and the Art History Department and Library, University of St Andrews.

There are many people – too numerous to name individually – who have given me help and valuable support during the long gestation period which has preceded this publication. To these people and to my family and friends for their forbearance, I also offer my thanks.

ACKNOWLEDGEMENTS FOR ILLUSTRATIONS

The illustrations are reproduced by kind permission of the following: Bethlem Art and History Collections Trust, Beckenham, Kent, and the Board of Trustees of the Victoria and Albert Museum, London, 59. The British Library, London, 2, 4, 45, 76, 106–7. The British Museum, 1, 3, 5, 7–9, 12–17, 21, 21a, 28, 32–42, 48–50, 60–2, 70, 72, 74–5, 77–88, 92, 94–5, 105, 108. Coram Foundation, London, 43. Courtauld Institute of Art, the Witt Library, London, 20, 64–5, 89. Henry E. Huntington Library and Art Gallery, San Marino, California, 71, 97. Philadelphia Museum of Art, Philadelphia (purchased by the SmithKline Beckman Corporation Fund), 98. The Royal College of Physicians, London, 104. The President and Council

of the Royal College of Surgeons of England, London, 11, 90, 99, 100–2. St Bartholomew's Hospital, London, 46–7, 91. Victoria Art Gallery, Bath, and the North East Somerset Council, 66–9. Wellcome Institute Library, London, 19, 63. Whitworth Art Gallery, University of Manchester, 22–7, 29, 30–1, 43, 51–8. Yale Center for British Art, Paul Mellon Collection, New Haven, Connecticut, 73, 96.

Preface

THIS book is written for those who are interested in the social history of medicine and those interested in the history of art. It is hoped that readers from both fields, and others, will appreciate the value of the information that can be drawn from the study of prints as a primary source of medical and social history. Throughout the book attention is drawn to the iconography of the medical images produced by British artists during the period from 1720 to the early nineteenth century. Both the nature and the function of medical images are discussed, and these are read, not as straightforward documents, but within a framework of recognisable artistic practices.

Satire was the language of the age; Gay, Swift, Pope and Fielding, amongst others, added wit and spice to their literary and poetic works. Hogarth incorporated the same ingredients into his works of graphic satire. To satirise and ridicule a subject does not necessarily invalidate its use as a basic resource for historical study; satire had to be based on the truth if its message were to be understood and passed on effectively. This 'truth', as far as the medical images are concerned, can be validated from perusal of contemporary medical treatises, papers and journals, and this has been done in this book.

It has been said that 'prints represent a pictorial rendering of the flow of events, moods and fashions and reflect social attitudes of the day.'[1] This is true to a certain extent, although prints could sometimes help to change social attitudes, as is shown. Nevertheless, both medical and artistic changes took place throughout the period considered here and these changes are reflected in social and political prints.

Hogarth laid the groundwork for a greater freedom in artistic expression: his criticism of the art establishment of the time coincided with an era of criticism of old-established values in other spheres. Members of the medical profession came under increasing scrutiny, along with their colleagues in law and the church. Satire and caricature were recognised weapons of controversy; even when these were embellished with symbols, emblems and metaphors and framed in allegory, contemporary readers 'got the message'. Deciphering such coded messages is both interesting and rewarding, as this book aims to show.

Introduction

❦

ocular demonstration will carry more conviction to the mind of a sensible man than all he would find in a thousand volumes . . .[1]–Hogarth

HISTORIANS, in general, have tended to neglect the iconography of medicine within a large number of satirical engravings. This book sets out to remedy this omission and to examine the views of medicine portrayed by eighteenth-century British graphic and literary artists, offering what is essentially a lay perception of medicine within certain genres of popular culture. It exposes a range of meanings behind the images produced and shows how representations of medicine do not just appear directly as illustrations of medical men with their patients being purged, bled or 'given a vomit' or taking part in some innovative fashionable treatment, although these aspects form part of a portfolio of medical images, they also appear indirectly [1]. William Hogarth, for example, demonstrates well the varied functions and use of medical images. He exposes the practices of quack or irregular doctors, offers illustrations of treatments accorded to patients, highlights the criticisms often directed at orthodox medical practitioners,

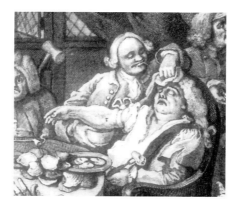

1. Bleeding the Mayor – detail from William Hogarth, *The Election Entertainment* from the *Election* series

makes use of aspects of disease for moral purposes in order to imply that disease was a just reward for past sins, to represent character defects or defects in decision-making on the part of the sufferer, to invoke sympathy or distaste, or to signify deteriorating health or circumstances. Attributes of sickness such as crutches, pills, potions and bandages have artistic as well as medical uses, and Hogarth makes use of these, sometimes in a peripheral way, in addition to portraying the physiognomy or pathognomy of sick people. He uses them both within the framework of his 'Modern Moral Subjects' and in his forays into the realms of 'High Art'.

It is difficult to separate Hogarth's use of medical images into pre-ordained categories: he uses them in different ways, sometimes within one scene, necessitating careful analysis of the scene for its full appreciation. Images used by artists who came after Hogarth can more easily be regarded as demonstrating particular aspects of medical care and of lay perceptions of it. For example, one group of prints might be shown to illustrate or allude to some aspect of treatment of illness, such as cupping, bleeding, or administering an enema: ill-health and the search for its relief provided a rich source of imagery for literary and graphic artists. Stereotyped medical characters could form another category of prints. Practitioners of any sort were seen as objects of ridicule and could usually be allied with rogues and charlatans (their brother professionals in Law and the Church were treated with no greater respect). The popular idea of a medical practitioner transmitted was that of a vain, greedy, arrogant, ambitious, often lecherous and ignorant man, indifferent to the suffering of his patients. The gullibility and naivety of patients was equally prevalent in prints, although they were sometimes portrayed as being helpless victims of ruthless medical men.

Other groups of prints might relate to quack, fringe or irregular medical practitioners, to the promotion of proprietary preparations of medicine, to innovative or fashionable medical treatments, or to the symptoms of disease which could be given shape and form by artists. Rowlandson illustrates '*Ague & Fever*', the former depicted as a bald, sinuous, leech-like creature enfolding his victim, whilst a furry, bear-like monster waits to pounce from behind [2]. The cause of disease is transformed into graphic figures by Gillray and Cruikshank; blue devils cause hypochondriasis (see p. 166), a battalion of imps and spirits cause cholic or headaches, and a clutching, biting, fiery demon causes the excruciating pain of gout [3]. The use of medical images for social, moral or political effect is common and each of these could form a category of prints. As many of these aspects overlap, however, simple classification of medical images as in a catalogue is not relevant to this book. What is offered in these pages is a view of those works of eighteenth-century artists in which images of medicine are used and exploited by the artists as part of their vocabulary to express meaning in narratives.

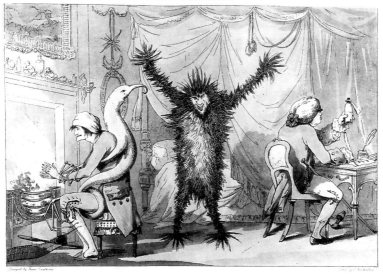

2. JAMES DUNTHORNE AND THOMAS ROWLANDSON: *Ague & Fever*

3. JAMES GILLRAY: *The Gout*

The use of medical images formed one way of communicating a social, moral or political message which would be widely understood, although the message was not itself necessarily medical in nature. For example, the quack or itinerant medical practitioner peddling his wares to a gullible audience might be converted by an artist into a politician proclaiming his beliefs in similar fashion. The image of a quack would have to work within a framework of recognisable attributes and characteristics in order to enable the artist to convey his message. Another example might be that of a politician or influential person afflicted with gout – portrayed in stereotypical fashion with heavily bandaged lower leg, crutches or footstool or in a 'gout-chair' – alluding to some moral laxity in his make-up, with the affliction his just

[3]

reward. The affliction might also allude to some unpopular or alleged defect in an area of policy or decision-making attributable to the sufferer. A third possibility is that of gout being portrayed as a symbol of lust. The significance of the affliction becomes apparent in the context of the scene portrayed.

The visual images can be compared with contemporary literary images, and the validity of both can be found by perusal of medical treatises of the time. Each type of image offers views of general and popular ideas of contemporary medicine. Fielding and Hogarth shared many ideas and even shared some fictitious characters in their work; and Rowlandson, who illustrated the 1805 edition of Smollett's *The Expedition of Humphrey Clinker* which described the latter's travails while 'taking the waters' at Bath, must have been aware of the contents of the novel. Artists did not live in isolation and, like other members of the population, they were affected by events taking place around them and by events which concerned the country as a whole. Close association between artistic, literary and intellectual friends and colleagues who frequented coffee-houses and taverns and read newspapers and journals led to discussion and dissemination of ideas which subsequently generated artistic and literary images.

If the medical images ultimately produced were to be understood by viewers and the points made were to be effective, they had to be based on what medical knowledge and care was available. Integration of aspects of art history, medical history and general social history can enhance the information to be gleaned from each area separately. Specialists in each of these branches of history might feel that their speciality has not been adequately covered in this book, but it is hoped that the value of such integration will be appreciated and that this will result in similar reviews of art, society and medicine in other periods of history, thus widening our knowledge of popular culture in the past.

Questions might be posed as to the value of such images in assessing the medical climate of the eighteenth century. It might justifiably be said that artists could be biased about any of these matters and that their images do not necessarily reflect the true picture in society as a whole. This argument could also be used in connection with information gleaned from diaries and letters but it does not mean that the information that any of these sources offers is of no consequence. In an attempt to eliminate bias, medical images from a number of artists are included in the book. Some selection of material has been inevitable in order to offer representations of images over the period of almost a century, but an attempt has been made to show a wide range of topics and artistic representations. Some independent control with regard to the validity of the medical images and practices portrayed is provided where descriptions of such practices and images correspond with each other.

Varied uses for medical imagery have already been mentioned but

questions remain over the reason for its inclusion in works of popular art. Artists had to earn a living. Patronage had clear advantages as it enabled artists to earn a livelihood, but the choice of image was then dependent upon the will of the patron and his 'position'. It is said, for example, that Hogarth was paid by some of the surgeons of the time for his engraving of *Cunicularii, or The Wise Men of Godliman in Consultation*, and that Perkins commissioned Gillray to portray the use of his tractors. It was said that, at one time, Gillray 'received a pension of £200 a year' from the Tories for his 'blasphemous parodies'.[2] These and other commissioned medical images were thus produced at the behest of people who had a vested interest in their production and in slanting the contents and presentation. In order to escape to some extent from the shackles that such patronage entailed, Hogarth sold prints from his series of 'Modern Moral Subjects' by subscription, leaving him freer to transmit his own messages in his non-conformist style. Medical imagery incorporated into these works would be in accordance with his own wishes and would include features drawn from his own experience or gleaned from his associates – both lay and medical – and from contemporary literary sources; both Hogarth and Rowlandson numbered medical men amongst their friends and associates. Hogarth became a Governor of St Bartholomew's Hospital (he had been born and spent some of his childhood in this area), and he supported Captain Coram both financially and practically in his venture to establish the Foundling Hospital. He had connections with the London Hospital, the Lock Hospital for venereal diseases and the Royal Bethlem Hospital, or 'Bedlam', the mental asylum portrayed in the final scene of *The Rake's Progress*. He painted 'Conversation Pieces', informal group portraits, of doctors and their families. He thus had ample opportunity to collect information of a medical nature for use in his works in different ways which will be described later. Rowlandson's friend and frequent supper companion, John Wolcot, who had studied medicine and practised for a time both in Jamaica and London and had then made a name for himself as a satirical writer under the name of 'Peter Pindar', probably provided first-hand ideas and material for some of Rowlandson's drawings.

In the eighteenth century prints were the primary way of conveying information visually on a widespread basis. Events were depicted and 'commented' upon, personalities and buildings portrayed and various kinds of knowledge disseminated. Prints decorated rooms, taught lessons, presented fashions, proferred political views, provided illustrations for books and periodicals and gave entertainment via print-shop windows or by means of portfolios which publishers lent for 'home-viewing', as indicated at the foot of some of the prints. Prints cost about 6d. per sheet, or 2s. for coloured ones – about three times the cost of a newspaper at that time. The relatively high price meant that they were produced and bought by the élite of the reading

public. In the middle of the century about 50,000 copies of political prints a year were produced compared with about seven million newspapers.[3] It would be difficult to estimate the number of prints containing medical imagery as these were not confined to one particular area. The output of prints, pamphlets, ballads and broadsheets soared throughout the eighteenth century. From the 1770s print-shops with window displays increased in number and hand-coloured etchings became popular.

Print-making was a specialist business, initially conducted mainly in London; print runs were limited and their distribution was confined primarily to London and other centres of culture and social activity such as Bath. This affected the material content of popular prints. The topics illustrated may have been chosen to satisfy a mainly metropolitan audience and their contents reflect their interests and activities. Well-known individuals were sometimes caricatured and artists took advantage of topical themes involving such characters as would be known to this audience. Satire performed a levelling function in society. It was a prophylactic against pomposity and pretentiousness. Matters of health were understood across Britain, but the emphasis shown in many prints with regard to the separation of the activities of the physicians, surgeons and apothecaries reflects this mainly London-based vision. Such separation was less noticeable in other parts of the country. In addition, many of the notorious 'quacks' illustrated were London-based. As printing presses proliferated, London no longer remained the sole venue for the production of printed matter.

Speculation has arisen as to whether satirical prints and cartoons shaped public opinion. Hogarth had set out to draw attention to reprehensible practices that occurred in society, producing what might be termed 'propaganda' in the twentieth century. *Gin Lane* and its associated print, *Beer Street*, helped to draw attention to the problem of alcohol consumption in society (see ch. 4). Rowlandson drew attention to the practice of transplantation of teeth, whereby the poor, in return for a small fee, could be persuaded to relinquish their teeth for the benefit of the rich (see ch. 9). This practice fell into disrepute partly because of the publicity resulting from Rowlandson's print. In some instances, therefore, satirists and cartoonists may be said to have influenced public opinion. Political polemicists always hoped for converts as a result of cartoons, but, as in the twentieth century, social or political opinion is seldom swayed by cartoons. Buyers of political prints were, and still are, usually politically aware members of society with their prejudices already firmly in place. Artists play upon popular prejudices and ideas. Stereotyping could become a matter of positive or negative image-making. Stereotypes of individuals offered a shorthand view of what that individual stood for. For example, John Bull, created by Dr Arbuthnot in the early eighteenth century as an incidental satirical character, evolved into a

down-trodden victim of ruthless governments which weighed him down with taxes, yet later became a bellicose, jingoistic, heroic figure, representing the backbone of the nation.[4] He became an immediately recognisable figure identified by his physiognomy and characteristic role in a political print. Stereotyped images of doctors with canes, periwigs and pomposities offered instant recognition of a physician. This image persisted throughout the century. A politician could assume this role in a political print: a few 'tools of the trade' as added attributes completed the transformation. It has been said that a cartoonist 'has the role of a therapist whose duty is to make the horrors of contemporary life palatable, or at least bearable'.[5] Perhaps the stereotypical view of a physician helped to generate more amusement and tolerance than animosity towards him.

The use of topical themes helped the artist to sell his prints. There was a tendency to use fashionable themes, such as the picaresque which spawned novels such as Fielding's *Tom Jones* and immortalised and romanticised Captain Macheath in *The Beggar's Opera*. Popular literature was aimed at a wide market and pamphlets and ballads described the life and eventual fate of notorious criminals. The central purpose was to serve as a warning to the reader about the life-style of the miscreant by such means as a didactic cycle of degradation, in which youthful misdemeanour leads to gambling, whoring, robbery, murder, death on the gallows and ultimately to dissection at the hands of the surgeon. This pattern was followed by Hogarth in his series *Four Stages of Cruelty*, but Hogarth offers the additional observation that the surgeons' activities were equally reprehensible – a common sentiment which highlighted hypocrisy on the part of the 'Establishment'. However, the majority of those convicted were not hanged at Tyburn and for the bulk of offenders secondary punishments were meted out. Bridewell offered reformative work – the Harlot in *A Harlot's Progress* had to beat hemp there – and in the early eighteenth century active debates were in progress regarding penal reform, with transportation as an alternative punishment. Some images inevitably tended to oversimplify what was a complex situation. Both literary and graphic artists tended to exaggerate a situation in order to give more impact to the intended message.

The questions as to who bought the prints and of how extensive was the market are important. It was essential for the artist or publisher to find a market. Hogarth's earlier 'Histories' were aimed at an educated 'middle-class' or aristocratic élite who would understand his moral and social messages, which are often detailed and embroidered in emblem and allegory. These works in particular require some knowledge from his viewers with regard to artistic conventions and the iconography of 'High Art'. His later, more popular prints were aimed less exclusively at a sophisticated clientele, although these prints too possess deeper significance for the more educated.

The general message of the later prints is more easily read and the prints could be reproduced in a cheaper fashion. Rowlandson's work was lively, often bawdy, amusing and direct – sometimes pornographic – requiring little intellectual involvement, and the artist often supplied a caption or backcloth to offer additional information or commentary upon the scene presented. His pen was his fortune and his output was prodigious – on many topics, of which medicine formed a small though apparently popular part: it has been estimated that he produced at least a hundred caricatures with medical themes.[6] Some of Gillray's political prints could be read on different levels in the same way that Hogarth had intended many of his prints to be read. Subversive elements are apparent, providing additional interest for astute readers, but the market dictated the type, relative accessibility and complexity of the image to a large extent, and 'works of Reynolds and those of the satirists were bought by the same rich and politically powerful sections of the public; the difference in their views reflects a dichotomy in the consciousness of that dominant class itself.'[7]

'As the buying public diversified in taste, many artists and writers cultivated greater self-expression and individuality (it was a way of being noticed)'.[8] Hogarth had made himself noticeable by this means earlier in the century and might be said to have paved the way for future artists to express themselves more freely and to escape from the bonds of tradition. Many images, especially those from later in the century, offended contemporary ideas of good taste with their crudity and vulgarity. This reaction formed part of the impact intended upon what was regarded as almost exclusively a male audience, and the complex puns, *doubles entendres*, paradoxes and deliberate ambiguities to be found in many prints added to their popularity. The reactionary element in prints seems to reflect some of the socially reactionary tendencies of the time. A theme of liberation was evident, both in society and in the world of art. Rowlandson initially depicts those in authority as repressive, trying to suppress youthful vigour and energy and to keep control of those in their charge. Later scenes indicate a revolutionary tendency in which the young disposes the old and carry off young wives and daughters.[9] The middle-aged and old then become mere voyeurs on life's scene. Medical men, past their prime, with scalpels as phallic symbols fitted into this scenario, their anatomy dissections being seen as a cover for 'who knows what'? 'Death', represented as a living skeleton was the ultimate voyeur. He could creep up unnoticed, pry into any nook or cranny, perform unseemly or lewd acts, and hide all his secrets in the grave. Rowlandson's drawings, often overflowing the canvas in untidy profusion, signified exuberance and vigour, an overthrowing of the existing order.

Gender and female sexuality seemed to cause some problem for artists, a problem which largely resulted in women being condemned as whores or

praised as madonnas, and consigned them to a passive role as objects to be surveyed by a male audience. Hogarth, for example, drew a Peeping Tom looking at the *Actresses Dressing in a Barn*: the Harlot was a temptress viewed by males in the initial episodes of her progress including a male audience which would view the prints. In contrast, the madonna-figure who breast-feeds her baby in *The March to Finchley* is surrounded by scenes of chaos and degradation, but remains 'isolated' in her allotted space. Repression and possession of women is prevalent in many scenes. *The Staymaker* ties up the young mother in stays, visually and literally confining her to the house and family – to be literally and metaphorically strait-laced. The whore, on the other hand, is relieved of her stays in the Tavern Scene in *The Rake's Progress*. Rowlandson's doctors 'ravish' female anatomical specimens, and young women are tied to old men while young 'pretenders' aim to take over their 'possessions'.

It might be asked whether the use of allegory, symbolism and rhetorical exaggeration invalidate the use of images as useful bearers of information for the medical historian. Symbolism, allegory and rhetoric were utilised by artists in a traditional manner and provided a frame of reference that would be well understood by an educated eighteenth-century audience whose members would be well-versed in biblical, mythological and historical themes. Even the less well-educated knew their Bibles well and would understand many visual references. Hogarth, particularly, made use of allegory by adorning the walls of the rooms depicted in his 'Modern Moral Subjects' with traditional biblical or mythological scenes, but he used these in a characteristically subversive manner. They cannot be dismissed as irrelevant details; Hogarth did not use details gratuitously, as is shown: they are important pointers to the moral meaning of the scene portrayed. Gillray, too, made satirical references to biblical stories, as in his 'Vaccination' scene in which he depicts the worshipping of the Golden Calf in a picture within a picture (see p. 241).

Some symbols were universally understood and taken for granted and had been used from early times, such as that of a skeleton. A skeleton signifies death, but the skeletons depicted often retained their living expressions and activities, thereby underlining the close link that was seen to exist between life and death [4]. Traditional 'Dance of Death' scenes display these features. Some contemporary medical material was incorporated into paintings or prints as part of this symbolic language or as part of a conventional theme. The use of artistic traditions and conventions does not necessarily cloud the contemporary issues, providing the frame of reference is recognised. It must be understood that Hogarth used them subversively, both to highlight what he saw as the defects inherent in slavishly following traditions and in order to draw attention to comparable defects in society, including health and health

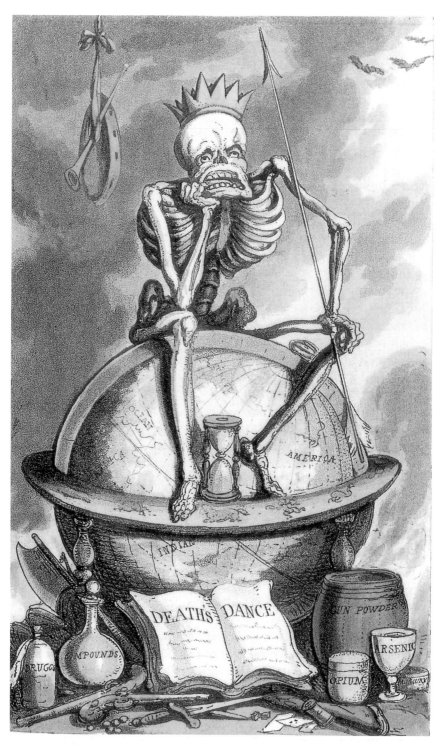

4. THOMAS ROWLANDSON: *Death Seated on the Globe*

care. Examples of this are seen in his use of a classical frieze on which to
dispay the background of quackery in the consultation scene of *Marriage-à-
la-Mode* and in his satirical portrayal of Mary Toft in mock-heroic style on
her 'sick-bed' in *Cunicularii*. Rowlandson continued in similar vein as can be
seen, for example, by his disrupting of the classical and orderly background
scenes in Bath where people went to 'take the waters'.

The different purposes of art raises another question. An artist might
illustrate contemporary literary work, as Hogarth did with his illustrations
for *Don Quixote* and Rowlandson with his drawings for *The Life and
Adventures of Tristram Shandy*. He might produce a work of art for his own
personal pleasure and enjoyment. This might be purely imaginary, or it might
be documentary evidence of a tour undertaken, or he might paint a portrait.
These last two categories require corroboratory evidence as to the nature of
their representational value. A work might be executed to amuse or titillate,
thereby involving exaggeration, manipulation, stereotyping or misrepresen-
tation. Some works were printed anonymously, and the historian should be
alert to the motive for such anonymity and its effect on its contents.

Although there is some danger in treating portrayals of medical scenes as
accurate representations, images were not completely erroneous. They could
not have functioned adequately without direct reference to actual practice.
The activities portrayed were familiar enough to the viewer to be judged
critically and for detailed artefacts to be recognised. In addition to this aspect
of medical practice, the images convey a good impression of popular beliefs
and attitudes, but they must be seen in eighteenth-century terms in order to
avoid misconceptions. There is a need to consider the images in the light of
what was happening at the time, including the state of medical knowledge and
to seek a rounded view of contemporary attitudes. The descriptions of the
events surrounding the Toft affair and of vaccination against smallpox show
to what extent contemporary philosophical and scientific issues influenced
public and medical opinion. If the prints are examined in conjunction with the
written evidence about particular maladies, treatments and incidents, they
can be seen to present a rich field for analysis, not only with respect to the
obvious issues of medical practice but also with respect to the use of medical
images in major spheres of contemporary concern. The 'truth' of the situation
portrayed can be verified by referring to contemporary medical literature. An
example of this is Hogarth's portrayal of the Harlot's treatment for syphilis.

Medical images from later in the century provide some evidence with
regard to contemporary medical developments and treatment of diseases.
'Taking the waters' became fashionable; increasing public awareness and
interest in natural scientific phenomena led to new techniques in electrical
treatment; quacks became more sophisticated in their transactions, and
vaccination against smallpox provoked controversy. Such episodes in the

history of medicine are well illustrated by Rowlandson, Gillray and others. The wide range and succession of fashionable remedies which became available during the eighteenth century is more clearly demonstrated through graphic images than through the written word even though the images are satirical in nature. Prints also draw attention to colourful characters such as Martin van Butchell, Dr Bossey, Dr Graham, Chevalier Taylor and Mrs Mapp. The images illustrate the search for alternative sources of healing at the time and incidentally provide some of the reasons why the public had difficulty in differentiating between the quack and the orthodox practitioner. They help to show how such a benefit as vaccination against smallpox could be regarded as an equally suspect form of treatment as many of the 'quack' ideas had proved to be. Quack and orthodox practitioner alike 'puffed' their own products or those of their colleagues.

The social, artistic and political climate changed, but attitudes towards the members of the medical profession did not change markedly until medical education improved in the early nineteenth century. The uniformly pejorative view of doctors that might be deduced from the majority of the images is mistaken, as is the case with the generally scurrilous images of lawyers or clergymen in popular prints: works of art play upon popular prejudices and ideas. Some doctors no doubt conformed to the unfavourable image and some of their practices can be confirmed in written accounts; satirical images rest on a foundation of truth. But many doctors did not conform to this image. Learned, skilful and humane practitioners existed (according to the precepts of the time), but they were not usually selected for portrayal in popular or satirical fashion unless they were associated with some reprehensible practice which was to be highlighted. Examples of these are the highly respectable John Freke and William Hunter who were portrayed in this way in *The Reward of Cruelty* [92] and *The Resurrection* scene at the Windmill Museum respectively. The practice rather than the man was the target for the barbed brush. The images of the more responsible and reputable doctors can be found in more sober and traditional fashion – conforming to the artistic conventions of the time – in portraits at the Royal Colleges of Physicians and Surgeons. These are outside the scope of this book.

The prominence and complexity of medical imagery of the time reflect the complex and ambivalent attitudes felt towards medicine and its practitioners in eighteenth-century Britain – aspects paralleled in literature, as is shown. Satire is sometimes considered to be an indication of what society feels is wrong with itself; it flourishes at times of social upheaval and rapid development. The eighteenth century was a time for self-examination in many aspects of society. The fact that medical practitioners and their treatments were amongst the targets of satirists reflects their often contentious role. Public expectation plays a part in role perception. The wide-ranging pejora-

tive images of the doctors may be perceived as a broad attack on the profession on behalf of the masses who were unable to speak for themselves and who welcomed such an attack on a profession that seemed to offer little consolation to them in their suffering. The doctor seems to be accepted in the role of healer, but as one having 'fatally' limited resources. Lack of understanding of illness was associated with lack of understanding of healers – partly through a cultivated professional mystique. The anonymity of the doctors presented may be partly due to the remoteness and inaccessibility of the physicians to most of the population. The number of physicians was relatively small and they generally attended the aristocratic and wealthy members of society. Attendance at hospitals was also relatively small. This inaccessibility and remoteness may reflect these facts as they applied in London. As previously stated, in the country, the division between types of medical practitioners was less marked.

Prints offer a primary source of information about aspects of eighteenth-century health care which can usefully be added to other sources of information to build up a composite whole. However, the images presented must be carefully examined and interpreted in order to explore their possible parameters of meaning. The nature and function of the medical images at the time they were produced can only be interpreted within an understanding of the various types of representations involved.

The medical world of the eighteenth century was a complex and changing one and some description of its history and of the prevailing conditions help to put the artists 'in the picture' and give relevance to the scene portrayed. The next chapter provides some of this background information and sets the scene from which the literary and graphic artists drew their medical images.

CHAPTER I

Setting the Medical Scene: the History of the Development of Medical Practice

Forasmuch as the science and cunning of Physick (and Surgery) to the perfect knowledge whereof be requisite both great learning and ripe experience, is daily within this realm exercised by a great multitude of ignorant persons, of whom the greater part have no manner of insight in the same, nor in any other kind of learning; that common Artificers as Smiths, Weavers and Women, boldly and accustomably take upon them great cures and things of great difficulty in which they partly use sorcery and witchcraft, partly apply such medicines unto the disease as to be noxious and nothing meet, therefore to the High displeasure of God, great infamy to the faculties and the grievous hurt, damage and destruction of many of the King's liege people most specially of them that cannot discern the uncunning from the cunning . . .

AN indication of the state of medical practice in the early part of the sixteenth century is contained in the preamble to the Act of 1511 for the regulation of medical and surgical practice, part of which is quoted above.[1]

Before this time no attempt had been made to regularise the profession. Dr Linacre, an Oxford graduate and MD of Padua, persuaded Henry VIII to enact a law whereby only those found duly qualified by the Bishop of London or Dean of St Paul's should practise physic. The basis on which the qualification was determined was generally the possession of a degree from Oxford or Cambridge, which would inevitably have been a classical one, ensuring a knowledge of Latin and Greek, Philosophy and Logic, with some studying of ancient medical treatises. It would not include any clinical teaching, nevertheless, it would allow the possessor to practise medicine anywhere in the country. Bishops outside London were also to carry out the duties of licensing and were to be aided by a board of assessors of physicians and surgeons of 'repute'. There were to be practitioners of special subjects also and 'records of licences granted for phlebotomy, dentistry, bone-setting, green wounds, ophthalmic diseases, mental diseases, gout and cramp, green sickness and sore breasts.'[2] Unlicensed practitioners were liable to a fine of £5 per month.

In 1518 the King granted a Charter to incorporate certain physicians in one body, a Company of Physicians (which became the Royal College of Physicians in 1551). The Company was given the power of making statutes and ordinances for the 'wholesale government and correction' of the College, and the number of persons 'practising physic' in and within seven miles of the centre of London. An Act of 1540 empowered the Company to ensure the purity of drugs sold by apothecaries, who at that time were members of the powerful Company of Grocers. A class of licentiates was added to the physicians already mentioned, who would be of lower status. These would consist of those (men) whose degrees had been obtained from an inferior university (that is, other than Oxford or Cambridge), of other than Anglican religious persuasion, or who were foreign, considered too young or insufficiently learned.

The surgeons followed the physicians in trying to order their profession. The dissolution of the monasteries between 1536 and 1539 had added recruits to a heterogeneous body of healers. These included many monks who had an elementary knowledge of medicine and minor surgery, barbers who had added phlebotomy (bleeding or 'breaking a vein') and minor surgery – such as lancing boils, setting fractures, reducing dislocated joints, and 'pulling' teeth – to their traditional role of shaving in the monasteries, where the monks had been forbidden to draw blood; military surgeons who had gained experience in the treatment of wounds and fractures during wartime; and a few itinerants who travelled from town to town performing operations such as lithotomy, herniotomy and couching for cataracts, men who were often skilled practitioners. In an attempt to obtain some order, the previously separate guilds belonging to the barbers and surgeons, which had been under religious auspices, united to form the Company of Barber-Surgeons in 1540. The functions of each group remained distinct and neither was allowed to encroach upon the functions of the other. Those who wished to join had to be registered at the Hall of the Company and to be apprenticed for a period of seven years and had then to undergo an examination conducted at the Hall by a Court of Examiners. The Charter entitled the Company to receive the bodies of four executed criminals each year for the purpose of dissection and study of anatomy.

> be it enacted that the said Masters or Governors of the . . . Barbers and Surgeons of London and their successors yearly for ever after their said discretions at their free liberty and pleasure shall and may have and take without contradiction four persons, condemned adjudged and put to death for felony by the due order of the King's laws of this Realm, for Anatomies . . . for their further and better knowledge instruction insight learning and experience in the said science or faculty of surgery.[3]

In 1564/5 the Royal College of Physicians also obtained a grant of four corpses yearly for dissection. The Fellows undertook to perform the dissections publicly in the College in rotation according to seniority, or were excused on payment of a fixed sum of money. Some Fellows lectured in anatomy at the Barber-Surgeons' Hall where the Barber-Surgeons' Company provided anatomy lectures for its members.[4]

The Barber-Surgeons' Company controlled surgery in London for 200 years and by a Charter granted by Charles I in 1629, extended its jurisdiction to seven miles from the centre of London. Existing guilds retained powers outside this area in cities such as Newcastle, Bristol and York.

What came to be called a 'Quack's Charter' was enacted in 1542.

> Be it ordered . . . that at all times from henceforth it shall be lawful to every person being the King's subject having knowledge and experience of the nature of herbs roots and waters or of the operation of the same by speculation or practice . . . to practise use and minister in and to any outward sore, wound, swelling or disease, any herb or herbs ointments bathes poultices and emplasters, according to their cunning experience and knowledge in any of the diseases sores and maladies aforesaid and all other like to the same, or drinks for the stone, strangury or agues . . .[5]

These persons were exempted from the previous restrictions as long as they only charged for the medicaments used and not for their services. These exemptions were deemed necessary because of the realisation that there were insufficient numbers of licensed practitioners to give treatment.

The physicians were anxious to gain power over the activities of all 'non-collegiate practitioners, sellers and handlers of physic, such as apothecaries, druggists and distillers',[6] and they nearly achieved this aim in a Charter from James I, but this was never confirmed by statute – a fact which was of significance later. They did achieve a measure of hostility with the apothecaries who were incensed by the physicians' right to oversee their premises. The apothecaries were anxious to obtain separation from the Company of Grocers whose members, they felt, were usurping their prerogative by selling such things as Oriental spices, mixtures of drugs and 'cordials'. In 1606 the apothecaries were incorporated as a separate section of the Grocers' Company, and in 1617 became an entirely separate Society by a Charter granted by James I.

The hostility caused by the physicians was not confined to that felt by the apothecaries. Some remained between the physicians and surgeons regarding their respective duties, partly because members of the College of Physicians claimed that they had a right to practise surgery as part of physic, a claim which was upheld in the 1540 Act. Many of the physicians did not intend to demean themselves by actually performing this manual craft, but wanted to

claim superiority over the surgeons who would thus only operate under their direction and would not be allowed to provide medication without their prescription.

The apothecaries maintained that the 1542 Act, 'The Quack's Charter', entitled them to give advice to patients as long as they only charged for the drugs they dispensed. This led to a practice whereby they could charge exorbitant prices for the numerous drugs which they felt were required for a condition which they had themselves diagnosed, although they modified their charges for poorer clients. The physicians did not approve of this practice of untrained practitioners diagnosing ailments. They tried to remedy the situation in London by opening a dispensary for the poor in 1678, where the sick could receive both advice and cheap medicines. By this means they hoped to under-cut the apothecaries' charges, but the move proved unsuccessful.

The apothecaries gained the legal right to act as advisers, in addition to dispensing, following a court case in 1703.[7] This virtually allowed them to practise a full range of medical activities themselves, and they only called in or consulted a physician in serious cases. In a later Act of 1722, the Apothecaries' Company was empowered to visit the shops of all apothecaries and to destroy any drugs unfit for use. In 1748 additional powers authorised the London Society of Apothecaries to appoint a Board of ten Examiners who could give a licence for dispensing drugs in London and within seven miles. Until then, anyone could open a chemist's shop and deal in drugs and poisons. Only in 1815 was the Society empowered to examine and licence all apothecaries in England and Wales; a clause stated that the apothecary must co-operate with the physician in the dispensing of drugs ordered by him. These measures led to a class of general practitioners with the right to practise medicine and also to assist and co-operate with physicians and surgeons.

Before 1815, the education of medical practitioners in England and Wales was variable. Many practitioners had degrees and licences from universities and colleges, but some of these were bogus and some practitioners had failed to complete their courses. Surgeons and apothecaries trained by apprenticeship; their training was mainly practical, but inconsistent in extent and standard. The physician often had no practical training and his education was mainly academic and classical, but some physicians came from the ranks of surgeons and apothecaries who had practised their trades successfully for many years. The purchase of a degree from such universities as St Andrews and Aberdeen entitled them to this change of status. Such a degree could be obtained by examination or on the basis of testimonials from men of medical eminence on behalf of the aspiring candidate. However, unless the degree were conferred by Oxford or Cambridge, the physician could not become a Fellow of the Royal College of Physicians; he could only become a Licentiate of the College. Dr William Browne, in 1753, in defence of the practice of

electing only graduates of Oxford and Cambridge as Fellows of the Royal College of Physicians, said that this was the only way of ensuring that physicians had the necessary 'approved learning and morals' and 'agreeable and social dispositions' for the proper performance of their duties.[8]

Medical education in Europe had improved with the foundation of a university at Leiden in Holland in 1575 by William of Orange, which was open to students of any nationality or creed. The teaching was in Latin, which was the common tongue of the educated. Many students from England and Scotland went to benefit from the excellent teaching there. Initially very little clinical teaching was done, but when Herman Borhaave became Professor of Medicine and Botany in 1709, he instituted a practice of clinical medicine which introduced bedside teaching into the training of physicians. John Monro, who studied at Leiden, was responsible for the idea of establishing a medical school in Edinburgh which was run on similar lines to that of the Dutch school. The foundation of the Royal Infirmary in Edinburgh in 1736 provided such a clinical teaching school. There, students were taught a wide range of subjects including medicine, surgery, anatomy, botany, chemistry as applied to pharmacy, and midwifery,[9] thus integrating what had previously been regarded as separate fields of study and opening the way for 'general practitioners'. Glasgow developed a similar school a little later.

As the knowledge of anatomy and physiology increased, the status of barbers and surgeons diverged and a wider education was considered necessary for the latter. Between 1720 and 1745, five great hospitals were set up in London in addition to the already established hospitals of St Thomas's and St Bartholomew's, and in the provinces similar charitable establishments were instituted. Surgeons were appointed to these on an honorary basis, as were physicians. The honour and status thus conferred provided welcome publicity, association with wealthy patrons and the opportunity to gain prestigious clients. Surgeons took on pupils and assistants, often from amongst those who had completed a usually recognised period of seven years apprenticeship. They received further training and experience for which the surgeon received an additional source of income.[10] Private lecture courses were established by physicians and surgeons and 'ward rounds' were attended by aspiring practitioners.

The surgeons soon felt that their increasing importance deserved separate recognition from the barbers, and this separation took place in 1745. After the Company of Surgeons was so formed, apprenticeships continued but were not enforced, and many irregularities were permitted. Restrictions on dissections which had been imposed by the Barber-Surgeons, who had forbidden dissections from being performed outside their own Hall, were lifted and private schools and lecture courses proliferated, but teaching under the auspices of the new Company of Surgeons was disappointing. William

Hunter established a private school of anatomy in 1746, to which the best students were attracted. Two years later he was appointed with surgeon Percival Pott as Master of Anatomy to the Company, but there were no prepared specimens and no systematic course of lectures arranged. Following criticisms and disputes and irregular proceedings by the Council regarding premises, the Company was dissolved in 1796. This enabled a Royal Charter to be introduced, with a new constitution, and in 1800 the Royal College of Surgeons (of England) was established.

The Apothecaries Act of 1815 empowered the Society of Apothecaries to enforce the acquisition of sufficient medical education on its future licentiates and this eventually led to the organisation of regular medical schools throughout England.

PREVAILING MEDICAL PRACTICES IN THE EIGHTEENTH CENTURY

During the eighteenth century orthodox medical practice was theoretically conducted on these tripartite lines, in London at least. Physicians, surgeons and apothecaries had separate but undefined roles and feuding between them was common. The first attempt at compiling a register only occurred after the formation of the Company of Surgeons in 1745, following the split from the Barber-Surgeons in that year, when a list of freemen of the Company was circulated to churchwardens of every parish in London and seven miles around. Otherwise, there was little supervision or registration. Outside this area, 'Visitations' by the Archbishop, who visited his whole Province within a year of his appointment, or by the Archdeacon or Prebendary who visited annually, would entail appearance of those licensed to practice at a church in a central position in the district at a specified hour prior to the Visit. 'Visitation Articles' dictated that,

> All Rectors, Vicars, Curates, Parish Clerks, School Masters, Physitions, Chirurgions, and Midwives are hereby required to exhibit or cause to be exhibited at the Time and Place aforesaid their respective Letters of Orders, Certificates of Subscriptions, Institutions, Admissions, Dispensations and Licences, upon pain of Law.[11]

The remote London Colleges, however, caused little practical concern. In the provinces the division by title had less meaning and the type of practice supplied was more simply on the basis of demand and opportunity. There, the apothecary-surgeon often filled the role of all three types of practitioner and he may have had a more successful practice in the area than the physician.[12] The physicians were the élite of the profession both socially and legally. Only they and a few distinguished surgeons were considered gentlemen, but their numbers were comparatively small. In 1708, there were 67 Fellows of the

Royal College of Physicians and 39 Licentiates. By 1740, the numbers were 54 Fellows and 24 Licentiates. The population of London was about 550,000 in 1708 and 600,000 in 1740, both figures representing about 9 per cent of the total population of England.[13]

The physicians attended the aristocracy, the upper classes and wealthy members of society, and some of them enjoyed royal patronage. Because they wished to maintain their status in society, they had to move in the social circles from which they hoped to gain clients and at least had to appear to be successful.[14] A physician's standards of taste, bearing and etiquette therefore had to be in keeping with his aspirations with regard to his ability to command large fees and of gaining acceptance as a gentleman. This led to satirical stereotyping of physicians. One of the trademarks accorded to them was a cane with gold or silver top. This was sometimes perforated and hollow so that it could contain some sweet-smelling substance with properties which, it was hoped, would act as antidotes to the hazards and smells of the sick-room. One particular cane, belonging to a notable physician, Dr John Radcliffe, had a gold-mounted cross-piece as a handle. This was handed down to his successor in practice, Dr Richard Mead. It was then successively passed to other notable physicians until it was presented to the Royal College, where it is now displayed.

The surgeon and the apothecary had a lower social status and income. Dr Samuel Johnson, in his *Dictionary* of 1755, defined a surgeon as 'one who cures by manual operation; one whose duty is to act in external maladies by the direction of the physician'. Treatment of such external maladies as cuts and bruises, dislocation and fractures of limbs, bleeding, blistering and cutting fell within his province. During the early part of the century, surgery was taught by the Professor of Anatomy merely as a footnote. The state of operative surgery by 1745 was still crude. Sedation of patients was inadequate and sepsis or gangrene was common following major injuries. Few serious wounds or injuries of the limbs were curable and amputation with a high mortality rate was often the only treatment available. Speed was essential in surgical procedures, plus strong attendants. William Cheselden was said to be able to perform a lithotomy operation for the removal of bladder stones in under one minute, his record time being 54 seconds.[15]

Anatomical knowledge was increasing and operating skill improving but the surgeon was often considered as cruel and ruthless in his practice of surgery as he was in that of dissection. With the development of private anatomy schools, sporadic anti-surgeon riots occurred. These were directed at the 'body-snatching' operations which took place in an effort to obtain sufficient dissection material for the classes. Few surgeons however, confined themselves to surgical practice. Some, especially those outside the London area, pursued general medical practice with the disapproval of the physicians.

Some were also involved in the treatment of venereal diseases or 'the pox' – a practice they shared to a certain extent with physicians and quacks[16] – and some combined their medical work with a literary or artistic career or even discontinued their medical work in favour of the latter (men such as Smollett and Goldsmith). The army and navy also absorbed a number of surgeons. Surgery, however, retained its inferior status because it was a manual trade.

Midwifery, although closely related to surgery, came under the auspices of the physicians. Men-midwives had attended royalty and the aristocracy in France since Jules Clement started the vogue in 1690 as midwife to the mistress of Louis XIV, and the practice extended to England, but prior to the eighteenth century, midwifery had been in the hands of the female midwife with an attendant surgeon only if absolutely necessary under strict rules dictated mainly by ideas of modesty. Sir Richard Manningham MD (Cambridge) and FRS established the first lying-in ward at the Poor Law Infirmary of the Parish of St James, Westminster in 1739, and wrote a manual for use there. The increasing number of men-midwives led to advances in care. Other lying-in hospitals were established by voluntary bodies, offering poor women and single girls some basic care and bed rest. The increasing presence of the male-midwives, however, caused hostility in traditional midwives who felt that their position was threatened, and in some physicians who thought that the man-midwife was gaining an unfair entrée into the homes of 'their' patrons. In the countryside, the 'old wife' continued to be the only available practitioner, with the apothecary-surgeon being called as a last resort.

After 1703, the apothecary had the legal right to attend and prescribe for the sick as long as he charged only for the drugs dispensed. This led to the practice of the apothecary regularly attending the sick, and calling in a physician (for the sum of 1 guinea) only if he considered it necessary, or of consulting a physician in one of the coffee-houses where such consultations took place – a kind of symbiotic relationship sometimes being established. Physical examination of a sick person was rarely contemplated, or was minimal, and treatment was often based upon an interpretation of symptoms described by the patient, a friend or a relative. Uroscopy was sometimes employed – a practice surviving from ancient times. The treatment so determined was still based on humoral lines[17] and usually included such practices as bleeding, purging, blistering or producing an issue.[18] The apothecaries were the most numerous members of the profession and their practice varied considerably, but they still carried the aura of 'trade'. Nevertheless, in 1747 R. Campbell in his 'General Description of All Trades' described the apothecary's as a 'very genteel business and has been in great vogue of late years . . . [some] practise surgery, man-midwifery and many times officiate as Physicians, especially in the country, and often become men of Large Practice and eminent in their way.'[19]

Medical care grew rapidly during the eighteenth century and the general standing of practitioners rose. This was partly due to increasing prosperity throughout the country and to the rise of a comparatively affluent middle class. Money became available to pay for medical care, not only for the upper class and aristocracy.[20]

In addition to the lying-in hospitals, other medical institutions were set up during the century in the form of medical charities, leading to the founding of hospitals and, later, dispensaries for the treatment of the poor.[21] By the end of the century, all sizeable English towns had a hospital. Although of benefit to many of the poor, such charities might now be seen as engendering deference on one hand and paternalism on the other. Overseers were appointed to ensure that parish money provided to aid the poor was done so on strict economical grounds and payment could be refused if a practitioner charged excessive fees for treatment. Hospitals offered 'charity prudently dispensed'. Even so, Dr Thomas Percival wrote, in 1771, 'it is a melancholy consideration that these charitable institutions, which are intended for the health and preservation of mankind, may too often be ranked amongst the causes of sickness and mortality.'[22] Confidence in the treatment offered in the hospitals was not helped by the demand, on admission, of an indemnity for burial charges in the event of subsequent death.

Some specialist hospitals were also established, such as the London 'Lock Hospital' for the treatment of venereal disease and St Luke's Hospital, which professed to offer a more humane approach to the treatment of lunacy than had its forebear, the Bethlem Hospital, or 'Bedlam'. A greater interest and more humane approach to the care of the mentally ill was stimulated by the advent of George III's madness. Concern with regard to the care of such patients mounted and, in 1815, a Select Committee was set up in the House of Commons to consider the matter.

The Foundling Hospital for the care of abandoned babies was another humanitarian project. This establishment contributed to new perceptions of child care and health which spread throughout the country.[23] The medical profession, too, benefited from the development of these charities through hospital appointments which could prove both lucrative and prestigious. Pupils were encouraged to attend the physician or surgeon on his 'rounds' and clinical teaching provided useful experience. Medical education improved. Edinburgh provided a medical education second only to that obtained in Leiden, but graduates from Edinburgh were only allowed to become Licentiates of the Royal College of Physicians, not Fellows – a situation which engendered some anger and rivalry between factions of the profession.

It has been argued that the physicians, although the élite of the profession, were dependent upon the fees and favours of their aristocratic patients and that such clients were able to exercise control over the course of medical

innovation over the century.[24] The form and content of medical theory of the time thus reflects their interests and obsessions. A successful practitioner would follow the tide of fashion if this were dictated by such clients. For example, the fashion of 'taking the waters' at Bath was a pastime which benefited physicians who supported the pursuit. The possession of a medical qualification did not necessarily affect the choice of practitioner whom the sick person sought if some outlandish practice were fashionable. The entrepreneurial skills of such practitioners as Joshua Ward, James Graham and Benjamin Perkins often meant more than any qualifications they might or might not possess.

At a time when an apothecary could charge for numerous drugs to treat a few symptoms – often with poor results – the 'quack' who could offer one universal panacea for all ailments had some appeal.[25] Such quacks or charlatans flourished and peddled their wares round market-places and fairs. These itinerants would have found insufficient custom in each place to set up local establishments. By travelling they were able to increase their sales and to escape retribution in the event of failure to provide value for money. Other quacks flourished by means of advertising and selling unique products or 'specifics'. Advertising on bill-boards and posters, in coffee-houses, in newspapers and journals provided them with a wide clientele. Postal sales also provided an outlet, but more popular were sales through such establishments as retail shops, stationers and printers where proprietors often acted as distributors of medicines.[26] Cures for venereal diseases provided a rich source of income for quack and intermediary. Many quacks claimed to provide a cure without the use of mercury – a specific treatment for the 'pox' – which had unpleasant and tell-tale side effects.[27] Bogus degrees, certificates claiming royal approval and 'authentic' testimonials with regard to the efficacy of products abounded. No proof of efficacy was necessary for such acclamation. Some of the nostrums produced contained effective ingredients such as opiates to relieve pain, brandy to promote a feeling of euphoria and mercury for the treatment of syphilis, but many illnesses which were claimed to have been cured by the quacks' nostrums would have resolved spontaneously without medication. The quacks were aware of the effectiveness of products which had no recognised curative value, but which nevertheless gratified the consumer and contributed to his well-being. (Similar products are termed placebos in the twentieth century.) Some quacks, particularly in London, became notorious for innovative treatments exploiting current scientific ideas, such as Dr Graham with his 'celestial bed' for the treatment of the barren and impotent and Katterfelto with his magnets – each taking advantage of the contemporary interest in new scientific discoveries with regard to electricity and magnetism.

Many quacks were foreigners who found little restriction on their practice

in England. Some even insinuated themselves into the houses of the aristocracy and obtained royal patronage. They preyed upon the ignorance and gullibility of the public of all social strata. The state collected taxes from the sales of the quacks' nostrums so preferred not to ban them, and the Royal College of Physicians was powerless to suppress them, partly because advertising and selling medicaments was not confined to quacks.[28] Some respectable physicians, who could not advertise their names in other ways, recommended nostrums and became associated with particular products. These nostrums sometimes became well-known preparations without which no household was properly stocked, for example, 'Dr James's Powder' and 'Dr Radcliffe's Famous Purging Elixir'.[29] The former product received some publicity from its inclusion in the children's publication, *Goody Two Shoes*, by Dr Oliver Goldsmith, published by the newspaper proprietor and patent medicine wholesaler, John Newberry:

GOODY TWO-SHOES

Chap. 1

CARE and Discontent shortened the Days of Little Margery's Father. – He was forced from his Family, and seized with a violent Fever in a Place where Dr James's Powder was not to be had, and where he died miserably.[30]

Self-medication was common and books recommending remedies for all ills were widely available. The Edinburgh physician William Buchan's *Domestic Medicine*, first published in 1769, enjoyed great popularity and was published in 142 separate editions.[31] Such a publication was commented upon later by a nineteenth-century writer as 'a treatise which I have frequently heard reprobated by gentlemen of the Faculty, for laying open to the world, in language so perspicuous, those mysterious secrets which had been before disguised in dog Latin'.[32]

John Wesley's *Primitive Physic* was published in 1747 and went into twenty-three editions by 1828. In it, Wesley prescribed home-made remedies for the treatment of 288 specific ailments. The *Gentleman's Magazine* also offered advice on medical matters. Ready-stocked medicine chests for males, females or horses included such items as laudanum, antimony, guiacum and lead, along with many other items for self-administration. Daily doses of certain drugs or even use of enemas was commonplace and became habitual. Tony Lumpkin complained to his mother in Oliver Goldsmith's *She Stoops to Conquer*, 'you have been dosing me ever since I was born. I have gone through every receipt in the Complete Huswife ten times over; and you have thoughts of coursing me through Quincy next spring . . .'.[33] This satirical reference to home medication was based on reality. One Thomas Turner, a Sussex grocer of the 1750s is said to have thought that a bath should be taken every spring, along with the annual blood-letting.[34] Such domestic medicine survived out

of necessity because of the impracticability of obtaining professional medical care in remote areas and because of the related expense. Other home-made remedies and advice were offered by the 'lady of the manor', wise-women, herbalists, midwives and those condemned in the 1511 Act who still flourished in some areas. The Methodist minister was often an amateur physician as well as preacher, Wesley being the most notable example. Buchan stated in his *Domestic Medicine* that almost all rural clergymen knew 'something of medicine. Almost all of them bleed, and can order a purge . . .'.[35]

Those who had problems with their vision could obtain spectacles from travelling pedlars and from stalls in the market-places. They were usually of the convex variety which had been in use since the middle of the fourteenth century. Concave lenses for the correction of near-sight were less common but had been available since the end of the fifteenth century. Most of the spectacles consisted of two lenses in metal, wood or horn frames joined together by a fixed bridge and perched on the nose. Many of Hogarth's characters possess these. The choir-master in *A Chorus of Singers* has a more efficient way of keeping his in place: his spectacles have extended pieces attached to the bridge which grip the wearer's temples by means of padded or circular end-pieces. This type, called 'temples', were not developed until the eighteenth century. Single or double hand-glasses were used as alternative visual aids.

Those people who were deaf might have the benefit of an ear-trumpet. Joshua Reynolds was a well-known bearer of one of these. A gentleman in Hogarth's *The Cockpit* uses a similar instrument.

Social and environmental conditions were the cause of much distress, and the failure of the medical profession to remedy many of the resulting ills whilst seeming to profit by them caused distrust and lack of respect for the profession. Overcrowding, insanitary conditions, poverty, lack of public and personal hygiene, prostitution, the prevalence of cheap gin, lack of medical care and ineffective remedies for the treatment of infectious diseases such as measles, typhus and smallpox, were all part of the London medical scene during the earlier years of the eighteenth century. Other areas did not escape from these problems, which increased as industrialisation resulted in migration of many people to the provincial towns. It was not until towards the end of the century that schemes for public health and sanitation took shape, with recommendations that the government should be responsible for public health measures with regard to water supplies, sewage disposal and school hygiene.[36] The importance of good ventilation in hospitals and prisons was a health factor appreciated by Revd Stephen Hales, who invented a ventilator system which was used in Newgate prison with consequent decline in the prevalence of gaol fever. Conditions in the navy improved with the appre-

ciation of the effectiveness of lemon juice or lime juice in the prevention of scurvy, and the comfort and health of army troops received attention. Vaccination against smallpox became more widely acceptable and more effective drugs came into use: for example, the use of cinchona bark from Peru in the treatment of ague or malaria was extended, and a decoction from the foxglove was found to be effective in the treatment of dropsy due to cardiac disease. Public health measures made more of an impact upon the general health of the nation than any other factors, but general medical care improved and this improvement continued and advanced more rapidly during the ensuing century.

Medical Images in Hogarth's London:
Early Satires

But there must still be a large number of the people without the sphere of the opulent man's influence, namely, that order of men which exists between the very rich and the very rabble . . . in this middle order of mankind are generally to be found all the arts, wisdom and virtues of society. This order alone is known to be the true preserver of freedom and may be called the People . . .[1]

TOWN and country; politeness and vulgarity; civic humanism and idiosyncratic idealism; polite and popular culture; patrician and plebeian classes: these are terms variously applied to aspects of society in the eighteenth century. Such descriptions tend to emphasise a polarisation of different groups of society. Was the reality not, rather, a steadily increasing number of individuals occupying the middle-ground between 'the very rich and the very rabble' referred to by Goldsmith, a group which felt able to criticise those who claimed to act on behalf of their 'inferiors', but which was itself reluctant to take on the responsibilities of those whom they criticised? Commerce might be considered as the fulcrum on which this group pivoted. Its interest in trade did not lead to the isolation of individual members in ivory towers in the country – in the position the landed gentry might be perceived to occupy – but led to new means of communication, indulgence in newly acquired luxuries which became more widely available to all members of society, wider views of the world and visions which did not necessarily include a paternalistic approach to the less fortunate members of society, but were, nevertheless, not blind to their plight. From their perspective the members of this group could see more clearly the faults and virtues of those people who might be either more or less fortunate than themselves; could understand but not necessarily agree with the aspirations of people to better themselves and to forsake their 'God-given' status in life. They questioned contemporary social and cultural conventions and some of the political, philosophical and ideological ideas which prevailed. Authority in any form, whether it were in matters of state, church, law or medicine, was questioned

and criticised. Non-conformist views spilled over into the world of literature and art and can be seen in the metaphors and images employed in contemporary literature and graphics.

Hogarth's intelligence and background placed him in this middle ground of an increasingly commercialised society. He was not critical of commerce as such: Britain was a trading nation; he himself worked in a 'free market' and had learned a trade as an engraver, and his livelihood then, and later as an artist, depended upon the selling of his products. He was, however, critical of the behaviour that could accompany commerce, which engendered illusions of easy wealth and luxury, and of the corruption that could follow. He displayed these views graphically in such early prints as the *South Sea Scheme* and *The Lottery* (1721), in which the effects of commerce can be seen as leading to moral, sexual and religious decadence. From his vantage point, Hogarth felt able to view both extremes of society and had no qualms about exposing the shortcomings of the one and the weaknesses of the other, and the vices and corruptions common to both.

Nature and nurture had combined to make Hogarth the non-conformist individual that he was. He criticised art critics and connoisseurs for what he saw as stultifying attitudes promulgated by the encouragement of young artists to emulate the works of the Old Masters such as Raphael, Michelangelo and Leonardo at the expense of original expression. The works of the Old Masters, encompassing religious, mythological, epic and historical themes, were considered by the art critics and connoisseurs to be morally and spiritually uplifting and, as such, of value in instructing the nation in matters of moral and political integrity. Hogarth thought that these paintings were largely irrelevant to contemporary life, especially in view of what was actually happening in society and the standards which were being set by those who professed to uphold civic values. He made use of classical themes and traditional emblematic images in many of his works, initially alongside his 'real-life' topical images, but increasingly he subverted them for his own ends. This aspect of Hogarth's work played an important part in his growth as an artist and in the part that he played in releasing artists from the bonds of convention. Two of Hogarth's prints in particular, *Cunicularii* and *The Company of Undertakers*, epitomise the satirist's view of members of the medical profession. For this reason, they warrant detailed analysis.

I. THE RABBIT WOMAN: ART AND GUILE IN THE CASE OF MARY TOFT

One of Hogarth's early prints, *Cunicularii, or The Wise Men of Godliman in Consultation*, 1726[2] [5], offers an example of how Hogarth used and subverted traditional emblematic images in the portrayal of a bizarre contemporary event. In this print he used the format of an idealised historical

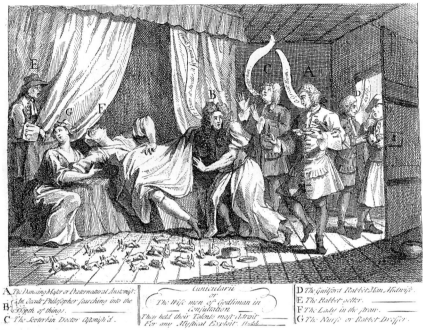

A *The Dancing Master or Preternatural Anatomist.*
B *Depth of things.* *An Occult Philosopher searching into the*
C *The Sooterkin Doctor Astonish'd.*

Cunicularii
or
The Wise men of Godliman in
Consultation
They held their Talents most Adroit
For any Mystical Exploit. *Hud.*

D *The Guilford Rabbit-Man-Midwife.*
E *The Rabbet-getter.*
F *The Lady in the straw.*
G *The Nurse or Rabbet-Dresser.*

5. WILLIAM HOGARTH: *Cunicularii, or The Wise Men of Godliman in Consultation*

painting but he depicted a real individual, Mary Toft, as the 'heroic' subject. Through his portrayal of this episode attention is drawn, not only to the subversion of art tradition, but also to aspects of contemporary philosophical, ethical, medical and theological opinion.

An amazing occurrence was announced in the *Weekly Journal* of 19 November 1726:

> From Guildford comes a strange but well-attested Piece of News. That a poor Woman who lives at Godalmin [*sic*], near that Town, was about a Month past delivered by Mr John Howard, an Eminent Surgeon and Man-Midwife, of a creature resembling a Rabbit . . .[3]

This event naturally caused a great deal of comment. Hogarth was an interested observer of the events taking place around him and he incorporated many incidents and references from contemporary situations, such as this sensational occurrence, in his works. Medical concerns appear to have occupied a particularly prominent place in eighteenth-century *mores* in Britain. When these were associated with topical situations involving some *causes célèbres*, playwrights, satirists, artists and print-makers were not slow to exploit them to their own advantage. Mary Toft, the 'Rabbit Woman', proved to be a particularly fruitful model for such practitioners. Hogarth's

print, in which Mary Toft is depicted with her accomplices and her medical attendants, is just one of many publications on this topic.

A letter written on 9 November 1726 by a gentleman at Guildford to his friend, a physician in Ipswich,[4] describes how a woman (Mary Toft) saw two rabbits, 'one black and one gray', in a field where she was weeding when she was five weeks pregnant. She and a companion ran after them but were unable to catch them. In the following 'Hopping Season' (August), 'something came from her, which the Surgeon by he Description judged to have been a Mole.' A mole was described in 1698 as: 'The Moon-Calf, which is a lump of flesh for the most part like the quisern of a bird, greater or lesser according to the time of its being there, which is commonly not above four or five months.'[5] Another source describes a mole as a fleshy mass caused either by defects in the 'informing faculty' or in the seed or menstrual blood.[6] A twentieth-century description is of an abnormality of the early developing placenta which becomes cystic and degenerates. The embryo does not continue to develop and bleeding, with expulsion of clots and all or part of the 'mole', occurs sooner or later.

In Mary Toft's thirty-first week, the letter continues: 'the liver of a Rabbet came from her, which her Husband brought to Mr Howard.' Mr Howard, the man-midwife, refused to attend Mrs Toft as he thought that Mr Toft's story was a hoax, but the next day Mr Toft brought further pieces of the thorax of a rabbit to him. Mr Howard then went to see the man's wife, and during the next few days delivered 'three legs of a Cat of a Tabby Colour, and one leg of a Rabbet: the guts were as a Cat's and in them were three pieces of the Back-Bone of an Eel . . . The cat's feet supposed were formed in her imagination from a cat she was fond of that slept on the bed at night.'

On Friday, 28 August, Mrs Toft went to church to give thanks for her recovery, but the following Sunday she became ill again. During the next few days pieces of rabbit were delivered of different size and colour, 'all bones broken, but no more cat's feet.'

The *Weekly Journal* of 19 November informed the public of the events as follows:

From Guildford comes a strange but well-attested Piece of News. That a Poor Woman who lived at Godalmin [sic], near that Town, was about a Month past delivered by Mr John Howard, an Eminent Surgeon and Man-Midwife, of a Creature resembling a Rabbit but whose Heart and Lungs grew without its Belly, about 14 Days since she was delivered by the same Person, of a perfect Rabbit: and in a few Days after of 4 more; and on Friday, Saturday, Sunday, the 4th, 5th, and 6th instant, of one in each day: in all nine, they died all in bringing into the World. The woman hath made Oath, that two Months ago, being working in a Field with other Women, they put up a Rabbit, who running from them, they pursued it, but

to no Purpose: This created in her such a Longing to it, that she (being with Child) was taken ill and miscarried, and from that Time she hath not been able to avoid thinking of Rabbits. People after all, differ much in their Opinion about this Matter, some looking upon them as great Curiosities, fit to be presented to the Royal Society, etc. others are angry at the Account, and say, that if it be a Fact, a Veil should be drawn over it, as an Imperfection in human Nature.

Mr Howard moved Mrs Toft to Guildford and confirmed all the rumours by inviting anyone who doubted the story to deliver a rabbit personally. This offer was accepted by Mr Nathaniel St André who set off to Guildford with Mr Molyneux, Secretary to the Prince of Wales, to deliver a rabbit. Mr St André was an adventurer who had come from Switzerland to London as a menial servant. He taught French, German, dancing and fencing and had then been apprenticed to a surgeon following treatment for a wound he had received. He was appointed as anatomist/surgeon to the Royal Household in 1723 – partly because of his ability to speak German – and he accepted a sword, previously worn by the King, as a sign of the latter's esteem. He also held a post of local surgeon to Westminster Hospital Dispensary. St André, on arrival in Guildford, duly delivered the trunk of a rabbit, following which, he immersed a small piece of its lung in water to see if it would float. The piece floated, indicating the presence of air and thus the likelihood that the rabbit had breathed. No blood or *liquor amnii* (fluid which normally surrounds a foetus in the uterus) was apparent at the delivery nor later when he delivered the head and fur (rabbits are usually born naked). These findings, however, were not sufficient to convince Mr St André of the true nature of events.

Another Surgeon to His Majesty's Household, Mr Cyriacus Ahlers, went to Guildford on Sunday 20 November to see these events for himself. He had no knowledge of delivery, but under the guidance of Mr Howard, delivered a rabbit which he was convinced came from the uterus, and he demonstrated the presence of milk which could be expressed from Mrs Toft's breasts – an occurrence consistent with recent pregnancy. Before returning to London, he presented the lady with a guinea and a promise to secure a pension for her from His Majesty. In his own *Observations concerning The Woman of Godlyman in Surrey*, he said:

I desir'd Mr Howard to let me take the Skin, with the Fore and Hind-part of the Rabbet along with me, to shew them to His Majesty, which at first he would not consent to: but having promised him that I would take care to send them back again he permitted me to take them, and so I put them in an Ox's bladder, which I had sent for, and turn'd Inside out.[7]

An abstract of a letter from Mr Howard dated 22 November 1726 stated that:

On Sunday last came hither Mr Ahlers, Surgeon to the King's household (by His Majesty's Orders) who took part of the 16th Rabbet from this poor Woman, and carry'd it to the King at Kensington . . . The Tuesday before I had Mr St André . . . who took part of one Rabbet from her which weighed 22 ounces, and these Gentlemen were both fully satisfy'd in the Truth of this Wonderful Delivery: as was also Mr Molyneux Secretary to the Prince, who was here also.[8]

Examination of the rabbit taken by Mr Ahlers showed that there were marks of a sharp instrument in the muscles round the vertebrae, lung parts floated in water and the rectum contained several hard pellets with bits of hay, straw and corn in them, but the *foramen ovale* (a foetal anatomical feature of the heart) was open.[7] The absence of some of the guts and feet of the rabbit were explained to him by Mr Howard as having probably fallen to the ground and been trampled underfoot.[9]

Mr Howard kept parts of the animals in spirits of wine as a preservative and on 26 November gave a demonstration in London before His Majesty and members of the Royal Society, at which the parts were shown, and to which reference was made in the *Weekly Journal*. The fact that some of the features demonstrated were those of foetal rabbits and some of adult rabbits convinced some observers, including Mr St André, that these were praeternatural rabbits.

After another delivery, George I notified Sir Richard Manningham and requested his attendance at Guildford with Mr St André. Sir Richard was a widely respected physician and man-midwife who, in 1739, was to establish the first lying-in infirmary in London as a school for midwives and medical pupils. In his Diary of the event Sir Richard wrote,

I found her in Bed, and after asking her several Questions in the presence of Mr St André, Mr Limborch [Surgeon], and several Women and Midwives, I proceeded to examine her Breasts, wherein was a small Quantity of thin Serous Matter like Milk: I then felt her Belly all over carefully, which was soft, and not much larger than ordinary, and by no means like a Woman with Child; the Right side of her Belly, indeed, was somewhat bigger than the Left, with a Hardness across it, which when I press'd, she said it gave her Pain.[10]

(The latter findings may be explained in twentieth-century terms as being due to some infection caused during 'nefarious' operations, the nature of which are divulged later.) Sir Richard continued:

I afterwards search'd the whole Vagina, and being well assured at that time all was clear from Imposture, I touch'd the Os Uteri [opening of the uterus], which was contracted in such a manner that it would not receive so much as the point of a Bodkin into its Orifice . . .

(The closely contracted *os uteri* precluded the possibility of imminent delivery and would seem inconsistent with a recent delivery.)

Sir Richard visited her again in the evening. No movements had been observed from the presence of so-called rabbits during his visits, but he was assured that these sometimes resumed if hot cloths were applied to her belly. The diary continues:

> Upon applying the first Cloth the Motion began, which they called the leaping up of the Rabbet, it was indeed a Motion like a sudden leaping of something within the right side of her Belly, where I had before felt that particular Hardness and as I sat on the Bed in Company with five or Six Women, it would sometimes shake us all very strongly.

Sir Richard left Mrs Toft and with Mr St André and Mr Limborch went to the White Hart Inn, but less than an hour later Mr Howard brought a piece of membrane which he said he had just removed and believed more was to come. Sir Richard thought that it was a piece of bladder although Mr Howard insisted that it was a piece of chorion (foetal membrane) and that he had more at home. At about eight o'clock a messenger arrived to say that Mrs Toft was in pain. They found her sitting in a great chair by the fireside, and in her vagina found a piece of 'skin': the *os uteri*, however, was closed as before. This 'skin' was similar in appearance to a piece of hog's bladder, and when Sir Richard asked for one with which to compare it, a bladder was brought 'fresh blown up'; both smelled of urine, and the only difference was the thickness of the 'skin'. Following this, Sir Richard said that he would not be satisfied that the affair was not a fraud unless he removed something from the uterus himself. Arguments ensued between Mr St André, Mr Howard, Mr Limborch and Sir Richard. St André stated

> that he was convinced of that Truth by examining the Rabbet he had taken from the Uterus: which at the same time had the exact Appearance of Animals, like such Creatures as must inevitably undergo the Changes that happen to adult Animals by Food and Air: and that they carried within them the strongest Marks of Foetus's.

He claimed that this proved to him that they were not bred in a natural way (therefore were praeternatural) and this might explain the state of the bladder and that it might be part of the chorion. Sir Richard agreed not to publish his own opinion until events were completed.

On Tuesday, 29 November, Mrs Toft was taken to London and lodged at Mr Lacy's Bagnio in Leicester Fields, where many eminent people visited her. On 3 December Lord Hervey, a courtier in the Royal Household, wrote to his friend Henry Fox:

> I was last Night to see her with Dr Arbuthnot, who is convinced of the Truth of what St André relates, every Creature in town, both men and women have been to

see and feel her: the perpetual emotions, noises and rumblings in her Belly are something prodigious; all the eminent physicians, surgeons, and man-midwives in London are there Day and Night to watch her next production.[11]

Hervey concluded:

the whole philosophical world is divided into two partys . . . and between the downright affirmation of the one hand for the reality of the fact, and the philosophical proofs of the impossibility of it on the other, no body knows which they are to believe their Eyes or their Ears.

On 4 December delivery again seemed imminent. Dr James Douglas, a respected Scottish physician, man-midwife and anatomist, Mr Mowbray (Maubray), man-midwife, and Mr Limborch all examined her in the presence of Sir Richard and all agreed that something would soon issue from her uterus. Many other persons of distinction who were present also examined her, but her pains ceased.

Events changed dramatically in the evening when a porter to the Bagnio made a statement to Magistrate Sir Thomas Clargis concerning a rabbit which Mrs Toft had procured clandestinely with his assistance. Her sister, who nursed her, insisted that this rabbit had been for eating purposes only. This episode was reported in the *Whitehall Evening Post* of 6 December:

The Woman who was said to bring forth Rabbits, was Yesterday committed by Sir Thomas Clargis to the Custody of the High Constable of Westminster for a Fortnight and she had been sent to Bridewell, but that the Patrons to this Imposture contend still, that she is near her Labour of more Rabbits; tho' some Discoveries have already been made, during the Strict Examination she has been under in the Town. We hear that the Surgeon of Guildford who delivered her of 17 Rabbits, is bound over. Doctors and Surgeons are permitted to visit her, but not under Three at a Time.[12]

A full confession of fraud was obtained from Mrs Toft on Wednesday, 7 December. It appears that, following her early miscarriage, an accomplice had placed the claws and body of a cat with the head of a rabbit into her womb whilst the opening still permitted such access. Later, parts were inserted into her vagina. Infection of the pelvic area was likely to occur as a result of this, leading to such hardness and tenderness as was elicited by Sir Richard on the 'right side of the Belly'. The purpose of the deception was in order to obtain a good livelihood, which the accomplice would share in return for the supply of rabbits. Others admitted to the sale of rabbits to Joshua Tofts. Mrs Toft, according to a report in the *Weekly Journal* of 17 December was 'ordered to be prosecuted upon a Statute of Edward III, as a vile Cheat and Imposter'.

The journal also commented, 'we hear a certain Person of Note has lately appeared to have gone distracted' – a remark that referred to Mr St André. It took some time for medical reputations to heal, and statements, letters and advertisements were published to vindicate the conduct of those who had been duped.[13] Mr St André, who had previously issued a pamphlet 'proving' that the rabbits were praeternatural human foetuses in the form of quadripeds, bought the remaining copies himself. He apologised in a public advertisement on 8 December, pleading on his own behalf 'He's half absolv'd, who has confest'.

It was said of him that: 'The additional celebrity of this man arose from fraud or ignorance, perhaps from a due mixture of both.'[14] His wealth still ensured him some faithful friends who, in due deference to him, forbore to have rabbit on the menu in his presence, and he retained his position in the Royal Household. One Mr Dillingham, an apothecary in Red Lion Square, had laid a wager with St André that within a limited time a cheat would be detected. He won his bet and with the money bought a piece of copper-plate on which three rabbits were engraved for use as a coat-of-arms.[15]

The readiness of various groups to exploit the situation was soon apparent, but to understand the ensuing publications fully, and the apparent gullibility of all concerned in the face of such a deception, it is necessary to consider events in their contemporary context.

Man had long been considered as superior to all other creatures; only he combined matter, intellect and soul. The fundamental distinction between man and animals underlay man's behaviour and any departure from the 'fixed and immutable' bounds between man and brutes was regarded with a mixture of horror, suspicion, curiosity and anxiety.[16] To be associated with brutes was debasing. Behaviour which was unacceptable in any form was popularly referred to in animal terms; man's 'animal nature' was implicated and, as such, should be subdued. Child-bearing was associated with the baser, more animal aspects of behaviour, and pregnant women were commonly said to be breeding. Mary Toft instantly fell into this category, and the lust with which she was said to be consumed compounded the charge. Yet the anthropocentric tradition was being questioned increasingly as the study of natural history began to suggest a new vision of the natural world. The occurrence of monstrous births such as those attributed to Mary Toft threatened the dividing line between man and animals. Were the boundaries between man and animals absolutely immutable? Opinion was divided.

Further problems arose over the persistent question of the effect of a pregnant mother's mental state and perceptions on the unborn child. In satirical fashion, Laurence Sterne drew attention to this unresolved question in his masterpiece, *The Life and Opinions of Tristram Shandy*, which he began in 1759. Tristram's father felt that the unhappy circumstances of his

son's conception would make him more vulnerable than usual to 'sudden starts, or a series of melancholy dreams and fancies for nine long months together'. Tristram lamented:

> I wish either my father or mother, or indeed both of them, as they were in duty both equally bound to it, had minded what they were about when they begot me: had they duly considered how much depended on what they were doing; – that not only the production of a Rational being was concerned in it, but that possibly the happy formation and temperature of his body, perhaps his genius and the very cast of his mind; – for aught they knew to the contrary, even the fortunes of his whole house might take their turn from the humours and depositions which were then uppermost.

The fact that the state of the clock (or, perhaps, of her menstrual cycle) and the completion, or otherwise, of its monthly winding, had been uppermost in his mother's mind at a critical stage of his 'begatting' worried Tristram. ' – I tremble to think what a foundation had been laid for a thousand weaknesses both of body and mind, which no skill of the physician or the philosopher could ever afterwards have set thoroughly to rights.'[17]

The question as to whether Mary Toft had been affected so that her offspring bore a resemblance to the animals which had startled her in early pregnancy seemed a very real one at the time. Reports of such occurrences had been published before: John Maubray, surgeon and man-midwife, had written in *The Female Physician* (1724) that if an animal such as a cat happened to jump up on a pregnant woman, it would, in his opinion, immediately impress a corresponding mark upon the child she was bearing unless that part were immediately wiped.[18] What might be considered as ignorance with regard to conception and 'generation' in the twentieth century should be understood in the context of medical understanding in the early eighteenth century.

A publication which came in the wake of the Toft case draws attention to the continuing controversy with regard to the effect of the mother's imagination over the foetus. This was designed to attack 'a vulgar Error, which has been prevailing for many Years, in opposition to Experience, sound Reason, and Anatomy; I mean the common Opinion, that Marks and Deformities, which Children are born with, are the sad Effect of the Mother's irregular Fancy and Imagination.'[19] Blondel, a medical practitioner and author of this publication, aimed his attack against a treatise written by another member of the medical profession, Daniel Turner MD, who had written as recently as 1723 about defects in the foetus arising from the force of the mother's imagination.[20] The foetus supposedly could be influenced by such things as a strong longing in the mother for something in particular, in which the desire of the mother was either gratified or disappointed, by a

sudden surprise, by the sight and abhorrence of an ugly and frightening object, by the pleasure of looking upon or of contemplating some delight, by fear and consternation, by excess anger, grief or joy.

Popular belief is expressed by Mr Wilson, the gentleman in Fielding's novel *Joseph Andrews* (1742), who, in discussing his long-lost son, told Parson Adams that 'He should know him amongst ten thousand, for he had a mark on his left breast, of a strawberry, which his mother had given him by longing for that fruit.'[21] Smollett, who was a doctor with an interest in midwifery, satirised this attitude later in his novel *The Adventures of Peregrine Pickle* (1751), in which the supposedly pregnant Mrs Pickle had plucked a peach and was about to eat it:

> Mrs Grizzle perceived the rash attempt, and running up to her, fell upon her knees in the garden, intreating her, with tears in her eyes, to resist such a pernicious appetite. Her request was no sooner complied with, than recollecting that if her sister's longing was baulked, the child might be affected by some mark, or deplorable disease, she begged as earnestly that she would swallow the fruit, and in the mean time ran for some cordial water of her own composing, which she forced upon her sister, as an antidote to the poison she had received.[22]

Turner had provided many instances to support his thesis, one of which was quoted by Blondel under the heading of 'Bartholin's cat':

> At Leyden in the Year 1638, a Woman of the meaner sort, who lived near the Church of St Peter was delivered of a Child well shaped in every Respect, but had the Head of a Cat, Imagination was that, which had given Occasion for this Monster: for being big with Child, she was frightened exceedingly by a Cat gotten into her Bed.

Many of the circumstances thought to be associated with the begetting of 'monsters' were evident during Mary Toft's 'pregnancy', the result of which might not have seemed completely incomprehensible at a time when 'monster' births were alleged to have occurred under similar provocation.[23]

Theological opinion seemed equally divided. A learned clergyman, Whiston, wrote a pamphlet to prove that Mary Toft's 'monstrous conception' was the completion of a prophecy of Esdras. This had included the omen that: 'wild beasts shall change their places, and menstruous women shall bring forth monsters.'[24]

What were people to believe?

Hogarth, an intelligent man who was alert to contemporary issues, lived in this climate and would have been aware of the questions and debates taking place and of the interest that was aroused by the astounding claim made by Mary Toft and her associates, which was supported by supposedly learned men.

Another contemporary interest to which Hogarth subscribed, and in which he already showed some aptitude, was that of physiognomy. Charles LeBrun, one of the foremost history painters of the seventeenth century, who helped to found the French Academy, worked to establish a framework of rules for academic art, in particular a system for depiction of character and passion as displayed in the expression and features.[25] The outer aspect, it was thought, was expressive of the inner man. LeBrun had looked for inspiration to the works of the Old Masters and felt that the passions depicted by these artists were essential for the production of a dramatic and dignified historical picture – the highest art form. Hogarth's skill in physiognomy is apparent in his works, including his print of Mary Toft, in which the characters are given appropriate expressions and gestures. Hogarth's 'physiognomic types' are related to aspects of social distinction. Social personality has been described as a creation of other people's thoughts, and thoughts, if verbalised frequently, can be metamorphosed into stereotyped images. Dress, stature, ugliness or physical deformity, therefore, could be used as signifiers of the physiognomy or character of the individual and of his social status.

These are not the only issues highlighted in Hogarth's print. Hogarth illustrates a man-midwife delivering Mary Toft's rabbits. The rise of man-midwifery was an area fraught with charges of professional and sexual misconduct. A woman who succumbed to the ministrations of a man-midwife was charged with immodesty and the midwife with immorality. Traditional midwives felt that their position was threatened by the man-midwife, and physicians who claimed that midwifery came within their purview – although the subject seemed more naturally aligned to surgery – opposed the intrusion of the surgeons in this area: the surgeons as men-midwives might gain access to the physicians' patients and take over their general treatment.

In the light of the above comments, Hogarth's print, *Cunicularii, or The Wise Men of Godliman in Consultation*, can be seen to encompass many aspects of contemporary concern. The subject matter of the print, the mock-heroic type of bedside drama, and the vulgarity of some of the physiognomic features of those depicted demonstrate the artist's subversive tendencies, as does the title of the print, associating the arrival of the medical 'wise-men' at the birth with those traditionally associated with the biblical theme.

The print was published on 12 December 1726, a few days after Mary Toft had made a full confession of fraud. The title 'Cunicularii' (*cuniculus* is Latin for rabbit or coney) implies that Mrs Toft is the equivalent of a rabbit-burrow. The word could also be used to mean an underground passage, and vulgar associations would not have been lost on Hogarth's readers. The 'Wise Men in Consultation' at her 'confinement' are portrayals of well-known participants in the affair. Doctors were often portrayed 'in consultation', or collusion, fees being increased according to the number of consultants

present, although such consultations were not always perceived by the public as being in the best interests of the patients. Hogarth provides clues to the identities of the participants by means of attributes given to the lettered characters in the underlying key. Identification of these figures is an essential first step in any detailed reading of the print. Effective satire had to be based on fact, and the identification of well-known characters was a prerequisite to the success of the print. If the attributes of those most concerned in the events are considered in conjunction with those provided by Hogarth, there seems to be little doubt, in most instances, about the identity of the individual being satirised.

'A' is described as 'The Dancing Master or Praeternatural Anatomist'. This character is most likely to be Mr St André, whose role has been described. Hogarth's illustration depicts him with a fiddle, or violin, under his right arm and in his right hand a specimen of a 'praeternatural' rabbit, its ears overhanging the board or card on which it is held. A fiddle alludes to musical prowess, as does the right leg raised in dancing posture, but a 'fiddler' may also allude to one who cheats or deceives. 'Fiddle-faddle' was a popular term applied to trifling or nonsensical discourse or to a 'trifler',[26] terms which might be said to apply to St André. In his left hand, St André holds up a scalpel or phallic stiletto in preparation for a dissection such as might be carried out by an anatomist, and as a symbol of the lust attributed to men-midwives and to him in this role in the print. The gestures, clothing and general appearance place him in 'polite' society, befitting his role as a placeman from the Royal Court.

Henry Fielding wrote that the human species was divided into two sorts of people, 'to-wit, *high* people and *low* people . . . High people signify no other than people of fashion, and low people those of no fashion.'[27] However this concept of fashion, he added, had lost its original meaning and was generally held to include a conception of birth and accomplishments superior to the herd of mankind. (The latter term provides another 'animal' attribute for those of low status.) Mr St André's 'high' status owed its position to fashion rather than birth.

'B' is described by Hogarth as 'An Occult Philosopher searching into the depth of things'. This description draws attention to the prevalent search for deep philosophical truths with regard to generation and the distinction between man and animal, and to the physical search for the true nature of Mary Toft's deliveries. Two individuals might qualify for this role. The most likely candidate is Sir Richard Manningham. It was said of him in one scurrilous publication that he was the wearer of a 'grate blak wig'.[28] Hogarth's character has such a wig. The character's transvestite appearance in female gown implies that he is usurping the traditional female role of midwife. As has been explained, this was a time when men-midwives were

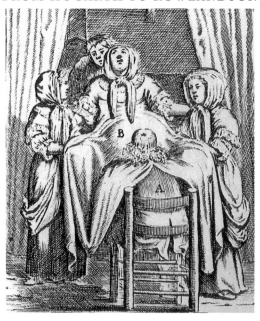

6. UNKNOWN DUTCH ARTIST: *The Man-Midwife*

increasing in number in London, amid controversy, and opportunities to make fun of the man-midwife were rarely missed. The physician's search beneath the voluminous skirt of Mrs Toft can be seen as a parallel with a Dutch print depicting a man-midwife performing a blind delivery with a sheet tied round his neck in order to preserve the lady's modesty [6].

One alternative suggestion for character 'B' is Molyneux, Secretary to HRH the Prince of Wales, who accompanied Mr St André to Godalming to deliver a rabbit. An article in the *Gentleman's Magazine* of 1842 suggests that the comments made about this character (B) were not in keeping with the sedate Manningham, but rather in accordance with 'novice and experiment-seeking' Molyneux, who prided himself on philosophical investigations and 'was the inventor or improver of a Telescope of which he boasted not a little' (p. 367). Molyneux (1689–1728) constructed a reflecting telescope in 1724, one of the earliest in England. He was a Fellow of the Royal Society and also a politician. The writer in the magazine thus equates him with the 'occult philosopher searching into the depths of things'. He also refers to verse XIII in Pope's broadsheet *Discovery: or The Squire turned Ferret* which was produced at this time, and to verse XXI which includes the words 'Molly had Ne'er a midwife been'.

Yet another suggestion is that Hogarth conflated the two characters, Molyneux and Manningham, into the one individual portrayed.[29] The print

and the ballad are not necessarily connected, and on balance it seems more likely that 'B' – seen fulfilling the role of man-midwife – represents Manningham, who played a key role in the proceedings as described.

'C' is described as 'The Sooterkin Doctor Astonish'd'. Mr Maubray, surgeon and man-midwife, was also involved in the rabbit affair and seems to be the most likely contender for this role. He had described the delivery of 'Deformed Conceptions' in *The Female Physician*, which includes descriptions of some particular births, especially in Holland. These were:

> often attended and accompany'd with a Monstrous little Animal, the likeness of any thing in shape and size to a MOODIWARP, having a hooked snout, fiery sparkling Eyes, a long round Neck and acuminated short Tail, of an extraordinary Agility of Feet. At first sight of the World's Light, it commonly Yells and Shrieks fearfully; and seeking for a lurking Hole runs up and down like a little Demon . . .
> (p. 375)

Following one such delivery, Maubray heard some of the company call it 'de suyger'. Its conception was traditionally held to be due to a woman spending too much time near her stove, the heat and dirt from which resulted in a 'Sooterkin'. However, the words 'soot erkinds' in Dutch mean 'sweet children' and 'de suyger' also means 'sweet' – a misconception on Maubray's part exploited by Hogarth. This serves to illustrate the belief that the outcome of a pregnancy could be influenced by external ante-natal events.

Ronald Paulson has suggested that 'C' represents Mr Ahlers. His name is inscribed on the impression in the Royal Library. His exclamation of 'A Sooterkin', it is postulated, is merely an allusion to Mr Maubray.[30]

The figures 'A', 'B' and 'C', one shown 'bearing gifts', one bending a knee and one raising his hands in ecstatic wonder, are a satirical representation of the biblical characters in the traditional nativity scene – a theme of high art often produced by the Old Masters of the Italian Renaissance.

'D' is described as 'The Guildford Rabbet Man-Midwife'. Mr John Howard was a surgeon and man-midwife from this town. He was the first medical attendant to see Mrs Toft at Godalming and was subsequently suspected of complicity in the fraud. In the print he is rejecting a rabbit on account of its size. 'It's too big,' he says, as he is offered a specimen by a man who has his finger to his nose in a conspiratorial gesture.

'E', 'The Rabbit getter', is probably Mr Joshua Toft, the lady's husband – the words being intended to portray him as both begetter and procurer of rabbits.

'F', 'The Lady in the straw', is Hogarth's representation of Mary Toft herself, the name 'Mary' being appropriate for Hogarth's biblical analogy. The implied connection between Mary Toft 'in the straw' and animal behaviour in similar circumstances would have been deliberate at this time of

debate over the role of man in nature. In many country districts farmers and poor people made little distinction between themselves and their animals: a woman expecting a baby was said to have 'got upon the nest'.[31] Mary is seen lying on a tester bed with an expression of agony and martyrdom in mock-heroic style. The rabbits at her feet range in size and state of dismemberment. For Hogarth, the fact that rabbits – or 'coneys' as they were sometimes called – were involved in the deception gave an opportunity to use another visual pun. The verb 'coney' means 'to dupe'. Rabbits were traditional symbols of lust and fecundity. The lust attributed to Mary Toft was for financial gain and she duped many people in the attempt to attain her goal. Her fecundity or her prolific 'deliveries' was the cause of her downfall. A verse in a contemporary broadsheet, *The Doctors in Labour* (see below, p. 49), contains the lines:

> 'Tis an unhappiness to be lamented,
> That people ne'er know when to be Contented,
> Had breeding seventeen Rabbits satisfied
> Poor Mary Toft the Plot had still been hid;
> But fond to make the Number up a Score,
> The prying World the secret did explore.

The last verse in this publication refers to the 'Coney-Warren being no more' when the deception was exposed. The numerous rabbits which Hogarth employs in his print are visual allusions to both the facts of the case and to the symbolic and verbal uses of the words 'rabbit' and 'coney'. Longing or lust is also implicit in the desire, or pica (pregnant whim), Mary was said to have for rabbits in her early pregnancy.

'G' is described as 'The nurse or Rabbet Dresser' and represents Mrs Toft's accomplice, the one who helped to 'look after' her and to prepare or 'dress' the rabbits for use.

In physiognomic terms 'E','G','F' and the unmarked character at the door are depicted as vulgar-looking individuals of plebeian stock in country-style dress. Mary and her sister are both inelegantly positioned, displaying muscular hard-worked arms and plain dresses. Such 'low' subjects were considered out of place in 'High Art'. Hogarth offers a comparison between these simple country folk and the aristocratic or 'polite' bewigged and well-dressed members of society with their mannerist gestures – the Court placemen. What Hogarth displays in his subversive manner is a significant role-reversal, the poor and uneducated country-folk playing upon the gullible susceptibilities of their betters, those usually regarded as great and powerful men in society.

The epitaph underneath the print,

> They held their Talents most Adroit
> For any Mystical Exploit[32]

comes from Samuel Butler's satire on puritanism, *Hudibras*, and refers to the relationship between fiction (high art) and realism (what was actually happening), heroism and mockery, and the consequences that resulted when these were confused.

Hogarth's print was well received. It was traditionally said that he was paid by some surgeons to produce it.[33] If this were so, it might indicate a willingness, and even some eagerness, on the part of these gentlemen to expose the failings of some of their 'superiors'. Physicians were generally recognised as being superior to surgeons both in class and professional status, the latter belonging to a mere manual trade.

After the dénouement, the main character in the drama, Mrs Toft, was remanded to Bridewell, the House of Correction, to await trial at Surrey Assizes, but the trial never took place. After a period in Bridewell where she was 'on view' to the public and where she had her portrait drawn by John Laguerre holding a rabbit on her lap, she was released. *Mist's Journal* of 21 January 1727 reported that 'The pretended Rabbit-breeder, in order to perpetuate her fame, has had her picture done in a curious mezzotinte Print by an able hand.'[34]

It was later remarked that in this picture, she 'displays a countenance expressive of utmost vulgarity'.[35] This remark is in keeping with the prevailing belief that character is shown in the features.

Printing presses were kept busy for many months in connection with the affair of the 'Rabbit Woman', but the impression left in the minds of the public was even more lasting. Hogarth re-introduced her into a theme of mass delusion in *A Medley: Credulity, Superstition and Fanaticism* (BM 1785) in 1762, a print in which he attacked both secular and religious credulity.[36]

This episode is not the last that was heard of Mary Toft. Her life of deception evidently continued, and in 1740, she was imprisoned for receiving stolen goods. Her death was reported in 1763. The *Daily Post* of 9 January 1727 describes Mr Howard's fate: 'Mr Howard appeared before the Bench of Justices last Saturday and was obliged to enter into recognisances of £800 . . . concerned in the cheat and conspiracy of Mary Toft, a constable having made an affidavit of an odd sort of conversation he heard pass.'

Many other publications appeared in the wake of the affair. The themes were generally concerned with the 'praeternatural' event and of the gullibility of the medical practitioners who were ridiculed as the truth emerged. Publications included the ballad *The Discovery: or The Squire turned Ferret*, by Alexander Pope, which describes the story:

THE DISCOVERY
(Alexander Pope)

I

Most true it is, I dare to say
 E'er since the Days of Eve
The weakest Woman sometimes may
 The wisest Man deceive

II

For D-----nt circumspect, sedate
A Machiavel by Trade
Arriv'd Express, with News of Weight,
 And this, at Court, he said

III

At Godliman, hard by the Bull,
 A woman thought long barren
Bears Rabbits, -----Gad! so plentiful
 You'd take her for a Warren.

IV

These Eyes, quoth He beheld them clear:
 What do ye doubt my View?
Behold this Narrative that's here:
 Why, Zounds! and Blood! 'tis true.

V

Some said that D--gl-s sent should be
Some talk'd of W-lk--r's merit,[37]
But most held, in this Mifwifery,
 No Doctor like a FERRET.

VI

But M-l-n-x, who heard this told,
 (Right wary He and Wife)
Cry'd sagely, 'Tis not safe, I hold,
 To trust to D-----nt's Eyes.

VII

A vow to God He then did make
He would himself go down,
St A-d-re too, the Scale to take
 Of that Phoenomenon.

VIII

He order'd Then his Coach and Four;
 (The coach was quickly got 'em)
Resolv'd this secret to explore
And search it to the Bottom.

IX

At Godliman they now arrive,
 For Haste they made exceeding;
As Courtiers should, whene'er they strive,
 To be inform'd of Breeding.

X

The good Wife to the Surgeon sent,
 And said to him, Good Neighbour,
'Tis pity that two Squires so Gent--
 Should come and lose their Labour.

XI

The Surgeon with a Rabbit came,
 But first in Pieces cut it;
Then slyly thrust it up that same,
 As far as Man could put it.

XII

(Ye Guildford Inn-Keepers take heed
 You dress not such a Rabbit,
Ye Poult'rers eke, destroy the Breed,
 'Tis so unsav'ry a-Bit.)

XIII

But hold! says Molly, first let's try,
 Now that her legs are ope,
If ought within we may descry
 By help of Telescope.

XIV

The instrument himself did make,
 He rais'd and level'd right,
But all about was so opake,
 It could not aid his sight.

XV

On Tiptoe then the Squire he stood
 (But first He gave her Money)
Then reach'd as high as e'er he cou'd,
 And cry'd, I feel a CONY.

XVI

Is it alive? St Andre cry'd;
 It is, I feel it stir,
Is it full grown? the Squire reply'd
 It is; see here's the FUR.

XVII

And now two Legs St Andre got,
 And then came two legs more;
Now fell the Head to Molly's Lot,
 And so the Work was o'er

XVIII

The woman, thus being brought to Bed
 Said, to reward your Pains,
St A-d-re shall dissect the Head
 And thou shalt have the Brains.

XIX

He rap'd it in a Linnen Rag
 Then thank'd Her for Her Kindness
And cram'd it in the Velvet Bag
 That serves his R---l H----

XX

That Bag ---which Jenny, wanton slut,
 First brought to foul Disgrace;
Stealing the Papers thence she put
 Veal-cutlets in their Place.

XXI

Oh! happy would it be, I wean,
 Could they these Rabbits smother;
Molly had ne'er a midwife been,
 Nor she a shameful Mother

XXII

Why has the Proverb falsely said
 'Better two Heads than one',
Could Molly hide this Rabbit's Head,
 He still might shew his own.

Another ballad, published in 1727, was titled *St André's Miscarriage: or A Full and True Account of the Rabbit Woman*, to be sung to the tune of 'The Abbot of Canterbury'. The seventeen verses include the lines:

1

Physicians, and Surgeons, and Midwives draw near,
Married Women, and Widows, and Virgins give ear,
 For it is a Woman, a Woman I sing,
 Who Rabbets sev'nteen from one C---y did bring.

2

Monsieur St A-d-e, that Anatomist rare,
Says all these same Rabbets praeternatural were;
And faith we must own there is something in that,
For the first that came out, did prove a black Cat.

6

He dissected, compar'd, and distinguish'd likewise,
The Make of these Rabbets, their Growth, and their Size;
He preserv'd them in Spirits, and . . . a little too late,
Preserv'd (Vertue sculp.) a neat Copper-Plate.

The last line of the ballad contains a reference to a drawing which was designed by George Vertue and engraved by his brother, James. It was entitled, *The Surrey-Wonder: an Anatomical Farce as it was Dissected at ye Theatre-Royal Lincolns-Inn-Fields* (BM 1778). Prints from the plate were published on 23 December 1726 [7] and advertised in the *Daily Journal* of that day. It illustrates a room in which Mary Toft, wearing a black mask, is

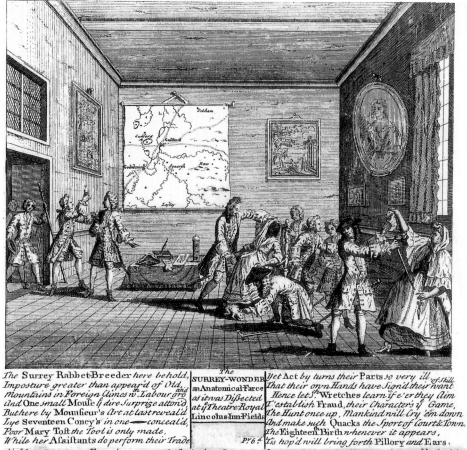

7. JAMES VERTUE: *The Surrey-Wonder: an Anatomical Farce as it was Dissected at ye Theatre-Royal Lincolns-Inn-Fields*

producing rabbits, one of which Mr St André is attempting to catch. Mr Molyneux is shown raising his hands in disbelief or disgust, while Mr Maubray is entering the room and displaying a bottle containing a preserved specimen of 'De Suyger' or 'Sooterkin'. The figures portrayed in the scene are identified in the second state of the print by letters above the characters in a similar fashion to that used by Hogarth in his *Cunicularii*. An accompanying verse reads:

> The Surrey Rabbit-breeder here behold,
> Imposture greater than appear'd of old:
> Mountains in foreign climes with labour groan'd,

And one small mouse ye dire surprize aton'd.
But here by *Monsieur's* art, at last reveal'd
Lye seventeen ------ conceal'd.
Poor Mary Toft the tool is only made,
While her assistants do perform their trade:
Yet act by turns their parts so very ill,
That their own hands have sign'd their want of skill,
Hence let such wretches learn, if e'er they aim
T'establish fraud, their character's the game.
The hunt once up, mankind will cry 'em down,
And make such Quacks the sport of Court and Town.
The eighteenth birth, whenever it appears,
'Tis hoped will bring forth Pillory and Ears.

The scene in turn is a reference to one which had been topically introduced into *The Necromancer: or Harlequin Dr Faustus*, currently being played at the Theatre in Lincoln's-Inn-Fields.[38] In this, Harlequin was converted into a female, pretended to be in labour, and was delivered first of a pig and then of a 'Sooterkin'. At the time there was some conflict in the theatre about the popularity of pantomime and its production in the place of serious works such as those by Shakespeare and Marlowe. Dr Faustus was popular and well-known to theatre-goers. Producer Rich staged his burlesque version of *The Necromancer* in 1723. It was received with acclaim by the theatre-goers but with dismay by those who regarded theatre as a medium for serious work. Rivalry existed between the two theatres in Drury Lane and Lincoln's-Inn-Fields, and a pamphlet was produced reflecting upon these circumstances.[39]

An advertisement in *Mist's Journal* of 17 December shows that members of the Playhouse joined in the general ridicule of St André:

Last week the entertainment called 'The Necromancer' was performed at the theatre in Lincoln's-Inn-Fields, wherein a new Rabbit Scene was introduced by way of episode; by which the Public may understand as much of that affair, as by the present controversy amongst the Gentlemen of the Faculty, who are flinging their bitter pills at one another, to convince the world that none of them understand anything of the matter.

The field of popular entertainment exploited the popularity of themes which revealed professional men or officials as dupes. It was an arena in which to display a rising scepticism concerning popular beliefs, medical accomplishments and institutionalised pomposities. Levels of expertise amongst medical men varied considerably, a circumstance which made the profession vulnerable to satire. Theatrical productions on such a topic as Mary Toft were commercially viable.

Prints from Vertue's plate *The Surrey-Wonder* may also have been those advertised in *Mist's Weekly Journal* of Saturday, 11 January 1727, and published by the purveyors of the 'Anodyne Necklace', 'guaranteed to ward off the congenital effects of syphilis in children' and with specific curative powers:

> The Rabbit affair made clear, in a full account of the whole matter: with the Pictures engraved of the pretended Rabbit Breeder herself, Mary Tofts, and of the Rabbits, and of the persons who attended her during her pretended deliveries, shewing who were and who were not imposed on by her. 'Tis given gratis no where, but only up one pair of stairs at the sign of the celebrated Anodyne Necklace recommended by Doctor Chamberlen for Children's teeth, etc.[40]

Prints were part of a rapidly expanding industry of popular communication in eighteenth-century Britain and they could be used profitably. This is an early example of a popular print being offered as a 'free gift' to attract trade. Purveyors of quack remedies did not lose opportunities to take advantage of the publicity accorded to Mrs Toft and artists employed on their behalf would receive due recompense for their work.

The images by Hogarth and Vertue were not the only ones on the market. A popular broadsheet containing twelve scenes illustrating all the circumstances of the fraud was also produced at the time (BM 1781). Entitled *The Doctors in Labour: or a New Whim Wham from Guildford. Being a Representation of ye Frauds by which ye Godliman Woman carried on her pretended Rabbit-Breeding; also of ye Simplicity of our Doctors, by which they assisted to carry on that Imposture, discover'd their own skill, and Contributed to ye Mirth of His Majesties Liege Subjects*, each scene is accompanied by a verse printed beneath it describing the story [8]. Mr St André is depicted throughout as a harlequin or 'Merry Andrew', a jester or buffoon in a multi-coloured, diamond-patterned outfit. In the final scene St André ends up manacled and seated upon a repenting stool, whilst Mary is taken away to prison by two constables.

None of the doctors involved in the affair was free from attack by writers on 'Grub Street', the hack writers of the day. Dr Douglas was vilified in a pamphlet entitled *A Shorter and Truer Advertisement . . . of Dr D-g-l-s In an Extasy at Lacey's Bagnio December 4th 1726*. This was written in nine verses by 'Flamingo', a nom-de-plume chosen as an allusion to Douglas's particular interest in this bird.[41]

Dr Arbuthnot, who had possibly been duped by Mary Toft like many of his colleagues, was a respectable physician, also remembered as the inventor of John Bull as the archetypal Englishman. He is credited with writing a poem which was entitled *Bunny's Dad*. This was issued in pamphlet form on 16 December 1726; much of it is obscene.[42] Vulgarity was prevalent in many of

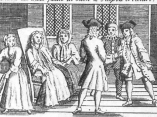
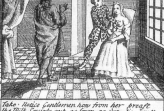

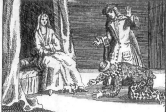
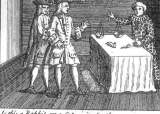
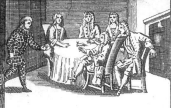

8. UNKNOWN ARTIST: *The Doctors in Labour; or a New Whim Wham from Guildford*

the verses produced at the time. The word 'coney' – pronounced 'cunny' in the eighteenth century, and often printed 'c-n-y' or 'c—y' – lent itself to association with female external genitalia and the sexual act.

Satire fed upon satire. Jonathan Swift published his *Gulliver's Travels* pseudonymously in October 1726, shortly before Mary Toft claimed public attention. The book was written in the style and format of a genuine travel book and was instantly popular. In it Swift made many satirical references to the medical profession using Gulliver, a young surgeon, as his vehicle. A lampoon ascribed to Swift was published in the following year containing Gulliver's supposed reflections on the gullibility of one of the medical men who played a major role in the Toft affair.[43] This is entitled *The Anatomist dissected or the Man-Midwife finely brought to Bed, being an Examination of the conduct of Mr St André Touching the late pretended Rabbit-bearer as it appears in his own Narrative*. He describes how 'our Lilliputian would have distinguished [the rabbit pellets] to have been nothing but a Parcel of mere Rabbit's Dung', adding, 'But if I am rightly inform'd as to the Nature of Mr St André's Education, I am strangely surpriz'd that He, of all People, should appear so unaquainted with the Materials of which the Strings of a Fiddle are compos'd.' The pun on the word 'Touching' on the title-page of the lampoon would have been appreciated by many of Swift's and St André's contemporaries – a word referring to the clinical practice of vaginal examination of a woman but popularly associated with malpractice and accusations of 'touching up' on the part of a man-midwife, and a highly charged sexual issue. The orthodox physician rarely examined his patients physically apart from palpating the pulse; there did not seem to be any necessity. History-taking and outward appearances provided most of the information required. Any physical examination was regarded as disturbing and threatening, especially one so intimate.

The affair and the publicity accorded to it expose another problem which persisted throughout the century, namely, the difficulty that the public experienced in differentiating between legitimate (or orthodox) and 'quack' medicine, both in terms of the practitioners involved and the medical procedures employed. Even in the late eighteenth century a procedure such as vaccination against smallpox, later recognised as beneficial, was regarded with understandable suspicion and even horror. Many fashionable treatments had come and gone, and who could believe that vaccination, which involved the introduction of matter from a cow into man, would be any more effective in preventing smallpox than, for example, the anodyne necklace had been in its recommended sphere? In addition, the idea that diseases from 'brutes' might be incorporated into man and that the bounds between the two might not be clearly defined continued to cause problems.[44]

One surgeon, Thomas Braithwaite, was concerned about the long-lasting

effects that the episode and its repercussions might have on the credibility of members of the medical profession. He penned his concern in topical form, conflating the events with Gulliver's experiences:

> It's well known that the Town had lately been amused with idle Relations by the Gullivers, St André's and Howards of the Age; and it is as certain that these Amusements have been carried on in their respective capacities of Surgeons, Captains, Dancing-Masters, Anatomists, Men-Midwives, Warreners, Coney-Catchers, etc. and they don't stick to tell us that there are Men of the size of one's little Finger, and others Sixty Foot high – and there are Flying Islands and Rational Horses; and that Human Excrements may be changed into Porraceous Matter, and that Mary Toft of Godliman has been delivered of Seventeen Rabbets; and that notwithstanding the Fraud is detected, an Account of the Delivery of the Eighteenth will be soon publish'd. When I reflect upon this strange Gallimatias, I am chagrin'd to think that the valuable Arts of Surgery and Anatomy must necessarily be brought into contempt by such monstrous Relations . . .[45]

He goes on to point with scorn at the facts which had deluded St André. The episode made a deep impression upon many people and Braithwaite was probably correct in his assessment of public opinion with regard to the medical profession, even though many of the latter claimed wisdom after the event.

The description of events surrounding the 'Rabbit Woman' demonstrates the high level of public interest engendered by such an occurrence, and shows the rapid response and counter-response met with in all kinds of popular media – newspapers, journals, pamphlets, poems, stage-plays and prints. The medical profession did not emerge with much credit.

This early work of Hogarth's embraces a wide range of social and scientific concerns, but without a full understanding of the parameters of its meaning, it might be dismissed as merely a minor production of a young artist. Even at this relatively early stage of Hogarth's career his representation of events illustrates his ability to draw – albeit somewhat subversively – upon the tradition of European history painting to give eloquent power to his composition and characterisations. The traditional death- or sick-bed scene flanked by figures whose gestures and expressions reinforce the narrative offers a particularly clear perspective of events. His artistic skills would have been appreciated by his artistic contemporaries. His satirical skill is directed at those involved in the Toft deception and also at the subversion of the grand rhetoric of history painting. In spite of the bizarre nature of this print of Mary Toft, Hogarth's interpretation of the event deserves to be taken seriously; in many ways it forms the foundation of his later narrative works.

II. THE COMPANY OF UNDERTAKERS

Et Plurima mortis imago.
(Everywhere the image of death)

The early eighteenth century was a period in which a new-found freedom of expression flourished on subjects ranging from politics and religion to such topics as hypocrisy in society and contemporary social and moral values. Traditional class systems were questioned with the rise of a middle or thinking class which had evolved since the Revolution of 1688. The professions, including that of medicine, did not escape scrutiny. A political paper, *The Craftsman*, started by Bolingbroke and Pulteney and first published on 5 December 1726, professed to be 'A Critique of the Times'. Initially it was published daily, but the following year it was changed to a weekly journal, the *County Journal, or Craftsman*. One of its aims was to expose 'how craft predominates in all Professions'. It describes the 'Faculty of Physic' as one which:

> abounds with Imposters, Cheats and ignorant Pretenders . . . in which number I include, not only those who call themselves regular Physicians, Surgeons, and Apothecaries, but likewise all persons who make it their business to preserve health and repair human conditions . . . they are for ever abusing one another as Quacks, Empirics, and ignorant Pretenders, recommending their own remedies to us as the only original and truly prepared specificks; at the same time they kindly forewarn us to beware of Imposters, trumpt up in imitation of their approved rememies [sic]; for which purpose they direct us to their shops or houses, and seal their preparations with their own Coats of arms to prevent counterfeits.

The writer continues:

> I shall enquire into the true nature of Quackery . . . wherever I find it, from the great Leeches of State, down to the humble astrological Physicians in Barbican and Moorfields: . . . whether they are Graduates, or not; Fellows of the College, or Licentiates only; whether they loll at ease in Spring Chariots, or plod the Streets in a thread-bare Cloak; whether their Fee is a guinea or a shilling; whether they kindly invite you to their houses at certain hours, or will hardly come to yours, if you send for them; whether they are favourite Court-Opicers, Stage-Mounte-banks, itinerant Horse-Doctors, Peripatetick Tooth-drawers, Oculists, Corn-cutters, or Barber-surgeons; whether they are old Men or old Women; first-born or seventh-born Sons; English, French, or High German Doctors . . .[46]

This extract gives an idea of the variety of people who were involved in some sort of medical practice. Nine years later, Hogarth produced his comment upon the prevailing situation in his engraving *The Company of*

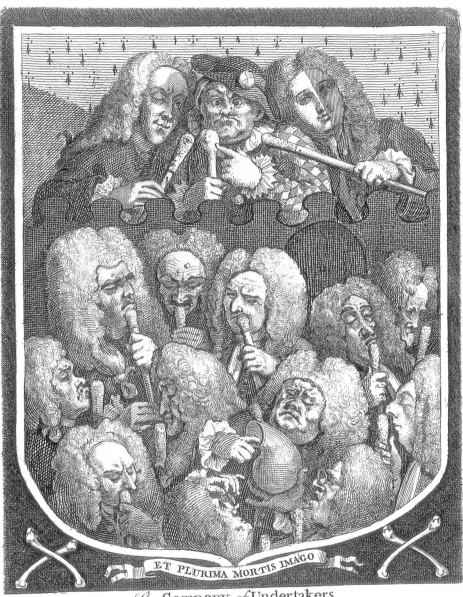

ET PLURIMA MORTIS IMAGO

The Company of Undertakers

Beareth Sable, an Urinal proper, between 12 Quack-Heads of the Second & 12 Cane Heads Or; Consul-
tant. On a Chief Nebulæ, Ermine, One Compleat Doctor iſſuant, cheekie Suſtaining in his
Right Hand a Baton of the Second. On his Dexter & Siniſter ſides two Demi-Doctors, iſſuant
of the Second, & two Cane Heads iſſuant of the third; She firſt having One Eye conchant, to-
wards the Dexter Side of the Eſcocheon; the Second Faced per pale proper & Gules, Guardent. —
With this Motto: — Et Plurima Mortis Imago.

A Cane broken with a Caution; or Honourable Personage, borrowed from the Greeks & is a Word signifying a Head, or the Head is the Chief Part in a Man; or the Chief in the Escocheon should
Honored of Such only, where Right Heralds have procured them Chief Place, Eminence, &c. amongst Men. Guillim
Reckoning of Clouds in Armes (with Upton) doth impart some Excellence. Published by W. Hogarth. March the 3. 1736.

Price Six pence

9. WILLIAM HOGARTH: *The Company of Undertakers*

Undertakers [9] which seems to encapsulate the commonly held attitude towards the medical profession that it was not always easy to distinguish the orthodox medical practitioner from the quack or charlatan and that, in fact, the dividing line between the two was rather ill-defined and the result of their ministrations similar. This was again a topical engraving. The print consists of 'portraits' of contemporary orthodox practitioners and three notorious unorthodox practitioners. The latter are represented as a 'trinity of Doctors' and appear in the upper part of the picture, designed as an escutcheon. The three were frequently in the news in the autumn of 1736, although each had been individually mentioned earlier. Some description of the exploits of the characters depicted and of the meaning of the heraldic terms used in the print goes some way towards explaining its meaning and the reason for the commonly held attitude towards the medical profession.

The etching and engraving for the print was completed by Hogarth in 1736 and prints were published on 3 March of that year, priced six pence. Hogarth's early years working as an engraver on heraldic designs and decorations provided him with the background knowledge necessary for this satire on the medical profession which is presented as a coat-of-arms for it. Originally, Hogarth had intended to call the print 'A Consultation of Physicians', but he changed this to its present title; both titles express his cynical opinion of the profession. The 'arms' as presented generally follow the rules used in heraldry but with some satirical additions, intentional puns and contemporary allusions. Topicality was an important factor in connection with both the publicity which this would engender and in order to portray a message realistically.

Hogarth also made play upon the historical connection between heraldry and the organisation of funerals. In early modern England, the fellowship of the College of Heralds had laid down rules regarding the number of mourners and types of armorial display allowed in the event of the decease of a member of the nobility. Their control encompassed the use of heraldry on monuments and commemorative plaques. These employed visual signs in a symbolic way in order to identify individual members of families and to indicate their rank. The heralds symbolised the stability and order of the state.[47] From the late seventeenth century, the heralds were challenged by men now called 'undertakers' – tradesmen with skills associated with funerals who took over the whole 'undertaking'.[48] Hogarth drew upon this theme using the undertakers, with mock-solemn expressions, holding batons – traditionally carried by those marshalling funerals – and linking them with the stereotyped doctors with their canes and solemn expressions when 'in consultation'.

The coat-of-arms provided by Hogarth is enclosed within a black border on which cross-bones are placed in such a position as to represent 'supporters'. Supporters are usually figures placed in a position of 'defence' on each side of

an escutcheon. They are regarded as a great honour in heraldry and only granted in special cases, although originally their appearance was a means of filling in blank spaces at each side of a round seal. Artists often depict beasts supporting or holding up the shield.[49] The black border signifies recent death as do the cross-bones, which also symbolise piracy and poison, and these, with the underlying motto ET PLURIMA MORTIS IMAGO (Everywhere the image of death)[50] are used by Hogarth to convey the impression that the images on the shield – in this case, the 'doctors' and 'quacks' – are associated with death no less than are the 'undertakers'. Swift too, had satirically associated doctors with death. Gulliver, whilst on his 'Travels', described how a prognostication of death was always within the doctors' power; recovery was not: 'rather than be accused as false prophets, they [the doctors] know how to approve their sagacity to the world by a seasonable dose.'[51]

Underneath Hogarth's coat-of-arms, making play with the technical language of heraldry, is written:

> Beareth Sable, an urinal proper, between twelve Quack-Heads of the Second and twelve Cane Heads Or, Consultant. On a chief Nebulae, Ermine, One Compleat Doctor issuant, checkie sustaining in his Right Hand a baton of the Second. On his Dexter and Sinister sides two Demi-Doctors, issuant of the second, and two Cane-Heads, issuant of the third, the first having One Eye couchant, towards the dexter side of the Escutcheon, the second Faced per pale proper and Gules, Guardent.

These words contain clues to the meaning of the print and lead to proper understanding of Hogarth's satirical comments.[52]

Beareth Sable, an urinal proper' – means that the field or background of the coat-of-arms is sable-coloured or black when used in heraldry and displayed by cross-hatching when portrayed in black and white [10], and the urinal on

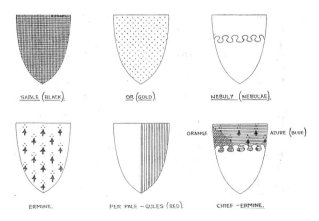

10. Diagram of heraldic terms for *The Company of Undertakers*

this field is the first, central and most important detail to be noted. 'Proper' is the natural colour and has no hatching or shading. One of Hogarth's medical men is holding a large urinal or urine flask to which reference is made, inspecting it through his eye glass, whilst a colleague is dipping his finger into the contents.

Between twelve Quack-Heads of the second and twelve Cane Heads Or, Consultant – the syntax in this phrase indicates that the Quack Heads (meaning those of the medical men in the lower part of the escutcheon) and the Cane Heads are judged equal in importance. By convention in heraldry, the word for a colour must only be used once. Thereafter, its appearance is referred to by number. 'Proper' is the second colour mentioned and becomes 'Of the second', meaning that the Quack Heads in the print are portrayed without hatching or shading. 'Or' means 'Gold', referring to the gold-headed canes held by the 'Quacks'. This colour becomes 'Of the third' at subsequent mention. The word 'Consultant' is not a recognised heraldic term but Hogarth may have introduced it to account for the activities of the occupants of the coat-of-arms as seen 'in consultation' around the urine flask. It was customary for more than one doctor to be consulted, and disagreement with regard to diagnosis and treatment was often the result. If this were so, the junior was expected to defer to the senior colleague. In 1753 the Royal College of Physicians gave a ruling that this was the expected practice. If it were found unacceptable, a third practitioner should be consulted.[53] This multiplicity of doctors in consultation is part of Hogarth's comment upon the practice and was noted in the print of Mary Toft, whose attendants were said to be 'in consultation'.

The upper part of Hogarth's coat-of-arms is separated from the lower by the type of wavy line termed a 'Nebuly' or 'Nebulae', and the part above this line is termed the 'Chief', the background of this being 'Ermine'. The incumbents of this section of the escutcheon are therefore *on a Chief Nebulae, Ermine*.

The central figure in the upper part of the escutcheon, whose upper half is drawn facing forward, is described in the words *One compleat Doctor issuant*. *Checkie* refers to the chequered or harlequin outfit worn by this figure, and the baton or cane held in the right hand is a bone *of the second* (natural) colour. The bone in question is a large humerus (upper arm bone) and may represent an extension or superior power accorded by Hogarth to the natural member of the holder in the print, who was a bone-setter by trade. It also represents an imitation of the canes held by the orthodox practitioners and by the funeral marshals.

Dexter and *sinister* indicate the right and left sides as depicted facing outward, and the *Demi-Doctors* in these positions are presented partly obscured by the central figure, each forming half a 'complete' doctor. The

term also describes their upper halves in heraldic terms. These characters are in their appropriate colours. The first 'demi-doctor' has an eye *couchant*, meaning lying down or 'sleeping'; his eyelid is closed and the eye has been transferred to the head of this individual's cane. Hogarth is possibly employing the closed eye as a visual pun for the operation of 'couching' which was carried out by the character depicted – who was an oculist – for the treatment of cataracts. The resultant wink given to his features may be associated with his ability to 'hoodwink' his clients. The term 'sinister' has a double meaning when applied to the 'doctor' on the left-hand side. This individual's accomplishments were not always regarded with equanimity.

Faced means looking outward, as does the character on the left-hand side of this part of the escutcheon, but may also refer to the features of his face which are described in the ensuing words. *Per pale* is a description of a vertical line or division in heraldic terms, and *Gules* refers to the colour red. Hence, the phrase *Faced per pale proper and Gules* means that the left half of the face of the second 'demi-doctor' is of natural colour and the right half red. *Guardent* means facing to the front. The individual portrayed by Hogarth in this way had a port-wine stain birthmark on his face to which he owed his pseudonym 'Spot Ward'. Hogarth has illustrated this in heraldic terms.

The 'Ermine' background is placed on an azure or blue colour according to heraldic markings, and to the dexter (right) side is a type of hatching which indicates orange colouring. This may imply the glowing success and esteem pouring upon the occupants of this section of the escutcheon who are literally head and shoulders above the rest, their heads being in the sky above the clouds which are signified by the Nebulae. Hogarth's footnote says that *The bearing of Clouds in Armes doth impart some excellence.*

Towards the left-hand side of the field is a circular area named a 'roundle' in heraldic terms which has been interpreted as a 'pellett or ogress'.[54] The former meaning, which would indicate a pill, seems a possibility; its large size is in keeping with the large quantities of medication dispensed without apparent benefit, but its resemblance to a door or archway may denote the ease with which the occupants of the two regions might be interchanged both physically and metaphorically with only a 'nebulous' line between them.

Hogarth chose the occupants of the escutcheon carefully. The twelve Quack Heads are said to portray some of the physicians of the day,[55] one of whom is supposedly Dr Pierce Dod (1683–1754).[56] This gentleman was an Oxford graduate and became a Fellow of the Royal College of Physicians in 1720. He had been appointed as Censor for the College on two occasions before the publication of Hogarth's print – in 1724 and 1732 – and was made a Fellow of the Royal Society in 1730. He held a position of Physician at St Bartholomew's Hospital from 1725 until his death. He was generally regarded as a pompous man and he was a determined opponent of smallpox

inoculation.[57] These qualities may account for his inclusion in the print. Smallpox was prevalent during the eighteenth century and inoculation was introduced by Lady Mary Wortley Montagu, wife of the British Ambassador in Turkey, in 1717 and was widely practised.

One of the other occupants is Dr John Bamber.[58] He trained as a surgeon and practised as such in the City of London for many years, amassing a fortune and acquiring large estates in the County of Essex. Then he practised as a physician, for which he received a dismissary letter from the Company of Barber-Surgeons who disenfranchised him from their Company in July 1724. He became a Licentiate of the College of Physicians on 5 October 1724 and obtained an MD from Cambridge in 1725. He was also connected with St Bartholomew's Hospital as an anatomist, physician and man-midwife. The latter occupation, as the subject of some controversy, perhaps accounts in part for his presence in the print. In addition, he resigned as lithotomist at the hospital in 1731 because the Board of Governors would not elect his son-in-law as his assistant. Hogarth had been appointed to the Board of Governors on 25 July 1734, so is likely to have been aware of this incident.

Physicians were seldom seen without their gold or silver-topped canes, the heads of which often contained vinaigrettes or pomanders with supposed disinfectant properties. Their fifteenth-century predecessors had used a sponge impregnated with similar substances and held to the nose, indicated in a woodcut from a medical text of 1493.[59] The pose of cane to nose was later stereotyped as being an affectation adopted by the profession and indicative of their arrogance and unwarranted superiority. It has been said that there were three criteria by which physicians could be recognised: their gravity, their cane heads and their periwigs.[60] Hogarth's doctors fulfil these criteria. Nine of them are sniffing their cane heads, whilst a large urinal (an emblem of medical themes used by artists for centuries and seen in many Dutch genre scenes) is being scanned by three others, two of whom are holding eye-glasses. The contents are being tasted by the third. Urinoscopy, or water-casting, was a medieval means of diagnosis based on the state of the stars and the inspection of the urine. Dr Thomas Willis (1621–75) anatomist and physician, discovered diabetes by detecting the sweet taste of urine, and the print may allude to this. All the 'doctors' display features of learned contemplation. The size of the urinal may indicate the importance which seemed to be attached to such an article.

Above the Nebulae are three figures who would have been familiar to Hogarth's viewers. It is significant that Hogarth refers to them as 'doctors' in his escutcheon. (He refers to the real 'doctors' in the lower part as 'quacks'.) Mrs Mapp or 'Crazy Sally' as she was sometimes called, was a notorious bone-setter who had learnt the trade from her father who was a farrier and bone-setter in Wiltshire. Hogarth has awarded her the 'Chief' or central

position in the escutcheon and has given her a humerus bone to hold – an intentional pun, perhaps. He explains Mrs Mapp's position in his footnote to the print which states:

> A Chief betokeneth a Senatour or Honourable Personage, borrowed from the Greeks, and is a word signifying a Head, as the Head is the Chief Part in a Man, so the Chief in the Escocheon should be a Reward of such only, whose High Merites have procured them Chief Place, Esteem, or Love amongst Men.[61]

On Mrs Mapp's left-hand side, Hogarth has portrayed Joshua 'Spot' Ward (1761). He was a notorious figure who rose to fame and fortune by the dispensing of a 'Pill' or 'Drop' of dubious merit. He, like Mrs Mapp, had no medical training; he had started his working life in a drysalter's business. He was mistakenly elected as a Member of Parliament in 1716 due to an error in returns, and later fled to France at the time of the Jacobite uprising. Whilst there, he 'invented' the medicine which made him famous and wealthy.

The third member of the trio 'honoured' by Hogarth as head and shoulders above the conventional medical practitioners was known as 'Chevalier' John Taylor (1702–72). This gentleman possessed a medical degree and had studied under surgeon William Cheselden (1688–1752) at St Thomas's Hospital. He became an oculist but he eschewed a conventional life-style and practised in itinerant fashion. His flamboyant life-style and colourful vocabulary earned him his place above Hogarth's Nebulae.

Hogarth indicated the extent of Mrs Mapp's ignorance by dressing her in a checked harlequin outfit such as was often worn by a quack's zany or assistant. She was, however, a highly successful bone-setter – hence her ossified baton, to the head of which she points purposefully – her profession more in keeping with a farrier of the time than a surgeon and dependent upon strength and possession of the 'knack' or art. Sarah Wellin, as she was then called, wandered from her home and settled in Epsom. Epsom in 1736 was a watering-place and a centre of fashionable company. Epsom water had been known for its medicinal properties since the early seventeenth century, and first described by Dr Nehemiah Grew, FRS (1628–1711). He extracted the salt and patented the process in 1698.[62] Young Sarah, according to a *London Magazine* of the time, 'had wrought such cures as seem miraculous in the bone-setting way.'[63] She was briefly married to Mr Hill Mapp, who soon parted company from her in possession of much of her newly acquired wealth, but she quickly recovered from this temporary setback and became remarkably successful. She was even consulted by the Queen. At the height of her popularity she travelled to London once a week in a coach with four horses and outriders and footmen to the Grecian Coffee-House, where she made her headquarters for these visits and where she carried out some of her cures. One of these was upon the niece of Sir Hans Sloane, to the mutual

satisfaction of all parties. In spite of her ugliness and obesity (Hogarth has provided her with a strabismus or squint), poets versed her praises and ballads were sung about her.

Artists, playwrights and journalists made use of these three individuals and their activities in a similar fashion to the way in which they had exploited the events surrounding Mary Toft. The *Daily Journal* of 18 October 1736 contained the following notice:

> On Saturday Evening there was such a Concourse of People at Lincolns-Inn-Fields to see the famous Mrs Mapp, that several Gentlemen and Ladies were obliged to return back for want of Room. She came there about Eight o'Clock in her Coach and Four . . . The Confusion at going out was so great, that several Gentlemen and Ladies had their Pockets picked.

Plays which were enacted on that evening 'By Desire of Mrs. Mapp, The Famous Bone-Setter of Epsom', were *The Wife's Relief: or The Husband's Cure* and *The Worm Doctor*. The cast of the latter included 'Harlequin Female Bone-Setter' and a 'Doctor Pestle'.[64] The following ballad was sung during the performance:

> While Mapp to th' actors shew'd regard,
> On one side Taylor sat, on th'other Ward
> When their mock persons of the drama came
> Both Ward and Taylor thought it hurt their fame;
> Wonder'd how Mapp cou'd in good humour be
> -Zounds! cries the dame, it hurts not me,
> Quacks without art may either blind or kill,
> But demonstrations shews that mine is skill.
> You surgeons of London, who puzzle your pates,
> To ride in your coaches, and purchase estates,
> Give over for shame, for pride has a fall,
> And the Doctress of Epsom has out-done you all,
> <div align="right">Derry down.</div>
>
> In physic, as well as in fashions, we find,
> The newest has always its run with mankind;
> Forgot is the bustle 'bout Taylor and Ward,
> And Mapp's all the cry, and her Fame's on record.
> <div align="right">Derry down.</div>
>
> Dame Nature has given her a doctor's degree,
> She gets all the patients, and pockets the fee;
> So if you don't instantly prove it a cheat,
> She'll loll in her chariot whilst you walk the street.
> <div align="right">Derry down.</div>

As Hogarth's print preceded this production, it would appear that his juxtapositioning of the 'Trinity of Quacks' in his print led to their association in other artistic, literary and even social spheres. The *London Daily Post* of 21 October 1736 made the comment that 'Yesterday she [Mrs Mapp] was elegantly entertained by Dr Ward, at his house in Pall Mall.' A partiality to drink led to Mrs Mapp's downfall, and she died in obscurity and poverty in December 1737: 'Died last week at her Lodgings, near the Seven Dials, the much-talked-of Mrs Mapp, the bone-setter, so miserably poor that the parish was obliged to bury her.'[65]

Joshua Ward, who is portrayed on Mrs Mapp's left-hand side in Hogarth's print, returned to England from his exile in France in 1733 following a pardon from George II. His arrival was heralded in the *Gentleman's Magazine* under the heading of 'Monthly Intelligence', July 1733, thus:

> There was an extraordinary Advertisement this month in the Newspapers, concerning the great cures in all Distempers perform'd with one medicine, a Pill or a Drop, by Joshua Ward, Esq; lately arriv'd from Paris, where he had done the like Cures. 'Twas said our Physicians, particularly Sir Hans Sloane, had found out his secret, but 'Twas judged so violent a Prescription, that it would be deemed Male-Practice to apply it, as he does to old and young, and in all cases.

The controversy which his prescription aroused was apparent in that announcement. The prescription for his 'Drop' and 'Pill' are contained in a letter to the 'Grubstreet Journal' of December 1734, said to have been in a communication from the French King's Physician.[66] The active ingredient was antimony. Antimony salts act as expectorants, cathartics, antipyretics and emetics, but their action is unreliable. Allegations of fatalities resulting from its use also appeared in the journal, for example: 'a Person who had a Palsy several Years on one Side, who four Hours after taking these Pills, was seized with a violent Fit of vomiting and purging, under which he died the same Evening.'[67] The same journal published an essay 'of Quack Doctor' on 9 January 1735 in which a reference to Dr Ward was made in the following terms: 'whose Abilities and great Success are too well known amongst the Undertakers, Coffin-makers, and Sextons . . . If he can kill by one Drop only, whilst others must fill Vials and Quart Bottles to do it, it shews him the greater Artist.' In defence of Dr Ward, the *Magazine* printed the following commendation: 'I will also suppose that 1000 persons come weekly to my Friend Ward, most of whom have tried the Doctors before to no purpose . . . to me and to many Thousands, it [the Pill or Drop] has been the Restorer of Health.'[68]

Alexander Pope wrote a couplet and a verse which mentioned Ward and also a highly respected member of the medical profession, Dr Radcliffe. Many respected members of the profession produced remedies which became

common household names, such as 'Dr Radcliffe's Bitter', and anecdotes relate to the admission by these gentlemen whilst in their cups, that most of their medicine or therapy was useless.[69] Some of their 'remedies' may even have held a similar threat to health as Ward's. Pope's couplet reads:

> Of late, without the least pretence to skill,
> Ward's grown famed physician by a pill.

and the verse:

> He serv'd a 'Prenticeship, who sets up shop:
> Ward try'd on Puppies and the Poor, his Drop;
> Ev'n Radcliff's Doctors travel first to France,
> Nor dare to Practise till they've learn'd to dance.

The reference to 'learning to dance' is a reflection upon a profession whose social accomplishments were often deemed as important as practical medical knowledge. This attribute was noted with regard to St André, whom Hogarth portrayed in dancing posture in his print *Cunicularii*.

In spite of all the allegations, Ward's influence and career prospered, probably because of his personality. He even obtained privileges from George II after successfully reducing a dislocation of the monarch's thumb. In lieu of payment, at his own request, he was permitted to ride his carriage through St James's Park, an honour usually granted only to persons of rank. This would no doubt have been good for publicity. The King allowed him an apartment in the almonry office, Whitehall, where he could tend the poor at his (the King's) expense. Charitable acts, including the dispensation of his Pill and Drop at houses which Ward set up as hospitals, became fashionable amongst the aristocracy. When an Apothecaries' Act was introduced into Parliament in 1748 to restrain unlicensed practitioners from compounding medicines, a clause was inserted specifically exempting Ward from the restrictions contemplated, because of his Royal patronage. This rendered ineffectual any efforts on the part of the Royal College of Physicians to censure him. A measure of his self-esteem is apparent in his Will, in which he requested that he should be buried in front of the altar in Westminster Abbey, or as near to the altar as possible, a wish which was not granted!

A full-length statue of Joshua Ward by Agostini Carlini (n.d.) can be seen in the Society of Arts in London. A statue usually represented a particular mark of respect and esteem accorded by a commissioning body. Sculpture was expensive, enduring and usually 'Roman' or classical in design, with features which endowed the subject with an aura of wealth, status and ambition. This particular statue fulfilled the latter criteria but it was commissioned for advertising purposes. Carlini was a friend of Ward, who paid Carlini £200 a year to keep the statue in his studio and appear to work at it when visitors or

11. THOMAS BARDWELL: *Joshua Ward 1685–1761*

patrons were about. After Ward's death his executors promised to continue the annuity, but this lapsed and the figure was relegated to a stable in Westminster until Ward's nephew, Ralph, presented it to the Society in 1793.[70]

A portrait of Ward, which hangs in the Royal College of Surgeons in London, may indicate some measure of the esteem in which he was apparently held by many, but may again be a self-advertisement [11]. This oil-painting by Thomas Bardwell was engraved by Baron and published in 1749. It is an allegorical painting, in which an individual's moral attributes are conveyed through symbolic language. 'Britannia' is here shown leading a crowd of sick and poor people and is offering Ward a purse as a reward for his services to them. He is pointing to the figure of 'Charity' – represented by a woman suckling her baby and with two naked infants by her side – indicating that the money should go to her. Behind him, 'Time' is holding back a curtain so that he may see what is preventing the sick and poor from entering his domain,

where one mother and her baby are already in the shadow of 'Death'. Ward, as a successful and benevolent practitioner, stands between the sick and poor and 'Death'. A verse beneath the engraving reads:

'Tis Thou, O Gen'rous Ward, thrice bless'd we see
Crouded with those that seek thy Charity.
The poor distress'd, the sick, the lame, ye blind,
Here seek relief from thee relief they find.
If volumes have been wrote on Faith and Hope,
Sure Charity deserves a greater scope.
O, happy Ward! thy charity's so great.
It wants not words to make it more compleate.
The multitudes that daily croud thy door
Loudly proclaim thee Father of the Poor.

Bardwell, the painter, was a well-known copyist and some of the characters in the crowd in this scene seem to have been 'borrowed' from Hogarth's paintings. For example some of the sick resemble those depicted by Hogarth at *The Pool of Bethesda*, a painting at St Bartholomew's Hospital [46].

The third member of Hogarth's trio in the 'The Company of Undertakers' styled himself as, 'The Chevalier John Taylor. Ophthalmiator, Pontifical, Imperial and Royal, who treated Pope Benedict XIV, Augustus III, King of Poland, Frederick V of Denmark and Norway and Frederick Adolphus, King of Sweden.' He knew several languages and had travelled widely. As previously mentioned, Taylor possessed a medical degree and had studied under William Cheselden (1688–1752) at St Thomas's Hospital. He later became an itinerant oculist and toured Britain in that capacity. He returned to London and was appointed oculist to George II in 1736. He seems to have been a colourful character and extravagant tales of his exploits have been written.[71] Members of the medical profession were more sceptical of his professional attributes, but he did have a good deal of ophthalmic knowledge. Hogarth obviously thought him a suitable companion for Mrs Mapp and Joshua Ward in his print; his use of extravagant language, bizarre clothes and claims for cures 'whether curable or incurable' earned him this place. Hogarth had previously been snubbed by royalty and deemed an unsuitable artist to portray a likeness of the Queen. In this print, the artist indicates his opinion of the trio – who had all been honoured in some way by the royal family – and, by inference, his perception of the lack of judgement shown by royalty.

The 'Chevalier' Taylor was also portrayed by Thomas Patch (1725–82), an artist who was born in Devonshire but spent most of his life in Italy. As part of his work he engraved genre scenes and caricatures that were popular amongst English collectors making the 'Grand Tour'. His patron, Sir Horace Mann,

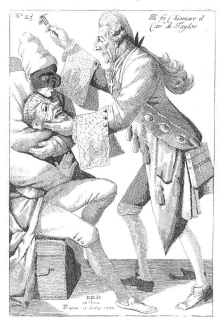

12. THOMAS PATCH: *Chevalier John Taylor*

described how 'the young English often employed him to make conversation-pieces of any member, for which they draw lots; but Patch is so prudent as never to caricature anybody without his consent, and a full liberty to exercise his talents.'[72] On this basis, Taylor must have agreed to his caricature which was produced by Patch in 1770 [12]. This illustrates a masked character holding a patient firmly in his arms whilst the Chevalier removes an eye which he holds aloft on a dinner fork. Other eyes decorate the front of the quack's frock coat – a satirical reference to the fact that he obtains his livelihood at the expense of other people's vision, or because of their lack of vision.

In the same year that Hogarth's engraving of the *Arms of the Company of Undertakers* was produced, an epistle 'To a young student at Cambridge, written by a Friend in Town' satirised the gullibility of the population through the medium of this trio, and questioned the value of any academic learning. It contains the following lines:

> 'Whilst you dear Harry, sweat and toil at College,
> T'acquire that out-of-fashion Thing call'd Knowledge.
> Your time you vainly mis-employ my Friend
> And use not proper means to gain your end,
> If you resolve Physician to commence,

Despise all learning, banish common sense;
Hippocrates and Galen never follow,
Nor worthy Aesculpius or Apollo;
But to bright Impudence oblations pay,
She's now the goddess, bears resistless sway,
Instinct by her vile Ign'rance gains applause,
And baffles Physick, Churchmen and the Laws.
By her such quacks as Ward have cur'd and slain;
How! Cur'd you cry. Yes, daring Ignorance
Can cure, as well as kill by perfect chance,
As fools by prating, such have often hit
Upon a Thought, and blunder'd into wit;
So drugs, that learned Mead would not endure,
Dispensed by Ward incautellous may cure;
From dangerous Revulsions now and then
May save one wretch, and next day poison Ten;
That one in ten, perhaps may be enough
To raise a name and furnish out a Puff.
And when a quack or thief gets once in vogue,
There still are Idiots to caress the Rogue,
Nay in this wise, polite and well-bred Nation,
Some Fops will poison take to be in fashion. . . .
In this bright Age, three wonder-workers rise,
Whose operations puzzle all the wise,
To lame and blind, by dint of manual slight,
Mapp gives the use of limbs and Taylor sight,
But great Ward, not only lame and blind
Relieves, but all diseases of mankind.
By one sole Remedy removes, as sure
As Death by arsenic, all disease can cure.[73]

It seems that Hogarth had grounds for his scepticism with regard to the medical profession and its practices. His show of scepticism is compounded in the print by the exchange of the 'titles' of 'Quacks' and 'Doctors', contrary to their appearances. It was not always easy to differentiate between the two.

CHAPTER 3

The Itinerant Quack

From various Parts, for various Ends, repair
A vast mix'd Multitude to Southwark Fair . . .

THE doctors and quacks in the *Company of Undertakers* were, according to Hogarth, interchangeable. Hogarth perhaps considered that the medical profession merely offered an illusion of success and questioned whether the orthodox practitioners offered any more of 'reality' than did the quacks. They might even be compared with artists or playwrights, who, in their own fields offered a world of make-believe.

Hogarth was concerned about the illusory aspects of life – with the apparent desire of many people to escape from reality – and with a world which abounded with folly, vice and ignorance. This concern may have been fuelled by memories of events such as the South Sea Scheme – founded upon imaginary investments – and the National Lottery, schemes which guaranteed quick profits for some, but paid scant attention to the fate of the losers and which, as Hogarth graphically portrayed in his prints on these subjects, led to moral, sexual and religious corruption. He had grown up in areas which had given him ample opportunity for observing the ways of the world and he intended to expose them. This was his aim in *Southwark Fair* – painted, signed and dated 1733 [13]. It was originally advertised as 'A Fair' or 'The Humours of a Fair' and prints of the subsequent engraving were to be delivered to subscribers of the as yet unfinished *Rake's Progress*.[1] The generic title 'A Fair' widened the net in which to embrace the folly of mankind, but later, by identifying a specific fair, Hogarth was able to incorporate realistic details which lent credence to the activities depicted in the scene.

Fairs travelled from town to town for saints' days and holidays, and although originating as markets were popular forms of entertainment. Southwark Fair was an important one, only St Bartholomew's Fair being considered more so, and was held on 7–9 September each year. By 1733 it was seen as a haunt of beggars, idlers and prostitutes. The main theme of this painting is the dominance in the affairs of man of illusion over reality, and Hogarth shows how fragile this illusion can be. He also portrays the

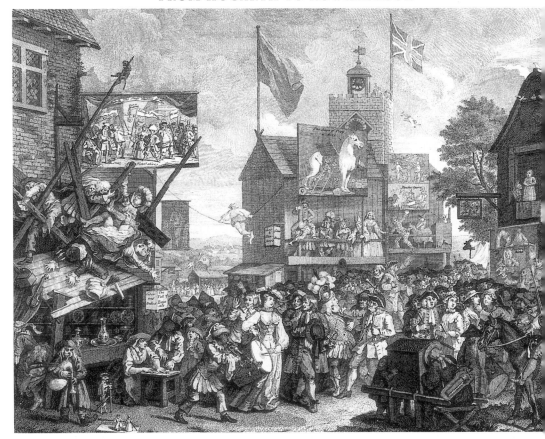

13. WILLIAM HOGARTH: *Southwark Fair*

corruption of art, in terms of the theatre, with a corresponding corruption of social values. Here can be seen gamblers, bawds, cheats and illusionists in both theatrical representations and real life.

The scene itself is set like a theatre, with real life centre-stage surrounded and dominated by an illusory world of theatrical backcloths and play-acting, with actors, tight-rope walkers, acrobats, an eighteenth-century 'bungee-jumper', and a juggler, many of these being recognisable figures of the day. The collapsing stage on the left illustrates the fragile nature of the illusory pursuits and indicates their repercussions on other aspects of society. At the time, the theatre itself was being trivialised with a change taking place from the acting of single plays to the performance of entr'acte entertainment of song and dance, with an afterpiece which often consisted of a farce or pantomime such as those mentioned in connection with Mary Toft and Mrs Mapp, or a short ballad opera. This practice was leading to the demise of

14. Fire-eating itinerant quack or mountebank with zany:
detail from *Southwark Fair*

serious theatre. Theatre booths operating in 1708–28 capitalised on the new trends and performed ballad opera, or combined tragic or historical theme with farcical elements.[2] Agitation against the acting of plays and 'drolls' at Fairs ensued, and forms part of Hogarth's scene.

Part of the illusory world is the 'quack' or mountebank who can be seen standing on his own special platform in the centre of the crowd [14]. Such a person travelled round to fairs and markets selling his nostrums or medicines. This character is dressed in a laced hat, long periwig and embroidered coat with lace cuffs, and is attended by his zany, who is wearing a chequered harlequin outfit and is 'quacking' or 'puffing' his master's wares. No seventeenth- or eighteenth-century mountebank was complete without his zany or 'Merry Andrew' – a term originally applied to Dr Andrew Boorde, physician to Henry VIII and noted for his ready wit and humour, who was the subject of many broadside ballads. The mountebank relied upon his wit and repartee, using extravagant and improvised language which often contained Latin-sounding words invented for the occasion in an attempt to imply knowledge which he did not possess. His dress was sometimes equally extravagant. Hogarth's quack has the added accomplishment of fire-eating, enacted by means of lighted tow in his mouth which smouldered and allowed him to puff out the impressive smoke – another illusion. The smoke in this case is equivalent to 'blinding' gullible members of the public or obstructing their true vision with pseudo-scientific jargon. Smoking was often used in seventeenth- and eighteenth-century literature and prints as a metaphor or symbol for the process of dying: the association of the quack doctor and dying is self-explanatory.

[69]

The quack was also a symbol of deceit and the 'embodiment of riches got by humbug and chicane'.[3] He was an appropriate figure for Hogarth to place in the midst of his theatrical scenes, representing both real life and an aspect of theatrical debasement or corruption. Hogarth's portrayal of the quack is based on the stock *commedia dell'arte* type of work in which harlequin and his companions were depicted in crude stage settings. These characters, based on Italian theatrical tradition, were originally portrayed by small professional acting companies in improvised comedy with a distinctive style. Farcical situations, buffoonery and caricature were their stock-in-trade. The actors had to be quick-witted, tough and adaptable in order to survive, with one actor often playing many parts; they were sometimes, therefore, masked. Speech was often colourful or nonsensical, and wit was frequently paired with stupidity. Harlequin, Pulcinella and Columbine were among the traditional characters who survived in the eighteenth century in harlequinades and pantomimes, but the use of stock material gradually declined. Punch and Judy puppet shows provide remnants of the tradition which survives today.[4] Many of the features associated with this theatrical tradition applied to the quack and his zany or accomplice: if they were not adaptable, nimble and quick-witted, they too perished. Contemporary lines describe the scene: 'And Merry-Andrews, joking Swell the train,/To tempt the Gazers to flock in amain.'[5]

Hogarth inveighed against the embracing of false values and man's blindness to the folly of his ways. He also thought that some contemporary artists and the artistic conventions they slavishly followed warranted equal condemnation. He sought to convey his social and moral messages through his paintings in his own realistic fashion. He was concerned with the truth of a situation. One of his aims declared at a later date was to create works which 'may be instructive to future time when the customs manners fasheons and humours of the present age may [be] changed.'[6]

The quack in *Southwark Fair* may have been part of an illusion created by Hogarth, but he was based on reality. Such a quack was Dr Rock, a notorious individual who features in a number of prints. One, by W. Shaftoe, shows him at his usual site in Covent Garden *c.*1740, on a raised platform in front of the Church of St Paul's [15]. He is standing in the centre of the platform holding an open book, from which he seems to be reading. The book symbolises his knowledge. If this represents the extent of his wisdom, the monkey imitating him may be presumed to be similarly equipped. The ape or monkey had some human-like features, so it was popularly thought that his intellect might be similar also. In early Roman and Greek times authors had used the epithet 'ape' to denote an ugly exterior and an evil disposition, and the term had been applied to sycophants, tricksters and hypocrites. Later, with the advent of Christianity, the term was applied to the enemies of Christ – associates of the

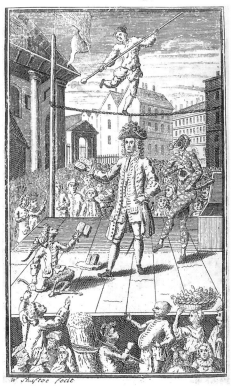

15. W. SHAFTOE: *Dr Rock in Covent Garden*

devil – and the ape was allied to sinners and implicated in the Fall of Man. It became a symbol of sin, malice, cunning, greed and lust. By the sixteenth century, however, the concept of the ape as the image of a fool had evolved. Folly was an ineradicable quality of human nature, so as merely foolish, the ape became dissociated from sin. He had become a source of amusement and tolerance as part of the 'human' mentality. In art he became a symbol for a fool as well as, in a different vein, a symbol of art itself as the 'ape of nature'.[7] Aspects of life were sometimes burlesqued in simian terms to denote the pseudo-human attributes of the creature. The monkey's presence here, imitating his master, symbolises the foolishness of both, each in a wig and stylish dress. Harlequin, or Merry Andrew, is also on the platform, wearing a large pair of spectacles over a mask. He dances attendance upon his master in order to attract the audience, as does the tight-rope walker performing overhead. The large box on the right of the platform contains the quack's nostrums or medicines. Dr Rock frequented the neighbourhood of St Paul's offering his 'Incomparable Electuary', the 'only venereal antidote', as one of his specific nostrums. He offered others for such inconveniences as 'stone',

16. WILLIAM HOGARTH: *Morning* from *The Four Times of the Day*

17. Dr Rock with his bill-board: detail from *Morning*

'tooth-ach', 'claps', 'gleets' and 'itch', as can be verified by perusing the *Gentleman's Magazine* of the time.[8]

Dr Rock also appears in one of Hogarth's scenes of every-day London life, *The Four Times of the Day*, etched and engraved from a painting in 1738 [16]. This series has been interpreted as a satirical assault on mythological allegory, the imitation of past models and the use of clichéd themes.[9] Hogarth transforms the traditional Arcadian characters and situations that appear in certain classical original paintings (*Points du Jour* scenes), into base, low-life and real characters of the London scene. For example, Aurora, the sun-goddess traditionally presented in 'Morning' scenes, is depicted by Hogarth as a frigid spinster, or presented in the form of a clock on the church in the engraving. She is painted in bright and glowing yellow, a light-source radiating outwards. Her warmth does not even radiate as far as the young boy in tow. She is oblivious to his suffering as she makes her pious way to St Paul's Church. Her style of dress, with its low neckline, and her use of a fan, which symbolises flirtation, as she looks towards scenes of debauchery and fighting, represent hypocrisy. Even the apparent church entrance is a sham as the real entrance is at the side of the building. Tom King's Coffee House is a den of vice; Dr Rock sells nostrums for 'social' diseases, and the traditional 'Arcadian' garden is represented as a pile of root vegetables and cabbage leaves in Covent Garden, Hogarth's venue. The real London 'Morning' lacks any kind of traditional harmony. In fact, by 1730, the 'piazza' at Covent Garden had become the domain of artists, actresses, writers and prostitutes – the reality that remained from the original dreams of 'arcadian' residences for aristocrats and men of distinction, designed by Inigo Jones.[10]

Dr Rock, in Hogarth's Covent Garden, is displaying his bill-board advertising his product beneath a royal coat-of-arms [17], suggesting royal patronage – the practice decried in *The Craftsman* (see p. 52). Goldsmith, referring to notorious quacks and to Dr Rock in particular, described him thus:

The first upon the list of glory is doctor Richard Rock, F.U.N. This great man, short of stature, is fat, and waddles as he walks. He always wears a white three-tailed wig nicely combed and frizzed upon each cheek. Sometimes he carries a cane, but a hat never . . . He is usually drawn at the top of his own bills sitting in his arm-chair, holding a little bottle between his finger and thumb, and surrounded with rotten teeth, nippers, pills, packets and gallipots. No man can promise fairer than he; for, as he observes, 'Be your disorder never so far gone, be under no uneasiness, make yourself quite easy; I can cure you.'[11]

A poster or hand-bill advertising one of Dr Rock's nostrums can be seen in one of Hogarth's later paintings, *The March to Finchley*, 1750 [43]. A man urinating and grimacing in obvious discomfort nearby may well be con-templating its effectiveness, or perhaps just demonstrating his contempt for the product. Such advertising on bill-boards and posters was common practice and commented upon by Daniel Defoe in his *Journal of the Plague Year* (1722):

> it is incredible, and scarce to be imagin'd how the posts of houses and corners of streets were plaster'd over with doctors' bills, and papers of ignorant fellows, quacking and tampering in physick, and inviting people to come to them for remedies . . .[12]

Defoe was describing the scene as it was just before the great plague of 1666, but the practice continued in the eighteenth century. Dr Rock is also seen in attendance upon the dying Harlot in Scene 5 of *A Harlot's Progress* (see Chapter 4).

In spite of attempts to discredit quacks during the mid-eighteenth century, many of them continued to flourish. The more successful and enterprising of them appeared in prints and caricatures. Dr Rock was a common target, perhaps considered as a good representative of his kind. In a mock letter from him 'to a physician in Bath', he offers his 'famous *sympathetical family pill*':

> Let the master of any family, or the mistress if she be master, take one of these at night going to bed, and another in the morning fasting, and they shall not only be well purged themselves, but the whole family, men, women, and children, shall equally participate of the same benefit.

Variations on this pill were said to have other social and domestic benefits and could be guaranteed to deter members of the household from straying from home.[13] This doctrine of sympathies was, perhaps, a forerunner of animal magnetism, a practice which is considered later.

Hogarth himself was portrayed as a 'quack' by artist Paul Sandby in a print entitled *A Mountebank Painter* published in March 1754. The subscription reads, 'O Will thy Impudence is the certain consequence of thy Ignorance.'

This print was one of eight etchings which Sandby produced to discredit Hogarth, whom he distrusted.[14] His satire was aimed at what he considered Hogarth's conceit in seeing himself as a 'great art painter' of religious, historical or epic themes, and he attacked Hogarth's one complete book on art, *The Analysis of Beauty* – published in 1753 – his treatise on aesthetics and ideas of Taste. In this commentary on physiognomy, form and line, Hogarth proclaims that an undulating line – the 'serpentine line' – is more beautiful than an angular one. In Sandby's print, Hogarth (H) is shown with his pug dog. He has been given the role of a 'quack' or mountebank, Sandby thus equating him with one who talks nonsense, who is, by Samuel Johnson's definition, a "boastful pretender to arts which he does not understand", one who chatters boastingly, brags loudly, and talks ostentatiously.[15] Sandby also sees him as advocating the use of unorthodox practices, producing worthless products and of having associates to support him in the same way as had a quack. Hogarth is said to be demonstrating to his admirers and subscribers that 'Crookedness is most Beautiful'. He is accompanied by his associates: the trumpeter, who has been likened to Benjamin Hoadly as his 'Puff' or zany, and a musician who has been likened to Joshua Kirby.[16] The 'fidler's' pose and instrument demonstrate the 'line' admired, and 'Hogarth' holds a stick of similar shape and points to the offending book which is resting upon a 'Fool'(S). Sandby draws a gullible audience which demonstrates satisfaction with the quack's product and he vividly illustrates the grotesque consequences of following the quack's advice.

At an earlier date Hogarth had accused some of the French portrait painters in similar, though verbal, terms. 'I laughed at the pretensions of these quacks in colouring . . .'. His words were aimed at artists such as Vanloo, who came to England in 1737 and who was one of many painters who employed assistants to paint the drapery and background to his paintings.

> If a painter comes from abroad, his being an exotic will be much in his favour; and if he has address enough to persuade the public that he had brought a new discovered mode of colouring, and paints his faces all red, all blue, or all purple, he has nothing to do but to hire one of these painted tailors as an assistant, for without him the manufactory cannot go on, and my life for his success.[17]

People on the fringes of society tend to attract the attention of other members of that society, and itinerant quacks belonged to this fringe-element. Notoriety and eccentricity added to their 'commercial' value – both for themselves and for the many artists and playwrights who used the interest engendered by such characters by including them, or references to their activities, in their own works. Quacks had the additional attribute as far as the graphic artists were concerned, in that in addition to their own picturesque qualities, they could be used to illustrate such characteristics as

pretentiousness, ignorance and loquacity, with which they were commonly associated, and to display the extent of human folly, stupidity and gullibility to which a large proportion of the population was subject. A particular practitioner might also provide a topical element in a piece of work.

Medical images of various kinds were used by artists because they were universally understood. Quacks came into this category. Their presence was well-known and recognised, and their practices both reviled and praised. Hogarth used images of quacks in various ways, and the use of quack images continued throughout the century.

Rowlandson was one of many artists who made use of such imagery. On his tours around the countryside he saw how itinerant quacks or mountebanks operated. He drew examples of practitioners in market-places in different localities, each plying his trade with the aid of 'Merry Andrew'-musicians or 'Black Pudding' in the *commedia dell'arte* tradition. 'Black Pudding' was the name given to the little black accomplice like the one illustrated in the drawing of *Doctor Botherum, The Mountebank*, 1800 [18].

18. THOMAS ROWLANDSON: *Doctor Botherum, The Mountebank*

The quack, impressively attired in wig, laced hat and sword, is standing on a platform erected in the market-place to display both his knowledge and his nostrums. 'Black Pudding' is also holding up a bottle, and 'Merry Andrew' is attracting the crowd with a large ladle and what appears, in some reproductions of the print, to be a gridiron. In his book *The Life and Adventures of Sir Launcelot Greaves*, Smollett refers to one of his characters, Ferret, in a similar role:

> the company were, upon reflection, indeed to believe that . . . [Ferret] had occasionally figured in the character of that facetious droll who accompanied your itinerant physicians, under the familiar appellation of Merry Andrew or Jack Pudding, and on a wooden stage entertains the populace with a solo on the salt-box, or a sonnata on the tongs and gridiron.[18]

Another attendant in Rowlandson's scene is extracting a tooth from an unfortunate customer – a practice which causes some of the onlookers to feel their own teeth or gums in sympathy, anticipation or dismay. A box behind the quack contains large quantities of the medicines already prepared to sell to gullible members of the audience. Dr Botherum is said to be based on a well-known mountebank dentist, Dr Bossy, or Bossey – a well-dressed German who travelled round, often attended by a drummer, whose task was to attract attention and probably to drown the cries of the patient.[19] The dental assistant in Rowlandson's print is wearing a drummer boy's hat. Rowlandson may be making the additional point that the latter could perform extractions just as well (or as badly) as his master.

Dr Bossey usually had a monkey to attract his clients. In this scene, 'Black Pudding' bears a striking resemblance to such a creature – a man dressed up as an ape. Was Rowlandson or the quack 'making a monkey' out of man? Rowlandson, like many of his contemporaries, was fascinated by the resemblance between the features of man and some animals, and he shared their idea of the importance of the body as an index of the mind.[20] Mountebanks or zanies kept monkeys which they utilised as accomplices in their 'tricks'. In some acts, they were seen on their masters' shoulders 'counselling' them or imitating them (as in the scene with Dr Rock). Rowlandson's use of the man/monkey figure imitating his master accentuates the theme of folly, trickery and knavery inherent in the picture of 'Dr Botherum'. Man's baser or 'animal nature' was again implicated. Dr Bossey is present in an engraving *Dr Bossey and the People taken from the Life* from a drawing by A. Van Assen published in 1792 (BM 8183) in which a monkey is holding up a phial of his master's nostrum, mimicking the mountebank. Rowlandson's scene, however, provides a more lively crowd involved in other activities associated with fairs and market-places overflowing his 'canvas' in untidy profusion.

Another similarly picturesque example is of a market scene in which a mountebank, dressed in the fashion of the previously described itinerant, is selling his nostrums to the accompaniment of a musical 'Merry Andrew'. A female assistant points to the elixir, and an elderly, hopeful recipient of the 'elixir of life' is awaiting his chance of rejuvenation. Potential customers of different age, sex and state of health watch the proceedings and some of them seem prepared to participate. In this and in other examples of mountebanks at work portrayed by Rowlandson, the surrounding village scenery lends credence to this aspect of eighteenth-century village life. Another scene offers evidence of the quack's credentials or pedigree. He is billed as the seventh son of a seventh son, thus exploiting a popularly held belief in such an individual's undoubted ability to heal [19].

Rowlandson provided a different setting in his drawing *The Quack Doctor Humbug Gives Advice Gratis* [20]. For this, he may have been influenced by seventeenth-century Dutch genre pictures of medical practitioners, in many of

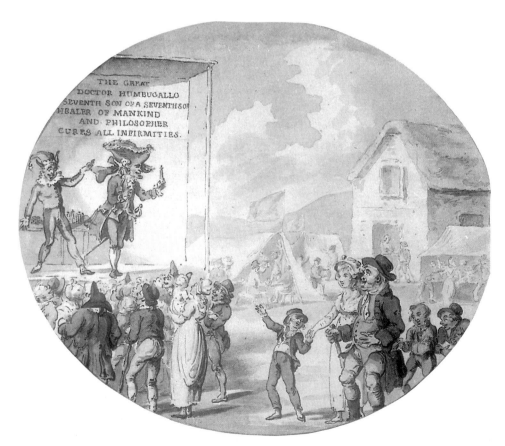

19. THOMAS ROWLANDSON: *The Mountebank at a Fair*

20. THOMAS ROWLANDSON: *The Quack Doctor Humbug Gives Advice Gratis*

which the successful, well-dressed physician can be seen inspecting the contents of a urine flask on which he will base his diagnosis of the patient's illness.[21] This practice of uroscopy or 'water casting' had been undertaken from ancient times and throughout the Middle Ages, and fitted in with the humoral theories of medicine. It was supposed that any abnormal change in the body humours could be detected in the urine. The urine flask took on a symbolic function in the same way as the physician's 'cane of office' did later. Hogarth included a urine flask in his print *Arms of the Company of Undertakers* and probably intended this to be an additional allusion to quackery. The practice of uroscopy fell into disrepute during the seventeenth century, but was still used by some quacks who recognised its psychological powers. 'Dr Humbug' is holding a urine flask to his nose, whilst a bashful young girl waits for his verdict on her condition. A servant or accomplice leers at the scene from behind the open door, pointing to the girl with a 'knowing' gesture, as if he knows the cause of the girl's sickness without need to inspect her urine! Love-sickness or pregnancy was the usual assumption. A certificate on the wall sets the scene as 'Dr Humbug's' room. Rowlandson may have had in mind Dr Theodore von Myersbach, known as the 'German Doctor'. It was said of him that: 'Myersbach offered himself as a rough-rider to a riding house in London, but being rejected commenced doctor.'[22] He had purchased a medical degree from Erfurt after starting life as a humble post office clerk in Germany, and arrived in London in the 1770s where he set up in practice

[79]

specialising in uroscopy. He dispensed drugs such as 'green drops', 'sweet mixture', 'silver pills' and 'red powder' on the basis of his findings, and built up a successful practice. Some of his nostrums contained opium and brandy, thus contributing to the feelings of well-being experienced by recipients. Procurement of abortion may have been part of his provenance.[23] A lively controversy between Myersbach and his supporters, and orthodox physician Dr John Coakley Lettsom, appeared in newspapers and magazines regarding the nature of the former gentleman's practice.[24] Rowlandson's print would have provided a topical allusion to this quack.

Whereas the presence of Hogarth's quacks forms a small part of a scene and provides a moral or social comment, Rowlandson's quacks form a central feature of his canvas; their social presence is acknowledged but the artist offers no moral judgement about their activities.

Political caricaturists appropriated the itinerant quack for their own purposes. His role fitted him for the artists' satirical personification of someone – such as a politician – who was considered an arrogant, boastful pretender who did little good for the body politic. Many political prints had little artistic merit, but were meaningful and amusing to contemporary readers. The 'hack' artists drew them and the print-publishers hastily produced them in large numbers – sometimes for 'propaganda' purposes – and the number of such prints proliferated in London as the eighteenth century progressed.

The St-te Quack (BM 3909) is an example of one such political print drawn by an anonymous artist [21]. A description will indicate how medical imagery was incorporated into the political field.

In the print, published in 1762, the third Earl of Bute is given the role of the quack doctor who is mounted on his platform offering his nostrums of *Pease or a Political Clyster* and *Union Squirt* as medication for the good of the country. Bute, a friend and adviser to the grandson of George II, rose rapidly in the political ranks following George III's accession to the throne in 1760. He and George III wished to bring about an end to the Seven Years' War with France by treaty, and to make peace at almost any price. In 1762, preliminary talks for a 'Peace of Paris' were being debated. England had enjoyed certain victories against the French and many citizens relished the humiliation that had been meted out to their enemy. Trade and agriculture had flourished during the war years and wealth, glory and prosperity were envisaged by many if hostilities continued and the French were subdued.

Bute's zany in the print is blowing a trumpet carrying a banner bearing the words *Wandsworth Epistle*. This refers to 'A Letter to a Gentleman in the City' dated 5 September 1762, which supported Bute's policy. The table on the zany's left holds nostrums or soporifics labelled with the names of publications which had indicated support for the peace proposals. On Bute's

21. Unknown artist: *The St-te Quack*

right-hand side is the Dowager Princess of Wales, George III's mother, balancing on a tight-rope. Bute's supposedly intimate relationship with her had been the subject of cruel and persistent rumours. The large boot balanced on her abdomen is a reference to Bute, in addition to being a phallic symbol, and the coronet on the sole depicts Bute's influence on the princess and the king – in effect usurping the role of the monarch. The presence of the clyster-pipe also had sexual connotations. A clyster-pipe or syringe had been used as a sexual symbol in seventeenth-century Dutch prints in which it was presented as a 'cure' for love-sickness and Watteau's drawing *The Remedy* presents a similar theme.[25] The banner flying over the platform and advertising the theatrical production behind the scenes also alludes to the relationship between Bute and the princess. *Pittius and Temple* on the play-bill refer to William Pitt and Lord Temple, who resigned their offices in May 1761.

Popular feeling against the proposed peace and its possible effects was strong. An allusion to the unwanted importation of French wares and customs is made by the pedlar on the right, who is selling her wares to a fashionable lady. An angry sailor is reflecting Admiral Hawke's and his sailors' displeasure by disputing a Scotsman's declamation that *He's a braw Doctor* on the grounds that *his d—d Drugs have almost poison'd H—ke & me*. The peace represented a considerable threat to the navy if the losses sustained by the French were restored to her and commercial concessions made. The 'Doctor's' 'Edinburgh degree' refers to the ascendancy of Edinburgh with regard to medical education and its superiority to much that England had to offer, and to the fact that Bute was a Scotsman, a fact indicated by his dress. This also indicated that he was an alien, with no right to administer to the English. However Bute was a landowner: many landowners – Scots amongst them – supported Bute rather than the return of a Whig government, which would entail increased land tax. A Scotsman and a Frenchman greet each other in the foreground whilst the devil, a pan-like satyr and a reminder of the evil which was prevalent in the councils of state, hopes to catch them in his net, exclaiming *This is as I would wish, the old alliance renew'd*. In spite of some of the avowed disapproval of Bute's policy, most of the bystanders in the print seem to be either amused or unconcerned by the events portrayed.

The term 'quack' placed Bute, who had no experience in government prior to his elevation to the senior posts by George III, in a position associated with lack of training, pretensions to leadership, ignorance and incompetence, offering a useless panacea for the country's needs. The words used by quacks in their 'puffing' were often meaningless jargon and such an interpretation could be placed upon Bute's recommendations. The depiction of a clyster-pipe was as a symbol of abuse against the 'body politic' – the instrument

having a double meaning in this print – and the complacent members of the crowd represented the gullible members of the population who were being thus abused by Bute's assumption of power over them and by his policies or 'remedies'. His form of entertainment was provided by his assumed association with the Dowager Princess of Wales – his 'zany'.

Hogarth's print *The Times*, published in September 1762 (BM 3970), was in support of Bute's government. Bute, as the king's representative and new prime minister, is shown as the lone fire-fighter trying to extinguish the flames of the Seven Years' War which are being fanned by those with pecuniary vested interests. In an earlier version of the print, Pitt, represented symbolically as Henry VIII, is the fire-fighter. Pitt is supported on crutches or stilts by the city mob and members of the mercantile class who wanted war to continue, but he is weighed down by the 'burden' of a £3000 pension given to him on his resignation by the king. Previously represented as uncorrupt, Pitt's reputation suffered after his receipt of this money. In the later version of the print, politicians Wilkes, Churchill and Temple, inhabitants of 'Temple's Coffee House', fire 'abuse' from their clyster-pipes – represented as fire-extinguishers – at Bute, a Tory, instead of at the flames. They are, in effect, attacking the court party. Bute is being supported in a small way by a few Scottish and English men carrying buckets of water: the Scots are identifiable by their 'quaint' uncivilised skirts. Another citizen takes a wheelbarrow of 'North Briton' and 'Monitor' papers to feed the flames. This unusually overt partisan approach on Hogarth's part gave rise to the label 'Times' appearing on one of the bottles of soporifics on the table in *The St-te Quack*.

Whilst many people decried those quacks who advocated stock remedies of doubtful efficacy, other practitioners were acclaimed for their equally suspect nostrums. Bishop Berkeley's tar-water was the rage for a time and Dr James, a highly respected medical practitioner, became rich and popular with his fever-powder. Horace Walpole wrote to his friend Sir Horace Mann, in October 1764: 'James's powder is my panacea, that is, it always shall be, for, thank God, I am not apt to have occasion for medicines; but I have such faith in these powders, that I believe I should take it if the house were on fire.'[27] Newberry, the publisher, puffed it in the childrens' book *Goody Two-Shoes* (see p. 24). James's opponents accused him of having stolen the recipe which had originated from a German, Baron Schwanberg. A caricature entitled *A Reply for the present to the unknown Author of Villany Detected*, published in 1724, depicts James as a medical highwayman stealing the recipe from its rightful owner.[28]

On other occasions orthodox members of the medical profession were equated with both quacks and politicians as men who did little to relieve

suffering but made a good living for themselves. Butler's *Hudibras*, illustrated by Hogarth, contains the following lines:

> The Quacks of government (who sate
> At th'unregarded helm of state) . . .
> And therefore met in consultation
> To cant and quack upon the nation
> Not for the sickly patient's sake,
> Nor what to give, but what to take;
> To feel the purses of their fees,
> More wise than fumbling arteries;
> Prolong the snuff of life in pain,
> And from the grave recover—gain.[29]

In December 1734, a writer in the *Gentleman's Magazine* compared Edmund Burke with the quack Joshua Ward in these terms:

> Do not the Populace attend Mr Ward in Crowds, and hath not his Pill been triumphant by the clearest Proofs of the Sense of the People? And hath not B. . .ke the same Mobfollowers, and Mob-applause?
>
> There is the strictest Analogy between Ward's Pill and B..ke's Politicks; the regular Dose of either does not weigh a Grain; 480 Doses of each are not worth a Penny; they have the same Poisonous Effects in Alehouses, and Brandy Shops; they have killed an incredible Quantity of Chairmen, etc. too much addicted to irregular Physic and irregular Politick . . . (p. 670)

Politicians and public servants depicted as medical practitioners were provided with similar remedies to those used by their counterparts. Swift, through the medium of Gulliver, had discussed how several kinds of public administration were subject to diseases and corruptions caused by the vices and infirmities of those who govern as well as by the licentiousness of those who obey. Similar types of treatments, he argued, should therefore be accorded to both the natural and the political body.[30] Hogarth, exploiting the popularity of Swift's book, undertook a political satire in 1726 which was entitled *The Punishment inflicted on Lemuel Gulliver*. He later changed the title to *The Political Clyster* on re-publication in 1757 [21A].

Hogarth's Gulliver is at the receiving end of an enema as punishment for urinating on the Royal Palace of Mildendo, an act which he performed in order to extinguish a fire which threatened to destroy it. A clergyman is officiating from his chamber-pot pulpit and the First Minister is observing the operation from his thimble carriage, both ignoring evils being perpetrated in the society around them. Gulliver is apparently tolerating the indignity and the iniquity of the situation without sign of dissent, a helpless victim of his captors. In the later publication, Gulliver represents England or John Bull,

The Punishment inflicted on Lemuel Gulliver by applying a Lilliputian fire Engine to his Posteriors for his Urinal Profanation of the Royal Pallace at Mildendo which was intended as a Frontispiece to his first Volume but omitted?

21A. WILLIAM HOGARTH: *The Punishment inflicted on Lemuel Gulliver*

benevolent, good-natured and gullible, allowing the Lilliputians (members of the government) to exploit him. The jibe in the print was against the medical profession whose remedies often seemed a useless and inappropriate punishment, as well as against Church and State.

The ubiquitous enema syringe would have been familiar to Hogarth's readers, the contents offering the stock remedies for many physical complaints and some psychological ones. The use of the enema varied and might be employed for problems as diverse as colic, diarrhoea, worms, relief of headaches, treatment of fevers and of venereal disease. Many artists thus found occasion to depict it in the hands of politicians treating the body politic and for the management of all manner of social and moral deficiencies. The instrument had an inherent prurient fascination which made it particularly useful as an item of ridicule, abuse and, in some circumstances, eroticism.

In Gillray's print *A New Administration; or The State Quacks Administering* (BM 6201), published in 1783, Britannia is about to be punished by an enema administered by the new coalition government headed by the 'Quacks of State', Fox and North. Fox is holding up Britannia's petticoats so that North, with a large enema syringe, may perform the necessary operation for the good of the country. The formation of a coalition government following the resignation of Shelbourne was considered by many to be a desperate

measure. 'Poor old England' was the verdict. She had no defence against the insults and abuse to which she would be subject; her broken shield symbolises her helplessness.

Everyone knew what to expect at the hands of Quacks.

CHAPTER 4

A Pox on You All: Medical Images in Eighteenth-century Themes of Morality

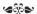

WHAT use are diseases? Their functional use as far as artists in the eighteenth century were concerned was manifold: they could offer visions of just desserts for past sins, represent character defects in the afflicted individual, have a symbolic function, invoke sympathy or distaste, signify deterioration in both health and circumstances, require social or political remedies, they could also offer some insight into the practices of the various practitioners involved in their treatment. Hogarth made use of all these aspects of disease in the Modern Moral Subjects, or 'Modern History Paintings', which are examined in this chapter. Matters connected with sickness were common to all members of society, so the messages conveyed through images concerned with such medical matters would be well understood.

Hogarth indicated in his *Autobiographical Notes* that he did not wish to depend upon patronage for his living and had found the practice of painting portraits and conversation pieces (small informal group-portraits) stultifying. In a bid for independence, he therefore embarked upon a series of paintings from which he sold prints by subscription whereby 'half a guinea being ye first payment for six prints' was followed by half a guinea on receipt of the prints (about £175 in present-day terms). The subscription ticket for the first series, *A Harlot's Progress*, was *Boys Peeping at Nature* (1730). This was an allusion to the lifting of a veil in order to seek out the truth. This method of payment released Hogarth from the bonds of patronage. The sophisticated ticket and the relatively high price charged for the prints indicate that Hogarth was aiming this series at a knowledgeable audience. Publicity was by word of mouth and through well-known contacts such as members of parliament, freemasons and literary acquaintances, and sometimes by advertisement in the newspapers. His satires had hidden depths. Although they often seemed to implicate other individuals, the purchaser himself could be the butt of the folly depicted, whether he were a member of the aristocracy or of the merchant class.

The series was a success and nearly 2000 sets were bought by subscription, but its production was partly to blame for the failure of Hogarth to obtain a royal commission to paint a portrait of the queen, since it was considered unseemly for the queen to be painted by the 'Harlot's' creator.

In keeping with his theatrical interests, these, his 'Modern Moral Subjects', as he called them, were designed as theatrical 'productions'. Each scene of a series was a 'set' based on real-life surroundings, and the events depicted were based on what Hogarth saw as reprehensible occurrences in society to which he could draw attention through the medium of his art. Characters were sometimes recognisable individuals or, at least, recognisable as character types. This gave his paintings and prints topicality and publicity value as viewers sought familiar faces. The controversial nature of his work when considered in relation to what the connoisseurs considered to be acceptable gave it added interest to his contemporaries. Here again, Hogarth subverted the 'High Art' traditions by including allegorical pictures on the walls in the background of his scenes as a convenient and significant means of expressing or reflecting the image that he was producing in a more realistic and up-to-date fashion in the foreground. He used themes from traditional art, which were supposed to be moral and uplifting and to give value and dignity to human nature, to draw parallels between what was perceived as 'good' (but was not necessarily so on close inspection) and what was happening in society at the time. He intended to show that old views of morality were not necessarily appropriate to contemporary society.

With these series of paintings, Hogarth deliberately set out to create a new style of painting for a new public. His audience of a mainly upper or 'middle-class' educated clientele would have been well-versed in the biblical, historical and mythological themes used, and in the meaning of traditional emblems and symbols. Comparable twentieth-century messages on the television screen or in satirical or social cartoons might include pictorial reference to such incidents as Nelson holding a telescope to his blind eye, or to the sinking of the Titanic. No explanation of these events would be deemed necessary to an educated audience. Whereas painters of historical themes had depicted important and distinguished people in one episode of moment, Hogarth chose to populate his paintings with dissolute characters whose actions, in a series of circumstances, were to be deplored. Deplorable actions, however, were also carried out daily by those people who claimed to be upholders of traditional values, and Hogarth intended to expose the hypocrisy prevalent in society.

Hogarth did not use details gratuitously: each had a part to play in disseminating his message, but some of the details are in coded form. The language and codes of expression in which a book is written must be understood before the book's meaning can be ascertained. Similarly, the

language or emblematic codes incorporated into a painting or engraving must be understood before its full meaning can be appreciated. Emblems and symbols are a kind of visual shorthand and they provide the equivalent of metaphors or similes used by writers and these form part of the language of graphic and literary art. Such codes or language are evident in the 'Modern Moral Subjects'. Although the scenes depicted in these 'Histories' cannot be taken literally, they gained much of their effect from their realistic frame of reference. The iconography was suggested by articles from contemporary newspapers and journals, as it had been for the engineering of *Cunicularii . . .*, the print portraying Mary Toft, the Rabbit Woman. If the message were to be taken seriously, the incidents enacted would have to be plausible. The medical images, therefore, were based on contemporary knowledge and practice and they can convey information about these to modern readers.

Hogarth's retrospective account in his autobiographical notes of the mode of conception of his narrative works differs from the recollections of George Vertue, who describes how Scene 3 of *A Harlot's Progress*, the first of Hogarth's 'Modern Moral Subjects', in which the harlot and the bunter are seen at a late breakfast, originally stood on its own. Hogarth then added a pendant to this scene in the form of Scene 2 of the later series, the pair representing allegorical scenes of Temperance in opposition to Luxury and Self-Indulgence. Only subsequently was the full narrative series developed.[1] The gestational period of *A Harlot's Progress*, although interesting, does not affect the medical imagery to be found in the works, and the series as a whole is considered from this aspect.

1. *A HARLOT'S PROGRESS*

> The snares are set, the plot is laid,
> Ruin awaits thee, hapless maid![2]

In the first of the series, *A Harlot's Progress* [22–27, 29–31], which was produced in 1732, six scenes show the painter inveighing against the kind of society which lured innocent victims to destruction, allowed exploitation of the poor and helpless by the rich and influential, and put self-interest before humanitarian principles. Hogarth deplored affectation and pretentiousness in any form. The country girl who aspired to be a lady, and who is not absolved from all blame for the circumstances in which she finds herself, embodied such pretensions, and her behaviour – with its rewards of loss of liberty, poverty and disease – reinforced Hogarth's moral injunctions against prostitution. Her untimely end may be seen as apt punishment for moral laxity and as a warning to others of the consequences of this way of life. The attitude of the doctors involved 'in consultation', the treatment offered to

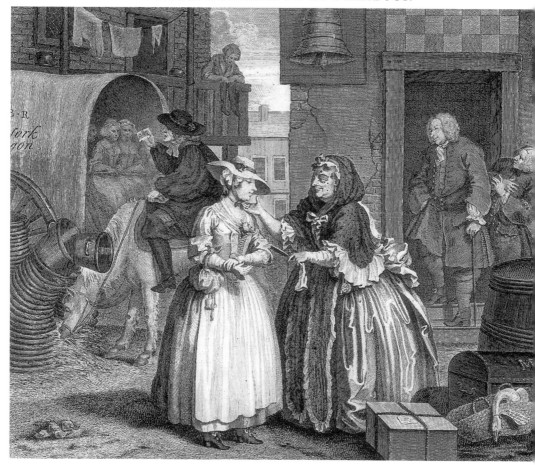

22. WILLIAM HOGARTH: *A Harlot's Progress, 1. Arrival in London*

their patient and its ineffectiveness, or even its contribution to her demise, also receive their share of attention from Hogarth's barbed brush.

The harlot who, in the first scene of the series [22], is presented as an innocent country girl, or, akin to the contents of her basket – a silly goose – is propositioned by a notorious bawd on her arrival in the city. A well-known pimp, with pendant nose signifying lechery, leers and masturbates in the background, while a clergyman ignores the proceedings. The latter is too engrossed in his own advancement to be concerned with the fate of this young girl and can be seen trying to decipher the address of the Bishop of London on the letter that he is holding: the Bishop was known as Walpole's agent for ecclesiastical preferment. A horse is a conventional symbol of base passion: the clergyman's horse is on a loose rein and it may be supposed that the

cleric's inattention allows both the horse and the young girl free rein to indulge in their base passions or animal instincts. At this stage, the Harlot can be seen to have had an opportunity for choice: she could carry out her original purpose, which was visiting her cousin to whom she was conveying the goose, or respond to the bawd's clear invitation to accompany her. (The terms 'Moll' and 'green goose' were popular terms for a prostitute.) In mythological terms, 'Virtue' in the guise of the clergyman, has his back turned to her, while 'Vice', represented by the bawd, confronts her directly. This choice of behaviour is based on the mythological 'Choice of Hercules', in which Hercules had to choose between Virtue and Vice. Hogarth has subverted this particular traditional history-painting theme by using a real-life situation, casting the harlot, a weak and vulnerable girl, as 'Hercules' and showing her choosing to follow the path of Vice. The choice, he submits, might be the subject of history painting but it was also subject to contemporary circumstances.

The chosen path of Vice and Intemperance leads to Scene 2 [23]. After beginning as a prostitute in the bawd's establishment, the young girl becomes the mistress of a rich Jew, living in the style of a lady with a black servant and a pet monkey apeing her frivolous ways. This existence comes to an end as another lover makes a hasty retreat from the room – the end symbolised by the over-turned table and the broken china. The cuckolding of the Jew is indicated by Hogarth's use of perspective: the pattern on the wallpaper behind the Jew can be perceived as a pair of antlers sprouting from his head, a sign of cuckoldry. The act of cuckoldry is another way in which the harlot could be seen as apeing her betters. By another trick of perspective, the young man's sword appears to stab the Jew in the back. Such visual images refer to actions taken. The actions of the harlot cannot be condoned nor can those of the merchant Jew. His pretensions have led him to become a collector of 'High Art' paintings to emulate his betters, and he has acquired a gentile mistress, but now he intends to treat her harshly; she can expect no mercy from him. The Old Testament pictures on the wall offer parallel situations to those enacted in Hogarth's scene. For example, in one picture, Jonah, who is sitting under the protection of a gourd, finds it eaten by a worm overnight: the harlot, whose infidelity is synonymous with the worm, can expect the loss of the protective cover that has been supplied by the Jew. The Jew's choice of Old Master paintings is presented as a dismal reflection upon the kind of paintings chosen and bought by wealthy but ignorant collectors from abroad or from shady dealers.

Cast aside by the Jew because of her duplicity, the young girl becomes a common prostitute in Drury Lane, as seen in Scene 3 of the series [24] in which symbols of her trade, such as the broomstick which has sexual connotations, are apparent. Phallic staves held aloft by the men entering the room symbolise the men's sexual desires on entering the establishment,

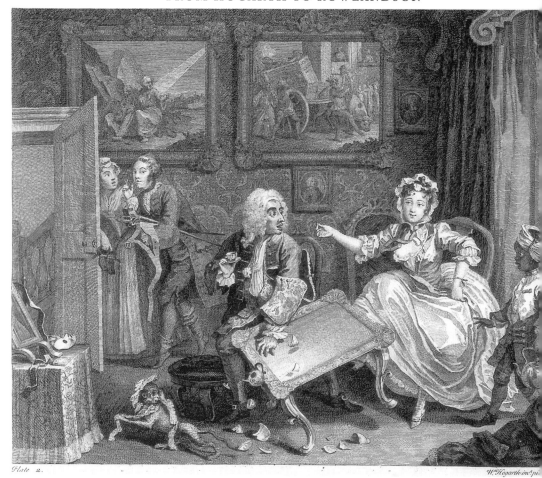

Plate 2.

W.ᵗHogarth inc.ᵗ pi.

23. WILLIAM HOGARTH: *A Harlot's Progress,*
2. *The Quarrel with her Jew Protector*

desires hidden beneath cloaks of authority. The harlot maintains illusions of gentility, with a maidservant serving tea. A kitten replaces the monkey and mimics her frivolity, and pin-up pictures of her idols – reprieved criminals who subsequently led successful lives, and whom she aspires to emulate – replace the Old Testament scenes. The watch that she holds, which indicates the time of 11.45, is one of numerous symbols of the passing of time and the transience of life; time is running out. In this context her health is shown to be threatened and her medical fate is hinted at by the presence of two medicine bottles and an ointment jar on the window-sill. The maidservant with 'saddle nose' (a manifestation of syphilis) is also an indication of what fate may have in store. Her immediate fate is imprisonment for the offence of prostitution

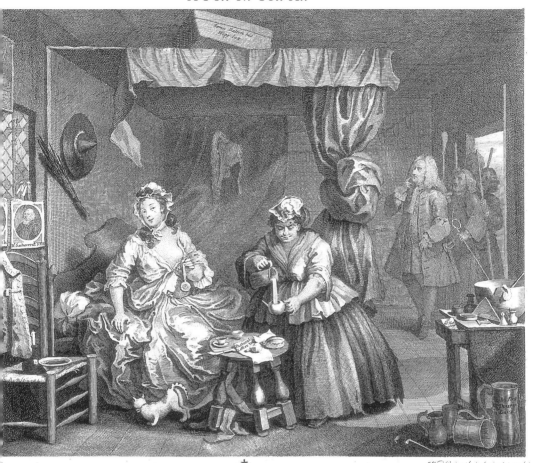

24. WILLIAM HOGARTH: *A Harlot's Progress, 3. Apprehended by a Magistrate*

and she is taken to Bridewell, the House of Correction [25], where her punishment is to beat hemp ('to mill doll') – to make rope – in the company of more disreputable miscreants. A 'Bartholomew doll' describes a tawdry, over-dressed woman, like one of the children's dolls sold at Bartholomew Fair. Hogarth makes play with the word 'doll' by over-dressing the harlot in the circumstances portrayed, but her finery helps to contrast her illusions of gentility with the reality of her situation: its deterioration is synonymous with the deterioration in her physical condition and her circumstances. Hogarth's scenes are intended to be read from left to right of the picture and further deterioration in the harlot's condition, both medical and social, is indicated by that of her fellow inmates on the right side of the scene.

The drama continues and in Scene 5 of the series [26] the harlot is dying of syphilis whilst two doctors argue about the merits of their respective

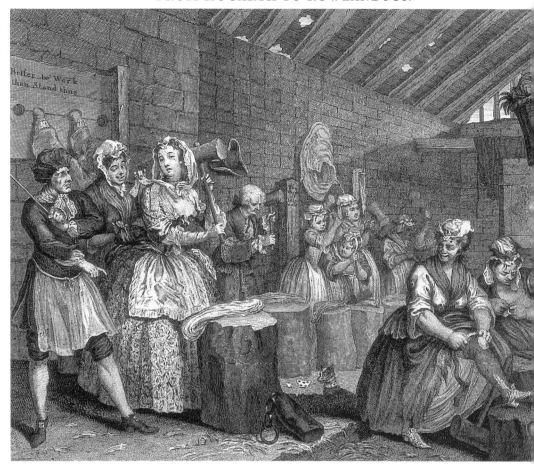

25. WILLIAM HOGARTH: *A Harlot's Progress, 4. Scene in Bridewell*

treatments and whether it is more effective in liquid or pill form, the
difference being indicated by the appropriate containers. These two doctors
are said to be Dr Rock (seated), who is associated with the paper bearing his
name on the close-stool nearby in state 3 of the print and who has been
mentioned earlier, and Dr Jean Misaubin.[3] The name of Dr Misaubin, the 'Pill
Doctor', was frequently in the papers. He was a French doctor, who had
received a Licentiate in 1719 and was therefore not a 'true' quack, but he
qualified as such in the eyes of many of his contemporaries because of his
arrogant and vain boasting. Fielding wrote about him in his novel *Tom Jones*,
stating that, 'The learned Dr Misaubin used to say that the proper direction to
him was, "To Dr Misaubin, in the World", intimating that there were few
people in it to whom his great reputation was not known.'[4] The writer

[94]

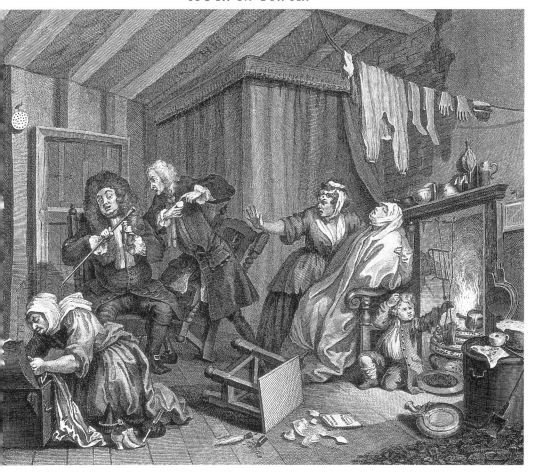

26. WILLIAM HOGARTH: *A Harlot's Progress, 5. She expires while the Doctors are Quarrelling*

satirised Misaubin in his play *The Mock Doctor*, which opened on 23 June 1732, and which he dedicated to him. Misaubin died in 1734 and was rewarded with an obituary notice in the *Gentleman's Magazine* which described him as 'Dr. Misaubin, the noted physician'.[5]

A portrait sketch, after a drawing by Watteau published in 1733, inscribed with the words 'Prenez des Pilules, prenez des pilules', shows Misaubin armed with a clyster-pipe or enema syringe and surrounded by the remains of his clients in their various worldly resting places (BM 1978). He also appears in a sepia and pencil drawing by Hogarth which is in the Windsor Library. This bears the names Dr Misaubin and Dr Ward and is dated 1733. The resemblance of the latter figure to Dr Rock is marked and seems the more

likely subject for this drawing. Ward did not appear in London until 1733.

Rock and Misaubin, in Hogarth's scene of the dying harlot, are complete with wigs, buckled shoes, lace cuffs and canes, the attire of successful physicians (or of pretentious quacks). The maidservant entreats them to attend to her mistress and to stop arguing.

The harlot is swathed in sheets or blankets and towels in consequence of yet another remedy which was often tried for this disease, vapour baths:

> get a shallow pan with a broad bottom, pour boiling water into it, to the depth of between two inches; having made a brick or large stone red hot in the fire, place it (half covered only) in the water. A perforated seat must be placed over the pan, on which the patient must sit, naked, with a good sized blanket wrapped all around him, letting it reach the floor, and excepting the head, covering the body entirely . . .[6]

The fire has been stoked up to aid this sweating process and in order to heat the brick.

Mercury was the treatment of choice for syphilis and had been for about 3000 years. It was supposed to have specific powers over syphilis. Its use promoted salivation and this salivation along with the vapour baths which induced sweating was thought to assist nature to open pores and let out the disease. In 1705, Thomas Sydenham, a well-respected physician, wrote: 'and truly I can think no instance can be produced where this Disease was eradicated any other way than by Salivation with Mercury.' He described his own method of application:

> I prescribe an Ointment made of two Ounces of Lard, and one Ounce of Quicksilver, nor do I mingle any of the hot Oyls or any thing else . . . I order the Sick anoint with his own hand his Arms, Thighs, and Legs, three Nights following; but he must neither touch his Groins nor his Arm-Pits, and his Belly must be carefully defended from the Ointment by a Flannel wrapt about it, and sew'd behind. After the third Unction, his Gums most commonly swell, and the Salivation rises . . . when the Salivation is come to a due height, that is most commonly, when 2 Quarts is spit in the Space of a Night and a Day, or if the symptoms vanish, tho' he spit less, which most commonly happens four Days after the Salivation comes to its height, his Shirt, and Sheets must be changed . . . Sometimes it happens . . . that after the first or second Unction, as soon as the Blood begins to be affected with the Quicksilver, Nature presently endeavours to expel the Enemy through the Bowels.[7]

Evidence of this latter expulsion is provided in Hogarth's print by the presence of the bed-pan placed in close proximity to a close-stool (a stool or box in which a chamber pot, usually made of pewter or brown earthenware,

27. The harlot's teeth lying on a paper bearing Dr Rock's name:
detail from Scene 5, *A Harlot's Progress*

is enclosed). One of the unfortunate consequences of taking mercury was mentioned by Sydenham: 'The Sick beginning to grow well, only that his Mouth is yet ulcerated (which is the genuine Fruit of Salivation).' This led to loosening of the teeth, and in this scene, the harlot's teeth can be seen lying on the paper which, in the third state of the print, is bearing Dr Rock's name and is directly associated with his specific remedy. On top of the close-stool next to this are a spittoon and a clay pipe [27]. The latter, with its obvious connection with smoking, symbolically alludes to the process of dying.

The mantelpiece sports evidence of other tried remedies in addition to a clyster bag with which to administer the inevitable enema. Although a syringe for the administration of an enema had been in general use by the fifteenth century, older methods were still frequently employed in the eighteenth. These consisted of a bag prepared from animal skin or pig or ox bladder to which a tube – formed originally from a reed or hollow stem – was attached. The bag was emptied by pressure with both hands.[8] This contraption was a clyster-pipe, and through the one illustrated, the harlot may be supposed to have received an appropriate enema to assist in the expulsion process.

Hanging from a nail by the door are 'prophylactic cases' (condoms, or French letters, said to have been invented by one Col. Cundum). These were made from dried intestines (usually the caecum which has a blind pouch) of such animals as sheep, lambs, calves and goats. They were rather stiff and became brittle unless stored in water. Some, used by army officers, were decorated with their regimental colours. Similar items, the necessity of which is implicit in the context of the scene, are present in another work usually attributed to Hogarth, *A Garret Scene*, a drawing executed in about 1726 [28]. In this the table is littered with remedies for the occupational hazard to which the resident of the garret is evidently exposed. Syringe, medicine bottles, ointment jar, condoms and plasters are in evidence on the table and window-ledge, and the harlot is bandaging her arm in order to treat or conceal some lesion. Her cheerful peg-legged servant, a bunter, or one who

28. Attributed to William Hogarth: *A Garret Scene*

collects rags, and a small cat contribute to a striking similarity to the later harlot scenes.

On the floor in the later scene, lies a paper on which the words 'ANODYNE NECKLACE' appear [29]. This was a well-known device 'guaranteed' to ward off the congenital effects of the disease in children, and advertised daily, as in the *Craftsman* of 2 December 1732 where it promises 'curative powers for Children's Teeth, Fits, Fevers, Convulsions etc. and the great specific Remedy for the Secret Disease.' It was with such a device that a print of Mary Toft and her attendants had been 'given gratis' in 1727 (see p. 48).

29. Advertisement or instructions for the use of an Anodyne Necklace: detail from Scene 5, *A Harlot's Progress*

Religious and mysterious properties were incorporated in the necklace, which was supposedly made from the bones of St Hugh.[9] A later article published in the *Gentleman's Magazine* under the heading 'Of Quack Doctors' refers to

> Dr Anodyne . . . His Necklace might be of great Use to those that breed Geese, to hang about the Neck of every Gosling, to make them breed their Teeth without pain. And however some may say he buys broken Marrow bones of the Butchers to make his Necklaces, I rather think he drills them out of the Jaw-bone of an Ass.[10]

The child by the fire for whom the necklace may have been purchased, and against whose existence the badly stored condoms have been ineffective, is more concerned with his head lice and his dinner than with his own or his mother's plight. A nurse showing a similar disregard for the patient is engaged in rifling through the contents of a trunk to see what she personally can salvage from the situation. Cracked walls and the pan boiling over symbolise the passing of time.

The mirror by the fireplace no longer reflects a true image; it is cracked and therefore the image is distorted and the harlot has not seen herself as she really was. The cracked mirror is another symbol of the transience of things. A mirror is also a symbol of vanity, the vanity of women who survey their own femininity. A woman is seen surveying herself in a different mirror in the final scene of the series. A spotless mirror symbolises the Virgin Mary: Hogarth's mirror in the final scene reflects a woman with blemished visage and, presumably, blemished morals similar to those of the harlot.

In this final scene of the series, the doctors' remedies having proved ineffective or lethal, a funeral scene takes place [30]. Only one attendant appears to show any regard or compassion for the deceased; this one perhaps seeing her mirror image in the coffin. The others continue their selfish or dissolute ways; pictures of lechery, intoxication, vanity, hypocrisy and lack of compassion. The presence of sprigs of yew and rosemary scattered amongst the mourners may illustrate the belief that these had disinfectant properties. They were also symbols of remembrance. At the time of the engraving, custom dictated that a sprig of rosemary was given to each mourner.[11] In this scene one girl is sadly displaying one of her fingers to a colleague and seeking advice or commiseration [31]. The swelling or peri-articular nodules which can be seen on the offending digit indicate another manifestation of syphilis. Sydenham commented upon such complications:

> if there be a Tumour upon any Bone, commonly called an Exostosis, which had continued so long, that the Bone is become carious, it is altogether in vain to attempt the Cure, either by Salivation, or any other method, unless care be taken of the Swelling, wherefore the Bone must be laid bare by Caustick, and the Exfoliation of it . . . must be endeavoured by proper Remedies.[12]

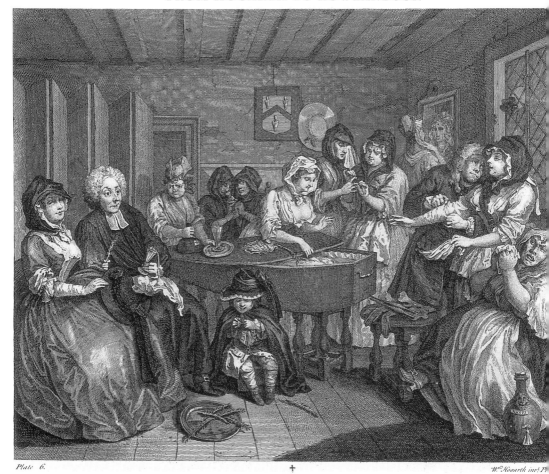

Plate 6. ✝ W.ᵐ Hogarth invᵗ Pᵗ

30. WILLIAM HOGARTH: *A Harlot's Progress, 6. The Funeral*

There appears to be every reason for the girl's tears.

The obscene coat-of-arms on the wall with its inscription, 'azure, parti per chevron, sable, three fossets [faucets] in which three spiggots are inserted, all proper', demonstrates once more Hogarth's play with heraldry. Shop signs, public-house signs and heraldic signs of nobility shared a common origin based on the name and occupation of the owner. These might be turned into visual puns of varying degrees of sophistication and pretentiousness.[13] The harlot's coat-of-arms aptly portrays her occupation, but its presence in the humble surroundings, or even its existence, is indicative of the pretentiousness which Hogarth perceived in his characters. Heraldic devices were the prerogative of the great.

The child's position as chief mourner also defies tradition and ridicules the

[100]

31. Swollen and diseased finger: detail from Scene 6, *A Harlot's Progress*

ostentation prevalent at some funerals. Small mourning figures on a tomb-stone were known as weepers. The small child here represents such a figure close to his mother's coffin. The whole scene ridicules the ostentation and expense attendant upon some funerals.[14] However, the escutcheon provided by Hogarth symbolises the whore's trade and the coffin contains its *memento mori* or consequence. Who is chiefly to blame for this course of events? Hogarth leaves the question open.

II. *MARRIAGE-À-LA-MODE*

> Where Titles deign with Cits to have and hold,
> And change rich blood for more substantial gold;
> And honour'd trade from interest turns aside,
> To hazard happiness for titled pride.
>
> – Garrick[15]

Marriage-à-la-Mode (1745) is the third of the series of Hogarth's 'Modern Moral Subjects', the second being *The Rake's Progress*, which is described later. Once again, Hogarth's audience of aristocrats and members of the rising middle-classes (usually a male audience) would recognise the circum-stances portrayed. In addition to highlighting aspects of amorality and life in high society, for which he blames a decadent foreign influence, Hogarth comments upon the disturbing practice whereby a merchant might be willing to sell his daughter for an aristocratic 'label'. The formation of interactive groups of society was one result of the increasing growth of commerce with its accompanying financial gains, but this, as here, could lead to pretentious aspirations, selfishness and lack of compassion. The series also exploits

[101]

general concepts and attitudes towards medical care and treatment and throws some light on the type of practitioners available to treat the 'secret illness' or 'pox'. Attributes of sickness, such as crutches, bandages, pills and potions signify more than meets the eye. As in the series *A Harlot's Progress*, some decoding of emblems and symbols helps to unravel the complex messages that Hogarth intended to transmit to his readers, and, as previously, traditional pictures on the walls in each scene mirror the events taking place.[16] An extra dimension is added here: the earl is dressed in all his English finery but he has been tarnished by exposure to foreign influences. His heir epitomises the French fop, and the architecture and decorations of the house are Italian. The deterioration in the family circumstances are associated with the incorporation of foreign manners and customs into their lives which will ultimately lead to their destruction. In contrast, the merchant's manners and attitudes are portrayed as plain, vulgar and boorish. The pictures on the undecorated walls of his house, depicting popular common themes, reflect an earthy Dutch influence commonly associated with trade.

Marriage-à-la-Mode [32–35, 37–39][17] is a series which follows the history of the two main characters whose marriage has been arranged on the basis of the interests of the couple's respective family fortunes. The weakening of the perceived importance of the basic institution of marriage in high society through the arranging of such matches is one of the social comments that Hogarth makes. Some of the consequences, which include the contraction of syphilis, form the medical interest. It is also of interest to note that defects in character or life-style are displayed as analogous to physical defects or disease.

The first scene, *The Marriage Contract* [32], is set in a room in Lord Squanderfield's house in which the earl is seen posed amongst his possessions, many of which are branded with the mark of his coronet to denote his importance. They include his crutches and his footstool, both apparently necessary because of his affliction with gout – generally regarded as a nobleman's disease – which is stereotypically indicated by his heavily bandaged and elevated foot. The earl fits the physical picture of a typical gout sufferer described by Sydenham. Thomas Sydenham (1624–89), who had built up a practice in London which was famous throughout Europe, and whose influence was still felt in the eighteenth century, had been interested in the natural history of disease. This interest is evident in his description of gout from which he personally suffered for thirty years:

> The gout most commonly seizes such Old men, as have liv'd the best part of their Lives tenderly and delicately, allowing themselves freely Banquets, Wine, and other Spirituous Liquors, and at length by reason of the Sloth that always attends Old-Age, have quite omitted such Exercises as young Men are wont to use.

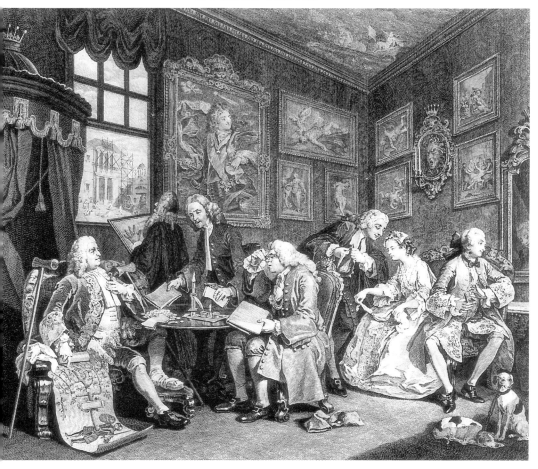

32. WILLIAM HOGARTH: *Marriage-à-la-Mode*, I. *The Marriage Contract*

Moreover they who are Subject to this Disease have large Skulls, and most commonly are of gross Habit of Body, moist and lax, and of a Strong and lusty Constitution, the best and richest Foundation for Life.[18]

In this instance it is implied that the Earl has received his just reward in the form of gout for his style of living. His mistaken ideas and lack of foresight with regard to the marriage contract being negotiated are also metamorphosed into the physical defect. The name 'French gout' was often given to syphilis and 'gout' could be used as a symbol for lust, the two factors not being entirely dissociated. Hogarth uses all these associations purposefully: the earl's character, his way of life, his decision-making on behalf of the young couple and on the way he spends his resources, are all bound together, placed on a footstool and symbolically labelled 'gout'. French forebears

appear in the family tree, implying to many at that time some intrinsic hereditary defect, confirmed in this series by the stigma – in the form of a black patch – graphically passed on to the succeeding generations.

A branch on the family tree, which goes back to William the Conqueror, is being negotiated in return for funding from a merchant for the completion of the partially constructed and architecturally flawed building which can be seen through the window, representing a further example of lack of foresight on the part of the owner. The two young people whose future is being arranged are not consulted during the process and do not seem to show much interest. The earl's foppish son, gazing into the mirror, carries a black patch on his neck which hints at some health problem. This is probably scrofula, a tubercular condition affecting the lymph glands especially in the neck, which was prevalent and thought to be passed on in families. Hogarth seems to be using this sign as a means of showing the transmission of disease and of character defects from father to child, and later in the series associates the sign with a venereal source of infection: the child of the union bears a similar patch in the final scene. The young lady involved in the marriage contract plays desultorily with her kerchief and listens to the murmurings in her ear provided by the young lawyer Silvertongue. Two dogs chained together in the corner provide emblems of the contracted marriage.

In Scene II, *The Tête à tête* [33], after the marriage, the young couple proceed to follow their own interests regarding 'high life' amid symbolic signs of hypocrisy and the breakdown of their marriage relationship; candles burn low, Cupid, whose bow-string is broken, is shown in the picture over the mantelpiece playing the bag-pipes, an instrument notably lacking in harmony. Signs of infidelity are evident, and the dog, a symbol of lust, has sniffed out a lady's cap from the viscount's pocket. The viscount's attitude is one of sexual exhaustion, but his broken, undrawn sword provides evidence of the sexual inadequacy or impotence of its owner, perhaps allied to the inherited weakness with regard to his physical and moral constitution – inferred from the 'taint' of scrofula.[19] The bust on the mantelpiece has had its nose, an organ with sexual connotations, broken and repaired but it is still disfigured as if by disease [34]. The surgeon, John Freke, observed with regard to Venereal Disease of the Bones, including that of the nose:

> [It] oftener begins its Mischief externally, first raising and thickening the Membrane by the Poisonous Medulla or Oil that lies under it. When the Os Nasi or Os Palati are at all affected, it seldom or never happens but that the whole of them is destroy'd. And although the Patient be quite clear in all other Respects, yet if the Compages of these Bones have been destroy'd, they will moulder away a long time after.[20]

Hogarth makes his moral point in this symbolic fashion. Neither the marriage nor the nasal repair can be complete in such circumstances. Sculpture,

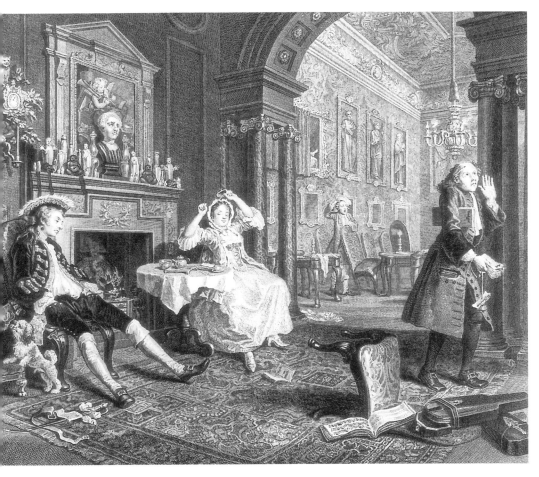

33. WILLIAM HOGARTH: *Marriage-à-la-Mode*, II. *The Tête à tête*

34. Roman bust on mantelpiece with disfigured nose:
detail from Scene II. *Marriage-à-la-Mode*

traditionally considered as a superior art form, is not always worthy of merit; another pointed comment made by Hogarth's image. The defect in the marriage relationship, beginning superficially, becomes deep, permanent and disfiguring, anticipating its final state which can be seen in Scene III – a pitted skull – a symbol of death.

The clock in the engraving shows the time to be 1.20 (12.20 in the painting) but the candles are still burning – an indication of night merging with day and of chaos and disorder in the household. The steward leaves the room in despair, carrying unpaid bills. A sign of hidden impropriety is indicated by the picture over which a curtain is partly drawn, exposing only a naked foot. This is an allusion to the hypocrisy which prevailed in society; private vices could be hidden from view but enjoyed 'behind the scenes'. In connection with the state of the marriage, it indicates also that the full truth of a situation is often hidden from society.

Scene III, *The Inspection*, involves a visit to the quack doctor by the young nobleman [35]. He is accompanied by a young girl who is holding a kerchief to the corner of her mouth: her youthfulness magnifies the extent of his debauchery. The kerchief probably conceals a chancre or syphilitic sore for which aid is being sought from the quack. The nobleman holds out a box of pills towards the quack, the lid of the box remaining on the seat of the chair indicating the area for which treatment is required. He seems to indicate the pills' uselessness, although apparently displays little concern. The woman behind him with open razor seems to dispute any challenge that he is making, but the razor may also represent a danger associated with visiting such a practitioner: 'secret' remedies, usually containing mercury, could have fatal consequences. The quack's title of 'Monsieur de la Pillule' is displayed as the author of the books in the left foreground of the picture. (The name 'Dr Pilule' was often applied to Dr Misaubin, one of the 'doctors' in attendance upon the harlot in *A Harlot's Progess*.)[21] The word 'pill' was cant for one who lays waste, and was a popular word for 'doctor'. Hence, M. Pillule may be described as one who 'wastes life'. The woman is said to have been modelled on Misaubin's Irish wife and the office on his room at 96 St Martin's Lane.[22] In this scene 'Monsieur' is portrayed as an unprepossessing person. His physiognomical imperfections may reflect Hogarth's suspicion and animosity (in keeping with many of his countrymen) towards the French in general, but may also be an allusion to the defects inherent in quacks, many of whom were foreigners. This quack is a 'Pox' doctor, professing to cure the 'French gout'. An analogy with the earl's gout in Scene I is apparent. This quack regards his client through myopic eyes as he wipes his spectacles. His toothless gums, depressed nasal bridge and bowed legs add to his unbecoming appearance. Such physiognomy helps to describe the character of the owner. The woman poses an equally unprepossessing zany or assistant.

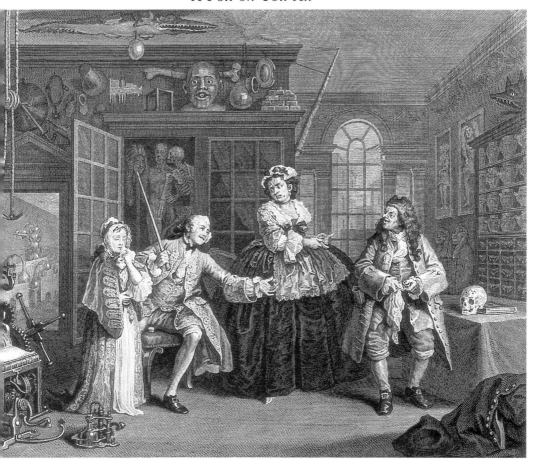

35. WILLIAM HOGARTH: *Marriage-à-la-Mode,* III. *The Inspection*

> To Galen's great descendant list, – oh list!
> Behold a surgeon, sage, anatomist,
> Mechanic, antiquarian, seer, collector,
> Physician, barber, bone-setter, dissector.
> The sextons, registers, and tombstones tell,
> By his prescriptions, what an army fell;
> Med'cines – by him compos'd will stop the breath,
> And every pill is fraught with certain death.[23]

Hogarth seemed to work by looking at a problem or an issue, analysing its aspects carefully so that he could characterise the relevant signs and symptoms, and then amalgamating different aspects of the issue to make a composite whole. In Scene III, the quack and his surroundings seem to

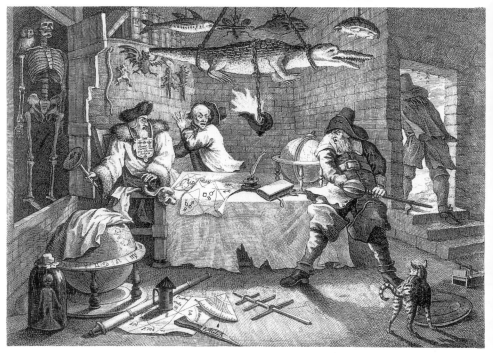

36. WILLIAM HOGARTH: *Hudibras Beats Sidrophel and Whacum*

represent quackery in general, the scene as a whole offering a background to quackery – its origins, its associations, its ineffectiveness, the type and gullibility of its patrons and the manner and personality of its practitioners.

There was a close link between magic and quack medicine which Hogarth had previously indicated in an illustration which he undertook for Samuel Butler's *Hudibras*. Although Sidrophel, the magician in this satire on puritanism, was a fictional character, aspects of his magic were reflected in beliefs and attitudes held by many members of society. Sidrophel's room contains objects and books suitable to one of his kind, as astrologer and magician. These include an alligator hanging from the ceiling, dried insects pinned to the wall, and a skeleton hanging in the cupboard [36]. It, and the quack's office in *Marriage-à-la-Mode*, bear some resemblance to *The Dispensary* described by physician Dr Samuel Garth in a poem which was widely read in the eighteenth century:

> Long has he been of that amphibious fry,
> Bold to prescribe, and busy to apply.
> His shop the gazing vulgar's eyes employs
> With foreign trinkets, and domestic toys.

Here mummies lay most reverendly stale;
And there the tortoise hung her coat of mail;
Not far from some huge shark's devouring head
The flying fish their finny pinions spread;
Aloft in rows large poppy heads were strung,
And near, a scaly alligator hung;
In this place, drugs in musty heaps decay'd;
In that, dry'd bladders and drawn teeth were laid.[24]

The quack's room is allied to the fashionable pastime of the seventeenth and eighteenth centuries of forming 'Cabinets of Curiosities' from 'odds and ends to excite wonder', particularly as interest in the discoveries of the Americas and East Indies grew. Curiosity rather than good taste dictated fashion: 'Almost every collection had monsters in it . . . when the collection was displayed, it rarely had any order in it. Stuffed birds stood on top shelves . . . mammals and fish hung from the rafters.'[25] Such collections attracted the public to the apothecary and the medical man. They acted as an advertisement and improved his social status. In Shakespeare's time, too, the apothecary was apparently recognised in this fashion. In *Romeo and Juliet*, Romeo says

I do remember an apothecary . . .
And in his needy shop a tortoise hung,
An alligator stuff'd and other skins
Of ill-shap'd fishes . . .
Were thinly scatter'd, to make up a show.[26]

In Hogarth's print, such curiosities add to the air of mystique and magical powers often accorded to quackery. Many of them have symbolic and medical connotations. A skull was an obligatory part of a quack's equipment, but its defective or diseased state in this instance specifically symbolises death. Powdered skull was still used as an ingredient of some remedies. The book on which the skull rests is equated with learning, but the presence of only one slim volume indicates how limited the quack's has been. The superimposition of the skull on the book indicates that the doctor is an authority on venereal disease,[27] a pox doctor. The padlock on the book may indicate that his secret remedy lies within.

The back of the room in the painting lies in shadow, and here a quack's historical background is suggested. If the items illustrated on the frieze above the cupboard are read from left to right – as Hogarth often intended his 'theatrical' productions to be read – the beginning of quackery or its monstrous birth is heralded by the picture of an abnormal infant, a freak of nature, intended either to evoke shudders or create amusement. Exceptionally, such a creature was accorded respect. A scarab illustrated below this infant, such as was used in ancient Egypt to ward off evil, was ineffective in

preventing its conception. The sword and shield represent a background of conflict, while spurs and tall hat might indicate a wandering or peripatetic scene of action. Many odd items such as old shoes, crushed lice, insects and crocodile dung had been used in the past as ingredients of drugs, and were still used by the unscrupulous. Most would do no harm, as they were pharmacologically inert, but their presence here symbolises the sterility and uselessness of some of the treatments available and presumably offered by the quack in the picture.[28] The next item on the frieze is similar to the broken remains of a vertebral column belonging to a large fish. This, with the large femur, may refer to the practice of bone-setting, an occupation often dependent upon strength rather than medical knowledge. (Hogarth had previously illustrated Mrs Mapp in such a role as described in *The Arms of the Company of Undertakers*.) In front of the femur is a model head with a pill in its mouth. Such a head was used as a shop model and usually displayed outside an apothecary's shop in order to advertise his wares. An animal or monster's head holding a ring in its mouth symbolically depicts a 'guardian of the way', and an open mouth is the gate of death.[29] The 'pill' in the open mouth of this model's head looks like a ring, thus indicating that the pills prescribed in this establishment would lead one to death.

A urinal represents the practice of urinoscopy whereby diagnosis of illness was made by examination of the urine, with or without the benefit of astrology. Some quacks still practised in this field. Hogarth possibly equates the large size of the urinal and the femur with the magnitude of the claims made by the practitioners associated with these items.

The activities of the barber-surgeon are represented by the shaving bowl. Such a bowl was used by him during the operation of bleeding or shaving. The narwhal's tusk to the right of this is the equivalent of a barber's pole. The latter originated from a lance which was wrapped round with bloodied bandages, carried in battle and held aloft so that the army surgeon could be located. In the print, it may also represent the mythical unicorn's horn, which was a highly prized and expensive medieval remedy and a supposed aphrodisiac. Its use persisted throughout the sixteenth century in this capacity in addition to its supposed ability to act as an antidote to poison when mixed with food.[30] As a phallic symbol, it denotes the area of concern to which this quack usually paid attention.

The pile of 'bricks' on the frieze is more difficult to identify. Tea was a popular but expensive stimulant, newly fashionable and obtained in brick form but usually prescribed in paper folders in small quantities.[31] The 'bricks' are unlikely to be pill-boxes as the latter were usually much smaller, such as that proffered by the nobleman. They could represent ordinary building bricks to indicate Hogarth's intention of 'building' the quacks' foundation or background in the frieze.

The vertebrae and the femur in the centre of the frieze point towards a tripod shaped like the gallows at Tyburn. (Tyburn was the place where London executions were carried out. It was situated at the junction of the Tyburn and Edgeware roads and was familiarly known as the 'Tyburn tree'. Hogarth drew the scene in Plate 11 of his series *Industry and Idleness*, in which the 'idle 'Prentice' is executed at Tyburn amid scenes of festivity and enjoyment which usually accompanied such an occasion.) In the quack doctor's room the 'scaffold' is placed on the top of a cupboard which contains a skeleton making amorous advances to a human anatomical model, whilst a wig-holder, with painted face supporting the quack's full-bottomed wig and simulating a decapitated malefactor, looks on. The allusion may be that the quack is to be identified with the decapitated wig-holder. The position of the nobleman's cane pointing to the face of the bewigged head in imitation of a physician's stereotyped and recognisable pose is no perspectival accident on Hogarth's part; it 'elevates' the simulated quack to the status of such a practitioner. The full-bottomed wig, such as was usually worn by physicians, offers allusions of sagacity and prestige. The skeleton is signifying death by its lecherous advances in the 'Dance of Death' tradition (see Chapter 10): the physician can only offer a similar outcome. Hogarth may again be making the point that in his view only a wig and cane distinguish the orthodox physician from the quack. An alternative theory suggests that the naked fellow represents a patient and the others are two physicians consulting,[32] but the former interpretation seems more coherent in the context of the scene.

Pictures of abnormal individuals hang on the wall as part of the oddities and exotica displayed. There was a great deal of interest in monsters, as was seen in the case of Mary Toft. Dr James Parsons, Hogarth's friend and Secretary of the Royal Society, wrote a paper on hermaphrodites and another concerning tumours of the head of a young labouring man 'now in St Bartholomew's Hospital'.[33] Contemporary interest, specimens from the Royal Society museum and information from Parsons may have provided the inspiration for these pictures. The picture nearest to the door illustrates a figure with two heads representing the two faces of Janus, a Roman deity who represents the desire to master all things. His faces were supposedly turned towards the past and the future. Hogarth uses the picture here to point to the quack's past and to his future and what he has to offer: the flawed skull on the table. Tales of the existence of ethnographic monsters proliferated. Many of these were thought to reside in the east, especially in India. A treatise written by a Persian physician in the fourth century BC, and elaborated over many centuries, told of headless people with their faces between their shoulders. Hogarth uses this iconographic model for another of his pictures. Monsters could be seen either as omens or as signifying divine justice.

Pharmaceutical vessels and jars, such as might be expected in an apothe-

cary's shop, line the shelves of a cabinet on the right of the picture. Above these a 'guardian' in the shape of a wolf with open jaws again symbolises the gate of death. Closed drawers beneath the shelves hide their contents from public view – another comment upon 'secret' remedies.

A stuffed crocodile or alligator is suspended from the ceiling with an ostrich egg likewise suspended from its under surface. These are symbols of quackery, used in many Dutch genre paintings of the seventeenth century and mentioned in Garth's poem. This reptile is equivalent to the salamander, a creature accredited in alchemic theory with the *elixir vitae* and believed to live in fire. An ostrich egg was supposed to ward off the 'evil eye' and was associated with miraculous conception.

An open door at the rear left of the picture reveals the quack's laboratory containing distillation apparatus such as an alchemist would use. One of the alchemist's chief aims had been to discover an elixir of life, a universal medicine which would cure all ailments and provide eternal life. Medicine had been considered as a magical or sacred art prior to the existence of alchemists. Astrology, magic, alchemy and medicine were often linked, and a large number of charlatans became involved. By the seventeenth century, alchemy was not uncommonly the subject of derision, although serious scientists such as Newton continued to be attracted by its potentialities. Hogarth depicts a typical scene of one such 'mad' alchemist reduced to penury in the Fleet Prison in *The Rake's Progress* [57]. His last penny (or gold coin) has gone into his crucible as a starter in his search for the philosopher's stone, but his search goes on. An allusion to charlatanism with regard to the quack's laboratory is apparent.

Two machines lying on the floor are explained in the adjacent books. One is shown to be for adjusting or setting shoulders and the other for pulling corks. Both are thus attributed by Hogarth to 'Monsieur de la Pillule', the office's incumbent and the author of the volumes. The two large tomes indicate his verbosity on the subjects (another characteristic attributed to quacks). The inventions have been 'seen' and 'approved' by the Royal Academy of Science of Paris. They furnish signs of the quack's skill and ingenuity, aspects which were also attributable to some notorious charlatans.

Freke read a description of an instrument that he had invented for the reduction of dislocation of the shoulder joint to the Royal Society on 23 June 1743, and this invention may have inspired Hogarth to design one for his quack. The second instrument has lewd connotations, which, it has been suggested, refer to Pope's *Rape of the Lock*, 'And maids turn'd bottles call aloud for corks'.[34] This may be more in keeping with the enacted scene. It is also a reminder of an apothecary's role of corking medicine bottles.

Two mummy cases stand behind the quack. Their presence can be explained in two ways, both of which Hogarth might have intended as

allusions. First, powdered mummy was a valued ingredient of medicines held in high esteem in the sixteenth and seventeenth centuries. It was an almost universal but expensive remedy, mostly adulterated or faked, but may have had value as a placebo, and was invariably harmless. Second, the mummy cases seem to signify orthodox, disdainful, superior and antique or old-fashioned medical practitioners whose mouths were closed in the face of events such as those proceeding in front of them, while each prominently displays a large ear, indicating that they hear about such practices. Pox doctors were regarded with some contempt in the field of contemporary medicine, but they could pose serious competition to the orthodox prac-titioners for whom this field could provide a lucrative practice.

The *London Tradesman* of 1747 commented that there was

> one Branch [of medical practice], belonging to the Doctor, which the Town Surgeon has almost monopolized to himself; that is, the cure of Venereal Disease; upon which alone the subsistence of three parts in four of all the Surgeons in Town depends; and three parts in four of the Practice depends upon the Ignorance in this very Distemper, which they all pretend to cure . . .[35]

Hogarth's picture illustrates the position of influence that the quack held in society, where members of the nobility, represented here by the viscount, went to him for advice. Those who claimed to cure syphilis, such as the quack in this scene, were aided by the natural history of the disease in which clinical manifestations resolve spontaneously and late sequelae may appear only after an asymptomatic interval of up to thirty years. One third of infections end in spontaneous cure.[36] All classes of society consulted the quack, and his practice was not confined to the market-place.

The contents of the room are used by Hogarth to draw attention to a quack's pedigree, his pretentiousness in aspiring to the position of physician from such humble and diverse beginnings, the dangers inherent in such practice and the gullibility of the public. All classes of society, including members of the nobility – as portrayed by Hogarth – were impressed by the outward trappings of pseudo-scientific knowledge and respectability and were prepared to expose themselves to the dangers associated with quackery.

In Scene IV of the series, *The Toilette* [37], we are led to believe that time has passed. The couple, according to their visiting cards, are now Lord and Lady Squander. The countess has not been idle during her husband's exploits and she has had a child, indicated by a rattle hanging on her chair. This is in the form of a 'coral' or necklace believed to act as a charm or amulet to ward off evil. Without this, it is implied, the child is exposed to danger. The scene portrays a *levée* taking place in the countess's boudoir, attended by fashion-able *castrati* Italian opera singers and by the lawyer who was present in Scene I of the series. Signs of impropriety abound: for example, the book on the

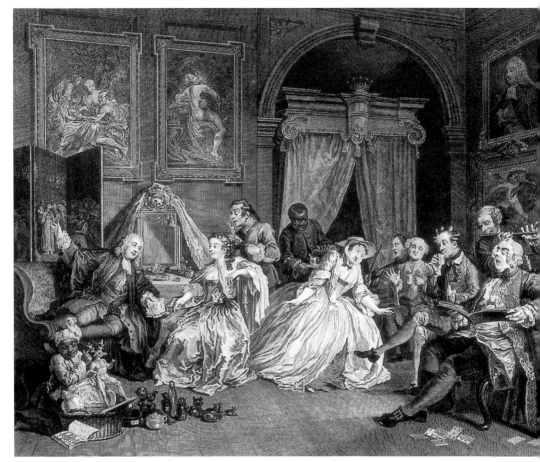

37. WILLIAM HOGARTH: *Marriage-à-la-Mode*, IV. *The Toilette*

sofa, *Le sopha* – a visual pun in this context – was known for its frank discussions of a sexual nature, and an assignation to attend a masked ball is being made by the lawyer and the countess. Purchases have been made at an auction room, a place where unaccompanied couples could meet without raising suspicions. The little black servant, sitting by the purchases, points to a statuette of Actaeon. Actaeon was a mythological hunter who was turned into a stag by Diana after he had accidentally seen her and her nymphs bathing, and was subsequently caught and eaten by his hounds (the verb 'to stag' means 'to discover or observe with lecherous intent'). This reference by Hogarth may anticipate the visit to *The Bagnio*, or public bathing establishment, depicted in Scene V [38]. But double standards prevail. Whilst the young earl has his liaisons with dubious characters, his wife's association with the lawyer, when discovered by her irate husband, results in the death of the

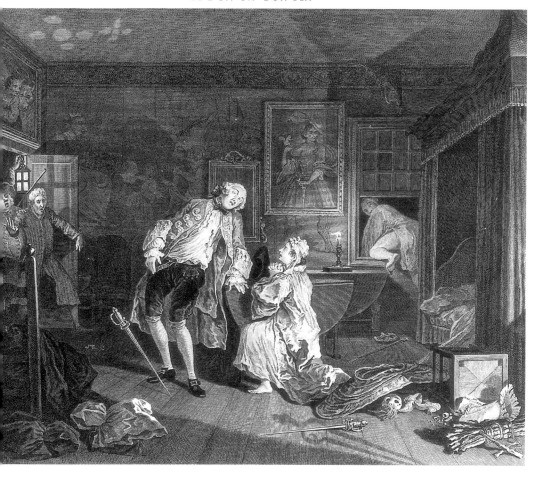

38. WILLIAM HOGARTH: *Marriage-à-la-Mode*, V. *The Bagnio*

latter by her lover's hand. Scene VI follows the lover's execution at Tyburn, the countess having taken an overdose of laudanum.

The countess's death takes place in Scene VI [39], *The Lady's Death*. The scene is set in the merchant's house which overlooks old London Bridge. A servant has been bribed to get the countess some laudanum (opium),[37] a substance which was freely available from druggists' or apothecaries' shops; the overturned bottle lies on the floor along with a broadsheet recounting a speech given by her lover on the occasion of his execution. The servant's cut-down coat has buttons missing, synonymous with his lack of mental faculties – a lack indicated also by his features and expression. The attending apothecary, who berates the servant for the transaction, is identified by a bottle of 'Julep' and an enema syringe protruding from his pocket.[38] A

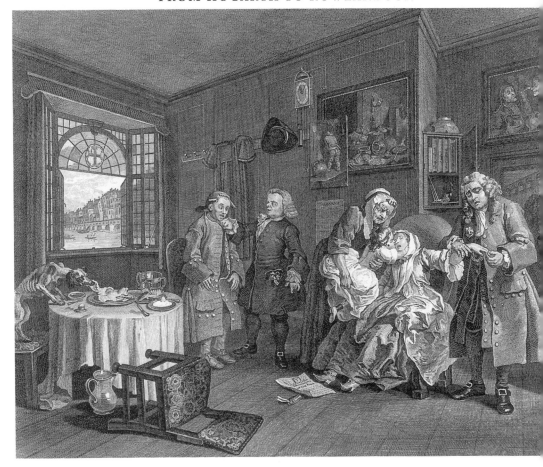

39. WILLIAM HOGARTH: *Marriage-à-la-Mode*, VI. *The Lady's Death*

nosegay takes the place of a physician's cane with its pomander in the head and serves a similar traditional function. Hogarth places the apothecary on a par with the servant; both are drawn in the same picture-plane and are of similar stature. The apothecary's stocky build and his stance are not those of a gentleman. Receding through the door is the physician, recognisable by his wig, cane held to nose and three-cornered hat underneath his arm. A sword hanging by his side is a badge of aristocracy, a rare honour accorded to physicians. The services of this élite member of the medical profession have been as ineffective as those of his inferior.

The merchant is engaged in the task of removing his daughter's ring from her finger, as, following suicide, the practice was such that the ring would be forfeited to the Crown if left in place. Pecuniary interests are still uppermost in his mind.

Only the old nurse and child appear to show concern for the countess. The child depicts a sad end to the marriage contract. Boys and girls wore skirts until the former were breeched at three or four years of age; girls usually wore bonnets even indoors.³⁹ This child, although dressed in skirts – known as 'coats' in the case of a boy – may therefore be male, but his diseased state indicates a shortened life-span with the subsequent end to this branch of the family tree. A female child would also denote the end of the branch, but sickness would not be necessary in such circumstances. The patch on the child's face matches the one which can be seen on his father's neck throughout the series, illustrating a supposed hereditary nature of the affliction, scrofula, which Hogarth has linked to syphilis in this series. Implicit here is a reminder of the biblical warning that the sins of the father will be visited upon the children. The congenital nature of the pox was mentioned by Moll Flanders in the book of that name written by Daniel Defoe in 1722, in which Moll reproached her 'gentleman' for associating with a whore: 'how would he be trembling for fear he had got the pox . . . and how would he abhor the thought of giving any ill distemper, if he had it . . . to his modest and virtuous wife, and thereby sowing the contagion in the life-blood of his posterity.'⁴⁰ Alexander Pope also referred to this aspect of syphilis in *An Essay on Man* in the words: 'When his lewd father gave the dire disease'.⁴¹ The stigmas of congenital syphilis that the earl has passed on to his 'posterity' include a large bossed forehead and sunken nasal bridge. A leg brace is evident as an attempt to correct rachitic effects also caused by this disease.

On the wall in the background, a picture depicts a man in the act of urinating into a chamber-pot, an act used to demonstrate contempt at the scene below. Crude and vulgar pictures on the walls of the merchant's house similar to those of many Dutch genre scenes, and the site and decor of the house, allude to the literal and metaphorical distance that separates the life of the merchant from that of the earl.

Hogarth made frequent allusions to syphilis in his paintings and engravings. Although gonorrhoea, known as the 'clap', was more prevalent than syphilis in the eighteenth century, its nature did not lend itself as readily to graphic illustration. Probably for this reason, as well as for the more devastating results of syphilis – lending it obvious educational possibilities – Hogarth's moral delinquents usually suffered from syphilis. This is an example of how Hogarth and other artists selectively emphasised those aspects of a subject which were adapted to pictorial and moralising narratives. Even so, syphilis was present in society, the effects were real and could be as devastating as those portrayed so accurately by Hogarth.

Numerous maidservants with 'saddle-noses' appear in Hogarth's prints. The harlot's servant, and the whore in the series *Industry and Idleness* provide examples of this particular effect of the disease amongst those whose life-style

40. Detail from Hogarth's
The Idle 'Prentice Betray'd by his Whore

held the risk of such an occupational hazard. This would be recognised by readers. The servant who appears in Plate IX of the series *Industry and Idleness*, in which the idle apprentice is betrayed by his whore and captured in a night cellar with his accomplice, has been provided with a leather patch to conceal the ultimately resulting disfigurement [40]. In his novel *Amelia*, Henry Fielding described the face of an unsavoury character named 'Bleary Moll' thus: 'Nose she had none; for Venus, envious perhaps of her former charms, had carried off the gristly part . . .'.[42] Venus was the Goddess of Love and the personification of venery or sexual indulgence.

The physical defects of 'Monsieur de la Pillule' in *Marriage-à-la-Mode* include secondary syphilitic effects. His nasal bridge is depressed – a feature emphasised by the removal of his spectacles – and the bowing of his legs can be attributed to recurrent inflammation and thickening of his shin bones which could be caused by this venereal infection. They were then sometimes referred to as 'sabre shins' because of their appearance.

The signs of syphilis portrayed by Hogarth could be used in the literal sense in connection with the disease and allusively in connection with life-styles such as prostitution and infidelity; it was useful as a means of offering moral judgement, as a reward for the wages of sin. Defects of character could also be alluded to in terms of such a disease, either defects in the character of an individual or collectively with reference to a number of individuals carrying out a practice such as quackery; the practice and the practitioner were 'diseased'. Hogarth also used a significant physical defect caused by syphilis – the nasal destruction which often occurred – to subvert the High Art tradition: the display of the highest art form, sculpture, venerated by the connoisseurs, was not necessarily something to look up to. These idealised models did not always warrant emulation either in the artistic execution of the likeness or in the moral rectitude of the subject. The popular term 'French gout' for syphilis

enabled Hogarth to make play with the term 'gout' in the series whilst also offering an opportunity to denigrate the French – a popular topic.

III. MOTHERS' RUIN: *GIN LANE*, AND THE ART OF ALCOHOL ABUSE

The complex nature of Hogarth's 'Modern Moral Subjects' means that they were aimed at an audience which had the necessary intellectual knowledge and understanding to appreciate them fully. Hogarth's art appealed to a group of progressive intellectuals from whom he drew his support. These, and others who patronised traditional paintings, subscribed to Hogarth's prints. His later series of prints were generally aimed at a less sophisticated audience, ostensibly to provide a direct moral message, but, as previously, they offered a challenge to the *cognoscenti* who could search behind the scenes for meanings of deeper significance than was superficially apparent. This was the case in the series *The Four Stages of Cruelty* which is examined later and in *Beer Street* and *Gin Lane*. Hogarth claimed that 'the Subjects of those Prints are calculated to reform some reigning Vices peculiar to the lower Class of People. In hopes to render them of more extensive Use, the Author has published them in the cheapest Manner possible.'[43]

These prints can be looked at from two points of view. Hogarth was simply contrasting healthy members of society in which beer drinking and affluence went hand in hand, as seen in *Beer Street* [41], with those members of society in want, for whom gin was the only refuge, as seen in *Gin Lane* [42]; or he was offering a direct moral message, pointing to the evils of spirit-drinking which led to degradation, and contrasting it with the beneficial effects of drinking beer which was regarded as the traditional drink for robust and cheerful English men and the reward for honest labour. Additional jibes or messages proffered in *Gin Lane* were aimed at the 'middle-men' in society, those who profited at the expense of the poor who succumbed to the evils of drink, and at those in society who could, if they wished, do something to help the situation.

Hogarth was interested in many humanitarian projects leading to reform, and his zeal with regard to social and moral problems continued throughout his life. Some of his images were produced in an attempt to draw attention to prevailing situations in the hope that some effort might be made to remedy the evils portrayed – what might now be termed propaganda. As such, exaggeration of events would enhance the effect. However, exaggeration does not necessarily imply unreliability with regard to the underlying situation. To demonstrate the various effects of a social problem within the confines of one print it was appropriate to illustrate as many of them as possible in order to convey the wide problem within the affected society. This is the case in the portrayal of *Gin Lane*, which was published in 1751.

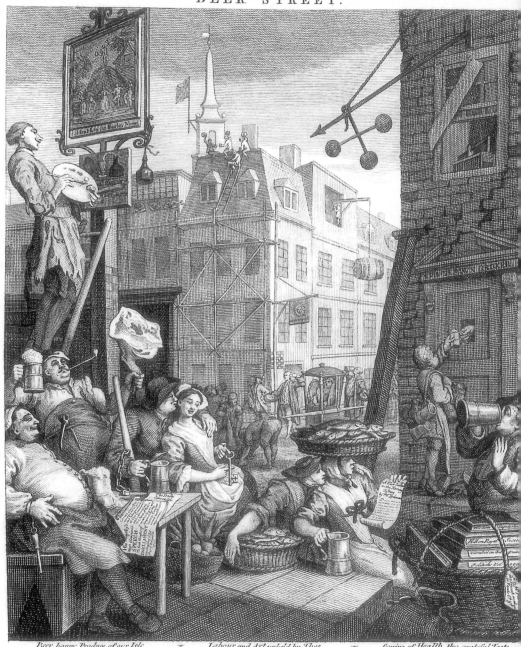

Beer, happy Produce of our Isle
Can sinewy Strength impart.
And wearied with Fatigue and Toil
Can chear each manly Heart.

Labour and Art upheld by Thee
Successfully advance.
We quaff Thy balmy Juice with Glee
And Water leave to France.

Genius of Health, thy grateful Taste
Rivals the Cup of Jove,
And warms each English generous Breast
With Liberty and Love.

Design'd by W.Hogarth

Publish'd according to Act of Parliament Feb. 1. 1751.

Price

41. WILLIAM HOGARTH: *Beer Street*

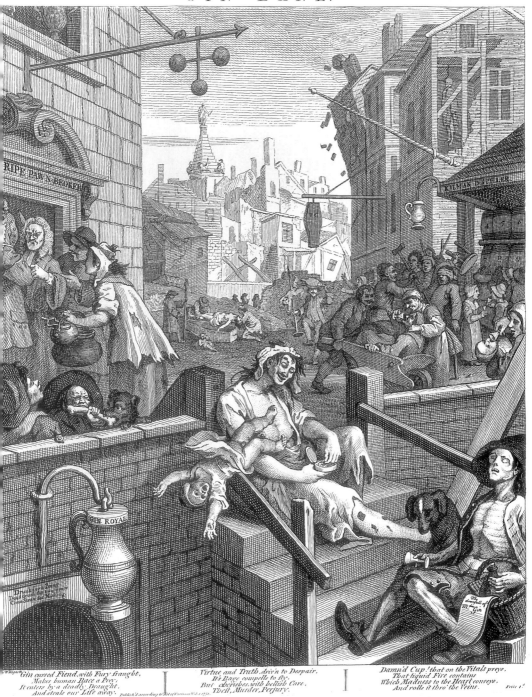

Gin cursed Fiend, with Fury fraught,
Makes human Race a Prey,
It enters by a deadly Draught,
And steals our Life away.

Virtue and Truth, driv'n to Despair,
It's Rage compells to fly.
But cherishes, with hellish Care,
Theft, Murder, Perjury.

Damn'd Cup! that on the Vitals preys,
That liquid Fire contains,
Which Madness to the Heart conveys,
And rolls it thro' the Veins.

Price 1'

42. WILLIAM HOGARTH: *Gin Lane*

Gin cursed Friend, with Fury fraught,
 Makes human race a Prey;
It enters by a deadly Draught,
 And steals our Life away.

Virtue and Truth, driv'n to Despair,
 Its Rage compels to fly,
But cherishes, with hellish Care,
 Theft, Murder, Perjury.

Damn'd Cup! that on the vitals preys,
 That liquid Fire contains
Which madness to the Heart Conveys
 And rolls it thro' the Veins.

These verses were written by Hogarth's friend and collaborator, the Revd James Townley, and accompany the artist's print. 'Alcohol abuse' is not a uniquely twentieth-century problem. Hogarth's print depicts the results of such abuse in the eighteenth century and highlights many of its social consequences. Some consideration of what was actually going on 'behind the scenes' of *Gin Lane* highlights, once again, Hogarth's concern with contemporary and topical events. Details which he portrays graphically can be gleaned from contemporary written sources, thereby giving them added authenticity.

Gin, whilst not the elixir of life that was looked for, was widely regarded as a universal panacea. If the outside world only offered hardship in the form of dirt, disease and poverty, the inner man could at least be relatively cheaply and quickly fortified with the juice of the juniper berry. Gin was introduced into England early in the eighteenth century by soldiers returning from the Low Countries, where they had enjoyed the 'Dutch courage' that it offered. Its popularity increased rapidly and disastrously between 1720 and 1750, especially in London, although other trading cities such as Manchester and Bristol were not immune to its effects. It was not taxed initially because the use of fermented barley in its composition provided a market for farmers and because the distillers had a powerful political voice. Its price therefore was low and its consumption overtook that of the traditional beverage of beer or ale as the favourite drink amongst the working class and poorer members of society. The more wealthy and aristocratic members of society drank wine, brandy or punch. Drunkenness was not seen as a vice in society as a whole. Its consequences were.

The first attempt at legislation was in a Parliamentary Bill of 1729 which required each retailer to take out a licence costing £20, and put a duty of 5s. per gallon on gin. The result of this was to suppress the distillation of good gin

and to increase the production of inferior products known then as 'Parliamentary Brandy'.[44] The sale and consumption of gin still flourished. For example, a paragraph printed in the *Old Whig* of 26 February 1736 gives the information:

> We hear that a strong-water shop was lately opened in Southwark, with the inscription on the sign:
> > 'Drunk for 1d.
> > Dead drunk for 2d.
> > Clean straw for nothing.'[45]

(This inscription was appropriated later by Hogarth for his 'strong-water shop' in *Gin Lane*.) Contemporary newspapers contain frequent announcements of sudden deaths in the taverns from excessive drinking of gin.

An Act of 1735 imposed taxes and licence charges upon retailers in a further attempt to curtail the distribution of gin. The preamble to this Act, stating the necessity for it, began:

> Whereas the Drinking of Spirituous Liquors or Strong Waters is becoming very common, especially amongst the People of lower and Inferior Ranks, the constant and excessive Use whereof tends greatly to the Destruction of their Healths rending them unfit for useful Labour and Business, Debauching their Morals, and inciting them to perpetrate all manner of Vices . . .[46]

The Act, which came into force on 29 September 1736, provided further impositions which caused anger amongst a large number of admirers of the product, and there was difficulty in enforcing the law. Gin continued to be sold by other names, including 'Ladies Delight', 'Cuckold's Comfort', 'King Theodore of Corsica', 'Strip-me-Naked', 'Cholick' and 'Gripe' Waters. Hawkers carried it in flasks and bottles in the streets; others set up chemists' shops and sold 'cholick water' and 'gripe water'. Some coloured the liquid and labelled bottles 'Take 2–3 spoonfuls of this 4–5 times a day or as often as the fit takes you'. When some of the evaders of the law were brought before the courts and it was observed that the chemists' shops were much more freqented than previously, it was stated in defence that the late Act had given many people the cholic and they therefore had need of the services of such establishments.[47]

The Act led to much discontent and rioting – urged on by opponents of the Ministry – and ballads lamenting the passing of 'Mother Gin' were sung in the streets. Those who informed against unlawful traders were treated unmercifully by the mob: rewards were offered for the discovery of perpetrators of violence against the informers, with little effect. Two months prior to the enactment of the Bill, in July 1736, *the Craftsman* had announced the publication of a print, *The Funeral Procession of Madam Geneva*, 'who died,

Sept. 29, 1736'. As this date approached, excitement increased; signs on liquor shops were draped in mourning black and some dealers made a parade of mock ceremonies for 'Madam Geneva's lying-in-state'. The *Daily Gazetteer* wrote:

> Last Wednesday (Sept. 29), several people made themselves very merry on the death of Madam Gin, and some of both sexes got soundly drunk at her funeral, for which the mob made a formal procession with torches, but committed no outrages.

Referring to the demise of Mother Gin in Bristol, the same newspaper adds:

> Many . . . willing to have their fill, and to take their last farewell in a respectful manner of their beloved dame, have not scrupled to pawn and sell their very clothes, as the last devoir they can pay to her memory.[48]

The Lamentable fall of Madam Geneva (BM 2278) and *To the mortal memory of Madam Geneva* (BM 2279) were two other prints expressing similar sentiments.

In 1743, the Act was repealed, 'whereas great Difficulties and Inconveniences have attended the putting the said Act in Execution, and the same hath not been found effectual to answer the Purposes thereby intended . . .'.[49] Parliament adopted more moderate proposals, drafted by a prominent distiller of the time. Lord Bathurst argued that since it was impossible to prevent the retailing of spirits, it would be better to licence it instead. This would result in price increases and reduced consumption, and also provide money for the European wars.[50] Distillers who were, at this time, forbidden to retail, petitioned for the right to do so in 1747, and the Act was modified accordingly. Gin consumption that had waned since 1743 increased, the birth rate decreased and the amount of drunkenness and criminal activity escalated. The latter, along with poverty and ill-health, was blamed on the consumption of gin.

In 1751, Corbyn Morris, an economic reformer who initiated plans for a general registry of the total population of Great Britain and of the annual increase and decrease by births and deaths, invited people to consider that

> The diminution of births set out from the time that the consumption of these liquors by the common people became enormous . . . the sickly state of such infants as are born, who with great difficulty pass through the first stages of life . . . Inquire from the several hospitals in the City, whether any increase of patients and of what sort, are daily brought under their care? They will declare, increasing multitudes of dropsical and consumtive people arising from the effects of spirituous liquors.[51]

Henry Fielding, a friend of Hogarth's, who became a lawyer and Westminster Magistrate in addition to pursuing his career as a dramatist and author,

wrote a tract in 1751 entitled *Enquiry into the Causes of the late Increase of Robbers etc. with some proposals for remedying this growing evil*. In the second section he drew attention to the evils associated with the consumption of gin, 'This odious Vice (indeed the Parent of all others) first introduced by the Danes'. He continued:

> A new kind of Drunkenness is lately sprung up amongst us – which – if not put a stop to, will infallibly destroy a great Part of the inferior People . . . the intoxicating Draught itself disqualifies them from using any honest Means to acquire it, at the same time that it removes all Sense of Fear and Shame and emboldens them to commit every wicked and desperate Enterprise . . .
>
> What must become of the Infant who is conceived in Gin? with the poisonous Distillations of which it is nourished both in the Womb and at the Breast.

Hogarth's thoughts on these matters were broadly in line with those of his friend. He wrote:

> When these two prints were designed and engraved, the dreadful consequences of gin-drinking appeared in every street. In Gin Lane every circumstance of its horrid effects is brought into view *in terrorem*. Idleness, poverty, misery, and distress, which drives even to madness and death, are the only objects that are to be seen; and not a house in tolerable condition but the pawnbroker's and gin-shop. Beer Street, its companion, was given as a contrast, where that invigorating liquor is recommended, in order to drive the other out of vogue . . .[52]

Hogarth, although aware of the detrimental effects of gin-drinking, does not mention crime amongst the poor as a consequence, as Fielding had done, and the only crime apparent in his print is that of self-destruction and neglect, including the neglect of those who could help to alleviate the distress that was prevalent.

Hogarth's prints *Beer Street* and *Gin Lane* constituted part of a general attempt to reimpose legislation on the sale of spirits. In *Gin Lane*, Hogarth points graphically to the total disintegration of a well-ordered society such as that depicted in *Beer Street*. A pamphlet entitled *A Dissertation on Mr Hogarth's Six Prints lately Publish'd* contained a *Genuine Narrative of the horrible Deeds perpetrated by the fiery Dragon*, GIN[53] In the Dissertation, the Bishop of Worcester asks, 'whether the criminals themselves and the crouds that sometimes attend them, do not bear in their countenance and their whole manner and Appearance, the plainest and most shocking Proofs that their Blood is inflamed by the habitual drinking of Gin . . .'it continues:

> Their infants wretched, half-naked tho' in the coldest weather, and half starved for want of proper Nourishment; for so indulgent are these tender Mothers, that to stop their little gaping mouths, they will pour down a spoonful of their own delightful Cordial . . .

Look on her Children, and you will see such a Parcel of poor little diminutive Creatures, that you will fancy yourself in the Country of the Pigmies . . . either they were begot with very ill Will, or that there was some Defect in the generative Powers of their Parents; one is bandy-legged, another hump-back'd, another goggle-eyed, another with a Monkey's Face, scarce one in its proper shape, and all of them wearing some visible mark of their Mother's Folly.

Hogarth's scene is set in the slum district of St Giles' Parish, Westminster, where in 1750 every fourth house at least was a gin-shop, and numerous brothels and places for receiving stolen goods existed.[54] The only thriving establishments appear to be the pawn-broker's, where the prosperous-looking owner 'Mr Gripe' (the name was slang for a usurer) is profiting from the search for funds to support the more profligate habits of his clients, the distillers and the undertakers: the coffin sign can be seen hanging outside the premises of the latter. The barber has hung himself inside his delapidated establishment. This state of affairs accords with the observations of a letter-writer to the *Gentleman's Magazine* in 1743:

Since Spirituous Liquors became common, the Baking Trade has very much decreas'd and what the Landed Interest has gained by them, it has lost in Bread and Beer; besides Meat, Butter, Cheese and other Eatables . . . [Spirituous Liquors] obstruct the carrying on of Trade in every Branch . . .[55]

The church tower in the background signifies the position of the Church, or of some of its incumbents, in relation to the conditions around them. The 'goodness' they profess is at a distance and difficult to reach. The statue of George I on the steeple of St George's Church, Bloomsbury (provided by a loyal brewer) symbolises the State and what appears to be its attitude of impotence, or lack of interest or concern in the face of what is happening in society. These two, Church and State, are linked in Hogarth's print with the pawn-broker whose sign, by an optical illusion, forms the Cross for the church, in effect blessing what goes on at the pawn-broker's and gin shop beneath the sign. The inhabitants of the scene illustrate collectively the effects that addiction has on life. The careless woman in the centre of the picture allows her half-naked child to fall, presumably to its death, whilst she takes a pinch of snuff. She herself suffers from intoxication, neglect and probably syphilis, indicated by the sores on her legs. The baby shows signs of 'Foetal Alcohol Syndrome', a name not appropriate for the eighteenth century but now used for a clinical condition resulting from maternal alcoholism. Hogarth's observational powers provide this infant with seemingly large round eyes situated between small palpebral fissures, lending what has been called an 'Orphan Annie' appearance to the face.[56] Small cheek-bones and small chin, an under-sized head, some degree of mental retardation, low birth

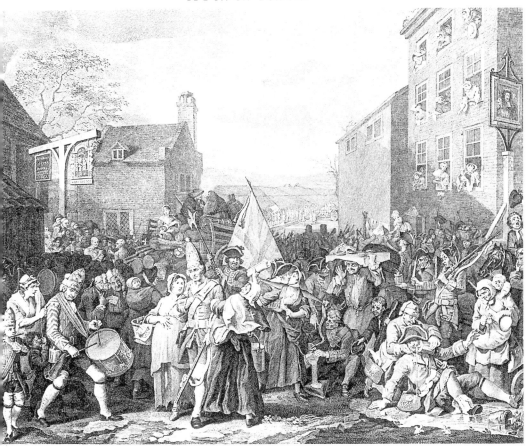

43. WILLIAM HOGARTH: *The March to Finchley*

weight and stunted growth form other features of the condition, providing an 'elfin-type' study not unlike Hogarth's infant who is 'wearing some visible mark of [its] Mother's folly'. Another such infant can be seen in Hogarth's painting, *The March to Finchley*. In this the baby reaches for his share of the contents of his mother's glass [43]. The appalling rates of infant mortality were attributed to gin: between 1730 and 1749, 74.5 per cent of all children christened were buried under the age of five years.[57] Contrasting images can be seen between the ideal of motherhood – that of madonna and child – represented by the mother breast-feeding her baby amidst a scene of chaos and unruliness in the painting of *The March to Finchley*, and the disreputable mother and child in *Gin Lane*. Whilst not recognising Foetal Alcohol Syndrome as such, Hogarth and Fielding, amongst others, seemed to observe congenital effects of maternal alcoholism: 'Unhappy mothers habituate

themselves to these distilled liquors, whose children are born weak and sickly, and often look shrivel'd and old as though they had numbered many years. Others again daily give it to their children . . . to taste and approve of this certain destroyer'.[58]

The baby to the right of the steps in *Gin Lane* is being fed on gin, whilst next to the coffin in the mid-ground in which is being placed the emaciated body of a woman, a weeping infant illustrates another form of neglect. (The emaciated body in the coffin can be contrasted with the obese body in its sedan chair in *Beer Street*, both in enclosed 'boxes'.) Close by the coffin, a child is impaled on a large skewer, an example of eighteenth-century 'non-accidental injury' attributed to gin mania, not so termed at that date but prevalent by any name and attested to by the perceived need to establish the Foundling Hospital at that time.[59]

> No expedient has yet been found out for preventing the murder of poor miserable infants at their birth, or suppressing the inhuman custom of exposing newly-born infants to perish in the streets; or the putting of such unhappy foundlings to wicked and barbarous nurses who . . . do often suffer them to be starved for want of due sustenance or care . . .

According to Dr William Buchan's *Domestic Medicine* (1769), half the children who died in London each year were killed by laudanum, spirits or proprietary sedatives.[60]

The cadaverous ballad-singer in the foreground of Hogarth's print is, or was, an itinerant ballad-seller. He was supposedly painted from a man who frequented the area whose cry was 'Buy my ballads, and I'll give you a glass of gin for nothing'.[61] The ballad for sale is entitled *The downfall of Mdm Gin*. His dog eyes the overturned glass with interest but looks healthier than his master, who has parted with most of his clothes and his flesh to support his gin-drinking habit.

Two charity-girls or orphans, so designated by badges inscribed 'G.S' on their sleeves representing St Giles' Parish, indicate the youthfulness (and lack of supervision) of some imbibers. This was a pointed reference to such Charity Schools which failed in their professed objective of preserving children from vagrancy and fitting them for some sort of regular work. A woman lies in a drunken stupor on the left-hand side of the steps with a snail crawling over her, indicating that she has been in this condition for some time. The pewter jug sign over the tavern doorway, 'Gin Royal', was a common sign: another of these hangs over the doorway of Mr Kilman's distiller's shop.

In *Gin Lane*, Hogarth presents alcoholism as a social, moral and economic problem, his visual images providing powerful propaganda points. His images are complex and open to numerous interpretations, but they made some impression upon the government, which, in response to petitions from

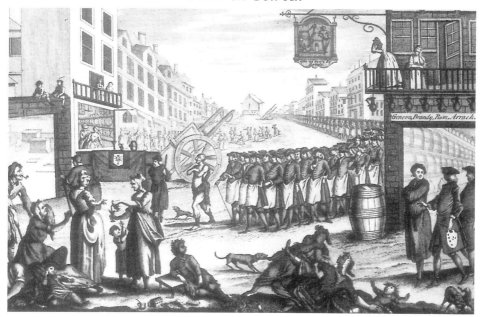

44. ARTIST ANONYMOUS: *The Funeral Procession of Madam Geneva*

physicians, magistrates' committees, clergymen and private citizens, introduced legislation which was enacted in 1751. This restricted licensing of premises and imposed further duties on the sale of spirituous liquors. Infringements were more rigorously checked and penalties incurred. Gradually the problem diminished, but not without some outcry from those who, for various reasons, disliked these measures.

The print, *Funeral Procession of Madam Geneva* [44], to which reference has already been made, was re-published and advertised on 29 September 1751: 'To those Melancholy Sufferers (by a late Severe Act) the DISTILLERS this Plate is most humbly Inscrib'd by a lover of Trade' (BM 2280, 3121). This was an engraved plate of a street in St Giles's, London, with a coffin on which lies a glass, noggin (a small mug or wooden cup which could hold a dram of alcoholic liquor, about a gill or quarter of a pint measure) and a key, being borne to a burial ground. It is followed by a poorly clad 'Loddy' described below as a 'Beggar well known about St Giles's, Seven Dials etc.', and a procession of publicans. In the foreground can be seen several women drinking and fighting, and a small child begging for a drink. The sign outside the local distiller's bears the words, 'Gin no more by Retale'. Verses underneath the print include the lines:

> GINS Fun'ral mourn, lo! near the Body
> In ragged State moves rueful Loddy,

Great Representative allow'd,
Of all who to her Empire bow'd:
DISTILLERS next, a gloomy Train
Who vent their loud complaints in vain . . .
Cheap Cordial for the Poors Relief!
One half Penny cou'd chace their Grief . . .

Unfortunately, some nurses were amongst those who succumbed to the temptation of 'Madam Geneva'. Prior to the dissolution of the monasteries in the sixteenth century, religious orders had been exclusively connected with nursing in special accommodation for the sick who could not be cared for in their own homes. Following this period, such accommodation was lacking and treatment at home was undertaken by good, bad and indifferent individuals, many of whom were illiterate and untrained. Nursing was not a profession and no set standards of education, experience or character were demanded, and there was no incentive for individuals to improve their expertise. Even when hospitals were being built in London in the eighteenth century, there was little distinction between those employed as domestic servants and nurses, similar menial tasks being expected of each. Some nurses were kind and skilful, but many were ignorant, dirty and often drunk.

The *Gentleman's Magazine* of Sunday 4 December 1748 informed readers that:

At a Christening at Beddington Surrey, the nurse was so intoxicated, that after she had undress'd the child, instead of laying it in the cradle, she put it bel.ind a large fire, which burnt it to death in a few minutes. – She was examined before a Magistrate, and said she was quite stupid and senseless, so that she took the child for a log of wood; on which she was discharged. (p. 570)

Rowlandson depicts a drunken nurse in charge of a young baby in a scene entitled *Death in the Nursery* [45]. This is from his 'Dance of Death' series of drawings from 1815–16, which are discussed later. In this scene a skeleton, representing Death, tenderly regards his small victim as he rocks the cradle. The nurse in charge here, sleeps with an overturned glass in her hand. An appended verse reads:

Drown'd in inebriated sleep
No vigils can the Drunkard keep.
– Death rocks the Cradle, as you see,
And sings his mortal Lullaby.
No shrieks, no cries will now its slumbers break;
The infant sleeps, – ah, never to awake![62]

Another scene from the same series, *The Dram Shop* [107], also depicts the evils of drink. The shop is crowded with customers, some of whom are clearly

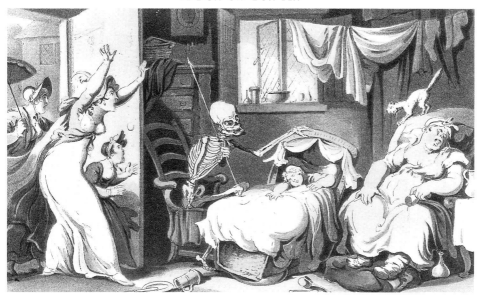

45. THOMAS ROWLANDSON: *Death in the Nursery*

intoxicated. A skeleton is filling a large vat with vitriol from which the bar attendant is dispensing the lethal doses. Rowlandson's tragi-comic images of the effects of alcohol abuse convey a direct message to his readers which needs little interpretation.

George Cruikshank's print of 1829, *The Gin Shop*, is more sinister than Rowlandson's *Dram Shop*, and full of allusions to death by drinking. The skeleton here holds up an hour-glass in one hand and states 'I shall have them all dead drunk presently! They have nearly had their last glass'. He is referring to drinkers who are standing inside a trap. A mother is feeding gin to her baby, whilst a child imbibes a similar potion. Yet another reaches up to a counter for her share as a man is served by a two-headed barmaid: one head on her shoulder is a skull and peeping out from beneath her dress is a skeletal foot. She is serving 'death' to her customers. The room is decorated with posters and coffins labelled as alcoholic beverages. A door behind the shop leads to the 'SPIRIT VAULTS' where a cauldron holding a spectre is surrounded by dancing 'spirits'. Another specimen is sitting on a barrel on the counter with a raised glass and a bottle. An open book also on the counter, offers a prosperous way of life. It reads, 'Open a Gin Shop: the way to Wealth', but the ways offered to the consumers only lead to 'The Gibbet, the Gaol, the Mad-house or the Workhouse'. This was 1829. The problem with alcohol abuse continued, and remains to this day.

CHAPTER 5

Hogarth at St Bartholomew's Hospital

HOGARTH'S attitude to 'High Art' seems to have been ambivalent. On the one hand he decried the members of the art establishment for perpetuating old ideas with the sterile use of traditional and conventional themes used in such works; on the other hand he wished to be considered as a 'great art' painter himself like his father-in-law, Thornhill. By this means he hoped to help establish a native school of art which would take the place of that of foreign exponents, increase the social acceptability of artists and even place them on a level with moral philosophers and epic poets in stature. The path for him to follow could be said ironically to be his own 'Choice of Hercules'. English art had suffered under Puritan rule and, apart from the production of 'likenesses' and works of Thornhill, little work of any consequence was produced by native artists. Fashionable gentlemen wanted paintings by famous Italian masters, not unknown native artists.[1] Hogarth was determined to show that he could produce works comparable with those of favoured foreign artists. Part of his attempt to attain recognition as a 'great art' painter led to his production of the paintings on the staircase at St Bartholomew's Hospital in 1736–7, paintings which are still admired today. As Hogarth explained:

> I entertained some hopes of succeeding in what the puffers call the great stile of History Painting: so that without having had a stroke of this grand business before, I quitted small portraits and familiar conversations and with a smile at my own temerity, commenced history painter, and on a great staircase at St Bartholomew's Hospital, painted two scripture stories, the *Pool of Bethesda* and *The Good Samaritan* with figures seven feet high. These I presented to the Charity.[2]

Hogarth's paintings at St Bartholomew's Hospital, *The Pool of Bethesda* [46], and *The Good Samaritan* [47], provide a remarkable illustration of the artist's facility for accurate observation of clinical appearances associated with disease whilst operating within definite forms of artistic reference, using realistic images of the sick in the service of High Art. Hogarth in many ways admired the tradition of the 'great stile' of painting, referring to it in many of

46. WILLIAM HOGARTH: *The Pool of Bethesda*

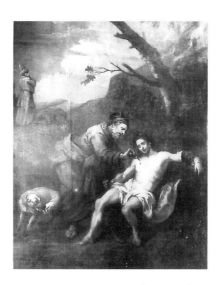

47. WILLIAM HOGARTH: *The Good Samaritan*

his works, though he often subverted its traditions. His originality is evident in these paintings as in most of his work. Some of the background to the circumstances surrounding his interpretation of the biblical themes of the paintings for the staircase at the Hospital puts them into their eighteenth-century context.

Although Hogarth claimed to have had no 'stroke of this grand business before', he had received some formal art training at the St Martin's Lane Academy, where life-drawing was encouraged, and he had gained further knowledge through the association with his father-in-law, Sir James Thornhill, whose work on the cupola of St Paul's Cathedral and on the ceiling of the Great Hall at Greenwich he had admired. Thornhill had become one of twelve directors of the earliest private school of art, which was established by Kneller in 1711. Following the latter's death in 1723, Thornhill opened a school in his own house, but ambitious plans for it failed and it remained small. Other private schools opened including one, in 1720, by Louis Charron and Vanderbank in St Martin's Lane. It was this school that Hogarth attended.[3] Life-drawings were taught there on Tuesday, Wednesday, Thursday and Friday from October to Spring each year at a fee of two guineas, and female models were available. After Thornhill's death in 1734, Hogarth opened a class in Peter Court, St Martin's Lane, furnished with equipment from Thornhill's house. This became known as the St Martin's Lane Academy, where members enjoyed equal status. Its exclusive purpose was for life-drawing and it became a popular venue for this type of work.[4]

Conventional training for artists had involved copying Old Masters such as Leonardo, Raphael and Michelangelo. (Dr Richard Mead, well-known physician and art collector, allowed copying at his house in Great Ormond Street.) Hogarth began in this way, until: 'it occur'd to me that there were many disadvantages attended going on so well continually copying Prints and Pictures, altho they should be those of the best masters nay even drawing after the life itself at academys . . .'.[5] He felt that this method was inhibiting to free style and thought.

A combination of circumstances probably led to his new venture at St Bartholomew's Hospital and his offer to paint the staircase free of charge. He had achieved some measure of financial security and fame from the production of prints of his painting of A Harlot's Progress; he had a sympathetic interest in charitable works, of which the hospital was an example, and he had many medical associates there. In addition, he disliked the thought of a foreign artist being commissioned to do the work; the services of a Venetian, Jacopa Amigoni, were said to have been sought for this purpose. Hogarth wished to promote the interests of native artists, including his own. Perhaps more importantly, this work would be on public display, offering a direct appeal to a growing number of prospective patrons and to influential

members of society who supported the Hospital on a charitable basis. Although the result was not considered an overwhelming success by his contemporaries and did not lead to the number of commissions which Hogarth would have liked, the paintings did become one of the sights to be seen on a visit to London, and Hogarth was made a Governor of the Hospital. They are now regarded as his most successful venture into this type of painting.

To conform with tradition, Hogarth drew upon the past for the themes for the paintings and to the Old Masters for the rendering of the figures portrayed. He also followed certain rules which had been established in European art, but added his own interpretation where he felt justified in so doing.

Reference was made in Chapter 2 to the subject of physiognomy, a subject of much debate in the art world during the eighteenth century. 'The Head', LeBrun had proclaimed, 'may well be said to be the Epitome of the whole Man.'[6] He produced numerous stereotyped and classified heads to represent the various 'passions' to which man was subject. Hogarth generally supported the basis of LeBrun's theory and had recommended the French academician's drawings of the passions for their order, simplicity and distinctness.[7] Passions attributed to 'animal spirits' or juices emanating from the cortex of the brain had been described by ancient philosophers, the seat of such passions being lodged in the soul. Simple passions were those of Love, Hatred, Desire, Joy and Sadness, whereas more complex ones included Fear, Boldness, Hope, Despair, Anger and Fright. Hogarth recognised that other agents might also make their mark upon the features, such as ill-health and constitutional factors, and he shows awareness of these in the facies (general appearances) of the afflicted who seek healing at the 'Pool'. The employment of his acute observational powers in the precincts of the Hospital may have contributed to this conviction. It has been said that Hogarth 'rarely ventured to exhibit scenes with which he was not perfectly well acquainted.'[8] He had been brought up in the vicinity of the Hospital and had ample opportunity for making such observations, and he had many friends in the medical profession with whom he could discuss the implications of his observations. Examination of the 'patients' at the 'Pool' in the light of the artistic traditions and of the contemporary medical knowledge provides some insight into both these aspects.

Hogarth, therefore, working within the conventions of the grand style used in previous biblical illustrations, developed his religious, caring and compassionate themes representing 'The Pool of Bethesda' and 'The Good Samaritan' in a way that was fully in keeping with the hospital's role. As part of tradition, and in order to make full use of the important site in the new, prestigious building, the works had to be on a large scale and painted in oils or

fresco. These works are in oils on canvas, the former measuring 20ft by 14ft and the latter 17ft by 14ft, each with figures measuring about 7ft high. *The Pool* is believed to have been painted in St Martin's Lane and pulled into position on the stairway; a stout peg still *in situ* may have been used for this purpose. *The Good Samaritan* was painted on site and scaffolding removed on 14 July 1737. The pictures are framed in the ornamental Louis XV Baroque style, and on the surrounding landing is more ornamental work of a similar kind. An inscription attests to the fact that the historical paintings were painted and given by Hogarth, and that he had paid for the ornamental work.

Underneath the painting of the 'Pool' are three small monochrome paintings representing St Rahere, who rose from humble origins as a street entertainer to be the king's favourite entertainer and eventually Founder of the Hospital for the poor. A dog jumping from the 'Pool' scene to the lower monochrome painting of Rahere connects the two, the divine and the secular. One of the paintings of Rahere depicts the saint receiving a sick man who is being carried on a litter. The appropriate biblical texts describing the scenes are also presented within ornamental surrounds. The passage from St John's Gospel describes the scene and the circumstances of *The Pool of Bethesda*:

2. Now there is at Jerusalem, by the sheep market, a pool, which is called in the Hebrew tongue Bethesda, having five porches.
3. In these lay a great multitude of impotent folk, of blind, halt, withered, waiting for the moving of the water.
4. For an angel went down at a certain season into the pool, and troubled the water: whosoever then first after the troubling of the water stepped in was made whole of whatsoever disease he had.
5. And a certain man was there, which had an infirmity thirty and eight years.
6. When Jesus saw him lie, and knew that he had been now a long time in that case, he saith unto him, Wilt thou be made whole?
7. The impotent man answered him, Sir, I have no man, when the water is troubled, to put me into the pool: but while I am coming, another steppeth down before me.
8. Jesus saith unto him, Rise, take up thy bed, and walk. (John 5:2–8)

The word 'Bethesda' has been interpreted as meaning 'Place of the Alkaline Salt' and the stirring of the water may have been due to the intermittent bubbling of a natural spring. Hogarth, probably under the guidance of his friend Bishop Hoadly, developed this theme in a way that is relevant to its contemporary context. Charity was the guiding principle and was the central theme in connection with both the paintings and the Hospital.

Hogarth's interpretation of the biblical story is set as if on a stage. The scenario broadly accords with the biblical text but the individual characters

could have been seen in the eighteenth-century hospital environment, and each provides his or her own story in true Hogarthian fashion, in which detailed observation enriches convention.[9]

Centre stage is Jesus, looking serene, calm and tranquil in LeBrunian (and Raphael-like) style, directing his compassionate gaze and outstretched hand to the 'impotent' man at his feet. The latter gazes back at Jesus with an expression of esteem and veneration. His well-developed muscles belie his apparent paralysis and support the twentieth-century diagnosis of Myotonia Congenita, a condition manifested by difficulty in initiating the action of walking, which may become normal after a few steps; muscles are well-developed or unusually large, resulting in an athletic build. Symptoms become worse during emotional upset or exposure to cold. This man, in his answer to Jesus, implied that it took him a long time to get down to the pool, 'while I am coming, another steppeth down before me . . .'. His conception seems to be of three-fold origin. He may owe his well-developed frame to a model from the life-class school at the St Martin's Lane Academy, his expression to the 'rules' of physiognomy, and his pose and situation to one of Raphael's paintings, *Healing of the Lame Man in the Temple*. In Hogarth's painting the expression of veneration of the lame man is exceeded only by that of the angel hovering overhead who is to 'trouble the waters'. His expression verges on the ecstatic.

The small group in the background towards the right-hand side of the painting, consisting of woman and child with a man deterring her from entering the water before the lady being carried on a litter, may also have come from Raphael's *Healing of the Lame Man*. It can be seen, however, that money has changed hands; the gate-keeper has apparently been bribed to allow the privileged and wealthy lady to take the place of the poor woman with her sick child. The mistress for whom preference is sought is 'beauty unadorned' in Venetian fashion and is said to be in the shape of Nell Robinson, a celebrated courtesan known to Hogarth (who made a study of her at the St Martin's Lane Academy) and living in the Chiswick area where Hogarth had his country residence. Her stiffly held, swollen and inflamed knee would be recognised by many as being the result of her promiscuous life-style and its retribution in the form of gonococchal or syphilitic arthritis. Her naked presence at the Pool in this pose seems to advertise her way of life. Articular complications of early syphilis most commonly involve the ankles, foot joints, elbows and shoulders, but may affect hands, wrists, knees and ankles, causing acute inflammation (periostitis) with pain, swelling, tenderness and limitation of movement. Arthritis following an infection with gonorrhoea two to three weeks previously, usually affects many joints at once and is accompanied by fever. Only one knee appears to be affected here. The lady's expression is one of sadness 'arising from the uneasiness the Soul feels

at some evil or defect, which the impressions on the Brain represent to her', according to the rules of physiognomy. A similar sadness pervades the pale features of the young girl behind Jesus. She modestly veils her head but her breast is partially exposed with a red area of inflammation clearly visible.

The mother with her baby looks pleadingly towards her assailant. Her sick baby may be suffering from either rickets or congenital syphilis. The two presented some similar features. Dr Francis Glisson (1599–1677) had described the signs of rickets in the seventeenth century,[10] and John Freke, surgeon at St Bartholomew's Hospital and friend of Hogarth, wrote about it in 1748.[11] Both referred to the flexibility of the joints which were unable to sustain the body, and to weakness. Glisson said that if children were affected 'within the first year of their age or thereabouts, they lose the use of their feet later by reason of that weakness.' Later they 'totally lose the use of their feet; yea, they can scarce sit with an erected posture, and the weak and feeble neck doth scarcely, or not at all, sustain the burden of the head.' He cites 'unusual Bigness of the Head' as a sign of the disease, and says that 'certain swellings and knotty excrescences are observed about some of the joynts. These are chiefly conspicuous in the wrists, and somewhat less in the ankles . . . some bones wax crooked.'

Freke follows his description of Rickets with one of a 'Scrophulous' Disease of the Bones which did not affect infants 'till they are completely formed'. This caused swellings of bones and led to bony destruction. Venereal disease led to similar destruction of the bones, according to Freke, who wrote: 'many are liable to reckon them one species, from the Effects they produce, but an account of the Numbers of Children who are descended from worthy Parents, being greatly affected with Scrophulous Complaints, I shall suspend my sentiments upon it.' Hogarth's infant's pallor, large unsupported head, swollen wrist and flaccid body seem to present a picture of rickets which was prevalent at the time. The child in the foreground who apparently requires a crutch to enable him to walk and whose spine is curved and arm bandaged may represent Freke's 'Scrophulous' condition.

Sadness and dejection are evident in the features of the old man on the right of the painting. He looks ashen-coloured and ill. He is leaning on a crutch and resting his hand upon his swollen ascitic abdomen. Freke wrote 'Of Tumours proceeding from Melancholy':

> the Blood at certain Seasons is liable to become void of all Floridness, appearing almost as black as Ink, which the Antients have termed the 'atra Bilis' or Melancholy of the Blood. When it is in this State, carcinomatous and cancerous Diseases are said to be occasioned from thence.[12]

LeBrun described the features associated with this: 'the Nostrils drawing downwards, the Mouth somewhat open and the corners down; the head

seems negligently hanging upon one Shoulder, the whole Face of a wan lead colour, and the Lips entirely pale.' The advanced state of malignant disease of this man would have been recognised by many eighteenth-century observers in the context of the Hospital.

The blind man on the left-hand side of the painting would also have been recognised by his pose and long stick. His presence was dictated by the biblical text, but was also a reference to one of the charitable functions of the Hospital. Freke had been appointed as the first eye surgeon there in 1727, 'Through a tender regard for the deplorable state of blind people . . .'.[13] His appointment was to 'couch and take care of the diseases of the eyes of such poor persons as shall be thought fit for the operation and for no other reward than the six shillings and eightpence for each person so couched as is paid on other operations.'[14] 'Couching' was an operative treatment which had been performed on the eye, especially for cataracts, since ancient times. The opaque lens was manipulated by a sharply hooked needle and broken up to displace the pieces below the level of the pupil. The opacity was thought to be 'inspissated humour' between the lens and the iris and not the lens itself. It was not until the eighteenth century that the true nature of the cataract was recognised, and the couching operation continued throughout the century.[15]

The rather angry looking woman on the blind man's left views the latter with sidelong glance. Jaundice, such as she displays, was supposed to indicate a choleric disposition (choler = bile) in line with the humoral theory of medicine, and Hogarth provides the apt physiognomy indicating an irascible temperament.

The pallid cachectic woman on his right, looking frail, emaciated and fearful, illustrates both the 'passions' of 'Hope' and the possible effects of a scrophulous tubercular condition. The colour of her face with its greenish tinge provided the contemporary label of the 'Green Sickness', a generic term for all anaemias, and termed 'Chlorosis' by Jean Varandal in 1615. In 1731, Friedrich Hoffman recognised an iron deficiency anaemia often associated with a 'Virginal pallor' for which Sydenham had advocated the use of iron. Sydenham suggested that 'the Sick must drink some mineral waters, impregnated with the Iron Mine such as Tunbridge Waters.'[16] This might explain the presence of this 'patient' at the 'Pool'.

Pain is expressed in the features of the man with the bandaged arm as he tries to protect it from the pressing crowd. 'Gout' as is suggested for this sufferer was a common complaint in the eighteenth century. It is an affliction which does not usually appear before the age of forty and is usually confined to males. Hogarth must have been familiar with the spectacle of gout sufferers experiencing the excruciating pain which is a feature of this condition, and LeBrun described the method to be used for the expression of bodily pain.

Although in the early stages the first joint of the big toe is the usual site of affliction, repeated attacks result in the involvement of other joints, one of which is the wrist. Mineral water therapy had been advocated by the Greeks, and throughout the Middle Ages certain holy wells were famous for their healing powers for certain diseases. Such a fashion was becoming established again in the early eighteenth century, as, for example, at Epsom where Mrs Mapp the bone-setter had found employment. The presence of this man with gout at the 'Pool' was appropriate for this condition.

The mentally handicapped girl displaying features now recognised as being due to thyroid deficiency (cretinism), such as stunted growth, obesity, coarse features, thick lips and 'dull' expression in keeping with her mental faculties, would not have had her condition understood. The presence of such a person was not uncommon in European paintings and Hogarth's character is not a stranger to such surroundings.

A man, who can be seen behind this group of people, walking away from the scene carrying a pair of crutches, may indicate that he or his master has been healed and has no further need of such support.

Even in his attempts to be accepted as a 'great art' painter, Hogarth seems to have been unable to keep his brush in check: satirical aspects, which would have been at home in his 'Modern Moral Subjects', appear. Although Hogarth demonstrates charitable acts in this painting, he also demonstrates uncharitable acts: the rich depriving the poor, bribery being accepted, displays of anger, selfishness and greed, and of perversion of the love that is charity which can lead to disease. He questioned whether Charity, even in the best of circumstances, was incorruptible. Hogarth may also have deliberately included the image of St Rahere in the monochrome painting beneath *The Pool of Bethesda* as a pointed reminder that someone from an underprivileged background such as his own could 'make good' and attain an esteemed place in society.

In the second painting, the Good Samaritan represents the caring attitude associated with the hospital, equating it with the inn where the traveller will stay until he is well. Convention and contemporary physiognomical rules again dictate the style and demeanour of the participants, pain being clearly demonstrated upon the face of the injured man. The biblical text for this is Luke 10:30–37.

In both these paintings, it is shown that charity transcends Old Testament law. The law forbade healing on the Sabbath and forbade a Levite or Pharisee from touching blood or dead bodies, which would make them ritually unclean. The Hospital represented practical charity unimpeded by texts and unwarranted authority. Actions rather than words were what mattered.

Although Hogarth made other forays into the realms of 'great historical painting', he reverted to his more popular style in the form of 'Modern Moral

Subjects', but *The Pool of Bethesda* and *The Good Samaritan* give an indication of Hogarth's involvement in contemporary events even in his 'great stile of history painting', which necessarily made direct reference to academic conventions. His remarkably accurate observations of people and medical circumstances gave a sense of immediacy to pictures which otherwise could have become merely minor examples within the long-established tradition of biblical history painting.

Hogarth employed typical pathognomic expressions in the features of his sick patients at the 'Pool'. There had been no intention and no necessity to overstate their condition. A later scene in which Hogarth again exhibits his observational talents on behalf of the sick is the *Polling* scene of *The Election* series of paintings, 1755 [48]. In this series on electioneering bribery and corruption, the maimed, sick and mentally handicapped are being used for

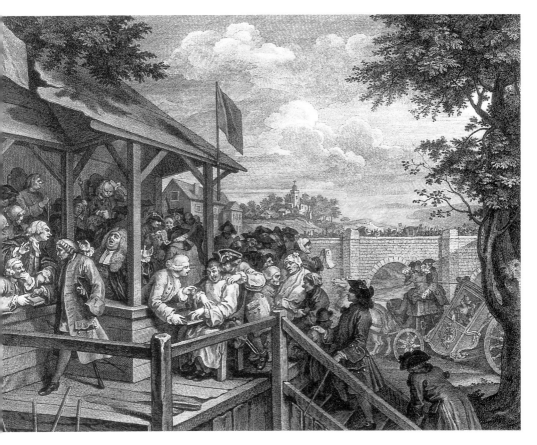

48. WILLIAM HOGARTH: *The Polling* from the *Election* series

49. Porters displaying nasal deformities popularly associated with drunkenness and debauchery: detail from *The Polling* from the *Election* series

their votes. The illustration of the man with cerebral palsy (twentieth-century terminology) displays his uncoordinated hands and distorted facial features. He is offered a pen with which to record his vote and directions on how to do so. He is secured into a wooden chair by a bar across his knees to prevent him from falling. Behind him, an invalid swathed in blankets appears pale and ill. This elector is being carried to the polling booth by two porters who seem to be sympathetic to his plight, but possibly concerned that their arrival may be too late to enable this voter to cast his vote before his demise. One of these carriers in the final state of the print [49] displays an enlarged nose, or rhinophyma, a condition now known to be caused by acne rosacea but in the eighteenth century popularly thought to be associated with excessive alcohol consumption. The other carrier is minus most of his nose, a misfortune consistent with the baser habit of promiscuity, resulting in syphilitic disease which destroys the nasal cartilage, so that the bridge of the nose collapses. This group is being followed by a blind man with his stick. One of his hands is resting upon the shoulder of a young person ahead of him on the staircase who is acting as his guide. Questions seem to arise regarding the validity of the oath being sworn by the gentleman on the right who has placed his hooked prosthesis on the proferred book. This man has survived leg amputation in addition to the loss of his left hand, and has hobbled to the booth with the aid of a wooden peg. His right hand is absent and a shortened arm secures his hat against his chest.

LeBrunian features are apparent on the faces of many members of this scene, which combines realism and topicality with Hogarth's facility for portraying physiognomy and the effects of illness and disease on the faces and bodies of those afflicted. The observational accuracy which Hogarth displays in recording such details with regard to the clinical features of his characters is an indication of the care and attention which he gave to his work. This care

50. JAMES GILLRAY: *Taking Physic*

and attention to detail, whether of expressions, actions or scenes is an important feature of his work.

Later in the century, artists such as Rowlandson and Gillray deliberately exaggerated features for their pathognomic studies of illness and the effects on long-suffering patients of the treatments offered to them. The multiplicity of pills and potions, their foul nature and the often demeaning method of administration entailing vomiting, catharsis, bleeding, leeching and the giving of enemas – with dubious benefit – provided rich pickings for caricaturists. *Taking Physic*, by Gillray [50], *Cathartic*, *A Gentle Emetic*, and *Breathing a Vein*, all drawn by Revd Sneyd and etched by Gillray, tell their own story. Medication had unpleasant and punitive associations which had been experienced by almost everyone. Its employment as punishment or treatment for vice, moral decadence, or political or social maladministration would have been universally understood. The patient was seen as a helpless victim of the medical profession. Headaches and colic provide a pair of studies for George Cruikshank; pain expressed in the features is seen to be caused by external circumstances entailing demons with darts, hammers and ropes. The excruciating pain of gout is graphically illustrated as being caused by a fiery dragon whose teeth and claws viciously attack a gout-distorted foot [3]. Such caricatures provided some sort of antidote to the misery suffered from both sickness and healers. The effect was immediate and required little intellectual appreciation.

CHAPTER 6

A Question of Taste, or a Taste of Madness

THE topic of 'taste' exercised many minds during the eighteenth century. Manner and appearance became acceptable social indicators, especially in London where a man's background might be unknown. The attributes of money, land or title – real or substantial indicators of value – were no longer useful as such in a society based increasingly on commerce, in which the former seemed correspondingly irrelevant. In his novel *Joseph Andrews* (1743), Henry Fielding describes how Mr Wilson set out to London when a young man, with no more than £6 in his pocket, to attain the character of a fine gentleman:

> the first requisites . . . were to be supplied by a taylor, a periwig-maker, and some few more tradesmen, who deal in furnishing out the human body. Notwithstanding the lowness of my purse, I found credit with them more easily than I expected, and was soon equipped to my wish.
>
> The next qualifications, namely dancing, fencing, riding the great horse [colloquially meaning 'to put on airs'], and musick, came into my head . . .[1]

Being seen in fashionable places, taking part in episodes of debauchery, gambling, and imprisonment for debt followed, until marriage to a moderately-rich widow led eventually to Mr Wilson's physical and moral redemption.

Some years earlier, Hogarth had furnished his 'Rake' in *The Rake's Progress* in a similar fashion to that of Mr Wilson; the Rake, however, proceeded to the mental asylum, Bedlam, where redemption would seem to have been too late for his salvation.

Both Hogarth and Fielding were satirising the discourse of 'politeness'. Increase in wealth was acceptable within strict parameters; certain standards of behaviour were only acceptable in those born to status and, it was claimed, should not be aped by those who had acquired wealth by other means. Changing attitudes towards the structure of society caused some uneasiness,

and evolutionary changes involving movement of classes from a vertical to a horizontal or more fluid structure, with more inter-active groups crossing previously insurmountable social boundaries, caused some social disorientation. Clothes, manners and gestures no longer offered firm points of reference with regard to social class.[2] The basis of a privileged élite was destroyed if people could change their position in society.

I. THE RAKE'S PROGRESS

The Rake's Progress (1733–4) seems to have been a sequel to *A Harlot's Progress* as a 'Modern Moral Subject'. It is a series of eight plates [51–58] in which the Rake leads an increasingly dissolute, or 'mad' life-style, starting with his rejection of a young pregnant girl on the inheritance of a fortune previously hoarded by his miserly father. He is first seen being fitted out or 'fashioned' for his new life-style by a tailor [51]. His aspirations to lead a 'high life' result in his imitating the aristocracy by indulging in costly, unnecessary extravagances; he holds a fashionable *levée* where he is seen with an assortment of hangers-on including dancing and fencing-masters [52]; he apparently owns a horse, employs a foreign musician and collects 'High Art' paintings – all examples of false aristocratic culture which were thought to endow the owner with 'taste'.

In Scene 3 the Rake is seen in a sordid drinking scene where whores abound. Images on the walls of august Roman emperors represent traditional ideals of behaviour, but only that of Nero remains unspoilt, providing a solitary role model for the Rake: Nero's profligacy resulted in his downfall. Such a portent goes unheeded. Emblematic images emphasise the ephemeral and sordid nature of the entertainment provided in the brothel: the 'posture woman' in the foreground prepares to perform a dance on a silver platter. Her discarded stays imply a freedom from any inhibition or restraint and her obscene dance which will culminate in her extinguishing the candle flame in her vagina forms part of the notorious scene of the kind which could be found at the Rose Tavern in Covent Garden.[3] A hint of the Rake's impending medical problems appears in the form of an overturned box of pills on the floor close by him, implying his contraction of syphilis or the risk to which he is exposed [53].

Debt follows, and the Rake is arrested for this while on his way to seek preferment at the Court of St James [54]. In this scene, his ill-fitting clothes offer an analogy with his ill-fitting or ill-conceived aspirations in society; he does not choose to eschew folly and return to his loyal former love, who has come to his rescue, but marries an ugly, elderly crone for money [55]. Gambling comes next, leading inevitably to the debtors' prison in this moral

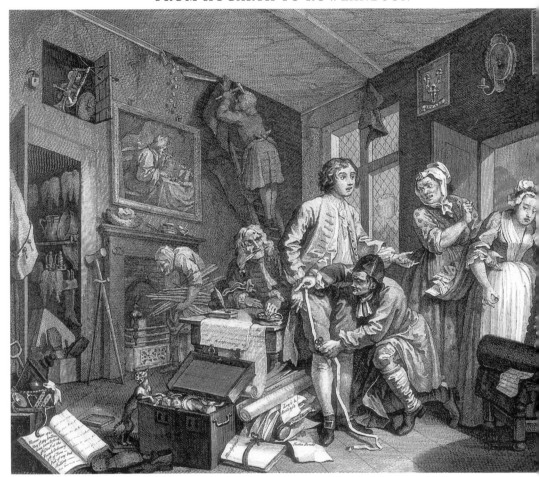

51. WILLIAM HOGARTH: *The Rake's Progress*,
1. *The Young Heir taking possession*

tale, leaving the mad-house and death as the ultimate means of escape. All this was in keeping with a generally held belief that the result of miserliness on the part of a parent would engender profligacy in an offspring, and makes the additional point that youth needs guidance from experience.

In addition to offering glimpses of the 'high life' which could be led by those with money, the series points at folly and madness and conveys eighteenth-century ideas of madness or states of 'unreason' through the medium of the Rake.

The first overt sign of madness, or disorder of mind, in the Rake's countenance is present in Scene 6 [56] where the young man's fist is raised and he is seen cursing Fate for the loss of his fortune at the gambling tables.

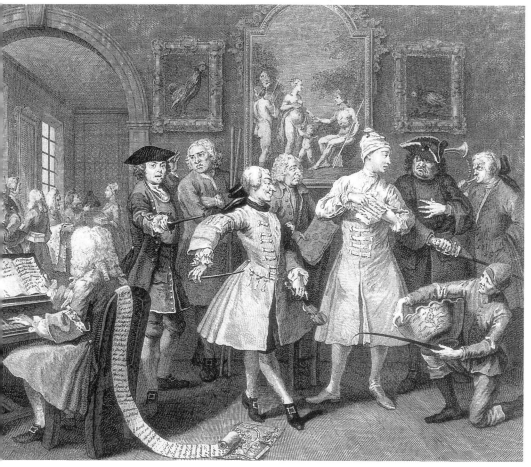

52. WILLIAM HOGARTH: *The Rake's Progress, 2. The Rake's Levée*

> In heartfelt bitter anguish he appears,
> And from the bloodshot ball gush purpled tears!
> He beats his brow, with rage and horror fraught;
> His brow half bursts with agony of thought![4]

This 'raving' with total lack of concern for the fire in the surrounding ceiling – a lack of vision shared by fellow gamblers – is in contrast to the melancholy suffered by the 'loser' on his right by the fireplace. Both these attitudes are seen as extremes of behaviour occasioned by the mad life-style being followed. Deviations from reason were seen as deviations into madness.

Sarah, his loyal mistress, was also associated with a lack of judgement akin to madness in her faith and trust in the Rake. She is seen 'falling into fits' while visiting the debtor in the Fleet Prison in Scene 7 of the series [57]. This was a

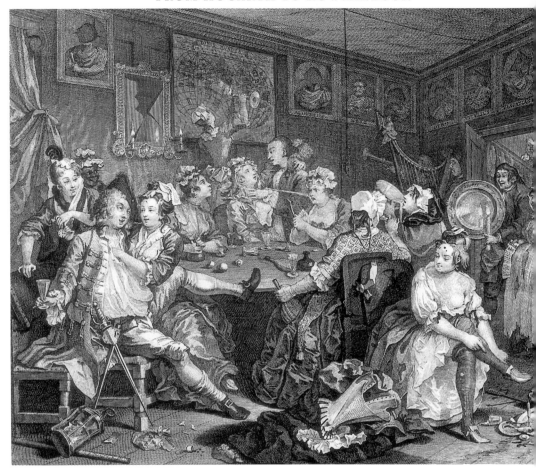

53. WILLIAM HOGARTH: *The Rake's Progress, 3. The Tavern Scene*

common state of 'unreason' especially amongst young females in society and said to be caused in some circumstances by 'passions of the mind'.[5] Samuel Richardson's 'Pamela' was subject to such 'fits', 'I knew nothing further till afterwards, having fallen down in a fit . . . he coming in, I fainted away again; and I was two hours before I came to myself . . .'.[6] Mrs Jervis gave Pamela her smelling-bottle and 'cut her laces'. Sarah, likewise, is offered a smelling-bottle. This usually contained some volatile aromatic spirit such as Spirit of Hartshorn or Sal Volatile.[7] Sarah is having her hand slapped in an effort to restore her to 'reason'. This scene also shows the Rake descending further into the depths of despair and 'unreason', whilst his elderly wife 'madly' harangues him – another example of the extremes of behaviour which were the result of 'madness' or folly. His mind is dwelling in the realms of fantasy, a

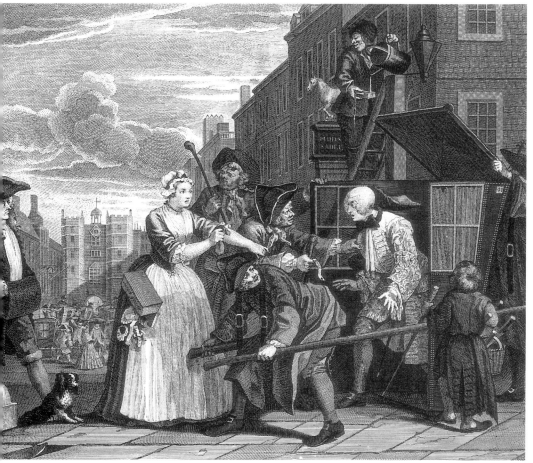

54. WILLIAM HOGARTH: *The Rake's Progress, 4. Arrested for Debt*

fantasy of escape through mad schemes graphically illustrated by images of
Icarus's wings over the bed and the alchemist in the background attempting to
make gold.

Dreams of making gold were commonplace images. A variation on the
theme of transmutation was attempted by Pitt in 1796 by courtesy of Gillray
in a print entitled *The Dissolution, or the Alchemyst producing an aethereal
Representation*. In this, Britannia's shield is about to be broken up in a pestle
and mortar, and Pitt, using Treasury gold, is seen distilling the House of
Commons in a large glass retort, changing it into a new House in which all the
members fall down worshipping at his feet.

The final scene in the series *The Rake's Progress*, Scene 8, shows how the
Rake's descent into melancholy – the opposite extreme to raving madness – is

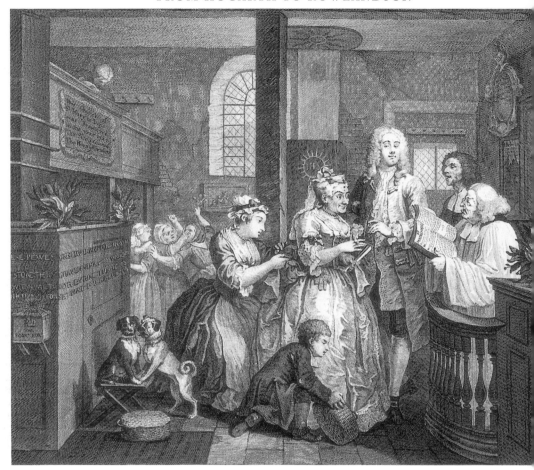

55. WILLIAM HOGARTH: *The Rake's Progress*, 5. *Marriage*

complete [58]. In the early eighteenth century, the idea was prevalent that dark melancholy was the result of self-denial and self-righteousness, a cold dry temperament with too much thick, black and sour bile 'purged from the spleen' and too little blood – in keeping with humoral theories – and that a remedy might be obtained by a change to riotous living. George Cheyne MD (1671–1743) opposed this idea and thought that the latter was the cause of the melancholy, as he had found from personal experience.[8] Decadence corrupted the passions. Hogarth's Rake supports this view.

The Rake's pose in the final scene of Hogarth's painting is purposely reminiscent of Caius Gabriel Cibber's statue 'Melancholy Madness'. The statues 'Melancholy Madness' and 'Raving Madness' peered down from the entrance gates of Bethlem Hospital (Bedlam, as the mental hospital was

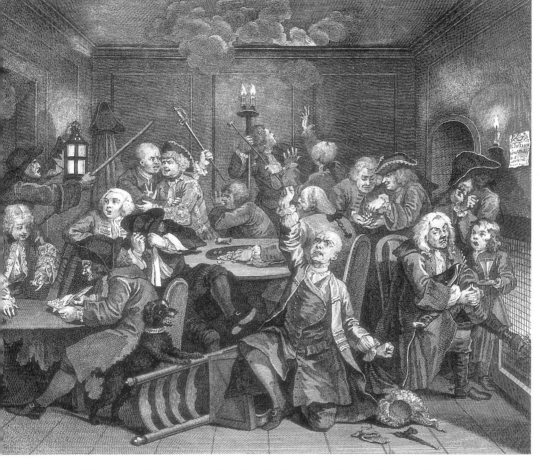

56. WILLIAM HOGARTH: *The Rake's Progress, 6. In a Gaming House*

known), and were both a familiar landmark to the citizens and a grim foretaste of the sight of afflicted inmates [59]. Alexander Pope described the statues in the first book of *The Dunciad*:

> Close to those walls where Folly holds her throne,
> And laughs to think Monroe would take her down,
> Where o'er the gates, by his fam'd father's hand
> Great Cibber's brazen, brainless brothers stand.[9]

James Monro (1680–1752) was elected Physician to Bethlem Hospital in 1728 and was mentioned several times by Pope. He devoted himself to the treatment of insanity and was said to be a skilled and honourable physician. Physicians at Bethlem were criticised by William Battie MD in his *Treatise on*

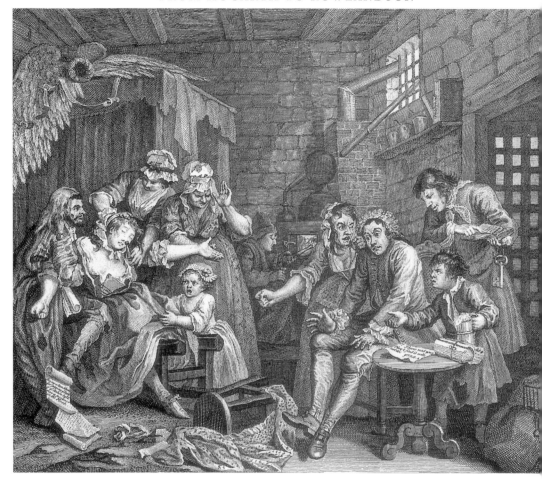

57. WILLIAM HOGARTH: *The Rake's Progress, 7. The Debtor's Prison*

Madness (1758),[10] but James's son, John, who joined his father at the Hospital in 1751 and remained in sole charge after his father's death, refuted the criticisms, although confessing that 'Madness is a distemper of such a nature that very little of real use can be said concerning it.' Lack of knowledge with regard to the cause of madness was equalled by the lack of knowledge with regard to its management. For treatment, Monro claimed: 'I will venture to say that the most adequate and constant cure of it is by evacuation', and for this, 'vomiting is infinitely preferable to any other.' He also advocated bleeding, purging and 'issues between the shoulders'. These methods, he felt, would restore the humours to their proper balance. He added, however, that knowledge of the subject could only come through observation, a sentiment shared by Battie in his *Treatise*.

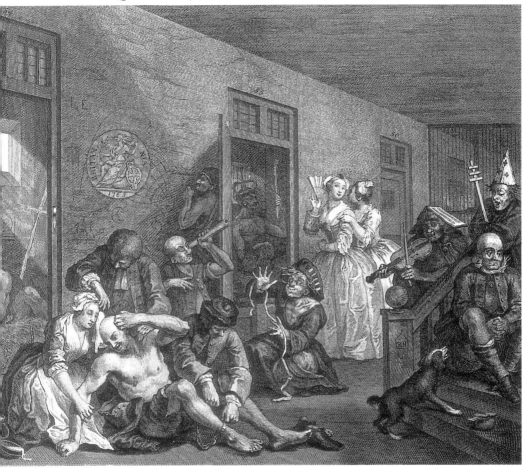

58. WILLIAM HOGARTH: *The Rake's Progress, 8. Scene in a Madhouse*

In the engraving of Hogarth's painting, the Rake is in Bedlam. He has a patch below his right breast, possibly as a result of an attempt at self-destruction. Suicide represented the extreme expression of melancholy and was so prevalent in England in the eighteenth century that it was often referred to as the 'English Malady'. An essay published in the *Gentleman's Magazine* in May 1737, 'On English Suicides: By a Foreigner', includes the following lines:

I could not, in several Weeks after my Arrival in this Metropolis of England, master the Astonishment it gave me, to hear of such frequent Self-Murders as happen here almost daily. . . . All the Reflections they make, before their coming to that frantic Extremity, are purely the Consequence of a black, gloomy, troubled

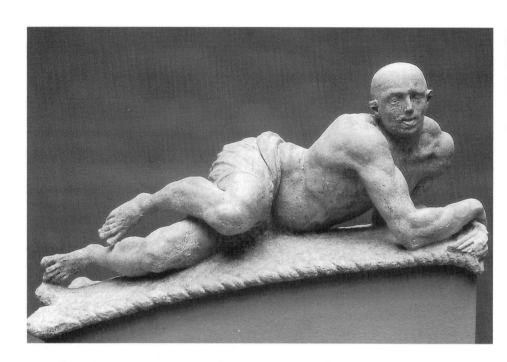

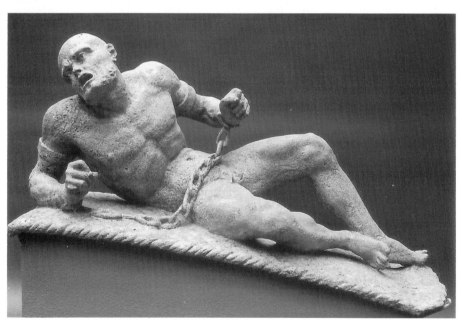

59. CAIUS GABRIEL CIBBER: *Melancholy Madness* and *Raving Madness*

humour, and a savage Disposition, unable bravely to support the Reverses of Fortune.[11]

The French adopted the word 'suicide' into their language as an Anglicism.

An advertisement in the same magazine in 1755 treated the topic in a light-hearted manner. It offered three 'remedies against life (with the King's patent)'. These would enable the partaker to commit suicide even when in company, without causing distress or inconvenience to anyone. It recommended it to 'men of pleasure', who, by fast living, sporting, whoring and drunkenness had spent their fortunes and ruined their families, so as to 'render life intollerable' – those such as the Rake.[12]

Violent or destructive outbursts are also manifestations of late or tertiary syphilis, and the Rake's distress may indicate that this self-destructive attitude is a suitable reward for his life-style. Such behaviour would have been seen in Bedlam but not recognised as being due to syphilis.

Bethlem Hospital was named from the original priory of St Mary of Bethlehem founded in 1247, when it opened as a religious house. It was seized by Henry VIII in 1547 and granted revenue to the Mayor, commonalty and citizens of London, and became a 'Hospital for the Cure of Lunatics'. Initially, no provision was made for the patient except confinement and 'medical relief'. Relatives or friends, if they were able, or the parish from where they came – which might be from any part of the country – were obliged to contribute to their support. 'Comfortable subsistence, tender care and the blessing of the Divine Providence' were relied upon to restore the sufferers to their family in an improved state of mind. In April 1675, work began on a new hospital at Moorfields, London and this was finished in July 1676 and described as 'an illustrious monument of British Charity'. Ned Ward, in *London Spy*, remarks to his guide with reference to Bethlem Hospital:

> I conceiv'd it to be my Lord Mayor's Palace, for I could not imagine so stately a structure could be design'd for any Quality inferior; he smil'd at my Innocent Conjecture, and inform'd me this was Bedlam, an Hospital for Mad-Folks: In truth, said I, I think they were Society.[13]

Two more wings were added in 1734 for 100 incurables, 50 of each sex. These were in addition to the 175 patients in the main building who were 'capable of being relieved', of whom 'an average of nearly two out of three are restored to their understanding'.[14] When a patient was admitted, he was delivered to a steward, who, under the direction of the physician, assigned him to 'such degree of care and confinement as his case may require'.

The wards were described as spacious and airy (321 ft by 16 ft 2in. by 13 ft high) and leading from these were 275 cells, each 12 ft by 8 ft Cesar de Saussure described these in *A Foreign View of England* (1676):

you find yourself in a long and wide gallery, on either side of which are a large number of little cells where lunatics of every description are shut up, and you can get a Sight of these poor creatures, little windows being let into the doors. Many inoffensive madmen walk in the big gallery. On the second floor is a corridor and cells like those on the first floor, and this is the part reserved for dangerous maniacs, most of them being chained and terrible to behold.[15]

According to the *Historical Account*: 'Every patient is indulged with that degree of liberty which is found consistent with his own, and general safety',[14] and Rule ix of the *General Orders for Bethlem Hospital* stated that 'No patient be confined in chains without the previous knowledge and approbation of the Apothecary.' (The apothecary was the medical attendant in residence who was supposed to visit the wards each day.) The Rake is being chained by the Keeper according to the rule that 'The frantic maniac, and the desponding lunatic must be secured from doing violence to themselves, and others.'[14] His nakedness is symbolic of his state of mind; poverty and madness were kindred spirits, nakedness being attributed to both states. Thomas Tryon (1634–1703), 'student in physick' and writer on philosophical, social, religious and medical subjects, wrote in the 1680s:

> For when men are so divested of their *Rational Faculties*, then they appear naked, having no *Covering, Vail* or *Figg-leaves* before them, to hide themselves in, and therefore they no longer remain under a Mark or Disguise, but appear even as they are, which is rare to be known in any that retain their Senses and Reason . . .[16]

Hogarth portrays the Rake with shaved head and 'stripped' of clothes, status and mental faculties. His pose in the original painting may be seen as an allusion to the Christ in a *pietà*, whilst Sarah, his loyal mistress, weeps over him like the Magdalen.[17]

According to Rule xi of the General Orders, patients had to be stripped and examined on admission in the presence of their friends, and, if necessary, the surgeon, and anything with which they might cause injury to themselves or others, removed. The gentleman standing behind the Rake in the painting may thus be the surgeon. His presence, that of the Keeper applying the chains to the Rake's ankle, and that of Sarah, in conjunction with the Rake's nakedness, may indicate his recent arrival on the premises following attempted suicide. The compassionate touch of the 'surgeon', who, in later states of the print (1763) is portrayed as a clergyman who seems to unite the two characters by his hands, does not comply with the usual references to a Bedlam in which inmates were treated in inhumane fashion. Confinement of the Rake 'for his own safety' was one of the 'treatments' available and being applied here.

Hogarth illustrates a large ward or gallery from which open individual cells

with grated windows, such as were described by de Saussure. Gates with open iron-work were erected in 1729 to separate violent patients from others. (At the time that the print was published, the wings for incurables were still under construction.) Other inmates in both the gallery and in two of the cells represent forms of madness in the setting of the mad-house which Hogarth, like Ned Ward, implied were equally prevalent in the world outside.

At one time, Dementia Paralytica, or General Paralysis of the Insane (GPI) accounted for nearly 20 per cent of mental hospital admissions and was the first major organic disease found in asylums, although the cause and effects were not fully understood until well into the nineteenth century. John Haslam, apothecary to Bedlam from 1795 to 1816, is said to have described a case of GPI in his *Observations on Madness and Melancholy* in 1798, which included clear clinical descriptions of those afflicted with mental disorders – such as alcoholics, melancholics, puerperal psychotics and schizophrenics – but made no differentiation between miscellaneous cases.[18] GPI is a manifestation of the third stage of syphilis and could become manifest many years after the initial infection. Overt sufferers of syphilis were not admitted to Bedlam under the general orders, but many of those condemned to this third stage were probably admitted unknowingly.

Hogarth's study of some of the inmates of Bedlam shows his close observation of the way in which madness could affect individuals, although he was ignorant of the cause. In the same manner he used in *The Pool of Bethesda*, he portrays classical features of mental disorders with appropriate LeBrunian expressions. Signs of clinical significance are present in the subjects (interpreted in twentieth-century terms). Delusions of grandeur often show themselves as a feature of GPI, elements of fashion being associated with the delusions. Hogarth alludes to regal and religious subjects and to contemporary figures in his deluded inmates. The man in the cell behind the Rake is consumed with religious fervour. Such 'enthusiasm' in preachers outside the Hospital was regarded as madness with destructive and chaotic effects – a kind of mania. Dr Thomas Willis wrote in *An Essay of the Pathology of the Brain and Nervous Stock* in 1672,

> After Melancholy, Madness is next to be treated of, both which are so much akin, that these Distempers often change, and pass from one into the other . . . if in Melancholy the Brain and Animal Spirits are said to be darkened with fumes and a thick obscurity; in Madness, they seem to be all as it were of an open burning or flame.[19]

The religious maniac's cell is decorated with images of saints. He is naked and holds a cross fashioned out of straw. His bed is of straw and manacles are

attached to it in case his behaviour requires further restraint. (One of the Rules for the Steward and Matron at Bethlem was 'To see that the straw on which the patients are laid, is changed when damp or dirty.') His face has been modelled on the second of Cibber's 'brainless brothers', 'Raving Madness'.

The second cell houses a 'king', naked except for straw crown and sceptre, whose deterioration in behaviour and lack of inhibition (features of GPI) are shown by his act of urinating against the wall in full view of the female visitors. Hogarth may be seen as condemning the madness of the State symbolised by this 'king'.

Between the two doors numbered 54 and 55, in the first state of the print, is a lunatic writing on the wall and calculating the longitude. A diagram of the earth is on his left, marked out with its poles and lines of longitude illustrating a contemporary interest. Jonathan Swift, who visited Bethlem and became a Governor in 1714, at one time tried to commit a friend, Jo Beaumont, to the Hospital because he had gone mad from 'thinking too long about the problems of calculating longitude'.[20] A plan proposed by William Whiston (1667–1752) which involved discharging a bomb from a mortar to aid in a similar calculation of longitude was regarded with scepticism. Hogarth changed this design in his later print edition of 1763, in which he placed a medallion of a deranged Britannia in place of the earth, indicating that Britain itself was mad. A chain connects this medallion to the door of cell number 54.

An astrologer in the form of a blind man looking through a paper telescope, a musician with flattened nasal bridge, and a pope holding a triple cross and wearing a dunce's 'mitre' add to the picture of deluded inmates. The mad tailor with tape measure is perhaps the same tailor who contrived to set the Rake up in suitable style in Scene 1 of the series. He is now present to measure up his downfall. His own style of dress concerns him no longer. Tailors were proverbially supposed to go mad with pride, and pride proverbially comes before a fall. The mask-like features of the depressed individual on the stairs who disregards the barking dog and the noise and activity around him could be exhibiting another late feature of syphilis along with his nasal depression, although his melancholia has been attributed to his unrequited love for 'Charming Betty Careless', the name of a contemporary prostitute which is carved on the stair rail next to him. She could be responsible for his plight. Dr Parsons had referred to the physiognomy of madness indicating that the madness was involuntary and the countenance not dependent upon wilful actions of the passions; the mad had no settled intention to produce a 'Passion'.[21] This man's lack of any expression illustrates this point.

The young lady and her maid standing at the door of cell number 55, the former peering hypocritically from behind her fan at the naked, urinating 'king', represent the kind of people who went to see the inmates. The *Historical Account* of 1783 describes how

The hospital used formerly to derive a revenue of at least £400 a year, from the indiscriminate admission of visitants, whom, very often, an idle and wanton curiosity drew to these regions of distress. But this liberty, though beneficial to the funds of the charity, was thought to counteract its grand design, as it tended to disturb the tranquillity of the patients.

A letter to the *Gentleman's Magazine* of 1748 requested an end to this practice of allowing visitors to view the inmates at Bethlem:

But those are fallen yet lower, who resort to an hospital, intended for the reception and for cure of unhappy lunatics, purely to mock at the nakedness of human nature, and make themselves merry with the extravagences that deface the image of the creator, and exhibit their fellow creatures, in circumstances of the most pityable infirmity, debility and unhappiness.[22]

A letter to *The World*, in 1753, included the following reference to a visit to Bethlem:

It was in the Easter-week that I attended my friend there; when to my great surprise, I found a hundred people at least, who having paid their two-pence a piece, were suffered unattended to run rioting up and down the wards, making sport and diversion of the miserable inhabitants . . . I saw the poorer wretches, the spectators, in a loud laugh of triumph at the ravings they had occasioned.[23]

The practice was discontinued in 1770 and attitudes towards mental illness became more sensitive. Until this date, the hospital was a popular site for such visitors who, under the guise of charity, could assuage their curiosity with regard to the inmates. Samuel Johnson and Boswell visited, and Steele took three schoolboys to see 'the lions, the tombs, Bedlam and other places which are entertainment to raw minds, because thy strike forcibly upon the imagination.'[24] On one visit, Steele encountered 'five duchesses, three earls, two heathen gods, an emperor and a prophet.'

Who were the more deranged, those from outside the hospital walls or the inmates? Hogarth's image of the asylum reflects the world and its passions in eighteenth-century terms. Decadence might corrupt the passions, but 'mad' or decadent behaviour is prevalent in the world in general and is only masked by the conventions of society. Thomas Tryon asks if the world is not 'a great *Bedlam*, where those that are *more* mad lock up those that are less.'[25] The activities of the inmates portrayed by Hogarth mirror those considered normal in different circumstances in society outside Bedlam.

Madness as endemic in society was a common theme. Captain Crowe, who, his nephew feared, would be branded as mad if he followed his desire to lead an unconventional life-style in Smollett's *The Life and Adventures of Sir Launcelot Greaves* (1760–61) exclaimed, 'Mad! what then? I think for my

part one half of the nation is mad – and the other not very sound – I don't see why I ha'n't as good a right to be mad as another man.'[26] In the 'Progress' of the Rake as a complete story, Hogarth indicates that the young man's eventual madness represents a moral and a social judgement, but he lays the blame for this as much on society in general as on the Rake himself. The Rake is stripped of the social conventions, symbolised by his nakedness, in the same way that his mental faculties have been stripped of reason.

In addition to his commentary on the social life of this period, Hogarth has provided an insight into the attitudes held by society towards mental suffering and its perceptions of madness. His insights are 'of the period' and adopt a characteristically sceptical stance, attributes which give him his special role as a commentator.

Towards the end of his life, Hogarth again illustrated his attitude towards the 'madness' of religious enthusiasm represented by the 'Saint' in cell number 54 at Bethlem. This was evident in *A Medley: Credulity, Superstition and Fanaticism* 1762 [60], part of which purported to show the manic or melancholic effects that such fanaticism could induce. A barometer emanating from a dismembered brain to which only an ear is attached and focused in the preacher's direction, is resting on two books, one by Joseph Glanvill on witchcraft, and the other containing the sermons of John Wesley. It shows a scale ranging from raving madness at the upper extremity to despair, madness and suicide at the lower end; ecstasy, lust, love, sorrow and agony come between. The congregation exhibits varying degrees of this 'barometric pressure'. A thermometer above the barometer 'speaks' for itself. In this print Hogarth attacks secular as well as religious credulity by again referring to Mary Toft and her rabbits in addition to other 'incredible' contemporary topical events.[27]

Hogarth was himself lampooned and put in chains in 'Bedlam' by Sandby in one of his etchings of the painter. This one is entitled *The Author run Mad* or *The Mad Artist in Chains* (1753) and was one of the prints produced by Sandby following the publication of Hogarth's book *The Analysis of Beauty*. In this print, 'Hogarth' is drawing on the wall in the manner of one of his own madmen in *A Rake's Progress*, and is holding up a stick fashioned in his proclaimed 'serpentine' shape. The satire is aimed also at Hogarth's conceit in aspiring to be a 'great art' painter. His pride and conceit have earned him the place in Bedlam in the print, where his delusions of grandeur can have full rein. In the background, he can also be seen at the top of the ladder, 'knocking of others who aspire to his mantle'.[28]

Politicians also found a place in 'Bedlam' by courtesy of contemporary artists. Fox did so via an engraving attributed to Isaac Cruikshank in 1784, in which the politician can be seen lying on a blanket laid on a bed of straw in a cell similar to those depicted in 'Bedlam' by Hogarth (BM 6496). Like one of

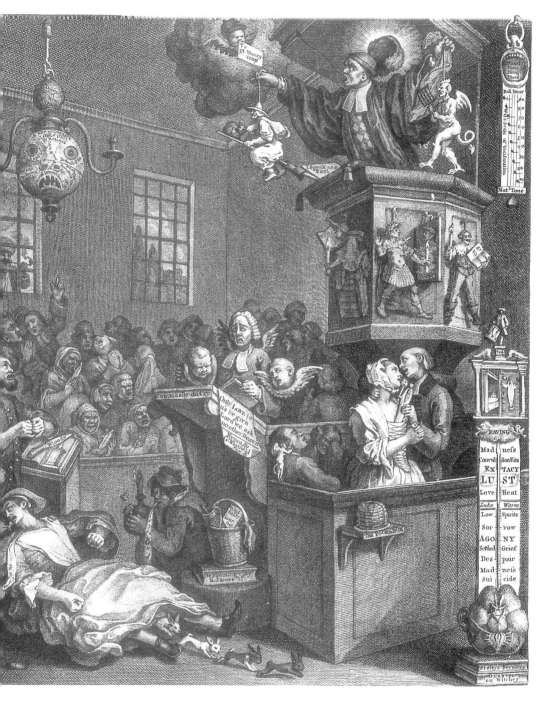

60. WILLIAM HOGARTH: *Credulity, Superstition and Fanaticism*

Hogarth's inmates, he is wearing a crown made of straw and is holding a sceptre of similar material in his hand. He is apparently a victim of his delusions of grandeur, saying to his visitor who views him through the cell door: 'Do you not behold friend Sam I have obtained the height of all my wishes?' At this time, the Coalition Government of Fox and North had become discredited. It was thought that Fox's future hopes of power and success were now merely 'delusions of grandeur' thus earning him a place in Bedlam.

Five years later, Pitt was placed in similar circumstances by Rowlandson, in a hand-coloured etching entitled *The Hospital for Lunatics*, published on 7 February 1789 (BM 7504). This shows Pitt seated on a chamber-pot in a hospital cell. He is holding a sceptre of twigs and is wearing a coronet of twigs. Above him is inscribed, 'went mad supposing himself next heir to a Crown'. In the next cell, Richmond is said to have gone mad 'in the study of Fortification', whilst in a third cell, a female – possibly the Duchess of Gordon – has been driven mad by 'Political itching'. Sexual innuendo would be intended with regard to the Duchess. All three 'victims' are pronounced INCURABLE.

Whatever the organic or biochemical basis of madness may be, its signs and even symptoms vary according to cultural assumptions of the time, as displayed by Hogarth's deluded inmates of Bedlam. 'Even the mad are men of their times'.[29] In the late seventeenth and early eighteenth centuries, passions were generally held to be responsible for the mental state. People were said to be mad when impassioned beyond moderation or 'reason'.[30] Pride, vanity, envy and anger could be all-consuming, constituting madness. During the eighteenth century the passions relinquished control to the 'nerves' and 'nervous excitation'.[31] 'Nervous complaints' came into vogue. Smollett's hero, Sir Launcelot Greaves, having been confined in a private mad-house, asks the doctor if his disorder is madness. The physician replies: 'O Lord! sir, – not absolute madness – no – not madness – you have heard, no doubt of what is called a weakness of the nerves, sir . . .'.[32] The boundaries of the states of 'Reason' and 'Unreason' became less well-defined and 'nervous sensibilities' came into being.

II. HYPOCHONDRIASIS

To the eighteenth century English mind, the distinction between sanity and madness seemed one not of kind but of degree, and a whole range of symptoms and dispositions (hypochondria, hysteria, depression, the spleen) linked the two.[33]

Graphic and literary artists show how insanity was popularly viewed. Rowlandson's etching of *The Hypochondriac* (1788), drawn from a design by

James Dunthorne, demonstrates how this condition was seen to be associated with extreme melancholy [61]. Here the symbolic figure of the skeleton as death was a useful role model as he wielded his fatal arrow.

Melancholy, hypochondriasis and the spleen, were considered to be one complex condition or malady. Dr Johnson's Dictionary of 1755 defines 'hypochondriacal' thus:

1. Melancholy; disordered in the imagination . . .
2. Producing melancholy . . .

The area below the costal cartilages or rib-cage is known medically as the hypochondrium and contains the liver, gall-bladder and spleen, the organs believed to be responsible for the condition of hypochondriasis. This, and the condition of hysteria, were thought originally to affect only women. Medical texts had even recommended holding a burning string close to the nose of a woman with hysteria to drive the wandering uterus – thought to be the cause of this latter condition – from the woman's upper body back to its proper site in the pelvis. Hypochondriasis became a fashionable English malady which gave rise to many treatises, pamphlets, poems, sermons and epigrams for more than fifty years. Names such as 'melancholy', 'the spleen', black melancholy', 'hysteria', 'nervous debility', and 'the hyp' were given to it. Opinions as to its cause often differed. Adair explained in one of his *Essays on Fashionable Diseases* (1790) how a specific diagnosis of an illness was not always easy, convenient or practicable if the doctor were ignorant of the cause. He might therefore gratify his patient with a 'general' term which may express the *nature* of the disease. 'If the patient or doctor were people of fashion, this may render the term fashionable' and it might then become a topic of conversation. He included such terms as 'spleen', 'hyp' and 'vapours' in this category, and these were used for those whom Adair regarded as 'sick by way of amusement, and melancholy to keep up their spirits.'[34]

In his *New Bath Guide*, which is described more fully in Chapter 7, Christopher Anstey relates Matthew Blunderhead's reminiscences with regard to the doctor's visit to himself and his sister whilst 'taking the waters' at Bath:

> I'm bilious, I find, and the women are nervous;
> Their systems relax'd, and all turn'd topsy-turvy,
> With hypochondriasis, obstructions and scurvy,
> And these are distempers he must know the whole on,
> For he talk'd of the peritoneum and colon,
> Of phlegmatic humours oppressing the women,
> From feculent matter that swells the abdomen;
> But the noise I have heard in my bowels like thunder,

Is a flatus, I find, in my left hypochonder,
So plenty of med'cines each day does he send
Post singules liquidas sedes sum end
Ad crepitus vesper' & man' promo vend
In English to say, we must swallow a potion,
For driving out wind after every motion;
The same to continue for three weeks at least,
Before we may venture the waters to taste;
Five times have I purg'd, yet I'm sorry to tell ye,
I find the same gnawing and wind in my belly . . .[35]

Once the theory of a nervous origin was accepted, it became increasingly fashionable. By the middle of the eighteenth century it was popularly known as 'the hyp' for men thus afflicted, and the 'vapours' for women, but it also became a word synonymous with lunacy. Many medical men regarded the condition as a disorder of the mind causing real physical symptoms (a psychosomatic disorder in twentieth-century terms) and it was difficult to cure. Robert James wrote in his *Medical Dictionary* (1743–5),

Hypochondriacus Morbis
No disease is more troublesome, either to the Patient or Physician, than hypochondriac Disorders; and it often happens, that, thro' the Fault of both, the Cure is either unnecessarily protracted, or, totally frustrated; for the Patients are so delighted, not only with a Variety of Medicines, but also of Physicians . .

One treatise on hypochondriasis was written in 1766 by John Hill, an eccentric English scientist, physician, apothecary and hack writer. Hill's treatise was a practical one which provided a summary of contemporary thought on the subject with an explanation of causes, symptoms and cures, including his own nostrums. The signs and symptoms described by Hill seem to be well illustrated by Rowlandson in *The Hypochondriac*. These include 'lowness of spirits and inaptitude to motion; a disrelish of amusements, a love of solitude and a habit of thinking, even on trifling subjects, with too much steadiness. Wild thoughts . . .'.

The print shows the patient seated in a chair with his arms folded inside the sleeves of his robe, giving the illusion of a strait-jacket being used to prevent him from harming himself. This was a device sometimes used for those declared 'mad'. That self-destruction is contemplated is indicated by the presence of the skeleton hovering over him with his lethal arrow and by the illustrations of his morbid thoughts, in the form of phantoms or spectres, which offer him tempting ways of ending his misery. A cup of poison is offered, a sword, a knife, a dagger, a rope and a pistol; death by drowning is indicated and even from the bite of a snake. A horse-drawn hearse depicts the ultimate scene contemplated. The sufferer is surrounded by black clouds, the

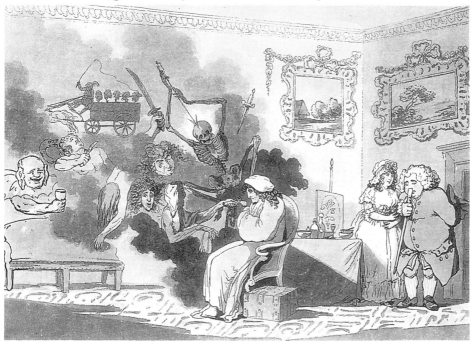

61. THOMAS ROWLANDSON: *The Hypochondriac*

only way out of which appears to be via the hearse withdrawing him from the scene of his melancholy. Behind the patient stands the physician, the stock character with tricorn hat and cane to nose. A pretty maidservant stands to his right next to a table on which are ranged bottles, bowls and a glass as evidence of remedies tried without benefit. The idyllic country scenes above these two contrasts the outlook on life in the two parts of the picture. Two verses underneath the picture describe the scene,

> The Mind distemper'd – say, what potent charm,
> Can Fancy's spectre breeding rage discern?
> Physics prescriptive, art assails in vain,
> The dreadful phantoms floating cross the brain.

> Until with Esculapian skill, the sage M.D.
> Finds out at length by self taught palmistry
> The hopeless case – in the reluctant fee.
> Then, not in torture such a wretch to keep
> One pitying bolus lays him sound asleep.

This MD may well be contemplating the final bolus. The cause of this patient's hypochondriasis is miserliness with no hope of a cure. The doctor's

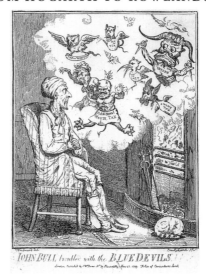

JOHN BULL troubled with the BLUE DEVILS

62. GEORGE WOODWARD: *John Bull Troubled by the Blue Devils*

fee is no doubt locked in the chest beside the patient and will not be forthcoming while the latter lives. *The Hypochondriac* presents a clinical picture of the sufferer and a stereotypical picture of the doctor who is more concerned about his fee and with the young servant girl than with the welfare of his patient.

'Melancholy' is seen in a print by George Woodward as a condition wrought by politicians by means of excessive taxation. *John Bull Troubled with the Blue Devils* [62] is an engraving which appeared in a folio of caricatures in 1799. John Bull, representing the archetypal Englishman, appears as a sad, downtrodden, poor old man in his nightcap, shirtsleeves and slippers. He is gazing with terror at various demons or 'blue devils' which are approaching him in a cloud of smoke from the fire. Demons in different guises represent the taxes to which he is subject, including income tax, additional housing tax, tax on hair powder, on windows, tea, salt and wine. The demons are accompanied by smaller winged 'devils'. They all seem devised to make John Bull miserable and 'Melancholic'.

Richard Newton depicts a *Visit to Bedlam* [63] and, as Hogarth had done earlier, begs the question of who are the sane, the inmates or the visitors? From which side of the bars is the reader viewing the inmates? The physiognomies of the man and his wife, who has been accused of cuckolding her spouse, show stereotypical features of those depicted as 'mad', with open mouths, raised eyebrows and staring eyes, making awkward gestures. The others in the foreground fare no better. Only the strange headgear in the form

63. RICHARD NEWTON: *A Visit to Bedlam*

of crown and chamberpot betoken the madness on the other side of the bars, with the handle of the chamberpot drawn to suggest the new moon, a portent of lunacy.

Rowlandson, in one of his drawings of contrasting states, *Doctor and Lunatic*, illustrates a raving madman, chained semi-naked in a barred room, whilst the doctor, calmly smoking his pipe, looks on. This and the previous image depict the insane as often illustrated, as raving maniacs. Images of madness changed as their condition received closer scrutiny. For example, the physician and anatomist Charles Bell published his *Essays on the Anatomy of Expression in Painting* in 1805. This contains his own illustrations of madness, completed after a visit to Bedlam.[36] His view was that madness is related to fear and terror and reflects the baser, animal aspects of man's nature. He depicts the madman as a cowering, shrunken individual, with watchful, troubled eye.

III. TREATMENT OF MADNESS

Treatment of the more profound and genuinely mentally ill in the eighteenth century was insensitive and even brutal. By mid-century, traditional ways of dealing with the mentally ill in Bethlem were being challenged by a new foundation, St Luke's Hospital for Lunaticks. William Battie MD who had been elected a Governor of Bethlem in 1742 after subscribing £50 to the Hospital, felt the need for a new approach to the treatment of such patients. He promoted the Foundation of the new hospital which opened in 1751 with Battie as its first physician. Battie also acquired two private madhouses in London.[37]

[167]

Ideals for the new Foundation included the provision of separate rooms for inmates and special diets, with servants who should be 'peculiarly' qualified for their work. A more rational approach to insanity was sought than had previously been considered. Coercion and 'physicking' by such means as purging, administration of emetics, blistering, use of caustics, raising issues and using cold baths were to be eschewed in favour of treatment by 'regime' and 'management', leading to a more humane approach. However, in some circumstances such 'physicking' might still form part of the regime. According to Battie, 'Madness . . . rejects all general methods, e.g. bleeding, blisters, caustics, rough cathartics, the gumms and faetid anti-hysterics, opium, mineral waters, cold bathing and vomits . . . nevertheless these and all pungent substances are to be tried with great caution, or rather not to be tried at all in fits of fury . . .'.[38]

Battie recognised that some patients recovered spontaneously without treatment or even after treatment was ended. By 1753, students were permitted to walk the wards and were given clinical instruction by Battie. Rational observation of the mentally ill, along the lines advocated by Sydenham with regard to organic medical diseases, was introduced. In his treatise of 1758, Battie pointed out that the application of some treatments for all 'madness' implied only one species of disorder and he proposed divisions into 'original' and 'consequential' madness, with or without brain disease, that is, mental illness with either organic or non-organic cause.

Rowlandson, in association with the architect Pugin, produced a drawing of part of the interior of St Luke's Hospital which was included in a series *The Microcosm of London* published by Ackermann in 1808–9. This was the second St Luke's Hospital in Old Street, which was built in 1786 following the move from Moorfields opposite Bethlem Hospital. Augustus Charles Pugin was born in 1762 and was the father of the more famous A. W. N. Pugin. He was a draughtsman to the architect Nash and entered as a student at the Royal Academy. He was a friend of the publisher, Ackermann, as was Rowlandson, an association which probably led to the publication of this series. Pugin provided the buildings in the series and Rowlandson the inmates, all in characteristic style. (The exterior of the building is illustrated in Payne's *Illustrated London*, 1846–7.)

Private madhouses flourished with no legal requirements for their regulation until some safeguards were introduced in 1774. A communication to the *Gentleman's Magazine* headed, 'A case humbly offered to the Consideration of Parliament' and dated 1763, describes a practice carried out at some of these establishments where impatient or slighted heirs were able to 'look after' their own interests by removing any inconvenient twig from the family tree and where troublesome members of families could be put out of the way:

When a person is forcibly taken, or artfully decoyed into a private Mad-house, he is, without any authority, or any further charge, than that of a mercenary relation, or a pretended friend, instantly seized by a set of human ruffians, trained up to this barbarous profession, stripped naked, and conveyed to a dark room. If he complains, or asks the reason of this dreadful usage, the attending servant brutally orders him not to rave, calls for assistance, and ties him down to a bed, from whence he is not released till he submits to their pleasure . . . the next morning a doctor is gravely introduced by the Master or the Keeper of the house . . . pronounces the unhappy person a lunatick, and declares he must be reduced by physic.

If the unfortunate 'patient' refused to submit to treatment, force was applied, and if he submitted and resigned himself to the situation, he was deemed to be 'melancholy' or sulky, which rewarded him with further dosing from the doctor. Either way, debilitation resulted and eventual impairment of mind.[39] Smollett's Sir Launcelot, forcibly incarcerated in a private mad-house by his rival for the lovely Aurelia, 'After mature deliberation, – resolved to demean himself with the utmost circumspection, well knowing that every violent transport would be interpreted into undeniable symptoms of insanity.'[40]

Public concern about the state of private mad-houses had grown since the early part of the eighteenth century, but no action was taken until 1763, when Parliament appointed a Committee to 'Inquire into the State of private Madhouses in this Kingdom'. The eventual Bill of 1774 provided limited safeguards with regard to private patients, but excluded provision for insane paupers in lunatic or general hospitals and workhouses, and those provided for in private mad-houses supported by the Parish.[41] No provisions were made for the enforcement of better conditions for the inmates or for the prevention of maltreatment.

With the advent of George III's recurring episodes of insanity, interest in the care and management of the insane received more attention than had previously been the case. Specialist mad-doctors emerged, some of them living in close quarters with their patients in private mad-houses. One of these was Dr Francis Willis. Rowlandson illustrated the controversial figure of this doctor, who became involved in the treatment of the king. The Reverend Doctor had studied theology at the behest of his father, but had no real inclination for a life devoted to the Church. While an undergraduate at Oxford, he had attended medical lectures in addition to pursuing his theological studies from which he graduated in 1734. He married in 1749 and moved to Lincolnshire where he began to practice medicine without a licence. He continued to do so for ten years, after which Oxford University conferred a medical degree on him, and in 1769 he was appointed physician to a hospital in Lincoln which he had helped to establish. There, he became known

for his treatment of mental disorders and patients were brought great distances to see him. He accommodated some of these in his own home and later moved to a larger house at Gretford, near Stamford, in order to have more room for such residents. His treatment of the mentally ill was controversial. He insisted on more gentle, humane care than was usual and allowed greater freedom for his patients. His system relied on 'a wholesome sense of fear in a setting of individual attention'. He won control and submission of his patients partly by inculcating a sense of fear into them and partly by his charismatic presence. Two patients shared a cottage with a keeper for each, and as recovery progressed, long walks and work in the fields became part of their management. A contemporary account of a visit to Gretford described a scene which might be encountered:

> As the unprepared traveller approached the town, he was astonished to find almost all the surrounding ploughmen, gardeners, threshers, thatchers, and other labourers, attired in black coats, white waistcoats, black silk breeches and stockings, and the head of each *bien poudrée, frisée et arrangée*. These were the doctor's patients: and dress, neatness of person and exercise being the principal features of his admirable system, health and cheerfulness conjoined toward the recovery of every person attached to that most valuable asylum.[42]

Convalescent patients ate dinner at the doctor's table. Scenes of this activity are provided by Rowlandson who illustrated the power of control exercised by Dr Willis, and the chaos which ensued in his absence. The pair of prints are entitled, *Doctor Willis at Home* and *Doctor Willis Abroad* and form a typical pair of Rowlandsonian contrasts [64, 65]. *Doctor Willis At Home* portrays the Doctor sitting in an armchair with a fierce, staring expression and whip in hand. His stare alone, well illustrated by Rowlandson, was reputed to reduce a man to submission. He is seated at one end of an oval table round which are seated distraught characters staring back at him. One patient is being led from the room by two attendants, and two others are being tied into strait-jackets such as were frequently used to restrain the 'unreasonable'.

A passage from a medical text published in 1772 contains information about the 'Strait Waistcoat':

> These Waist-coats are made of ticken, or some such strong stuff; are open at the back, and laced on like a pair of stays; the sleeves are made tight, and so long as to cover the ends of the fingers, and are drawn close with a string, like a purse, by which contrivance the patient has no power of using his fingers; and, when he is laid on his back in bed, and the arms brought across the chest, and fastened in that position, by tying the sleeve-strings fast round the waist, he has no power in his hands . . .

The passage continues:

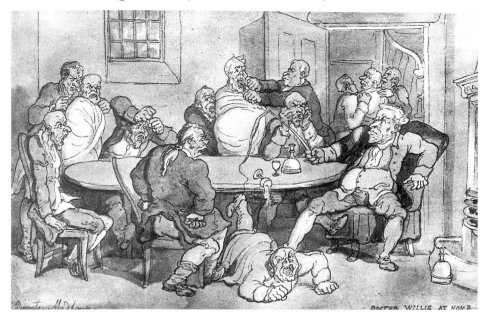

64. THOMAS ROWLANDSON: *Doctor Willis at Home*

It is of great use in practice to bear in mind, that all mad people are cowardly, and can be awed by the menacing look of a very expressive countenance; and when those in charge of them once impress them with the notion of fear, they easily submit to anything that is required.[43]

The second print, *Doctor Willis Abroad*, portrays the scene in the absence of the Doctor. A sub-title 'or Bedlam broke Loose' refers to Bethlem Hospital, a word which had become associated in the common language with madness, chaos and lack of reason. In the absence of any restraining influence, the patients are exhibiting acute signs of derangement. A couplet underneath the print runs, 'When we are sober we're sad. / When we are drunk we're mad.' Rowlandson is allying the state of madness with drunkenness, both being regarded as states of 'Unreason'. In this scene, Rowlandson's characteristic style of drawing with its unruly lines and untidiness lends emphasis to the chaos depicted.

Dr Willis was called in to attend to George III on 5 December 1788, and made use of a strait-jacket during his management of the king, thus provoking much antagonism to his treatments – not least by other physicians who had been overlooked in a search for medical advice with regard to the monarch's condition.

Rowlandson produced a political print at that time, entitled *Blue and Buf*

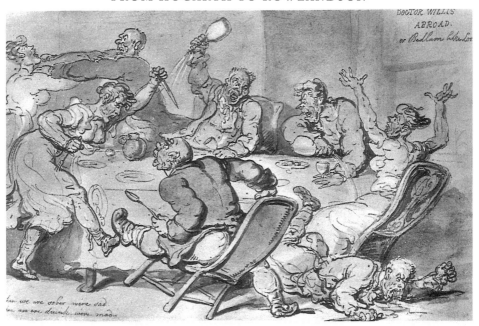

65. THOMAS ROWLANDSON: *Doctor Willis Abroad*

Loyalty (BM 7394), in which Dr Willis is portrayed with Sheridan, a member of the opposition party in Parliament. The print is divided into two halves; the left labelled 'Sunday' and the right, 'Saturday'. The question 'How is your patient today?' receives the answer, 'Better, thank God' on 'Sunday' and 'Rather worse – Sir – ' on 'Saturday'. The patient in question is George III and the question itself was occasioned by Dr Willis's attendance upon His Majesty on 5 December 1788. This had angered members of the opposition party and the satisfied look on Sheridan's face in response to 'Saturday's' poor prognosis with regard to the king's illness gives some indication of the antagonism felt towards Dr Willis.

The idea that the mad could be reduced to submission by means of a fierce staring expression is used by Rowlandson again in his engraving of *Death and Napoleon* (1813). In this print, which heads a printed broadsheet, Death as a living skeleton is sitting on the barrel of a cannon staring at Napoleon who is sitting opposite to him on a drum. Napoleon, whose sword lies broken on the ground, is trying to discountenance Death by staring at him in similar fashion. In the background, the Battle of Leipzig is raging.

Rowlandson's prints in this sphere, as in many others, not only corroborate evidence obtained from other sources with regard to attitudes held towards madness and its treatment, but also provide a valuable indicator of scepticism

– in one sector of the public at least – to the activities of those involved in the treatment of medical conditions, including the treatment of mental disorders.

The Retreat in York, set up by Samuel Tuke, a Quaker, in 1790 following the untimely death of a patient in the asylum in that city, provided a more compassionate approach to the treatment of the mentally ill. The bad conditions found in many of the private or profit-making establishments which existed at the time were brought to the attention of the public and in 1815, a Select Committee was set up in the House of Commons. This led to an Act for the Regulating of Madhouses, and county asylums were set up. Conditions for the patients improved, although some of Tuke's essential vision for management was lost as the size of these establishments and the number of mad paupers escalated. Containment of patients, rather than management in family-sized units as Tuke had advocated, became the pattern. Monuments to the age in the form of large obsolete Victorian asylums can still be seen in cities and large towns throughout the country.

CHAPTER 7

Fashions in Health and Treatment

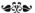

I. TAKING THE WATERS

Fashion has long influenced the great and opulent in the choice of their physicians, surgeons, apothecaries, and midwives; but it is not so obvious how it has influenced them also in the choice of their diseases . . .[1]

DIFFERENT fashions in medical treatment for both real and imagined diseases waxed and waned during the eighteenth century. Some of those in vogue can be visualised through the works of contemporary literary and graphic artists. Although many were of an ephemeral nature, one long-lasting fashion was that of 'taking the waters'.

In 1798 Rowlandson produced a series of drawings, *The Comforts of Bath*, which was used to illustrate the 1858 edition of Christopher Anstey's *New Bath Guide* (first published in 1766). This series satirically depicts the activities, both social and medical, which took place in the Spa. These drawings can be compared with those of other graphic artists and with contemporary medical and literary observations of the activities in Bath in an attempt to evaluate Rowlandson's perceptions and representations of this fashionable health trend. Rowlandson's style of drawing with its disordered and unruly lines, in addition to its content, evokes similar disorderliness in society in Bath and emphasises the satirical points he makes about the Spa.

The Greeks had practised a cult of natural mineral water therapy under carefully regulated conditions and this practice had continued intermittently during later periods. It came into vogue again in the first quarter of the eighteenth century, mainly for the treatment of gout, a generic name used for many types of arthritis and rheumatism. Hydrotherapy had been re-introduced at several spas such as Buxton and Malvern and the thermal waters at Bath appeared to be particularly suitable for this practice. Queen Anne visited Bath in 1702–3, thereby giving it fashionable status. The waters caused a temporary exacerbation of the gout which was thought to 'clear the system' and long periods of remission often followed. In addition to those afflicted with the gout, sufferers from other conditions such as consumption

and melancholia were often sent to take the waters in the hope of obtaining similar benefit. James Adair, a Scottish physician, described how:

> From a well grounded opinion that Bath waters are very beneficial in colics produced by gall-stones, and other cases of defective bile, a very considerable proportion of the patients who resort to that place, go with a strong prepossession that their complaints are bilious . . .[2]

To accompany treatment, medical advisers were necessary and leading physicians such as Falconer, Haygarth, Cheyne and Parry settled there in addition to other less notable practitioners. Richard Steele wrote 'On the Manners of the Bath Visitors' in 1713 and noted, 'The physicians here are very numerous, but very good-natured. To these charitable gentlemen I owe, that I was cured, in a week's time, of more distempers than I have ever had in my life . . .'.[3]

The activities at Bath had exercised the minds and pens of many writers and artists, including Tobias Smollett (1727–71). Smollett had attended medical and anatomy lectures at Glasgow University and had been apprenticed for five years to two Glasgow surgeons. Owing to his poor health, he was released from his apprenticeship in 1739 and proceeded to London. He passed the requisite examination at the Surgeons' Hall and in 1740 served as a surgeon in the Royal Navy on the *Chichester*. After some time in Jamaica he returned to London, and in 1744 was practising as a surgeon and living in Downing Street. He was apparently unsuccessful and the following year he moved to cheaper accommodation, where he wielded his pen in addition to his knife. *The Adventures of Roderick Random* was his first successful literary venture and appeared in 1748. Although he then decided that a literary career would form his main interest, he retained an interest in medicine, and, on the grounds that a degree would serve him well, he sent a fee of £28 and two sponsorship certificates to Aberdeen University, receiving a diploma of MD in return. He proudly displayed this on the title-page of many of his works. He received his MD in 1750, and in the same year *The Adventures of Peregrine Pickle* was published. He produced numerous works including novels, translations, medical essays and histories and edited many more (including an edition of Smellie's *Midwifery* in 1752). His 'Essay on The External Use of Water'[4] was written in support of the surgeon Archibald Cleland, who criticised the facilities provided at Bath for the bathers and the vested interests of the physicians there who acquired fortunes for themselves but failed to benefit many of their patients.

Smollett counted some eminent medical men amongst his friends and acquaintances, as can be verified from perusal of his letters.[5] During the last ten years of his life, probably suffering from consumption or tuberculosis, his health deteriorated and he travelled widely in search of a suitable climate and

treatment. A visit to Bath inspired his humorous novel *The Expedition of Humphrey Clinker*, in which Matthew Bramble, the main character, visits Bath in his search for health. His views of Bath and those of his niece, Lydia, are based on Smollett's own experience supported by information given to him by Mr Cleland and approximate to those of Anstey. Rowlandson assimilated them all in his inimitable way into his drawings *The Comforts of Bath*. He also drew ten plates for the 1805 Edinburgh edition of *Humphrey Clinker* and must have been familiar with its contents.

Medicine in some form plays a part in many of Smollett's works. Apart from his academic excursions, he comments upon contemporary medical practitioners and their practices and upon common beliefs regarding these. His fictitious physicians, surgeons and apothecaries reflect his own medical experiences and his attitudes and numerous letters confirm some of the latter. They all help to provide a backcloth for the artists of the time.

A few words about the origin of *The New Bath Guide* help to explain the nature of Rowlandson's drawings which later accompanied it. Christopher Anstey visited Bath for the benefit of his health following the death of a near relative. To amuse himself and his friends while he was there, he wrote a series of 'poetical epistles', penned 'to shoot folly as it flies'.[6] These were first published in 1766 as *The New Bath Guide*, which went on to more than twenty editions. Its popularity was partly due to its novel style but also to the inclusion of portrait sketches of known characters in the city. It professed to be a guide to warn the unwary traveller of the 'whirlpools and rocks' in the voyage of life. Anstey later settled in Bath with his family.

The Revd John Penrose, a Cornish clergyman who visited Bath in 1766 seeking a cure for his gout, wrote letters almost daily to his daughter at home. In one of these he mentions the *Guide* in the following terms:

> We have read 'The New Bath Guide', a series of Poetical Epistles, describing the Manners and Humours of the People. Some of it is very well, but upon the whole scarce worth the Price it is sold at, five shillings. But it is the Fashion to read it: and, who would be out of the Fashion?[7]

The first plate of Rowlandson's *The Comforts of Bath* [66], illustrates an oedematous (fluid-swollen) man who is suffering additional torments at the hands of the doctors, as one inspects his tongue and two others palpate his pulse. One of these holds up a time-piece and the other holds cane to chin in a contemplative gesture. A nurse slumbers in the background. The practice whereby many practitioners were consulted was previously satirised by Hogarth. Anstey refers to Hogarth at the beginning of his *Guide*: 'I'm certain none of Hogarth's sketches / E'er formed a set of stranger wretches' (p. 3). The 'wretches' include the members of the Blunderhead family, whose memoirs form the basis of the *Guide*. The head of this dynasty refers to his declining

66. THOMAS ROWLANDSON: *The Comforts of Bath*, I. *The Doctor's Visit*

health and to the distance that he has travelled (260 miles) in order to restore it. Over-indulgence had contributed to his present condition, a practice to which physician George Cheyne had earlier drawn attention when condemning the evils of luxury. Cheyne had weighed 32 stone before 'recovering' by following a milk and vegetable diet. He described his own 'conversion' in the *Gentleman's Magazine* in 1735.[8] His treatise, *Observations on Gout and the Bath Waters* (1720), proved popular and seven editions were printed in six years. In it he ascribed the acquisition of gout to 'Ignorance or Negligence of the Exact Rules of living', although he did concede an hereditary predisposition or 'Taint' for the disease in some people.[9]

Anstey's Matthew Blunderhead, whose presence at Bath is ascribed to Lady Blunderhead's over-indulgence of her son and heir, writes to his mother about the practices at Bath:

> For the people say here, be whatever your case,
> You are sure to get well if you come to this place . . .
> As we all came for health, as a body may say,
> I sent for the doctor the very next day,
> And the doctor was pleas'd, tho' so short was the warning,
> To come to our lodging betimes in the morning;
> He look'd very thoughtful and grave to be sure,
> And I said to myself, – there's no hopes of a cure!

[177]

But I thought I should faint, when I saw him, dear mother,
Feel my pulse with one hand, with a watch in the other. (p. 4)

And so, as I grew every day worse and worse,
The doctor advised me to send for a nurse.
And the nurse was so willing my health to restore,
She begged me to send for a few doctors more;
For when any difficult work's to be done,
Many heads can despatch it much sooner than one;
And I find there are doctors enough at this place,
If you want to consult in a dangerous case! (p. 10)

The mention of a watch to check Matthew Blunderhead's pulse seems to have
occasioned him some concern. The first efficient instrument of precision used
in clinical medicine was the 'pulse watch' which was invented by Sir John
Floyer (1649–1734) and was introduced as a 'Physician's Pulse Watch' in
1707. It was timed to record one minute. Such a watch was not widely used
for some time, and more effective pulse watches were not available in general
practice until the nineteenth century. Having his pulse 'timed' may well have
been an unusual event for Mr Blunderhead, and a point worthy of illustration
by Rowlandson.

Smollett gave a description of a 'coterie' or 'knot' of practitioners waiting,
rather like vultures, to relieve the sick, principally of their money. In his novel
The Adventures of Ferdinand Count Fathom (1753), he writes:

Every knot was composed of a waiting-woman, nurse, apothecary, surgeon, and
physician, and sometimes a midwife was admitted to the partie; and in this manner
the farce was commonly performed.

A fine lady, fatigued with idleness, complains of the vapours, is deprived of her
rest, tho' not so sick as to have recourse to medicine; her favourite maid, tired with
giving her attendance in the night . . . recommends to her mistress a nurse . . . The
nurse, well skilled in the mysteries of her occupation, persuades the patient, that
her malady, far from being slight or chimerical, may proceed to a very dangerous
degree of the hysterical affection, unless it be nipt in the bud by some very effectual
remedy: then she recounts a surprising cure performed by a certain apothecary . . .
The apothecary being summoned, finds her ladyship in such a delicate situation,
that he declines prescribing, and advises her to send for a physician without delay.
The nomination of course falls to him, and the doctor being called, declares the
necessity of immediate venaesection, which is accordingly performed by a surgeon
of the association.[10]

The order of participation of the accomplices varied, and, in a satirical
drawing by Woodward in 1793, even an undertaker is ominously included in
the 'partie'.

67. THOMAS ROWLANDSON: *The Comforts of Bath*, III. *The Pump Room*

Rowlandson produced a similar scene to that of the first plate of *Comforts of Bath* in 1808. This is entitled *The Consultation or Last Hope*, and the number of practitioners has increased. Five surround the patient, engaged in examination and consultation, whilst others wait on the sidelines for their turn. The mantelpiece sports evidence of many tried remedies and the nurse still slumbers. Other drawings of Rowlandson's illustrate a number of doctors 'in consultation'.

The third plate of the series *The Comforts of Bath* shows the sick, the lame and the fashionable, sampling the waters in the Pump Room [67], 'At a place where they tell you that water alone / Can cure all distempers that ever were known' (Anstey, p. 11). Smollett wrote of this via the pen of Lydia in *The Expedition of Humphrey Clinker*:

> The pumper, with his wife and servant attend within a bar; and the glasses, of different sizes, stand ranged in order before them, so you have nothing to do but to point at that which you chuse, and it is filled immediately, hot and sparkling from the pump. (p. 38)

In a personal letter which Smollett wrote to Dr William Hunter in 1762, he commented upon the benefits that he had experienced during a stay in Bath:

[179]

Since my arrival in Bath I have . . . slept very well . . . I drink moderately of the water, ride out every day on the Downs . . . I believe my breathing so easily is owing to the warmth and moisture of the air at Bath, which seems to be peculiarly adapted to my Lungs. Yet I can feel a very sensible Effect from the waters. I have no sooner drank a large Glass of them Hot from the Pump than my Face, my Hands, and Feet begin to glow; and this sensation is succeeded by an itching and tingling all over the Surface of my Body . . . I think I can plainly perceive these mineral waters opening up the obstructed Capillaries, and restoring the Perspiration . . . I intend in a few days to bathe with a View to open still more effectually the Strainer of the Skin . . .[11]

The Strangers' Assistant and Guide to Bath (1773) informs its readers that the Pump Room where water is usually drunk, serves as a meeting-place for company every morning from eight to ten o'clock. A band plays music in the gallery during this time. Water may be drunk between the hours of 6 a.m. and 2 p.m. in the summer season, and 7 a.m. and 4 p.m. in winter. The common method employed was to drink half the prescribed quantity before breakfast and the rest before noon, but the timing and quantity could be varied according to the nature of the disorder for which it was to be taken. Usually a half to three pints was recommended in 24 hours. The guide contains a description of the water, which was clear, colourless and sparkling when first drawn, but on standing acquired a slight wheyish tinge, with an ochery precipitation. It contains 'Sulphur, common salt and selenites, iron in small quantities and aerial volatile substances.' The guide compares the latter to what the 'modern philosophers call "fixible air".' The efficacy of the waters was said to be due to the exhalation of this air.

The medicinal effects of the waters were to be gained from both internal and external use and amongst the many complaints for which Bath waters were said to be beneficial was 'The Gout'. This says the Strangers' Guide, bears first place amongst the remarkable cures by:

bringing the paroxysms of this disorder to a happy crisis by fixing them in their proper situation . . . the extremities, and thus relieving the head, stomach, and vital parts, in promoting the exit of gouty matter by an easy and gentle perspiratory discharge, and thus in a manner most agreeable to nature, giving a full and compleat termination to the paroxysm.

Of the Bath Waters, Cheyne wrote:

I have often observ'd, with Admiration, the Wisdom and Goodness of Providence, in furnishing so wonderful an Antidote to almost all the Chronical Distempers of an English Constitution and Climate, which are chiefly owing to Errors of Diet, or rather, as a Sacred Writer expresses it, To Idleness and Fulness of Bread. The Rankness of the Soil; the Richness of the Provisions; the living so much on Flesh

Meats; the Inconstancy of the Weather, and the indulging in Sedentary Amusements, or speculative Studies, directly leading thereto. To Remedy all which, kind Heaven has provided Bath Waters as the most Sovereign Restorative in all the Weaknesses of the Concoctive Powers.[9]

It was recommended that the waters should be taken both internally and externally to 'prevent those rigidity of the limbs which frequently are produced by Gout'. Other disorders for which the waters were recommended included 'paralytic complaints'. It was recognised that metallic substances such as arsenic, copper, antimony, lead and mercury either taken by mouth or 'by means of fume', by miners, plumbers and gilders, could result in some form of paralysis. These sufferers could be improved by the waters. Bilious disorders, dysentery, gravelly conditions, 'Hysteric and Hypochondriac Disorders', rheumatic complaints, skin lesions and many more disorders were also said to be alleviated, although caution was recommended in the presence of fevers, inflammations, cancers and 'maniacal complaints'.

Blame for the prevalence of gout in the eighteenth century has been partially attributed to the presence of lead which was used to line the barrels containing port, wine and spirits, with contamination of the contents. The use of pewter drinking vessels and pans was common, and acidic drinks such as cider dissolved some of the metal, causing a disorder known as 'Devonshire colic'. Sometimes balls of lead were suspended in rough cider to sweeten it, with similar results. Lead poisoning caused damage to the kidneys, leading to an increase in the uric acid levels in the blood and the consequent deposition of uric acid crystals or gouty concretions in the tissues. Joints were destroyed in the condition known as 'Tophaceous Gout', causing excruciating pain. 'Gravel' in the urine was also associated with the increased blood uric acid levels. Benefit from the waters was obtained by means of increased fluid intake and diuresis, or increased urinary output from the kidneys, the 'gravel' being expelled in the urine.

Rowlandson's *Pump Room* illustrates the pumper drawing the water, whilst a young lady serves it to the customers. Two of these are sampling the water and others wait their turn. On the left-hand side of the picture, an invalid in his gout chair is being wheeled forwards. A sedan-chair, officially called a Glass chair or Bath chair, disgorges another afflicted individual. Rows of seated clients may be enjoying the music of the band which was mentioned in the guide, although the players are not seen in this view. The original Pump Room was built in 1704–6 and enlarged in 1751, before demolition and reconstruction in 1795. Rowlandson's scene is of the room before the 1795 restructuring took place. Two important features remained. One of these is the statue of Richard Nash in the niche on the rear wall. Richard Nash, or Beau Nash as he was known – referred to as 'King Nash'

and the 'real Founder of Bath'[12] – was an entrepreneur and gambler, who had gone to Bath from London to seek his fortune. This was in 1705. He soon became the major figure there and Master of Ceremonies. During the early part of the eighteenth century, the attractions of Bath had not been confined to its waters. Pickpockets, gamblers, duellists and quacks also found visits to Bath beneficial. Nash diagnosed the ills of the city and was determined to improve matters by way of regulation of the society, and promotion of projects which included cleaning the streets and restructuring much of the city. The latter was accomplished with the help of architect and wealthy businessman, John Wood, and Ralph Allen. Between them a handsome city with entertainments in the form of concerts, assemblies, theatres and gardens was established and Nash introduced regulations for the activities within the Baths. His rules of conduct, of orderly living and good manners, became established and the city thrived. Some London physicians had poured scorn on the medicinal use of the waters, fearing competition from the success of a provincial spa, but pressure from local doctors, headed by Dr William Oliver (1659–1716), led to the construction of the first Pump Room. Even after his death in 1761, Nash continued to overlook the scene through the eyes of his statue, sculpted by Prince Hoare and placed in the Pump Room. In this, his right hand is resting on a plinth on which a plan of the proposed new General Hospital is displayed – another worthy project.

A long-case Tompion clock, made and presented to the city by Thomas Tompion in 1709, is the second feature which sets Rowlandson's scene. Both this, and the statue of Nash can be seen in the Pump Room today.

Artist John Nixon offers a satirical scene of the Pump Room also showing the statue and clock. Nixon's scene is an example of the kind of drawing known as a 'droll' or comic scene, of the type which proved popular at the time. Amongst his invalids in the Pump Room are three dogs in the foreground which seem to wish to socialise in the manner of their human counterparts, illustrating the kind of scene described by Smollett: 'the Pump-room . . . is crowded like a Welsh fair; and there you see the highest quality, and the lowest trades folk, jostling each other, without ceremony, hail-fellow well-met.'[13] Nixon portrays the social mix catered for by the end of the century. Nixon was a friend of Rowlandson and sometimes collaborated with him in his work. The two were together in Bath in 1792, the year in which Nixon painted this scene. In 1784, Humphrey Repton also painted the scene. He includes an old man whose knees are flexed and who requires support from the gentleman behind him in addition to a stick. His paralysis may now be attributed to peripheral neuritis, an affliction which can be caused by chronic lead poisoning, with such demonstrable effects. The unpleasant taste of the water is clearly indicated by the expression on the face of the lady close

to the pump. A series of couplets underneath Repton's painting describes some of the inhabitants of the scene:

> Hither the Sick, the Gay, the Old, the Young;
> Impell'd by Hope of Change, successive throng:
> Here the light Widow, ogling every Beau
> Hopes to forget, and get a Husband too,
> Here Fops get Fortunes, Cits get rid of Cares,
> And Doating Husbands fancy they get Heirs.

These paintings can be compared with Rowlandson's view, in which the Georgian windows are opened wide to admit chairs, invalids and the elements. Colonnades were added later to provide covered access to the entrance.

Plate VII of Rowlandson's series, *The Comforts of Bath*, illustrates the *Comforts of Bathing*. The *Strangers' Guide* describes the proceedings associated with such bathing, and refers to the original bather – one 'Bladud' – whose statue overlooks Rowlandson's scene. Legend has it that Bladud, son of the ancient British king Lud Hudibras, suffered from leprosy and was forced into exile from his father's court. He became a swineherd and in the course of his wanderings came upon a steaming swamp by the bank of the River Avon. The pigs wallowed in the warm mud and their previously blemished skin emerged healthy. Bladud followed suit and was cured of his leprosy. He returned to court and, on becoming king in due course, established his seat at Bath and built cisterns to retain the healing waters. The statue remains and underneath are inscribed the words:

> Bladud son of LudHudibras Eighth King of the Britons from Brute. A Great Philosopher Mathematician bred at Athens and recorded the first discoverer & founder of these Baths, eight hundred sixty three years before Christ, that is two thousand five hundred and sixty-two years to the present year 1699.

In 1773 there were three main public baths, the King's, the Hot, and the Cross-Bath, and a fourth belonging to the Duke of Kingston. These had their own springs. In addition there was the Queen's Bath, which was supplied with water from the King's Bath, and the Lepers' Bath, which was supplied from the Hot Bath.

The King's Bath was the largest (65 ft 10 in. by 40 ft) and contained several springs, the greatest of which flowed into a large lead cistern about four feet below the surface. Several pipes were inserted into this to yield the water for drinking, 'as the water flows upwards in a strong, long and uninterrupted stream, all communication between the water which supplies the pumps used for those who drink the waters, and the water in the Baths, is prevented'. That was the theory as stated in the *Strangers' Guide*, but Smollett was concerned

with the lack of hygiene connected with this practice. In his 'Essay on The External Use of Water' he described his concern with regard to bathing there, using information given to him by the surgeon, Mr Cleland: 'some may be apprehensive of being tainted with infectious distempers; or disgusted with the nauseating appearances of the filth, which, being washed from the bodies of the patients, is left sticking to the sides of the place.' Smollett also communicated his concern in a letter to 'Dr Lewis', written by Matthew Bramble in *The Adventures of Humphrey Clinker* thus:

> Two days ago, I went into the King's Bath, by the advice of our friend Ch—, [Cheyne], in order to clear the strainer of the skin, for the benefit of a free perspiration; and the first object that saluted my eye; was a child full of scrophulous ulcers, carried in the arms of one of the guides, under the very noses of the bathers . . . we know not what sores may be running into the water while we are bathing, and what sort of matter we may thus imbibe; the King's evil, the scurvy, the cancer, and the pox; and, no doubt, the heat will render the virus the more volatile and penetrating.[13]

Cheyne in his *Observations* wrote of how,

> The Sulphur in the Bath Waters is evident to the senses, swimming in large Clusters on the Tops of the Baths mix'd with Earth, and some vegetable Substances . . . and is found an excellent Remedy in Scurvies, Leprosies, Ringworms, and other Foulness of the Skin . . .

After conversing with Dr Cheyne regarding the construction of the pump and cistern, Bramble continues with criticism of the drinking water: 'it is very far from being clear with me, that the patients in the Pump-room don't swallow the scourings of the bathers. I can't help suspecting that there is, or may be, some regurgitation from the bath into the cistern of the pump.' Anstey's Mr Blunderhead seemed equally concerned. In a letter to his mother, he wrote,

> So while little TABBY was washing her Rump,
> The Ladies kept drinking it out of a Pump. (p. 42)

Rowlandson's Plate VII illustrates the mixed bathing taking place in the King's Bath. (The Queen's Bath was for females only.) Cleland had informed Smollett how, 'Diseased persons of all ages, sexes, and conditions, are promiscuously admitted into an open Bath, which affords little or no shelter from the inclemencies of the weather.' Rowlandson's 'mix' included people of all ranks, ages and decrepitude, some seeking support from fellow bathers or from stone columns and some still clutching their crutches. None of them seems to be enjoying the experience. In the middle of the Bath, according to the *Strangers' Guide*, was a covered wooden building for the accommodation of bathers in bad weather. This was furnished with seats and niches on the

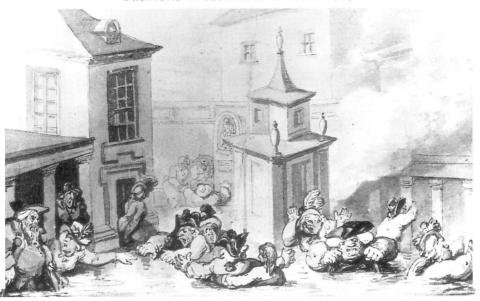

68. Thomas Rowlandson: *The Comforts of Bathing*, or *The King's Bath*

outside and niches and seats of stone were likewise round the sides of the Bath. Other wooden buildings afforded protection from the weather and had doors which could be closed to confine the steam and thus increase the temperature. Rowlandson depicts a disconsolate-looking man seated under cover in one of these buildings on the left-hand side of the picture. His original painting of the Bath [68] includes a pavilion-type building or 'kitchen' which was not present in Plate VII of the series accompanying Anstey's *Guide*. The 'kitchen' was over the hot spring and had to be replaced several times as its condition deteriorated. Adjacent to the Bath were several chambers called 'slips', in two of which fires were kept constantly burning. These rooms served as dressing-rooms. A lady on the left-hand side of the picture is emerging from one such chamber.

Altogether, Rowlandson's scene conjures up a general impression of disorder with its leaning buildings, false perspectives and melée of untidy people. As he was an artist with a facility for accurately portraying topographical scenes, it may be assumed that his intention was to convey the impression of disorderliness inherent in the structure and organisation of the baths as well as in the bathers by this means.

Bathing dresses could be hired at 6d. per time if the bather did not purchase one for his own use. The bathing dresses for the women were loose and shapeless garments, whilst those worn by the men consisted of waistcoats and canvas drawers. These were criticised by Cleland because, 'the nature of that

dress, which, being made of canvas, grows cold and clammy in a moment, and clings to the surface of the body with a most hazardous adhesion.' Cleland pointed out the dangers of ladies remaining in such wet clothes and being obliged to wait in 'a cold slip' for their respective chairs. The bathing dresses were all stained a yellow-brown colour by the minerals present in the water. The bathers pushed round a small tray which floated on the surface of the water and on this a handkerchief, a small posy of flowers and a snuff box might be carried, to be used in an attempt to disguise the sulphurous smell emanating from the water. Lydia described the dress and the Bath when writing to her friend:

> Right under the Pump-room windows is the King's Bath; a huge cistern, where you see the patients up to their necks in hot water. The ladies wear jackets of brown linen, with chip hats, in which they fix their handkerchiefs to wipe the sweat from their faces . . . my aunt . . . contrived a cap with cherry-coloured ribbons to suit her complexion . . .[14]

Fashion, it seems, was still uppermost in some people's minds. Rowlandson takes his satirical point further by dressing his bathers in their usual attire. The street outside, the Pump Room and the Baths were inhabited by similar members of society, who could view the scene from balconies surrounding the steaming cauldron, or through the windows of the Pump Room as described by Lydia and by Smollett in his 'Essay', in which he relates how Cleland deplored the necessity for women to

> 'mingle with male patients, to whose persons and complaints they are utter strangers' and to 'be exposed in a very mortifying point of view, to the eyes of all the company, in the Pump-room, as well as to those of footmen and common people, whose curiosity leads them to look over the walls of the Bath.'

The Revd Penrose's description of the scene in a letter to his daughter reads:

> By the Way, we looked into the Bath, and saw People bathing, several Persons both Men and Women, and one Child in Arms. The usual Time of Bathing is between six and nine in the morning, when there is a fresh Supply of Water. For the Water which rises one Day is discharged before the next Day, so that every morning there is clean wholesome Water. The Persons bathing have most of them a Person to go into the water with them whom they call a Bath Guide: and the Water is deep enough to take one up to the Neck, unless a tall person. All round the bath, and round a Building in the midst of it, called the Kitchen, are Seats covered all over with Water. They do not go into the Water naked (for both Sexes bathe in the same place, and that Place public) but in a Canvas Dress prepared for the Purpose . . .[15]

Anstey drew attention to the fact that although the medical profession recommended bathing to their patients, they did not participate in the practice themselves:

> And to-day many persons of rank and condition
> Were boil'd by command of an able physician. . . .
> But what is surprising, no mortal e'er view'd
> Any one of the physical gentlemen stewed;
> Since the day that King Bladud first found out these bogs
> And thought them so good for himself and his hogs,
> Not one of the faculty ever has try'd
> These excellent waters to cure his own hide;[16]

Another method of applying water to an afflicted site was by the Pumper pumping it directly on to the area. This sometimes necessitated up to one thousand pump strokes per day, entailing an endurance feat for both invalid and Pumper.

Cleland recommended various improvements to the facilities at the baths and invented an enclosed warm chair to replace those described as

> paultry chairs made of slight cross bars of wood, fastened together with girth web, covered with bays, and, for the most part, destitute of lining; these machines standing in the street till called for, are often rendered so damp by the weather, that the Bathers cannot use them without imminent hazard of their lives.

Cleland also proposed that a Bagnio should be erected with proper conveniences for Cupping, Sweating, Bathing, Pumping, and Fomentation, supplied by a pipe from the 'kitchen' of the King's Bath. He offered to finance the project himself, but all his propositions were rejected by the physicians who responded by coming to a resolution to exclude all surgeons from consultations on the subject of plans for improvements. Antagonism between these two branches of the medical profession apparently continued. Smollett's 'Essay' provoked little response and was limited to one edition.

John Nixon provides another view of the King's Bath which he painted in the year 1800. The bathers here include one with a goitre conversing with a deaf individual, one with a hand on a wooden 'splint' and others in varying states of health and vigour. Nixon's representation is superior to that of Rowlandson in purely topographical terms, but his scene fails to convey the same liveliness and character.

The sufferers of gout, as has been indicated, were amongst the main beneficiaries of the amenities offered at the Spa. Some medical practitioners such as Cheyne recommended: 'a proper diet including total abstinence or great Abstemiousness in Flesh, Fish and strong liquors . . . wisely managed exercise . . . Evacuations . . . dilution by proper liquors . . . [taken] Blood warm on an empty stomach.' 'Proper Liquors' included mineral chalybeat waters and a variety of teas. Cheyne also advised a few 'well-chosen Remedies' including mercury which, he said, would break down the 'Gouty'

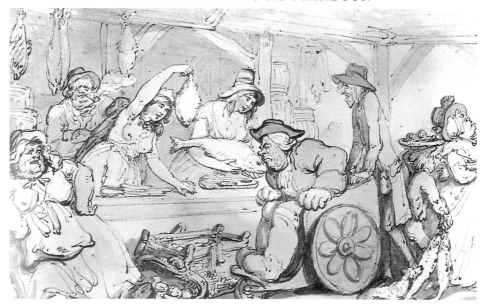

69. THOMAS ROWLANDSON: *The Comforts of Bath*, IV. *The Fish Market*

salts. Rowlandson, amongst others, highlighted the kind of life-style which continued to be followed by these sufferers – the style which had contributed to their disability in the first place. Foods now known to be rich in purines, such as fish roes, whitebait, sprats, sardines, herrings, bloaters and mussels were amongst these and can be seen at the fishmongers in Plate IV of the series, where they are being sought by a chair-borne individual, whose left leg is wrapped in flannel as was customary practice when the gout was troublesome [69].[17] The perspectives in this scene are contrived to make it appear as if the irascible-looking man is about to consume a large fish there and then. The portrayal of gout as a symbol of lust seems to be apt for this man as he eyes both the phallic fish held up for his approval and the young lady displaying her own and the piscine attributes.

Other tempting but unsuitable foods and wines for the invalid are displayed in Plate IX of the series. Portrayal of over-indulgence in food and drink was sometimes used by artists as a metaphor for human folly and the stereotypical signs of gout represented a lifetime of folly. Here the portrayal is both factual and metaphorical.

Moderate exercise was part of the regime advised whilst in Bath, and horse-riding was thought especially beneficial because of the erect posture required, and the constant change of air inhaled. The doctor advised Miss Blunderhead to ride after she had followed the rest of his advice:

[188]

He gives little Tabby a great many doses,
For he says the poor creature has got the Chlorosis,
Or a ravenous Pica, so brought on the vapours
By swallowing stuff she had read in the papers;
And often I marvell'd she spent so much money
On Water-dock Essence and Balsam of Honey,
Such tinctures, elixirs, such pills have I seen,
I never could wonder her face was so green.
Yet he thinks he can very soon set her to right
With 'Testic' Equin' that she takes ev'ry night;
And when to her Spirits and strength he has brought her,
He thinks she may venture to bathe in the Water.
But Prudence is forc'd ev'ry day to ride out,
For he says she wants thoroughly jumbling about.[18]

Plate V displays the benefits of riding for old and young. The contrasting vigour of humans and animals according to age and inclination, is clearly shown.

The more hazardous aspects met with during a day's perambulations or in taking the air in a sedan chair when complying with such regulations can be seen in Plate XII of the series. The Royal Crescent is topographically illustrated in the background. Here again, Rowlandson both literally and metaphorically illustrates the upset of conventions which occurred in Bath. 'Reality' has tumbled from the seemingly ordered system in the background. Another illustration entitled *Bath Races* by Rowlandson is a variation on the same theme [70].

The ultimate end to folly is death and Rowlandson presents this as appropriate to Bath in a scene from his 'Dance of Death' series, entitled *The Pump Room Door* [71]. Other 'Dance of Death' scenes and the symbolic use of the skeleton motif in prints are described in Chapter 10.

The social aspects associated with 'taking the waters' formed an important part of life at the spas. Assemblies, balls and concerts were part of the social scene, but those afflicted by gout were prevented from taking their full part in these activities. Christopher Anstey alluded to a way of alleviating their affliction other than by bathing in or imbibing the sulphurous water at Bath in his 'epic' in epistolary form, *An Election Ball*, written from that city in 1776. In this, 'Mr Inkle writes to his wife, Mrs Dinah Inkle, at Glocester':

– And so, as I told thee before, my dear wife,
I'll go to the ball tho' it cost me my life –
Must I be shut up, till, like my poor neighbour SNARLER,
I be smok'd like a joss in mine own little parlour?
No – I'd have thee to know I can walk pretty stout,

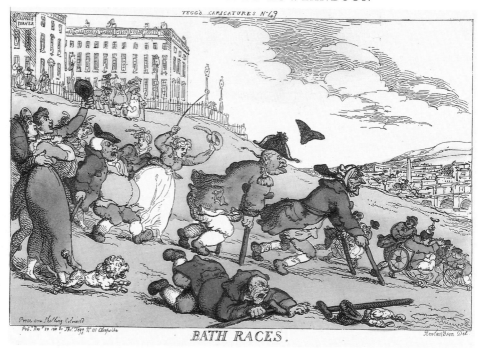

70. THOMAS ROWLANDSON: *Bath Races*

> Since I've found an infallible Cure for the Gout,
> For the Doctor I've try'd, has with Wedges and Pegs
> So stretched out my Sinews, and hammer'd my Legs,
> My heel I can raise, and my Toe I can bend down,
> And, by Jove, I'm resolv'd to get out of the Bilboes,
> And shake at the Ball both my Legs and my Elbows.[19]

Nash had noted the presence of quacks or charlatans as one of the more reprehensible aspects of Bath life. Some quacks became more innovative in their dealings with the public as the century advanced and they took advantage of prevailing social fashions and situations.

The doctor to whom Anstey referred was a notorious practitioner, Abraham Buzaglo, a Jew who had first attracted attention with his invention of a heating apparatus, before transferring his inventive capabilities in the direction of the gout and setting up practice as a 'Gout doctor'. He wrote *A Treatise on the Gout*, bearing the following heading:

A Treatise on the Gout: wherein The Inefficacy of the usual Treatment in that dreadful Disorder is demonstrated, the Facility of a speedy and radical Cure to be

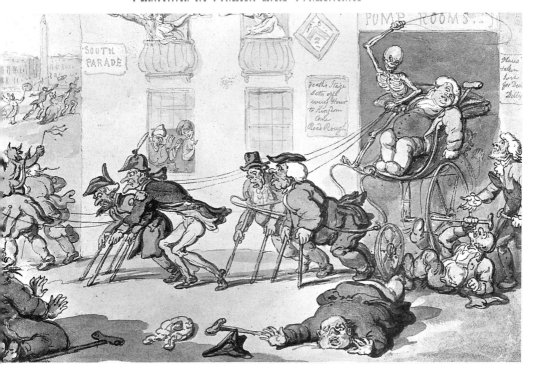

71. THOMAS ROWLANDSON: *The Pump Room Door*

effected between the Fits, and prevent their Return, by a peculiar Mode of muscular Exercise, Is established to Conviction; and A New and Infallible Discovery of sure and certain Relief during the Fit, in every Gouty Case whatever, is offered to the Public, on the indisputable Evidence of many extraordinary Cures, on Persons of the first Rank.

In this treatise Buzaglo deplored 'The Prescriptions of the Faculty' which, he said, 'consist generally of Flannels, Patience and sleeping Draughts' – the latter usually meaning opiates.[20] Exercises such as horse-riding which was recommended by physicians, he said, would 'remove indigestion, create a good Appetite, divert Thought, Shake and exercise the body, warm the rider, and procure Rest. These Effects are produced by a Single Motion, by jolting the Body' (p. 23). But horse-riding, he claimed, was not always appropriate. By trying out experiments on his own limbs, Buzaglo 'devised Exercise and means of restoring Limbs and joints to their usual state'. Moreover, he added in his *Treatise* what was no doubt a popular recommendation: 'Living low, and Abstinence from good Wines and Victuals are no Part of the Cure'

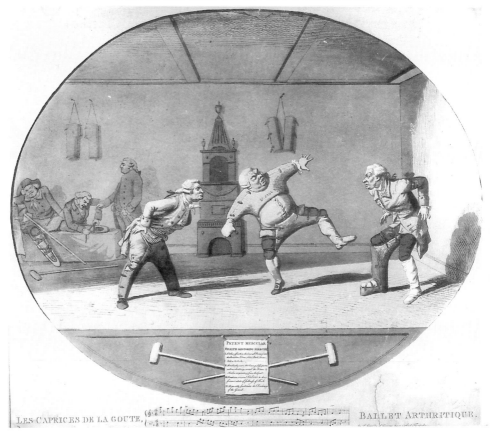

72. PAUL SANDBY: *Les Caprices De La Goute, Ballet Arthritique*

(p. 28). His treatment involved the participation of the sufferer in a series of muscular exercises and activities with the aid of 'wedges and pegs'.

Paul Sandby produced a satirical representation of Buzaglo's establishment – furnished with one of the quack's heating stoves – in his *Ballet Arthritique*, published in 1783 [72], in which the quack is shown supervising the fitting of wooden 'bootikins' to a client, whilst others gyrate uncomfortably encased in various wooden trappings. A placard in the foreground of the print enumerates the benefits to be gained from the 'Patent Muscular Health-Restoring Exercise':

 I. It takes off within the hour all Pains from the Shoulders, Elbows, Sides, Back, Knees, Calves & Ancles.

 II. It radically cures the Cramp, dissipates callous Swellings round the Knees & Ancles originating from the Gout.

[192]

III. It restores wasted Calves to their former state of fullness of Flesh.

IV. It greatly facilitates the Discharge of the Gravel.

Sandby designed the placard in similar style to that which set out the 'doctor's' recommendations in his *Treatise*, although the latter advocated exercises for thirteen different ailments which he set out in his own advertisements. Sandby also supplied a line of music to accompany *The Ballet Arthritique*.

Buzaglo advertised extensively and added the following information:

The ladies and children's hour of exercise is daily from 11 to 12, gentlemen from 12 to 3.

** Patients may agree for a perfect cure, or by the month, by the year, or for life.[21]

The 'doctor' is also mentioned in a 'Dance of Death' scene by Woodward, in which a gouty old man capers with Death – in the form of a skeleton – complaining 'Buzaglo's Exercise was nothing to this!'[22]

Horace Walpole made frequent reference to 'bootikins' which he wore because of his affliction with gout. He found them beneficial, but the type of 'bootikins' to which he referred were probably made of flannel. In a letter to George Montagu, he wrote: 'I have been laid up with a fit of gout in both feet and a knee . . . and am, considering, surprisingly recovered by the assistance of the bootikins and my own perseverance in drinking water.'[23] Large flannel socks or 'bootikins' are worn by many of Rowlandson's gouty sufferers.

Rowlandson used his artistic skill and non-conformist tendencies to point out pretentiousness both in art and in human behaviour. The scenes at Bath offered an antidote to the 'establishment'. This antidote was operative in two spheres: firstly in connection with classicism in art, with its contrived order, simplicity and elegance and its associated moral principles; and secondly with respect to social class, in which the upper echelons of society professed a similar superiority in moral worth and order. The architecture of Bath with its classic regularity offered Rowlandson an ideal backcloth. He demonstrated that a regular existence did not necessarily accompany outer elegance, which might be a mere façade. He offered a view of reality, with its social and human folly. To achieve his aim, however, and to provide credibility, the representations of the activities at Bath needed to ring true in a general sense. References to contemporary accounts of the activities have shown that contemporary observers shared his perceptions. Rowlandson's boisterous portrayal of these activities provided more impact on his viewers than a bland reportage of events would have done, thus contributing to his popularity as an observer of contemporary scenes. His subversive portrayals required less intellectual effort in their unravelling than did Hogarth's.

Sea-water bathing

'Taking the waters' at Bath was not universally acclaimed. One critic of the use of the mineral waters there was Dr William Heberden (1710–1801), physician to George III, who thought that sea bathing was preferable for gouty persons. A transference of 'society' to Brighton from Bath gradually took place. This was largely due to the Prince of Wales, who first went there in 1782. In the same year, William Cowper wrote:

> Your prudent grandmammas, ye modern belles,
> Content with Bristol, Bath, and Tunbridge Wells,
> When health required it, would consent to roam,
> Else more attached to pleasures found at home,
> But now alike, gay widow, virgin, wife,
> Ingenious to diversify still life,
> In coaches, chaises, caravans,and hoys,
> Fly to the coast for daily, nightly joys,
> And all, impatient of dry land, agree,
> With one consent to rush into the sea.[24]

Immersion in sea-water became accepted as an alternative to immersion in the mineral waters at the spas. (Even drinking sea-water had its advocates.) Smollett had strong opinions about its value for both his fictitious characters and for himself. Matthew Bramble, continuing his journey from Bath in his search for health, wrote to Dr Lewis from Scarborough: 'You must know I have received benefit, both from the chalybeate and the sea . . .'[25] and his nephew who accompanied Matthew Bramble, wrote to a friend at Oxford: 'You cannot conceive what a flow of spirits it gives, and how it braces every sinew of the human frame. Were I to enumerate half of the diseases which are every day cured by sea-bathing, you might justly say you had received a treatise.'[26] On his own behalf, Smollett wrote to Dr [? William] Hunter: 'This is the twentieth day of my bathing in the sea from which I have received such Benefit as almost transcends Belief.'[27]

In his 'Essay', Smollett had eschewed the mineral content of spa waters for bathing purposes, stating:

> I can easily conceive how extraordinary cures may be performed by the mechanical effects of Simple Water upon the human body; and I fully believe that in the use of bathing and pumping that Efficacy is often ascribed to the mineral Particles, which properly belongs to the Element itself, exclusive of any foreign assistance.

The seaside places provided similar social entertainments to those of the inland spas, as Mr Bramble's nephew told his friend with regard to Scarborough: 'the diversions are pretty much on the same footing here as at

Bath.'[28] By the time that the Pavilion at Brighton was habitable (1787), the old fishing port of Brighthelmstone had become a fashionable resort under its shortened name. Rowlandson went there with his friend Wigstead in 1789 and between them they produced *An Excursion to Brighton*, a production which included eight aquatints by Rowlandson.

A print by John Nixon published on 15 July 1789, illustrates *Royal Dipping*. George III went to Weymouth for such immersions during a period of convalescence from a bout of his recurrent insanity. In this print, he does so to the accompaniment of a band of musicians who are wading in the water with signs of incipient sea-sickness. The actual event was recorded as having been accompanied by a rendering of 'God save Great George our King' issuing from a neighbouring bathing machine which concealed the musicians.[29]

II. AERIAL, AETHERIAL, MAGNETIC AND ELECTRICAL APPLICATIONS

Towards the end of the century, especially in London, some of the quacks became more sophisticated in their modes of practice. They benefited from the power of advertising by means of handbills, newspapers and journals, and some achieved notoriety. The dividing line between orthodox medicine and quackery was still undefined. Oliver Goldsmith, in his 'Letters from a Citizen of the World' (1762), wrote:

> Few physicians here go through the ordinary courses of education, but receive their knowledge of medicine by immediate inspiration from Heaven. Some are thus inspired even in the womb: and, what is remarkable, understand their profession as well at three years old, as at threescore. Others have spent a great part of their lives unconscious of any latent excellence, till a bankruptcy; or a residence in jail, have called their miraculous powers into exertion. And others still there are, indebted to their superlative ignorance alone for success; the more ignorant the practitioner, the less capable he is thought of deceiving . . .[30]

Some quacks flourished. Four main reasons for their success have been suggested: the low therapeutic effect of orthodox medicine; the lack of registration and regulation of practitioners which allowed foreign mountebanks to obtain royal licences to practise in England; 'patient power', which dictated the kind of attention required by those with money to pay for it and which the quack was happy to provide; and the entrepreneurial opportunities available through the increasing powers of advertising, communications and marketing of services and medicaments.[31]

Another reason was the growing public awareness and interest in natural scientific phenomena. Techniques of electrical treatment, for example, were of widespread interest. One particular quack who marketed such interest was

Dr James Graham, who became the butt of many satirical prints and occasioned a great deal of comment in newspapers and journals. A description of his background and his means of achieving notoriety by exploiting the new scientific discoveries, associated with the gullibility of the public, goes some way towards explaining the success of such quacks. Artists in their turn reflected the interest both in the scientific phenomena and in the quacks' use of them.

Dr James Graham, son of a saddler, was born in Edinburgh in 1745. He studied medicine at the University there, but there is doubt as to whether he ever completed his studies. He went to Pontefract in England, where he began to practise medicine, and then went to America in about 1772, where he specialised as an oculist and aurist, spending about two years in Philadelphia. There he became acquainted with Franklin's experiments with electricity. These, undertaken in 1753, gave support to prevalent ideas regarding the medicinal uses of electricity. Later, Franklin carried out experiments on its possible use in the cure of paralysis, and word spread of cures of blindness and dropsy.

One use for electricity was demonstrated in a political print which was published in 1770. In this print, entitled *Political Electricity; or An Historical & Prophetical Print in the Year 1770* (BM 4422), the coast of France is depicted. Numerous subjects are shown linked together in an 'Electrical Chain', with Bute, in the form of an electrical machine, having a handle in his head turned in order to generate electricity. Bute, the Princess of Wales and others are alleged to have been in treasonable communication with the French Ministers and to have received bribes from them to procure a treaty on terms which were thought to be detrimental to Britain. The electrical chain, suggested by Franklin's experiments, is carried across the sea. Such electrical effects could be seen as a form of political subversion.

The Methodist preacher John Wesley made some dramatic claims for the therapeutic properties of electricity. Preachers often acted as amateur physicians, and medical advice from one as well known as Wesley was highly regarded. A notice in the *Westminster Journal* in 1772 provided the information

> that Mr Wesley has procured an Electrical Machine at the Foundry at Moorfields, where any person may be electrified gratis from nine to twelve every day except Saturdays and Sundays . . . Mr Wesley says that Electrifying in a proper Manner cures St Anthony's Fire, Gouts, Headaches, Inflammations, Lameness, Palpitations of the Heart, Palsy, Rheumatics, Sprain, Wan, Toothache, Sore Throat and Swelling of all sorts.[32]

Such claims were welcomed by unscrupulous practitioners and the current interest in scientific phenomena made many people easy prey to charlatans.

Graham returned to England in 1774, and in Bristol in that year was advertising 'wonderful cures'. He practised for a time in Bath and in 1777 met the historian Mrs Catherine Macaulay (who later became his sister-in-law). A description of how six Odes were publicly introduced and read to this lady on her birthday, 2 April 1777, by Dr Graham described the latter as, 'well known, perdie in many a corner of a Country Newspaper, for the Infallible Cure of Human Maladies'.[33] Dr Graham presented Mrs Macaulay with a copy of his works – containing his 'surprising Discoveries and Cures' – in which he claimed to have cured her of 'the obstinate maladies your fair and delicate frame was afflicted with'. She supported his claim in a letter in the same publication saying, 'I have the Happiness to declare, that a great Part of my Disease immediately gave Way to your Balsamic Essences, and to your Aerial Aetherial, Magnetic, and Electric Applications and Influences.'

Graham admitted that he gained his first 'start' by his treatment of Mrs Macaulay. A print published in 1780 (BM 5766), in which Graham can be seen wearing a medallion inscribed with the words 'Female Historian' – a reference to Mrs Macaulay – and holding a box of 'Aetherial Pills', makes fun of the doctor, using his own descriptive terms. Under the title *The Quintessence of Quackism*, it is said to be 'founded on principles truly chimerical aetherial magnetical, electrical, and immaterial, & the four quarters of the globe ransack'd to make it ingeniously, ridiculous'. It is dedicated 'to the Emporor of Quacks, by myself'. A monkey, holding a duck with the words 'Quack, Quack' issuing from its mouth, is standing on Graham's head. Two giants, Gog and Magog, stand on either side of him, one holding a sketch of a plan of the Temple of Health, the establishment opened by Graham two years previously. Underneath the print are the words:

> See sirs, See here a Doctor rare,
> Who Travels much at home,
> Here take my Bills, take my Bills
> I cure all ills past, present and to come.

Graham went to Paris in 1778, where Mesmer was causing a sensation with his use of 'animal magnetism' in the cure of diseases, and where he may have met Benjamin Franklin in person. He took advantage of the public interest in the possibilities accorded to electricity and magnetism and in the autumn of that year opened his 'Temple of Health' in the Royal Terrace, Adelphi, London. A large golden star was attached to the front of this building and the words 'Templum Aesculapis Sacrum' placed over the entrance.

Aesculapius was probably a priest-physician from early Greek civilisation to whom remarkable medical cures were attributed, and who was later deified. His life and activities became part of Greek mythology, as did that of his daughter Hygeia. The symbol associated with Aesculapius is the caduceus,

two snakes entwined around a staff. This was the caduceus carried by Mercury and was a protective symbol initially disguised to shield him from the evil eye of Juno. That carried by Aesculapius was a single serpent on a staff. The former was adopted as the badge of the medical profession by Sir William Butts, physician to Henry VIII.[34] It remains today as a medical emblem. Greek temples, in addition to being places of worship, became sanatoria named Aesclepieia where worshippers could seek cures for their ailments with restoration to good health. Graham thus planned his 'Temple' in accordance with this classical tradition.

He placed his patients on a magnetic throne or in a bath into which electrical currents could be passed. He also recommended milk baths, dry friction and such aerial and aetherial remedies as were partaken of by Mrs Macaulay. He became a fashionable quack and received many glowing testimonials from aristocratic patients, which he published for all to see. He claimed that his personal attention was necessary for effective results and charged highly for such attention.

The 'Temple of Health' contained rooms in which highly decorated electrical machines, jars, conductors, insulated glass pillars, an 'electrical throne' and chemical apparatus vied in opulence with sculptures, paintings, and stained glass windows. Music and perfumes pervaded the atmosphere. In contrast, the entrance hall was decorated with crutches and similar aids discarded or left as votive offerings by clients who, having visited the temple, no longer needed them. One apartment, the 'Great Apollo Apartment', was described as being sacred to that god. (The Greek god Apollo was supposedly the father of Aesculapius.) In this apartment, Graham gave lectures, sold his nostrums and provided a show to promote custom. He advertised publicly for 'goddesses' of youth and health, whom he then posed as examples of the physical perfection to be attained by following his practices. All this was in keeping with the fashionable classical style similar to that of Bath, with its aura of elegance and affluence and its health-giving potential. It was also in keeping with the pretentiousness of Graham's position.

His main claim to fame was in the cure of sterility for those who slept on his 'Celestial Bed', said to have cost £10,000. Graham described this as

> twelve feet long by nine feet wide, supported by forty pillars of brilliant glass of the most exquisite workmanship in richly variegated colours. The super-celestial dome of the bed, which contains the odoriferous, balmy and ethereal spices, odours and essences, which is the grand reservoir of those reviving invigorating influences which are exhaled by the breath of music and by the exhilarating force of electrical fire, is covered on the other side with brilliant panes of looking glass.
>
> On the utmost summit of the dome are placed two exquisite figures of Cupid and Psyche, with a figure of Hymen behind, with his torch flaming with electrical fire in

one hand and with the other supporting a celestial crown sparkling over a pair of living turtle doves on a little bed of roses.

The chief principle of my Celestial Bed is produced by artificial lodestones. About 15 cwt. of compound magnets are continually pouring forth in an everflowing circle . . .[35]

The bed was constructed with a double frame which moved on an axis and could be converted into an inclined plane. Mattresses filled with sweet-smelling new wheat or oat straw mingled with rose leaves, lavender and spices were covered with coloured silk sheets. The whole was designed to 'infallibly produce a genial and happy issue' for those whom pregnancy had eluded. Sometimes the mattresses would be filled with 'the strongest, most springy hair, produced at vast expense from the tails of English stallions'. This inclusion implied an 'influence by association' between acknowledged virility and fertility of the stallions and the occupiers of the bed. The value of the bed with regard to conception does not seem to have been recorded, but its fame was not in doubt, and for a time the Temple flourished.

In 1781, Graham moved his establishment to Schomberg House, Pall Mall, where it was named the 'Temple of Health and Hymen'. ('Hymen' or 'Hymenaeus' was originally the name of the song sung at marriages among the Greeks, but the name became personified as that of a Greek god, and Hymen became another of Apollo's sons. He was thereafter invoked in marriage songs.) The establishment opened in a blaze of publicity and was as sumptuous as its predecessor and as blatantly exploited sex and the magic of electricity and magnetism.

However by 1783 the Temple was losing money, and soon afterwards it closed. The machines and the bed were sold to pay outstanding debts. Graham left London and returned to Edinburgh. He lectured there and in various other towns, including Manchester, whose inhabitants received the benefit of such medicinal compounds as his 'Antiscorbutic Essence', 'Aethereal Amber', 'Pearl Essence' and his

Aethereal Ambrosial Quintessence of Gold! Honey! and Rosa-Solis! or Sundew, – for nourishing and rejuvenating the body, clearing and illuminating the mind, for preventing and remedying the decays and evils of old age, and most happily lengthening out human life to the longest possible period of mortal existence![36]

Some of his ideas were sound. He advocated frequent washing for personal cleanliness – not widely practised in the eighteenth century – fresh air and exercise, and he recognised that an excess of alcohol consumption had an adverse effect on physical and sexual performance. Some of his ideas were forward-looking: he recommended that parents should receive a small premium on the birth of each child and advocated the control of certain

hereditary conditions by practical eugenics. Other ideas were not so sound: he deplored the practice of sleeping in double beds which, he claimed, was akin to 'matrimonial whoredom' with 'man and wife continually pigging together in one and the same bed', and he advised against masturbation claiming that this enfeebled the body, mind and memory.[37]

In 1789, he published *A New, Plain and Rational Treatise on The True Nature and Uses of Bath Waters*, in which he criticised some of the methods used 'in regard to bathing in, pumping with, and drinking these wonderful and powerful Waters' and the regimens associated with these practices, but his behaviour became increasingly bizarre. He had introduced and recommended a system of earth-bathing before leaving London, and in his *Treatise* he proclaimed beneficial effects of 'earth', 'extending her sweet lap to receive and to treasure up the rich influence of the Heavens . . . to those who chastely solicit her favours, – who assiduously cultivate her friendship and her smiles . . .'. In 1790 he described his personal experience of its beneficial effects during an episode in which he had been naked in the earth for eight successive days, six hours each time, and for twelve hours on the ninth day.[38] Another episode in the following year described how he and a young lady at Newcastle were supposed to have 'stripped into their first suits' and were each 'interred up to the chin, their heads beautifully dressed and powdered, appearing not unlike two fine grown cauliflowers.'

Religious enthusiasm followed and a period of lunacy during which he was confined to his own house in Edinburgh as a lunatic. Opium may have contributed to this. In spite of his 'Aethereal Ambrosial Quintessence' and his secret of living until at least 150 years of age, he died suddenly on 23 June 1794, aged 49 years.

Like the quacks, playwrights and artists were not slow to exploit such natural phenomena as electricity and magnetism and the opportunity for them to do so was provided by the portrayal of characters such as Graham. A short play was produced by George Colman the Elder and presented at the Haymarket Theatre on 2 September 1780 entitled *Genius of Nonsense*, in which the actor John Bannister appeared as the Emperor of Quacks, mimicking Graham.[39] It was described as 'An original, whimsical, Operatical, Pantomimical, Farcical, Electrical, Naval, Military, Temporary, Local Extravaganza', parodying Graham's own hand-bill. Views of the Temple of Health were specially designed and executed for the set.[40] The play was never printed but was well reported. Dr Graham heard of the projected satire and threatened to sue for libel, but Colman was determined to expose the quack and insisted that Bannister imitate him as closely as possible. His performance 'brought down the house'.[41] Graham was denied the evidence with which to pursue his suit as he was unable to get a hand-bill or programme of the performance.

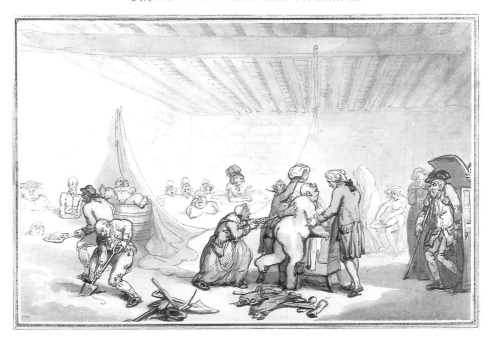

73. THOMAS ROWLANDSON: *Dr Graham's Cold Earth and Warm Mud Bathing Establishment*

Rowlandson satirically illustrated *Dr Graham's Cold Earth and Warm Mud Bathing Establishment* c.1785–90 [73]. Dr Graham himself is in attendance, consoling an obese gentleman who has been deprived of his clothes, crutches and his wig in order to undergo the benefits of having his back scrubbed with a long-handled brush and then being immersed (or interred) in the earthy trench being prepared for him by a man on the left of the picture. A gouty individual emerging from a sedan chair hobbles towards a similar fate. Gout was one of the many ailments which Graham professed to cure by this method of treatment. Other clients are shown in various degrees of immersion and discomfort with only a sheet hanging untidily from hooks on the wall separating male from female participants. This drawing is set out broadly along classical lines, but the falling curtain represents the 'collapse' of the style's pretentious allusions to modesty and virtue. In addition to the artistic hypocrisy, as Rowlandson saw it, he exposes the hypocrisy and 'naked' values of Graham's establishment by literally exposing the participants in the practices offered there, and untidily displaying them in his own unconventional artistic style.

A different view of Graham's earth-bathing establishment at Panton Street, Haymarket, London, was provided for readers of the *Rambler's Magazine*.

Here the doctor is supervising the immersion of young ladies, while more can be seen through the window, arriving at the establishment.[42]

The jargon or mystifying language often used by quacks and the hyperbole associated with their 'puffing' are pointedly alluded to in the caption displayed underneath a half-length oval woodcut portrait of Graham from the same magazine. Sense can be made of the words only with difficulty:

Tot
Hele, Ar n Edsci, Ent
If Ici; Ngen
I Ou Scelest, Ia Lrhe
Tori ca, Lwhi
MSic A, lsa, tir Ica; Landm Ov
in G. D.
O Ct; o Rt Hi
Sh Ea, Di smo
Sts Ubm: I ssi Vel Yded, ica Te
Db, Yana' dm Ire Ro Fhi:
St. A Lents. Al Ov Erofh Iswa
Rmd Oct Ri Ne; S.
and his most
obedient humble Servant,
THE RAMBLER
Feb. 1783[43]

The letters of each word in the above caption are in the correct order, in English, but the gaps between the words, and the cases of some of the letters are incorrect as is the punctuation, making the whole appear to be written in an unknown language, a reference to the pseudo-scientific jargon or what appeared to be blatant nonsense spoken by Graham and other quacks. Transcribed the caption reads: 'To the learned, scientific, ingenious, celestial, rhetorical, whimsical, satirical and moving Doctor, this head is most submissively dedicated by an admirer of his talents, a lover of his warm doctrines, and his most obedient humble Servant . . .'.

III. 'WONDERS! WONDERS! WONDERS! AND WONDERS!'

Gustavus Katterfelto, a contemporary of Graham's with whom he appeared in a print entitled *The Quacks* [74] in 1783, was another notorious practitioner who exploited scientific interest. He was a native of Prussia, a conjuror and quack who provoked notoriety with his advertisements in newspapers headed 'Wonders! Wonders! Wonders! And Wonders!' He modestly described himself as 'the greatest philosopher in this Kingdom since

Isaac Newton',[44] and gave lectures and demonstrations on 'philosophy, mathematics optics, magnetism, electricity, chemistry, pneumatics, hydraulics, poetry, styangraphy, palenchics, and caprimantic arts' – the last three mentioned being topics of his own fertile imagination invented to impress people with his knowledge. He gave daily lectures at 22 Piccadilly, London, from 8 a.m. to 6 p.m. His 'solar microscope', which formed part of his demonstrations, was advertised in the *Morning Post* of 22 July 1782 in which it was stated that:

> The insects on the hedges will be seen larger than ever, and those insects which caused the late influenza will be seen as large as a bird, and in a drop of water the size of a pin head, there will be seen above 50,000 insects; the same in beer, milk, vinegar, blood, flour, cheese, etc. and there will be seen many surprising insects in different vegetables, and above 200 other dead objects.[45]

In case these 'wonders' failed to attract sufficient interest on their own, other attractions were offered to the discerning client: 'N.B. After his evening lecture, he will discover all the various arts on dice, cards, billiards, and E.O. tables.'

Katterfelto himself recovered from an illness – which may have been influenza – with the aid of 'Dr Bato's medicine', and afterwards prepared and sold this nostrum at 5s. a bottle in true quack fashion. Black cats later became part of his performances and were associated with his conjuring tricks and electrical demonstrations, but they were said to be associates of the devil – a belief with which he too became associated. In 1784, he professed to have discovered the secret of perpetual motion and claimed that this had incurred the interest of the royal family. For a time he prospered, but interest in him waned with the waning of the influenza epidemic. He then travelled round the country with his family, his curiosities and his tricks. One of the most popular of these took place at Whitby, in Yorkshire, in which it is said that his daughter was raised to the ceiling supposedly by means of a great magnet, after she had donned a massive steel helmet secured with leather straps underneath her armpits. Little more seems to have been heard of him, and he died in 1799.

The satirical print *Quintessence of Quackery* (BM 6327) includes a song dedicated to those 'Princes of Puffs, who exist at the Wholesale Puff à de Puff Warehouses, the sign of the Devil and Black Cat, Piccadilly, the Temple of Health, Pall Mall . . .'. Verse viii contains the words:

> Thus Puffing become now the Trade,
> Of Katerfelto and Graham, well known,
> Whose Mouths confessedly are made,
> For nought but Puffing alone.

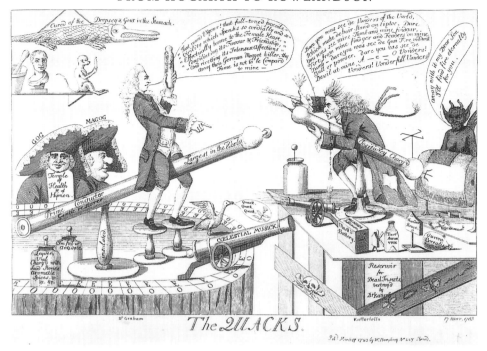

74. ARTIST UNKNOWN: *The Quacks*

The engraving of *The Quacks* (BM 6325) shows Graham and Katterfelto as rivals in their accomplishments. Graham is shown standing on an E/O gaming table, an allusion to one such table which had been in use at his Pall Mall establishment until it was broken by Westminster Justices on 1 August 1782.[46] The letters E/O represented Even/Odd numbers and this new game with letters had been introduced after all games 'with numbers thereon' had been declared illegal following the Gaming Act of 1739. This too became illegal in 1745.[47] Graham is standing astride a large phallus on which are inscribed the words 'Prime Conductor Gentle restorer' and 'Largest in the World'. His feet rest upon glass insulators to protect him from the electrical current passing through him to earth. In his left hand he is holding up a 'medicated tube' – also with sexual connotations – and he is pointing to the 'Conductor' and saying, 'That round Vigour! that full-toned juvenile Virility which speaks so cordially and so Effectually home to the Female Heart, Conciliating its Favour and Friendship, and rivetting its Intensest Affections Away Thou German Maggot killer, thy Fame is not to be compar'd with mine.' Other references to Graham's electrical demonstrations and his exploitation of the subject at his 'Temple of Health' include two Leyden jars, one labelled 'Leyden Vial charg'd with Load Stones, Aromatic Spices etc. etc. etc.', and the other, 'Tin Foil or Antidote'.

The Leiden jar or phial was invented in 1745 to accumulate and store electrical charges. It consisted of a glass jar coated inside and out with tin foil. A flexible metal chain attached to a knob was made to connect with the inner coating of the jar. It was an early form of condenser, used as a primitive battery in order to demonstrate the effects of electricity. Loadstones (lodestones) were pieces of magnetic iron ore (magnetite) later known as magnets, which, when freely suspended, came to rest with their long axis North/South. This property was recognised as important for navigation. (The name loadstone is derived from the Anglo-Saxon word meaning 'way' or 'course'.) Leyden jars and loadstones were not usually connected as they are in this print, but the demonstrable capabilities of magnetism could be as dramatic as those of electricity (as Katterfelto showed in Whitby), and Graham made use of both.

The figures of Gog and Magog represent two large porters who were part of Graham's establishment, as shown by Gog's label 'Temple of Health and Hymen'. Harry Angelo, a court fencing master to George IV, described how:

> At the door [of the Temple of Health] stood two gigantic porters, with each a long Staff, with ornamental silver head, like those borne by parish beadles, and wearing superb liveries, with large, gold-laced cocked hats, each was near seven feet high, and retained to keep the entrance clear . . .[48]

'Gog' and 'Magog' were two legendary giants of unknown ancestry. It was said that the Emperor Diocletian had thirty-three daughters who all murdered their husbands. As a punishment, they were cast adrift in a ship in which they eventually reached Britain, and there they became the mothers of a race of giants whose fathers were demons. Brut, the first King of the Britons, slew all but Corineus and Gogmagog, who were brought to his palace on the site of the Guildhall in London. It is said that 'Corineus' was too difficult a name to remember, so Gogmagog shared his name with his partner. Gogmagog was armed with bows and arrows and a globe of spikes to represent ancient inhabitants of the land, and clothed in half druidical and half ancient British dress, whilst Corineus had a spear and shield to accompany his conventional Roman attire. Their effigies remained in the Guildhall until destroyed by the great fire in 1666. New wooden figures were carved from fir-wood by Richard Saunders – a carver of ships' figureheads – in 1708, each 14 ft 6 in. high. They stood threateningly in the Great Hall guarding the entrance to the Council Chamber, until they too were destroyed by fire as a result of a German bomb in 1945. Citizens of London would have recognised these figures from two wickerwork and pasteboard replicas of them which accompanied the Lord Mayor's Processions at his Annual Show. New figures have again replaced the old. Gog and Magog's presence in connection with Graham's establishment signifies the pretentious grandeur of his Temple with which they were thus

associated by comparing it with the Guildhall. They also represent a threat to any unwelcome intrusion into its affairs.

Plate III of Hogarth's *Marriage-à-la-Mode* [35] illustrates some of the attributes associated with quackery, namely, suggestions of learning, verbosity, use of drugs and of ancient remedies. In *The Quacks* some of these features are again presented. An alligator is suspended from the ceiling, with the words, 'Cured of the Dropsey & Gout of the Stomach'; a bust of one of the Ancients, possibly Galen, offers a hint of learning; and a pestle and mortar give the impression that medicines are compounded by the owner. An image of a monkey mirrors that of Graham, an association with folly (see p. 71). In case there remains any doubt regarding the entitlement of Graham to the name, a duck is near his feet proclaiming the words 'Quack, Quack, Quack'. A thistle next to these words shows the Scottish origin of the 'Quack'.

A miniature cannon is inscribed with the words 'Coelestial Musick', such as was blasted forth at the 'Temple'. This is aimed at Katterfelto, the other Quack illustrated in the print. The two Quacks are aiming sparks at each other, Graham's charges being greater than those of Katterfelto and occupying more of the print. The latter Quack's foundation or platform is less secure than Graham's, indicating perhaps his complete lack of any medical credentials, and the skull and cross-bones suggest the more deadly aspects of his trade. Katterfelto is crouching over a cylindrical conductor inscribed 'Positively Charg'd'. His feet are less securely placed than Graham's, on the insulated base of the cylinder. A trident projecting from the rear of the conductor is directed at a barrel-shaped receptacle – an electro-static generator – attended by the Devil, with whom Katterfelto was said to be associated. The devil says, 'Away with it my Dear Son. I'll find fire eternally for you.' The devil was seen as a reminder of the evil which lurked everywhere, not least in the presence of these quacks. Katterfelto shouts to Graham, saying, 'Dare you was see de Vonders of the Varld, which make de hair stand on tiptoe, Dare you see mine Tumb and mine findgar, Fire from mine findgar and Feaders on mine Tumb – dare you was see de Gun fire viddout Ball or powder, dare you was see de Devil at mine A—e— O Vonders! Vonders! Vonderful Vonders!'

To illustrate these 'Vonders', Katterfelto's hair is standing on end and sparks issue from his finger and thumb in Graham's direction. His whole body seems charged, as is a smaller version of a cannon similar to that of Graham's and pointing in the direction of the latter. Surrounding him on his platform can be seen a Leyden jar, a small rectangular box labelled 'Arcanum Sublimum', 'Mask'd Battery', a bottle containing an elixir of life under the pseudonym 'Tinctr Aurum vivae', a balloon labelled 'Aurora Borealis' in recognition of his astronomical interests, a small windmill – symbolic of 'imagery in the air', or of wantonness – a dead scorpion and a signboard with

the name 'Thunder House' printed on it. This, in association with an electricity conductor which can be seen at the end of Katterfelto's cylinder, might imply an interest in the natural phenomena of thunder and lightning. Benjamin Franklin had performed experiments to test his theory that lightning was an electric phenomenon in 1752. The first of these involved a long pointed wire which was extended upwards from a steeple, to see if electrical charges could be observed at the lower end of the wire when a thunder cloud passed overhead. Kite experiments followed, and lightning rods as suggested by Franklin became fashionable.

A row of insects is displayed on one of the struts of the platform, and underneath the platform is a receptacle or 'Reservoir for Dead Insects destroy'd by Dr Katterfelto', an allusion to his microscope demonstrations of dead insects.

Artistically, the print is of poor design and construction, but its content with regard to the two quacks is of some interest and complexity. A quite elaborate knowledge of the quacks and their practices is required in order to obtain the full benefit of the scenario.

Similar demands are also made by a political print which exploits the subject of quacks, politicians and the fashion for ballooning in its imagery. The fashion for ascending in balloons captured the imagination at this time. It had been introduced from France where Blanchard, a distinguished and enterprising French aeronaut, made his first ascent on 21 November 1783. Excitement about the flights grew. In December 1783, when the craze for ballooning was at its height, Horace Walpole wrote: 'balloons occupy senators, philosophers, ladies, everybody.'[49] Poems, epigrams, satires, pamphlets and even prophecies were written about ballooning and about the possibilities of searching the heavens by this means. The following year, some concern arose in France with regard to the possible dangers associated with the practice and, in 1784, express permission from the king was an essential precursor to flight. In spite of acknowledgement that the machines were liable to accidents, the fashion continued and even increased. A farce entitled *Aerostation; or The Templar's Stratagem* was enacted at Covent Garden in October 1784. The following January, Blanchard crossed the Channel from Dover to France, but a disaster in July of that year, in which a balloon caught fire resulting in the death of two French aeronauts, heralded a decline in the fashion.

Contemporary newspapers and journals were continual sources of iconography. In the same way that publicity with regard to Mary Toft spawned prints, so the publicity accorded to the practice of ballooning spawned associated prints. *The Aerostatick Stage Balloon* (BM 6284), published in 1783 [75], is one example. In this print, the Pope and the Devil are passengers on a flight in a balloon which is laden with a cargo of notorious people who

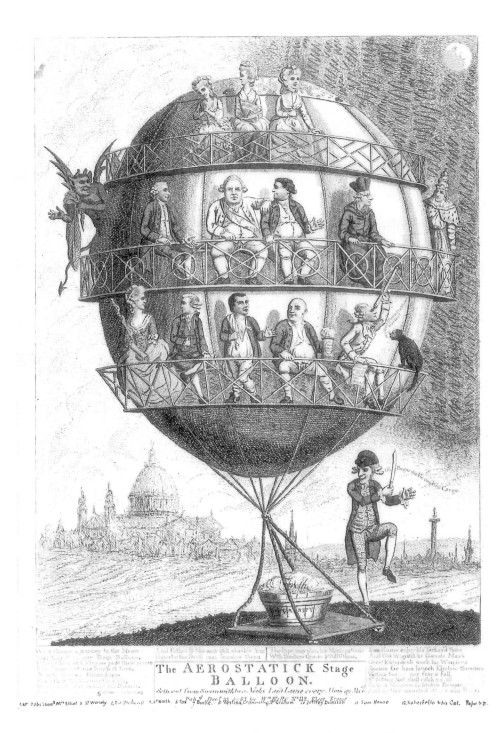

75. HANIBAL SCRATCH: *The Aerostatick Stage Balloon*

are arranged in three stages or balconies around it. In the top stage are three ladies who were known for their amours: Grace Elliot, Perdita Robinson and Lady Worsley. On the centre stage between the Devil, who is holding a net, and the Pope, are politicians North and Fox, each holding a thread, the other ends of which are attached to the nose of the Duke of Portland. On their right is politician Burke dressed as a Jesuit. On the lowest stage are Graham and Katterfelto and other notorious people including 'Vestina', the goddess of Health who advertised the virtues of Dr Graham's celestial bed.[50] One advertisement describes her activities thus:

> Vestina, the Rosy Goddess of Health! presides at the evening lecture, in the Temple of Health, Adelphi, assisting at the display of the celestial meteors, and of that sacred vital fire over which she watches, and whose application in the cure of diseases she daily has the honour of directing.[51]

In the print she sits next to the doctor, and at the other side of this stage is Katterfelto. He is gazing up at the moon through his telescope, watched by his black cat which is sitting on the rail saying, 'Are there Mice in the Moon Master'. In his left hand, Katterfelto is holding a paper inscribed with the words, 'Wonders, Wonders, Most Wonderful Wonders'. Between them are two other contemporary characters, Jeffrey Dunstan, Mayor of Garrat, and publican Sam House, an eccentric publican who supported Fox; during the Westminster election, House kept open house at his own expense. He was easily recognised by his attire and by his completely bald head on which he never wore a wig or a hat. He featured in many cartoons of the time. The significance of all these people would have been recognised by many of the print's 'readers'. Notoriety, flamboyancy and pretentiousness seem to have been amongst the factors common to them, enabling them to rise above London by means of a large tub of 'Froth and Vanity'.

Beneath the print is a verse which describes how each individual might carry out his schemes on arrival at the Moon:

> Who choose a journey to the Moon
> May take it in our Stage Balloon,
> Where love-sick Virgins past their prime
> May Marry yet and laugh at time.
> Perdita – W—sley Fillies free
> Each flash their lunar Vis-a-Vis
> There N—th may realize his Dreams.
> And F—x pursue his golden schemes
> And Father B—ke may still absolve 'em
> Howe're the Devil may involve them,
> The Pope may plan his Machinations
> With Panders Quacks and Politicians.

Sam House enjoy his tankard there
And Old Wigs still be Garrat's May'r.
Great Katerdevil work his Wonders
Spruce Gr—ham launch Electric thunders.
Vestina too – nor fear a fall
Satans net shall catch ye all.

These are the words of the Frenchman who cuts the guy ropes and watches as 'up they mounted W—e and R—e'. In this print, the artist combines amusement and topicality with social, moral and political points – all good selling features.

IV. ANIMAL MAGNETISM

Magnetism continued to provide imagery for print-makers. A print by Collings entitled *Magnetic Dispensary* [76], published in 1790, satirically illustrates another method of therapy by this means, which owes a great deal to a pseudo-scientific adventurer named Mesmer. Franz Anton Mesmer (1734–1815) had qualified in medicine in Vienna in 1765, and had produced a thesis in which he maintained that the planets influenced the human body in sickness and in health by what was thought to be a mysterious fluid. He later called this healing influence, 'animal magnetism'. He thought that 'Magnetic Therapy' emanated from the laying of hands on the sick person and that this increased planetarian influences. Following controversy over his methods of treatment in Vienna, he emigrated to Paris where he soon became a popular practitioner, and named Marie Antoinette as one of his many famous clients. For his treatments, Mesmer used *baquets* (oak tubs) containing dilute sulphuric acid and magnetised iron filings, and pierced with moveable iron rods. His patients stood or sat round these, holding hands and applying the rods to affected areas of the body, and he touched each patient with a 'wand'. He later realised that actual magnets were not essential to his treatments, and he developed his techniques of hypnotism or 'Mesmerism'. His theories of electro-magnetism sounded scientific and plausible to laymen. He even began to 'mesmerise' patients by remote control and 'magnetised' water-basins, shrubs and parts of gardens and forests, so that patients exposed to these would be cured of their various complaints. Miraculous cures of imaginary illnesses followed, probably in response to his magnetic personality.

In spite of unfavourable reports from commissioners appointed to investigate Mesmer's claims, he attracted numerous pupils and followers, and when driven out of France he continued to practise in Switzerland. He returned to Paris six years after his exile, and was granted a pension from the French Government.

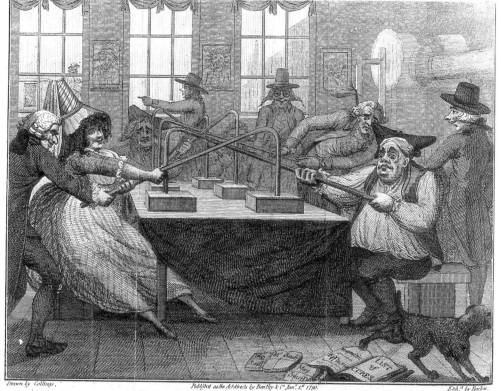

Drawn by Collings. Publish'd as the Act directs by Bentley & C° Jan'. 1ˢᵗ 1790. Etch'd by Barlow.

MAGNETIC DISPENSARY.

76. COLLINGS: *Magnetic Dispensary*

Illustrations of Mesmer's *baquets* exist, and satirical versions of the English method of group therapy also appeared. The *Magnetic Dispensary* (BM 7748) was produced as an illustration to verses on Animal Magnetism. In this print, clients are demonstrating the influences produced from either the magnetic effect of clinging on to metal bars or from the presence of the pretty girl in their midst. On the wall of the room are three pictures. One is of Loutherbourg, an artist who gave up painting temporarily in the 1780s when he became involved with certain aspects of quackery. He believed that he possessed the power of healing by the 'laying-on-of-hands' in a manner similar to that practised in the seventeenth century by an Irishman named Greatrakes. Loutherbourg and his wife, who lived in Hammersmith Terrace, London, both claimed to have this miraculous gift of healing, which they publicised. A pamphlet was produced on their behalf in 1789 entitled *A List of Cures performed by Mr and Mrs Loutherburg of Hammersmith Terrace, without Medicine. By a Lover of the Lamb of God*. They were accordingly

besieged with supplicants wanting the 'free' cures offered. However these supplicants found that they were required to pay for tickets in order to secure a place in the crowd with others seeking similar aid, a state of affairs which caused a good deal of acrimony. Loutherbourg added his own nostrums to their practice, which led Horace Walpole to write: 'Loutherburg, the painter, is turned an inspired physician. His sovereign panacea is barley-water; I believe it is as efficacious as Mesmerism . . .'.[52] The popularity of the couple ceased with the death of one of their clients. An angry mob stormed their house, and the pair fled.

The second picture on the wall is of Yeldell, who has been provided with donkey's ears. One of Mesmer's disciples was named d'Eslon and his name had been associated with the word 'Esel' – meaning 'donkey' in French – earning him donkey's appendages in French prints. Yeldell may have earned his ears by being a similar follower of Mesmer.

The third picture on the wall, in which the name of the figure is unclear, is probably that of de Mainaudiac (or de Manneduke), a qualified doctor who also advertised magnetic cures or 'animal magnetism' and was the rage in London about 1786. Angelo described 'Dr De Manneduke' as amongst those who 'obtained a living by pretensions to science'. He held 'conversazions' in his drawing-rooms on Sunday evenings for several seasons where,

> might be seen young ladies and old ladies, fainting, weeping, laughing, and sighing, by sympathy, whilst the doctor, twiddling his fingers right in front of their visages, made them expose themselves by his senseless fascination . . . the lords of creation exposed themselves to the same absurdities and tom-fooleries . . . until worked up to a 'crisis', they grinned, or sobbed, or stared, or languished as though they were possessed – and so indeed they were – with that capricious demon Fashion, who makes fools of too many of the great, without respect to age or sex.[53]

Such a supercharged emotional atmosphere seemed to spell sexual danger leading to 'touching' or 'touching up' while 'under the influence'.[54]

As far as mesmerism itself was concerned, it was even felt by some that the security of the nation could be under threat if people could be influenced and controlled by pre-arranged magnetisation of the environment. Could Mesmerism be equated with a dangerous revolution of compulsive power? Rowlandson's print, *The Two Kings of Terror* or *Death and Napoleon* (BM 12093), depicting Napoleon staring compulsively at Death in a battle for supremacy, illustrates this point as does another Rowlandson print, previously mentioned in Chapter 6, in which Dr Willis reduces his patients to submission by his fierce staring expression [64].

On the floor in the print *Magnetic Dispensary* is an open book with the words 'Magnetic Effluvia' on one page and 'List of Cures' on the next. A dog

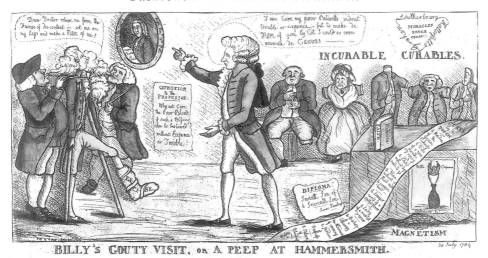

77. Attributed to Dent: *Billy's Gouty Visit, or a Peep at Hammersmith*

displays contempt by urinating on the 'List of Cures'. Packets labelled 'Mag[ic] Snuff' can also be seen on the floor.

The verses accompanying this print contain the lines:

> . . . Pretending pains about my head,
> The Irish priest of nonsense said –
> Whate'er my pains, I might be sure
> The magnets, if apply'd, would cure;
> As proof – for but a guinea, I
> Six times their influence might try;
> Those not succeeding, six times more –
> Another guinea, and encore!
> Then talk'd of wonder-working snuff,
> Gum lotions, scurvy-grass and stuff,
> And slanged profanely about grace,
> With hypocritic length of face:– Said I,
> – What need of those or these,
> If magnets be to give me ease?[55]

Loutherbourg was allied with Graham and Katterfelto in a political print published on 20 July 1784 (BM 7545) and entitled *Billy's Gouty Visit, or a Peep at Hammersmith* [77]. This shows Prime Minister William Pitt visiting the 'healer', whose 'Diploma' indicates that he is the seventh son of a seventh son, to be cured of the unpopularity occasioned by his attempt to transfer the tobacco tax from Customs to Excise. Two gentlemen accompanying Pitt to

the healer are puffing tobacco smoke into his face to cloud his vision. In the print, Pitt's 'unpopularity' has been metamorphosed into gout which is indicated by his heavily bandaged foot and lower leg in stereotypical fashion. The bandages are marked 'Excise'. Loutherbourg points to Pitt's portrait on the wall, saying: 'I can cure my poor Patients vidout trouble or expence – but to make de Man of you by Cot I could as soon animate de Canvas.'

'Cures by a touch' – alluding to his 'laying-on-of-hands' – are described on a long scroll of paper lying on and overflowing from a table, and hopeful clients with incurable conditions such as a missing head or absent members await similar results. They are seated underneath a triangle made up of the three names of Loutherbourg, Graham and Katterfelto. Inside the triangle are the words, 'Miracles never cease!!!'

V. TRACTORISATION

The vogue for electric and magnetic stimulation continued with the advent of Elisha Perkins' 'Metallic Tractors'. Perkins was born in 1741 in Connecticut into a medical family, and he in turn received some medical training at Yale University. He practised locally as a country doctor until about 1796, when he invented his 'Tractors', which he made from some mysterious alloys in a small forge in his house. The alleged presence of gold in the tractors helped to justify their high price: ten guineas a pair to the general public, five guineas to members of the medical profession and free to clergymen. The 'Tractors' were metal rods about four inches in length, flat on one face and rounded on the other, with one end sharp and the other blunt. Two of the rods were held together and their points were drawn downwards and outwards over the affected area of the body in order to attract or draw out disease. Amazing cures were claimed with their aid.[56] In addition to the diseases they were said to attract, they also attracted a great deal of attention and provided a lucrative living for their inventor. Perkins found that he could

> remove chronic rheumatism, some gouty affections, pleurisies, inflammations in the eyes, erysipelas, and tetters; violent spasmodic convulsions, as epileptic fits; the locked jaw; the pain and swelling attending contusions; inflammatory tumours; the violent pain occasioned by recent sprain; the painful effects of a burn or scald; pains in the head, teeth, ears, breast, side, back and limbs; and indeed most painful kinds of topical affections.[57]

Tractoration for about twenty minutes a day was recommended, except for those of a delicate constitution for whom caution was advised, with limited use of the tractors at intervals of two to three days. Perkins' colleagues were not impressed and in 1797 expelled him from the Connecticut Medical

Society, but many influential people recommended their use and George Washington purchased a set for the use of his own family.[58]

Although interest in the tractors faded in America, their fame spread to Europe followed by Perkins' son, Benjamin. He was welcomed in London, where he set up practice. He also practised in Bath and in 1797 published a pamphlet on the subject.[59] A surgeon at Bath, Charles Cunningham Langworthy, published his 'Review' of Perkinean Electricity, and collaborated with Perkins in treating patients and selling tractors. Langworthy said that success of the operation was much better and occurred more rapidly in winter than in summer but

> In either Season, perspiration on the hand of the operator, or any oily substance on the seat of pain, completely prevents all beneficial effects; and the instruments succeed better in the hands of some operators, than in those of others, in proportion as such operators are more or less impregnated with electricity.[60]

Any failure was thus satisfactorily explained!

Popularity of the 'Tractors' increased, and in 1803 a Perkinian Institution was established in London for the treatment of poor people who could not otherwise experience the benefits of 'Tractoration'. Provincial branches of the Institute were also set up. However, criticism and scepticism soon followed. Imitation 'Tractors' were found to be equally effective, including some of wood painted to resemble the original tractors, made by Dr John Haygarth of Bath. Associated pseudo-scientific jargon enhanced the prospect of 'cure'. It was gradually realised that there was no electrical or magnetic influence involved and by 1810 the fashion had died, and Perkins had returned to America with his fortune.

Gillray illustrated a patient receiving treatment by means of these *Metallic Tractors* [78]. In his print, published in 1801, a 'Tractor' is being applied to the reddened and bulbous nose of a client. Fire leaps from the offending protruberance as his disease is withdrawn. As further indication of the 'electro-magnetic' influence taking place, the tail of the operator's wig is also 'charged', and elevated to a horizontal position. On the table amidst the ingredients of a recently made punch drink – excessive use of which was popularly thought to cause the red, or 'port-light' nose – is a newspaper entitled 'The True Briton'. Three columns of print follow from which can be read the words

> just arrived from America the Rod of Aesculapius. Perkinism in all its Glory – being a certain Cure for all Disorders; Red Noses, Gouty Toes, Windy Bowels, Broken Legs, Hump Backs. Just discover'd, the Grand Secret of the Philosopher's Stone with the true way of turning all Metals into Gold. pro bono publico.

METALLIC-TRACTORS.

78. JAMES GILLRAY: *Metallic Tractors*

Perkins is said to have commissioned this print.[61] Two weeks after the print was published, Gillray received a note bearing the following message:

> Mr Perkins presents his compliments to Mr Gillray with many thanks, and the enclosed acknowledgement for the print, which he has seen with great satisfaction . . . and he also asks as a particular favour, that no person may ever know any communication has taken place between Mr G. and Mr P. on this subject, and that no Discovery of that nature may be made through the presentation of this check – Will Mr Perkins be gratified in his wishes to see this print exhibited in other print shops also? He likewise begs to ask what would be charged him for a dozen impressions?

It would seem that such satirical representations cannot necessarily be viewed as 'victimisation' of the practitioner. In some circumstances they represented welcome publicity for him. It is not known whether Isaac Cruikshank was similarly engaged to include a small case inscribed 'Tractors' into his version of *Taking Physic* (BM 9804), published in the same year. (Gillray's *Taking Physic* [50] had appeared in 1800).

Another print entitled *The Tractors* (BM 9926), published in 1802 and attributed to Williams, advocates the use of metallic tractors as a new cure for scandal. In this print, an old maid, Mrs Thickness, is suffering 'tractorisation'

to her tongue in an effort to extract all the venomous gossip to which she was addicted. The lady in question has her head held in a vice and her legs tied to a chair as the operator, 'S. W. Fores', applies the tractors. 'Malignity', 'Detraction', 'Scandal', 'Envy', 'Hypocrisy', 'Innuendos' and 'Half Hints' are extracted, the latter setting fire to a globe of the world portrayed on a screen behind her. Behind this screen three young ladies watch the operation in amazement, and advocate its practice on other tongues 'in our Town'. The caption beneath suggests that this treatment may be more effective in preventing murders than 'all the Poenal Statutes'. Fores published this print as one of a 'Folio of Caracatures lent out for the Evening', a useful means by which to attract publicity and subsequent revenue.

'Fashion' was thus a useful area for the quacks to exploit. If cure for some disease did not follow, usually little harm was done. As Adair said,

> Fashion, like its companion Luxury, may be considered as one of those excrescences which are attached to national improvement; and which so far resemble the moss of fruit-trees, and the mistletoe of the oak, as not to be entirely useless though they may be occasionally injurious.[62]

CHAPTER 8

From the Womb . . .

I. TOUCHING ON MIDWIFERY

ALTHOUGH Hogarth poked fun at the man-midwife in his print *Cunicularii* and drew attention to attitudes towards pre-natal influences and the occurrence of 'monsters', he did not pursue these topics further in his works. He did, however, attend one of William Hunter's early anatomy dissections and lectures on the gravid uterus. Hunter remarked:

> You cannot conceive anything lying snugger than the foetus in utero. This puts me in mind of Hogarth. He came to me when I had a gravid uterus to open and was amazingly pleased. Good God, cries he, how snug and compleat the Child lies. I defy all our painters in St Martin's Lane to put a Child in such a situation. He had a good eye, took it off and in drawing afterwards very well expressed it.[1]

Unfortunately, Hogarth's drawing has not survived.

Like other branches of medical practice, midwifery did not escape Rowlandson's pen or the artist's pencil or brush, and he throws more light on the subject.

The role of midwife throughout the centuries has traditionally been filled by women. During the eighteenth century the women's role remained paramount, but their training for the position often left much to be desired. Laurence Sterne described how some midwives were drawn from the ranks of 'good wives' in his novel *The Life and Opinions of Tristram Shandy*:

> In the same village where my father and mother dwelt, dwelt also a thin, upright, motherly, notable, good old body of a midwife, who, with the help of a little plain good sense, and some years' full employment in her business, in which she had all along trusted little to her own efforts, and a great deal to those of nature, – had acquired, in her way, no small degree of reputation in the world . . . She had been left, it seems, a widow in great distress, with three or four children, in her forty-seventh year; and as she was at that time a person of decent carriage, – grave deportment, – a woman moreover of few words, and withal an object of compassion . . . the wife of the parson was touched with pity . . . there was no such

thing as a midwife, of any kind or degree to be got at, let the case be never so urgent, within less than six or seven long miles riding . . .²

As a kindness to the parish and to the widow the wife of the parson arranged 'to get her a little instructed in some of the plain principle of the business, in order to set her up in it.' The parson paid the fees of 18s. 4d. for the Ordinary's licence and the 'good woman was fully invested in the real and corporal possession of her office, together with all its rights, members, and appurtenances whatsoever.'

Artists often portrayed nurses as elderly, such as those administering to Rowlandson's Dr Syntax when, on one of his tours round the countryside, he was badly bruised and ordered by the doctor to be 'cupped' [96], and the nurse who took the countess's child to bid farewell to its mother in the final plate of Hogarth's *Marriage-à-la-Mode* [39]; drunken, such as the nurse portrayed by Rowlandson in *Death in the Nursery* [45]; and lazy, such as the nurse in attendance at Bath whilst the doctors 'consulted' [66] and the one sleeping by the fire in Hogarth's *The Christening*. These portray an untrained, uneducated servile woman as the archetypal figure of a nurse in the eighteenth century. The midwife's image, according to Rowlandson, did not differ markedly from that of her sister, as he illustrated in his drawing of Dickens's Sairey Gamp, *A Midwife Going to a Labour* [79].

Little training was generally expected or given. A book entitled *The English*

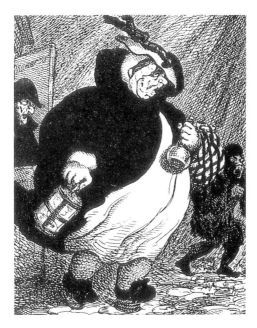

79. THOMAS ROWLANDSON: *A Midwife Going to a Labour*

Midwife published in 1682 contained some practical but limited advice. Its title-page stated that 'the whole fitted for the meanest capacities'. Some country midwives were illiterate and unable to take advantage of even such limited information as was offered. Conditions for mothers and the training of midwives did improve during the eighteenth century, however, particularly in London.

Only when problems arose was intervention by medical men contemplated. Opposition to the role of 'man' as midwife came from both the traditional midwives, who felt that their position was threatened, and from physicians, who thought that surgeons so practising would gain access to 'their' patients and that their own 'supervisory' role over the surgeons would be usurped. Moral questions were raised with regard to the motives of the men who wished to practise midwifery. Many women objected to the presence of men during their labour, as did their husbands, and lack of modesty was attributed to those women who submitted to their ministrations.

William Smellie (1697–1763) played a large part in changing this situation and in introducing a more scientific approach to the study of obstetrics. He had spent eighteen years as a country doctor in his home town of Lanark, and a short time in Paris before settling in London in 1739. There he started training courses for midwives in his own home and took his pupils on home visits amongst the poor. Altogether he trained over 900 pupils – 'exclusive of female students' – and 1,150 poor women were delivered in the presence of pupils, plus 'those difficult cases to which we were often called by midwives, for the relief of the indigent'.[3] As a result of the experience he gained, he wrote his *Treatise on the Theory and Practice of Midwifery* in 1752 (edited by Tobias Smollett). This began with a survey of midwifery from ancient times. He condemned more recent works by those who copied the theories and practice of old writers such as Hippocrates, Galen and Aetius, commenting that old ideas were still held by midwives 'Of the lower sort, whose heads are weak enough to admit such ridiculous notions'.

His *Treatise* described the management of natural labour and delivery of the child and also the management of 'laborious labours'. He noted that:

> A general outcry has been raised against gentlemen of the profession, as if they delighted in using instruments and violent methods in the course of their practice; and this clamour hath proceeded from the ignorance of such as do not know that instruments are sometimes absolutely necessary, or from the interested views of some low, obscure illiterate practioners, both male and female, who think they find their account in decrying the practice of their neighbours. (p. 241)

With regard to the midwife, Smellie recommended that she should be decent, sensible, of middle-age, able to bear fatigue, know the bones of the pelvis, how to 'touch' women,[4] and to have easy recourse to a male

practitioner who should 'make allowance for the weakness of her sex' and not condemn her actions, as to do so might inhibit her from seeking his attendance in future. 'Touching' or vaginal examination of women by men-midwives was deliberately misconstrued by moralists such as Philip Thicknesse in his *Man Midwifery Analysed* (1764) as a process of 'feeling'. Man-midwifery was indicted as being 'little better than a cover for adultery' and the man-midwife as a sexual predator.[5]

The instruments that Smellie used principally and recommended were the 'small forceps, blunt hook, scissors, and curve crotchets'. Forceps had been invented by Peter Chamberlen (the elder, 1560–1631), but kept a secret by his family for 125 years.[6] The secret gradually became known after the death of the last male member of this medical family in 1728. In his book, Smellie referred to the 'secret' as 'Chamberlain's "nostrum" until 1733'.

As Smellie indicated, the use of instruments was fiercely criticised and this criticism had not abated by the end of the century. One critic was the publisher S. W. Fores, who was the author of a *Man-Midwifery Dissected*, under the pseudonym of John Blunt. The full title of this book gives an indication of the antagonism with which the man-midwife had to contend:

> *Man-Midwifery Dissected or, the Obstetric Family Instructor (Price 3s.6d.) for the use of Married Couples, and Single Adults of Both Sexes, containing, A Display of the Management of every Class of Labours by Man and Boy-Midwives; also their Cunning, indecent, and cruel Practices. Instructions to Husbands how to Counter-act them. A Plan for the Complete Instruction of Women who possess promising Talents in order to supersede Male-Practice. Various Arguments and Quotations, proving, that Man-Midwifery is a personal, a domestic and a national Evil.*

In this publication he proposed an educational plan for midwives 'calculated to render male midwives unnecessary'. However: 'the gentleman employed to deliver these lectures shall not be a man-midwife by profession lest his own interest should cause him to withold necessary instructions from female pupils.'

Fores suggested a 'Frontispiece' for the book, which was etched by Isaac Cruikshank and printed in 1793, entitled *A Man-Mid-Wife* [80]. This print is divided into two halves and compares the practice of the homely midwife on the **right** side with the man-midwife on the **left**. This orientation was no accident. The only aid or equipment that the former has is her hand, which holds a pap vessel or feeding cup. The pan warming on the fire contains the necessary sustenance for the mother and infant, the latter being represented by the plaque to the left underneath the fireplace depicting a baby in womb-like frame surrounded by warmth, food and care. In contrast, the left half of the print depicts the male version of the midwife with all his accoutrements – horrific instruments such as were described by Smellie – and medicaments,

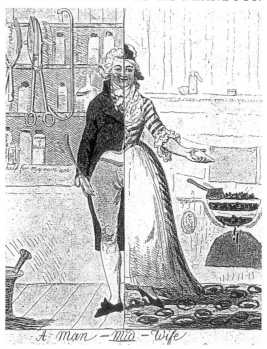

80. ISAAC CRUIKSHANK: *A Man-mid-wife*

plus love potions and philters on a shelf for the practitioner's 'own use', thereby casting aspersions upon his intentions. The print visually transmits some of the reasons for the antagonism felt by many people towards the man-midwife. Underneath the print are the words:

> A man-mid-wife, or a newly discovered animal, not known in Buffon's time; for a more full description of this *Monster*, see, an ingenious book lately published price 3/6 entitled, Man-Midwifery dessected, containing a variety of well authenticated cases elucidating this animals Propensities to cruelty & indecency sold by the publisher of this Print who has presented the Author with the Above for a Frontispiece to his Book.

The reference to 'Buffon' is to George Louis Leclerc, Comte de Buffon (1707–88), a French gentleman who studied law, but devoted his life to the study of scientific subjects. He was elected a Member of the French Academy of Science in 1739 and appointed Keeper of the Jardin du Roi and of the Royal Museum. This led to a particular interest in natural history and to the publication of his work *Histoire Naturelle, génèrale et particulière*. The first edition was in forty-four quarto volumes with detailed plates of mammals, birds, reptiles, fish and minerals and was published over a period of fifty years

from 1749 to 1804. Its appearance caused a sensation and provided an impetus for the study of nature. An English translation with 300 plates contains notes and observations by William Smellie. Volume II contains Buffon's studies and experiments on 'Generation' in different species.[7] The man-midwife was an 'unrecognised species'.

A few male practitioners did establish themselves in the field of obstetrics. One of these was William Hunter (the physician and anatomist) who had followed Smellie from Scotland and stayed in his house in London in 1741. Glasgow University conferred a Doctorate of Medicine on him in 1750, an action which elevated him to the status of physician, but he continued his surgical practice for a further six years before disenfranchising himself from the College of Surgeons. He then became a Licentiate of the Royal College of Physicians.[8] Hunter was a more elegant and refined gentleman than Smellie and gained entrée into many aristocratic homes in the course of his work, whereas Smellie had worked amongst the poor. Hunter's book *The Anatomy of the Gravid Uterus* (1774) took him twenty-five years to complete. Unlike Smellie's *Treatise*, it was an anatomical and embryological book rather than a practical guide to obstetrics, and owes most of its success to the artist Jan Van Rymsdyk who received little recognition for his valuable contribution of beautifully executed plates of the foetus *in utero*.[9]

Hunter added a great deal to the knowledge of obstetrics and to the standing of men in that practice. His own character was not without blemish, however; he is known to have assisted in clandestine deliveries with subsequent concealment of illegitimate babies.[10] The reputations of some medical men did not enhance their collective image as men of honour. Even the medically respected Dr Richard Mead became notorious as an old lecher.[11]

The presence of a competent assistant at a birth could pose a problem. Whilst contemplating a confinement outside London, Mr and Mrs Shandy disagreed about the attendant whom they wished to be present at the birth of their child 'as the famous Dr Manningham was not to be had',[12]

> my mother . . . began to cast her eye upon the midwife . . . notwithstanding there was a scientific operator within so near a call as eight miles of us, and who, moreover, had expressly wrote a five shillings book upon the subject of midwifery, in which he had exposed, not only the blunders of the sisterhood itself, – but had likewise superadded many curious improvements for the quicker extraction of the foetus in cross births, and some other cases of danger which belay us in getting into the world . . . my father was for having the man-midwife by all means, – my mother by no means.

Dr Slop was the 'scientific operator' mentioned, who eventually applied the forceps to Tristram at his delivery to the detriment of the latter's nose, or, one

may deduce, at the risk of his future manhood. Dr Slop, who wished to be called an *accoucheur* – a French name used as a more fashionable and acceptable alternative to 'man-midwife' – has been said to be based upon Dr John Burton of York, a leading and able physician and man-midwife who had acquired the name of ' Dr Slop' early in his career, before Sterne wrote his novel. He had written *An Essay towards a complete New System of Midwifery Theoretical and Practical* which was published in 1751. This contained '18 Copper Plates' by George Stubbs, representing the artist's first venture into print-making. Some of the prints illustrate Stubbs' own dissections of a foetus *in utero*.[13] Dr Burton had also invented in 1751 a particular type of forceps which had slender blades controlled by a screw handle. The assumption that this author and inventor was the 'scientific operator' seems well-founded. The doctor was otherwise generally persecuted because of his Roman Catholic religious persuasion and his Tory political leanings.[14]

Smellie is also mentioned in the novel under the pseudonym of 'Andrianus Smelvgot'. However the satirists saw him, Smellie provided the impetus necessary to establish better facilities for mothers and their babies, and a number of lying-in hospitals and charities were founded. Better training was offered to midwives and gradually a reduction in the mortality of mothers and babies was achieved.[15]

A drawing attributed to Rowlandson entitled *The Village Doctor* (BM 5274) is of a male country practitioner and was published in 1774. This portrays a man who apparently plays the parts of apothecary, probe-surgeon, and man-midwife, according to his sign-board. The prefix 'probe' no doubt refers to the contentious part played by men in the field of midwifery.

Rowlandson, as Hogarth had done, took advantage of topical situations to form the basis of some of his popular prints. *A Medical Inspection, or Miracles will Never Cease* [81] was one such print (BM 12333). In 1814, a woman named Joanna Southcott who claimed to be a Prophetess declared that she was pregnant. Two factors made this remarkable: Joanna was aged 64 years, and she declared that she had been impregnated by God. Joanna was born in Devonshire about 1750 and had spent a great deal of her life as a domestic servant. She had followed the Methodist Faith and, being persuaded that she possessed supernatural gifts, she wrote and dictated prophecies in rhyme and declared herself to be the woman spoken of in the Apocalypse (ch. xii), affirming that, when beyond the age of sixty, she would be delivered of Shiloh on 19 October 1814. The imminent 'virgin' birth was said by her followers to be a sign of the millennium. Many doctors examined her and a number of these confirmed her pregnancy, and she confidently awaited the birth of the 'Messiah'. The print depicts contemporary characters who were associated with the events. These include Parson Towser or Tozer, who was her preacher and devoted supporter (one of supposedly 100,000 followers),

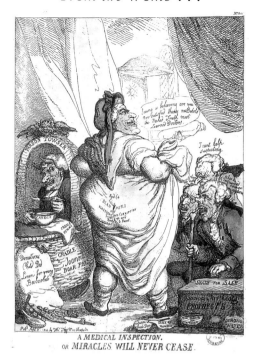

A MEDICAL INSPECTION.
OR *MIRACLES WILL NEVER CEASE*.

81. THOMAS ROWLANDSON: *A Medical Inspection, or Miracles will Never Cease*

shown in a cradle spouting horns from his head, a sign of cuckolding and possibly an accusation of devilry. Joanna is displaying herself to three doctors. A coral, pomatum, clyster-pipe, feeding cup and lewd captions also appear. Stories in the popular press gave conflicting reports about events, and caricaturists made the most of the situation until Shiloh failed to appear and it was said that Joanna was in a trance. She died of dropsy on the 29th of the same month. The *Gentleman's Magazine* of 27 December 1814, noted the death of Joanna Southcott in the following words:

> the notorious Joanna Southcott, who, in conjunction with many others, had long practised on the ignorance and credulity of a large body of the lower classes. We have purposely abstained from detailing the gross and impious absurdities which have originated from this woman and her followers; and lament that very many persons of respectable condition in life, from whom better things might have been hoped, have suffered themselves to be deluded by her most irrational and abominable pretensions . . . (p. 678)

In spite of such denunciations, followers were still said to be in existence in 1860.

As had occurred almost a century previously in connection with Mary Toft, the ignorance of some doctors and the gullibility of many members of the public were highlighted, and the situation was exploited by artists. Popular ideas with regard to procreation do not appear to have changed markedly in the intervening years.

Accoucheurs could be involved in politics at the whim of an artist. Williams gives this role to both Pitt and Bonaparte in his print *The Rival Accoucheurs, or who shall deliver Europe*, published in 1801 (BM 9544). Pitt, with obstetric forceps labelled 'Income Tax' protruding from his pocket, states that his prescription of mint seed (guineas) is the best remedy for the world for such a delivery. Bonaparte, pointing to his pile of cannon-balls, declares that these are quicker and more certain. This print reflects the antipathy felt by many to subsidies going to foreign powers via taxes, and disappointment that 'the deliverance of Europe had miscarried'.

II. WHAT BECAME OF THE CHILDREN?

Hogarth's zeal with regard to social and moral problems continued throughout his life, many aspects of it appearing in his works. This zeal embraced many areas of contemporary concern, and child care was one of them. Children had usually been regarded merely as small versions of adults, but during the eighteenth century more attention was paid to their individual needs. The Foundling Hospital was established in 1739, for example, though not without some controversy. Hogarth, who supported the charity, highlights some aspects of child care in his works. His knowledge of events in this area was no doubt gained through his connection with the Foundling Hospital.

Swaddling of babies

Concern regarding some child care practices grew during the 1740s as the incidence of child mortality soared.[16] The use of restrictive clothing was one of the causes for concern as it became recognised that this impaired health. This applied to babies, especially those of aristocratic and upper class families, who were trussed up in tight swaddling clothes, as well as to older children who were encased in stays or corsets and regarded as small versions of adults. Hogarth provides examples of such 'parcelled' babies in *The Christening*, c.1729, *The Enraged Musician*, 1741 [82], *The Strolling Actresses Dressing in a Barn*, 1738 [84], and in his illustration of the baptism of 'Tristram Shandy' in Sterne's novel. (Hogarth supplied illustrations for the second edition of this work.) Free play was impossible.

The *Gentleman's Magazine* published letters and articles on these topics such as the observations made by Revd Dr Hales in 1743:

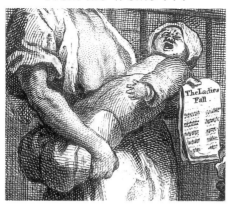

82. A tightly swaddled baby: detail from William Hogarth:
The Enraged Musician

Young tender Infants, who are often swathed up in such a Manner, as must needs greatly incommode their Breathing, and consequently be often very hurtful to them; for when their tender Bodies are close confined in Swathings, neither their Breast nor Belly can rise so freely as they ought to do, when the Child draws in its Breath.[17]

Dr Hales was a versatile clergyman who was interested in natural sciences and philosophy and had some training in mathematics and physics. He did important work on the dynamics of blood circulation and on respiration, and campaigned for improvements in ventilation on ships and in prisons, designing a ventilator on the windmill principle which was fitted on to the roof of Newgate prison. Improvement in ventilation led ultimately to a decrease in the incidence of gaol fever. With regard to infants, Dr Hales also observed:

There is another very bad Practice in relation to Infants, the ill Consequences of which few Nurses seem to be aware of . . . Ignorant Nurses taking the soft Part of the Skull, for a great Defect in Nature, are apt, too often, to attempt to close the Mold of the Head as they call it: That is, to compress together, by Stroking and Bandage, those Parts together; not knowing that the intermediate Soft Parts will turn to Bone . . . thus compressing their Brains, and thereby causing convulsive Fits . . .

Dr Hales's comments in the *Gentleman's Magazine* illustrate his practical concern in physiological matters.

It had not been generally thought that children needed special consideration with regard to health matters until late in the seventeenth century.[18]

From that time and throughout the eighteenth century, several progressive books on children's diseases were published. One of these was sent to one of the Governors of the Foundling Hospital and was published anonymously by its Committee in 1748. The third edition of this book bore the name of the author, Dr William Cadogan – a respected physician – and the title *An Essay upon Nursing, and the Management of Children from their Birth to Three Years of Age.* Cadogan decried the mode of dress to which the 'Heirs and Hope of a rich Family' might be subjected:

> besides the Mischief arising from the Weight and Heat of these Swaddling–Cloaths, they are put on so tight, that the Child is so cramp'd by them, that its Bowels have not Room, nor the Limbs any Liberty, to act and exert themselves in the free easy manner they ought. This is a very hurtful Circumstance, for Limbs that are not used, will never be strong, and such tender Bodies cannot bear much Pressure. The Circulation restrained by the Compression of any one Part, must produce unnatural Swellings in some other . . . To which doubtless are owing the many distortions and Deformities we meet with every where; chiefly among Women, who suffer more in this Particular than Men.

Cadogan was appointed one of the Physicians to the Foundling Hospital in 1754.

In Volume II of *Pamela*, Richardson refers to Locke's *Treatise on Education* in which John Locke, a philosopher with some medical training, 'forbids too warm and too strait clothing'. John Locke first published *Some Thoughts concerning Education* in 1693. This was written as 'the private conversation of two friends' concerning education suited to 'our English Gentry'. This he considered to be the Duty and Concern of Parents, the welfare and prosperity of the Nation depending upon it. He proclaimed that education started in the cradle and advocated plain and simple diets, fresh air and exercise, and an end to 'strait-lacing', 'hard bodices' and 'cloths that pinch'. The book went into many editions, one of which 'Pamela' was supposed to have studied. She adds her own comments:

> How often has my heart ached, when I have seen poor babies rolled and swathed, ten or a dozen times round; then blanket upon blanket, mantle upon that; its little neck pinned down to one posture; its head more than it frequently needs, triple-crowned like a young pope, with covering upon covering . . . pinned down; and how the poor little thing lies on nurse's lap, a miserable little pinioned captive, goggling and staring with its eyes, the only organ it has at liberty, as if supplicating for freedom to its fettered limbs.[19]

Hogarth's portrayals of parcelled babies do not seem to imply criticism of the practice but more an awareness of it as part of a general way of life. His involvement as a Governor in the activities of the Foundling Hospital seemed

to provoke in him a more critical attitude towards aspects of child care, his concern culminating in his exposure of different forms of child abuse in his print *Gin Lane* (see Chapter 4).

Youthful fashions

Not only babies were confined in restrictive clothing. Many of the portraits of children at this time show young girls dressed in the kind of 'hard bodices' mentioned by John Locke. Hogarth's study of the Graham children is an example.

The wearing of stays was another fashion which received increasing criticism from some quarters. Later in his essay, Cadogan commented, 'I could wish it was not the Custom to wear stays at all; not because I see no Beauty in the "Sugar-loaf" Shape, but that I am apprehensive, it is often procur'd at the Expense of the Health and Strength of the Body.' Hogarth provides an illustration of a fashionable young mother being fitted for stays in *The Staymaker* (c.1745). Hogarth is using them to illustrate the literal and metaphorical restriction of a young wife and mother. The woman modestly hides her face from the staymaker behind a mask and is thereby rendered anonymous or 'faceless' and so represents any young mother. Hogarth seems to suggest that the 'stays' are to 'confine' the wearer within bounds of convention – as a wife and mother at home – in contrast to the discarded stays in evidence in the foreground of Plate III of *The Rake's Progress* [53], and at the bagnio in Plate V of *Marriage-à-la-Mode* [38]. Their abandonment in these scenes is analogous with both the sexual and physical freedom or licence being permitted under the circumstances. If young daughters were to be well brought up, they too would have to be confined. Their education in this sphere started early.

Traditional stereotyping of women is in evidence here. Women were largely condemned by artists as whores, or praised as madonnas – a role which consigned them to a passive life-style in a male-assigned environment as objects of male survey. A woman could be regarded as a possession, a temptress or a madonna,

> they can be constructed as 'men's-imagined-women', signifying men's desire to control women's sexuality in the family, and enjoy it outside it, and displace the quality they fear in themselves (such as passivity, openness and emotionality) onto the body of a woman, where these qualities can be controlled.[20]

Encasing a woman in stays proclaims the need for her to be controlled and moulded. Her comfort and health might be sacrificed to fashion, to contemporary ideas of beauty and to male dominance.

Fashion and the consequent 'moulding' of the female shape was described

by Mr Inkle through the pen of Christopher Anstey in *An Election Ball* written in 1775. When writing to his wife from Bath, he exclaimed,

> Lack a day! how her throat doth our MARGERY raise,
> How shove up her bosom, and shove down her stay?
> For to make a young lady a true polite figure
> You must cramp up her sides that her breast may look bigger;
> And her's tho' a chicken as yet, my dear Dinah,
> Stand forth full as plump, and as jolly as thine are;
> And why should ye leave any charm for conjecture.
> Like the figure you see in your grandmother's picture.
> With her neck in a ruff, and her waist in a girdle,
> And her throat like a ram's that is caught in a hurdle,
> Her head like the Baptist's when plac'd on a charger –
> I'm sure, my dear wife, you have long'd to enlarge her,
> You never as yet did those beauties conceal,
> Which Nature intended your sex to reveal[21]

Such moulding and control could also be used by artists in the political arena as Gillray showed. His print *Britannia in French Stays, or re-Form at the Expence of Constitution* [83] is an example of such use. Drawn in 1793, it shows Thomas Paine, in his original trade of staymaker, trying to lace Britannia into the uncomfortable fashion of revolution.

Infant feeding

The feeding of infants was another of Cadogan's concerns, and in his *Essay* he stressed the vital importance of breast-feeding, both for mother and baby,

> When a Child sucks its own Mother, which with a very few Exceptions, would be best for every Child, and every Mother, Nature has provided it with such wholesome and suitable Nourishment; supposing her a temperate Woman, that makes some Use of her Limbs; it can hardly do amiss . . .
> . . . Most Mothers, of any Condition, either cannot, or will not undertake the troublesome Task of sucking their own Children; which is troublesome only for want of proper Method; Were it rightly managed, there would be much Pleasure in it, to every Woman that can prevail upon herself to give up a little of the Beauty of her Breast to feed her Offspring.

He chauvinistically proclaimed the benefit which would accrue to the husband also: 'There would be no fear of offending the Husband's Ears with the Noise of the Squalling Brat', and more optimistically, suggested that 'The Child, was it nurs'd in this Way, would be always quiet, in good Humour, ever playing, laughing or sleeping.' He deplored the custom of sending infants to be suckled or dry-nursed by another woman: 'No other Woman's Milk

can be so good for her Child; and dry-nursing I look upon to be the most unnatural and dangerous Method of all; and according to my Observations, not one in three survive it.'

Gillray cynically comments upon a revival of breast-feeding in the upper classes in the 1770s, promoted by the example of the Duchess of Devonshire. In *The Fashionable Mamma, – or The Convenience of Modern Dress*, published in 1796 (BM 139206), a stylishly dressed woman is shown dispassionately feeding her baby through conveniently placed slits in her dress. A picture on the wall showing a plump matronly figure breast-feeding a baby offers a homely comparison with the dutiful woman who, fearful of disarranging her dress, refrains from touching the infant who is held in position by a nursemaid. A coach outside awaits the lady's pleasure.

The Foundling Hospital

Hogarth was one of the Governors of the Foundling Hospital to whom Cadogan had referred his 'Observations'. Hogarth reflects the benefit of breast-feeding in the serene and contented countenance of the mother breast-feeding her baby whilst sitting in a cart surrounded by the malpractices and

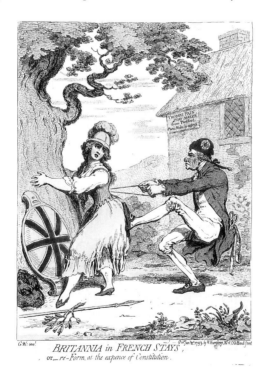

83. JAMES GILLRAY: *Britannia in French Stays, or re-Form at the Expence of Constitution*

disorder of the 'mob' in *The March to Finchley* [43]. This painting was offered as the prize in a lottery following its engraving. Prints were sold for 7s.6d, and for an extra 2s.6d, the chance to win the original painting was an additional incentive to buy. By the closing date for such Subscription Prints 167 remained, which Hogarth presented to the Foundling Hospital. One of these won the draw and the picture was then displayed at the Hospital.

The Foundling Hospital was a Charitable Institution set up by Captain Thomas Coram, a naval captain, who, having seen the appalling neglect and abuse of many unwanted children in London, spent many years in an attempt to set up a refuge for them. This he succeeded in doing in 1739. Hogarth supported him in his venture, both financially and practically, as he and his wife fostered two children in their own home for some years. Hogarth attended Courts and General Meetings at the Hospital as an active member, a 'Governor and Guardian'. The Institution was incorporated by Charter in 1739 and the Governors were authorised to ask for alms on behalf of the charity and to receive subscriptions. Hogarth prepared a 'head-piece' to a Power of Attorney drawn up for this purpose. This 'head-piece' indicated the aims of the charity and the circumstances that it expected to allay. It shows Captain Coram with the charter under his arm and with a beadle in front of him carrying an infant whose mother has dropped a dagger with which she might have killed the child. The baby will be cared for at the Hospital. A new-born baby is seen abandoned close to a stream, and another parcelled infant is being left by its mother near the roadside to await rescue by some passer-by. The training that the Hospital hoped to provide for the growing orphans was illustrated by the emblems held by both boys and girls in their separate groups, a plummet, trowel and card for combing wool amongst the boys, and spinning wheel, sampler and broom amongst the girls. A member of another group dressed as sailors, holds up a mathematical instrument used in navigation. Hogarth's 'head-piece' thus indicates the fate of some infants whose mothers could not look after them, and the help that the Hospital hoped to give to them and to their children.

In 1722, Daniel Defoe described the fate of some babies through the words of Moll Flanders as she contemplated the future of her own infant:

> it touched my heart so forcibly to think of parting entirely with the child, and for aught I knew, of having it murdered, or starved by neglect and ill-usage (which was much the same), that I could not think of it without horror. I wish all those women who consent to the disposing their children out of the way, as it is called, for decency's sake, would consider that 'tis only a contrived method for murder; that is to say, a-killing their children with safety.[22]

This continued to be the fate of many unwanted children. Building of the Hospital commenced in 1740, but in March 1741, temporary accommo-

dation in houses in Hatton Garden near to the Charity School was opened to receive infants. Hogarth painted a shield to put over the door showing a young naked infant extending its arm in a gesture of appeal for help. This has not been preserved, but the image appears as a coat-of-arms in an engraving by N. Parr after a drawing by Samuel Wale, *Admission of Children to the Hospital by Ballot* (1749). The West Wing of the Foundling Hospital was finished and inhabited by such children in 1745. Wale's drawing purports to be 'An Exact Representation of the Form and Manner in which Exposed and Deserted Young Children are Admitted into the Foundling Hospital'. Regular admissions to the Hospital were limited to ten boys and ten girls. This limitation was dictated by the availability of suitable foster mothers who were retained by the Foundation in counties surrounding London – though sometimes further afield – and to whom infants were sent soon after baptism. Frequently, however, the gates were opened to 100 hopeful mothers. To cope with these, a ballot system was devised. In the print, mothers, officials and ladies are in attendance and black or white balls are being drawn from a bag according to the number of places available. (In reality the balls were red and black.) The lucky mothers draw white (red) balls and their infants gain admission.[23]

Coram did not allow money to be spent on paintings for the Hospital, but Hogarth was instrumental in persuading artists to offer work and he saw it as a place for the public exhibition of paintings by British artists. The Foundling Hospital with its works of art did become a fashionable visiting place in London, attracting funds for the work of the charity and a venue for the display of the artists' work. Amongst the paintings still displayed at the Coram Foundation are roundels of other old and respected London institutions. A roundel of the Foundling Hospital which is displayed alongside the others sets it in an ancient tradition, politically elevating it to a higher status in order to lend it respectability. The edifice itself was designed on classical lines to give a respectable public face to the project, and portraits of distinguished patrons gave the Hospital the acceptable aura of a charitable body. Graphic art was not the only artistic work displayed at the Hospital. George Frederic Handel gave many musical recitals there, including the *Messiah*, and the proceeds from these went to the Charity. On Handel's death in 1759 the Hospital inherited 'a fair copy of the score and all parts of my oratorio called The Messiah'. He also donated the chapel organ.

The public image of the Hospital was imposing, but it was an austere place for the orphans. Children were taught reading and crafts but not writing: this gap in their knowledge would prevent them from taking over the roles of legitimate children. The bed-rock of the civic humanist – that is, birth and place in society – was felt to be threatened by education. Dispensation of the latter had therefore to be controlled.

The financial difficulties of the Hospital, the great demand for places and the plight of a large number of children – many adding to the numbers of deaths recorded in the Bills of Mortality – led the Governors to appeal to Parliament for help. This was given on condition that all children brought to the Hospital would be taken in. From June 1756 to March 1760 this was done, and the Treasury paid for their upkeep. This practice gave rise to many abuses of the system, and a deterioration in standards of care. It was decided in Parliament that this state of affairs could not continue, and the Hospital gradually reverted to being a private charity. Jonas Hanway, a philanthropist who became a Governor of the Hospital in 1758, felt that the Hospital could not and should not carry out the functions that were required of the parishes. He worked hard to make the parishes recognise their obligations. As a result, an Act of 1767 made compulsory the principles adopted by the Foundling Hospital and already implemented by some enlightened parishes. The fate of 'foundling' children improved and mortality figures fell.

The Foundling Hospital project from the outset had not been without its opponents, many of whom regarded its inception as a licence to promiscuity. Although a rural site had been proposed for the Hospital on the grounds that it would benefit the health of the orphans, in reality it was felt by many that it should be 'out of sight'. A contemporary satirical print (BM 2438) illustrating the former viewpoint shows an engraving in heraldic fashion, with supporters in the shape of a naked man and woman leaning on an oval shield containing a stag, encircled by a serpent with an apple in its mouth, a reference to the Fall of Man. The Foundling Hospital is in the background with a naked and blindfolded figure representing the goddess of Fortune on her wheel in front of it. A procession of men, all with horns – indicating cuckolding – are being led by a horned cleric. On the reverse side of the print, the chorus of a song proclaims:

> Then since things are so;
> As you very well know,
>> Resolve with your Wives to be quit;
> At your loss ne'er repine,
> But with Women and Wine,
>> A race of young Foundlings beget
>> My brave boys,
>> A race of young Foundlings beget.

Cadogan had advocated a simple life-style for the orphans and had recommended the way that they should be dressed, fed and kept clean: 'some imagine that clean Linnen and fresh Cloaths draw, and rob them of their nourishing Juices . . . I think they cannot be changed too often, and would

have them clean every Day; as it would free them from Stinks and Sourness . . .'. As regards feeding, he said:

> The general Practice is as soon as a Child is born, to cram a Dab of Butter and Sugar down its Throat, a little Oil, Panada, Caudle or some such unwholesome Mess, and the Child stands a fair Chance of being made sick from the first Hour. It is the Custom of some to give a little roast Pig to an Infant; which, it seems, is to cure it of all the Mother's Longings . . . There are many Faults in the Quality of their Food; it is not simple enough. Their Paps, Panadas, Gruels, etc. are generally enriched with Sugar, Spice, and sometimes a Drop of Wine; neither of which they ought ever to taste.

Pap consisted of bread boiled in milk and mashed, whilst a panada was made by boiling oatmeal in water. One of these items is being spoon-fed to the tightly bound infant in Hogarth's engraving *Strolling Actresses Dressing in a Barn* [84], an example of the dry-nursing deplored by Cadogan. The infant's food is in a small pan which is balanced upon a crown next to a chamber-pot, whilst a tract serves as a table-cloth. Britannia, it would seem, is likely to get similar fare in Gillray's print, *The Nursery – with Britannia reposing in Peace* (BM 9895). Here she is being rocked in a cradle by Addington. Hawkesbury brings forward a 'French chair' or 'commode' while Fox hangs up napkins by the fire to dry. 'Opiate pills' and 'Composing Draughts' are near at hand, and a pan of 'French Pap' lies on the floor nearby.

In Hogarth's print of the 'Strolling Actresses', an actress is dispensing a dose of gin for the relief of toothache to a colleague near to the feeding baby. A dose for the infant is not inconceivable if its crying threatens to disturb the ensuing performance.[24]

Cadogan had invited those who were unconvinced by the poor quality of care offered to children, to look at the Bills of Mortality, where, 'he may observe that almost Half the Number of those, who fill up that black List, die under five Years of Age.' One of the contributing factors to this state of affairs was probably connected with the consumption of gin (see ch. 4). Smallpox also took its toll of young lives, but measures were in hand to remedy this.

III. VACCINATION

> Now look around, and turn each trifling page,
> Survey the precious works that please the age . . .
> What varied wonders tempt us as they pass!
> The cow-pox, tractors, galvanism, and gas,
> In turns appear . . .[25]

Smallpox, an almost universal scourge of mankind and well-documented in southern Europe from classical times, was widely accepted as an act of God

against which there was no defence, at least in the Western world. Although some measures were taken by the State during the eighteenth century in an effort to prevent the introduction of infectious diseases into the country, such as the insistence upon strict quarantine controls, smallpox was always present to a varying degree, sometimes reaching epidemic proportions. The ensuing mortality rate was high, taking its toll of many young lives. Means were sought whereby a mild form of the disease could be acquired which would then protect the sufferer from a more virulent form. A method of direct inoculation of the infected matter from a patient suffering from such a mild attack was widely used in the East, usually via the nostrils or by scratching the skin, and two papers had been read to the Royal Society in 1713–16 describing the methods employed in Constantinople. The practice attracted little attention in Europe until Lady Mary Wortley Montagu (1689–1762), wife of the British Ambassador at Constantinople, studied its use there. She wrote to a friend describing the practice:

> The small-pox, so fatal and so general amongst us, is here entirely harmless by the invention of in-grafting, which is the term they give it . . . There is a set of old women who make it their business to perform the operation every autumn, in the month of September, when the great heat is abated. People send to one another to know if any of their family has a mind to have the smallpox; they make parties for this purpose, and when they are met (commonly fifteen or sixteen together), the old woman comes with a nutshell full of the matter of the best sort of smallpox, and asks what veins you please to have opened. She immediately rips open that you offer to her with a large needle (which gives you no more pain than a common scratch), and puts into the vein as much venom as can lie upon the head of her needle, and after binds up the little wound with a hollow bit of shell; and in this manner opens four or five veins . . . The children or young patients play together all the rest of the day, and are in perfect health to the eighth. Then the fever begins to seize them, and they keep to their beds two days, very seldom three . . .[26]

Lady Mary had her own son inoculated or variolated as the practice was later called. (Variola is the Latin name for smallpox.) On her return to England she informed George I of the method, urging its use in this country, although she foresaw opposition from the medical fraternity as she had indicated in her letter from Adrianople.

> I am patriot enough to take pains to bring this useful invention into fashion in England; and I should not fail to write to some of our doctors very particularly about it, if I knew any one of them that I thought had virtue enough to destroy such a considerable branch of their revenue for the good of mankind. But that distemper is too beneficial to them, not to expose to all their resentment the hardy wight that should undertake to put an end to it.

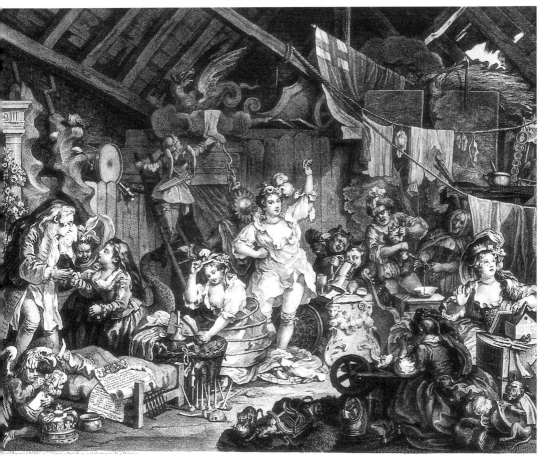

84. WILLIAM HOGARTH: *Strolling Actresses Dressing in a Barn*

Six condemned criminals in Newgate prison were offered their freedom if they consented to be inoculated. These tests proved successful. Members of the royal family were afterwards inoculated and royal approval given.[27] Dr Richard Mead (1673–1754) later supported the practice and published a paper to this effect in 1747. His support led to its widespread use. In 1766, the Revd John Penrose wrote to his daughter describing the practice provided by a doctor in Hertfordshire

who has an House fitted up for the Reception of Patients, and has inoculated thousands without ever one failing under his Hands. His Price is five Guineas. For which he finds them Meat, Drink, Washing, Lodging, and whatever he thinks they ought to have. He keeps them upon a very Spare Diet; brings a Person with the Small-Pox upon him into a Room where the Party to be inoculated is, to take the

Infection from; gives them Water to drink; will not suffer them if sick, to lie down, as long as they can possibly stand; absolutely prohibits their approaching any Fire; lets them go out in Cold, Rain, Wind, Snow, any Weather, by Night as well as by Day, nay absolutely forces them out, if they complain of sickness. It is a common thing for such as are not past the Small-Pox, to make a Party of three, four or more to go to this Doctor's for inoculation, as for Ladies to make a Party of Pleasure.[28]

The clergyman's informant had been a recipient of such treatment. A notice in the *Gentleman's Magazine* in December 1770 informed readers that 'His R. H. Prince Edward and Princess Augusta Sophia were inoculated for the smallpox . . .',[29] but the practice was not without risk of provoking a severe form of the disease with fatal consequences.

This was the position until Edward Jenner produced his method of 'vaccination'. Jenner was born in Berkeley, Gloucestershire in 1749. He was a country medical practitioner who had trained at St George's Hospital in London, where he had studied as a pupil of surgeon John Hunter and had shared his interest in the study of Natural History, but after three years in London, he returned to Gloucestershire. There, in the course of his work, he heard of the belief in many country districts that those who had had cowpox – a naturally occurring disease in the udders of cows – were protected against smallpox. After many years of observing this phenomenon he determined to put the theory to the test. On 14 May 1796, he introduced some of the lymph, or matter, taken from cowpox vesicles on the finger of a dairymaid, Sarah Nelmes, who had been infected with cowpox whilst milking Blossom, into the arm of a boy named James Phipps. On 1 July 1796, he inoculated the boy with smallpox matter in the usual way. The boy did not develop smallpox. After a while, Jenner inoculated others in similar fashion, but he was not content just to prevent the occurrence of smallpox in his own country district, he wanted the whole country to benefit from the practice. A stock of cowpox matter was therefore necessary. Jenner wanted to use inoculated matter from one inoculated person to another without it becoming too weak to be effective. He published his results in July 1798 in *An Inquiry into the Causes and Effects of the Variolae Vacciniae, a Disease discovered in some of the Western Counties of England, particularly Gloucestershire, and known by the name of 'The Cow-Pox'*. The medical name of 'Vaccinia' for cowpox, led to the description of its inoculation being known as 'vaccination'. The vaccinia virus (cowpox) is now known to be a variant of the variola virus (smallpox) and gives rise to immune antibodies to the latter, although the immunity is less permanent than that acquired from an attack of variola.

It has been argued that Jenner's work was not new and was merely a rediscovery of a technique used previously. For example, a Dorset farmer,

Benjamin Jesty had vaccinated his wife and two sons with cowpox material in 1774. Jenner, however, was the first person to investigate the subject fully, to show that 'cowpox' could be transmitted from person to person and to follow up his vaccination procedure with an attempt to inoculate smallpox material to demonstrate immunity.

The practice of vaccination was a magnificent achievement. Jenner was rewarded with £10,000 from the Government in 1802, with an additional sum of £20,000 in 1807. He practised in London for a short time following his acclaim, but soon returned to his native Gloucestershire. His achievements formed the basis for the study of immunity which has continued and developed since.

Jenner's work did not receive universal acclaim. Many inoculators opposed his vaccination procedures. As newly vaccinated patients were not adequately isolated from smallpox patients and medical hygiene was poor, many developed a severe reaction through vaccine contamination.[30] This lent support to opponents of the procedure. One of those in opposition was Dr Rowley of Oxford who, in 1805, published a pamphlet entitled *Cow-pox Inoculation no Security against Smallpox Infection*, in which he mentioned the fate of a boy who was said to have an ox-face after vaccination. Facing the first page of the Introduction to this work is a coloured copper-plate engraving of the *Cow-Poxed, Ox-faced Boy* who seems to have swollen glands affecting the shape of his face as a result of the infection. The emotive description given by Rowley and corroborated by another anti-vaccinator, Moseley, correlated well with the contemporary interest in physiognomy. The suggestion of a bovine expression caused some alarm. Rowley wrote: 'Dr Moseley, who sensibly first exposed the errors of vaccination, saw this case of the ox-faced boy by my desire. He observed to me, that the boy's face seemed to be in a state of transforming, and assuming the visage of a cow.' Moseley's anti-vaccination sentiments produced the following response from a supposed reader of one of his publications:

> Oh Moseley! thy book nightly phantasies rousing,
> Full oft makes me quake for my heart's dearest treasures;
> For fancy in dreams, oft presents them all browsing
> On commons, just like little Nebuchadnezzar.
> (There)! nibbling at thistle, stand Jem, Joe and Mary,
> On their foreheads, Oh horrible! crumpled horns bud;
> (There)! Tom with his tail, and poor William all hairy,
> Reclined in a corner, are chewing the cud.[31]

Byron classed 'cow-pox' with 'tractors' – a passing fancy. This seems hardly surprising when considered in the context of the time. How were the general public to assess the value of a measure involving the extraction of

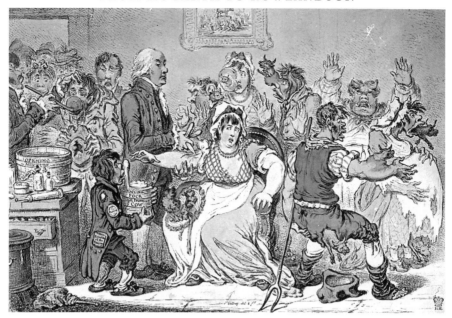

85. JAMES GILLRAY: *The Cow-Pock – or – The Wonderful Effects of the new Inoculation*

infected material from sores produced in an illness contracted from an animal (cowpox) and accept that this would prevent them from succumbing to another (and much more serious) illness, smallpox? 'Quacks' had made extravagant claims before.

Graphic artists drew attention to the controversy that was engendered by the practice. Gillray illustrated the hypothetical complications associated with vaccination in his own satirical style in a print *The Cow-Pock – or – The Wonderful Effects of the New Inoculation* which was published on 12 June 1802 [85]. After the title were the words 'Vide – the Publication of yᵉ Anti-Vaccine Society'. In this print, Jenner himself is portrayed holding a scarifier and vaccinating an anxious-looking woman. On his right is a small boy who is wearing a badge which identifies him as a Charity boy from the St Pancras District, London. The vaccination session is taking place in the Inoculation Hospital set up in that District. (Institutions for free vaccination had been set up in various locations in London amidst controversy which raged between rival societies.[32]) The boy is holding a tub labelled 'VACCINE POCK hot from yᵉ COW'. Protruding from his pocket is a book entitled 'Benefits of the Vaccine Process'. Behind him is a chest on which a larger tub labelled 'OPENING MIXTURE' can be seen, from which an assistant is ladling a dose of the mixture to a client who has not yet been vaccinated. Also on the chest are

medicine bottles, one labelled 'VOMIT', a box of pills and an enema syringe. In front of the chest is a close-stool and on the floor beside this is a clyster bag. These seem to imply the use of such measures as an accompaniment or preliminary to vaccination. Those already vaccinated are showing alarming signs of development and extrusion of cow-like tumours issuing from different parts of their bodies, presumably aided by the 'Opening Mixtures'. One of these, a pregnant woman on the right-hand side, is delivering a miniature cow from beneath her skirt. A man next to her with his hands raised in horror, is sprouting horns: a *double entendre* in connection with his supposed cuckolding resulting in this strange delivery to his wife. On the wall at the back of the print is a painting depicting people prostrating themselves in front of an altar on which a cow is standing. This is an allegorical reference to the biblical story in which Aaron, in the absence of Moses, makes a Golden Calf for the Israelites to worship. A print such as this would have had more of an impact on the 'readers' than a mere condemnation of the practice or a further issue of pamphlets. The print predates Rowley's pamphlet by three years, but ideas sown in the minds of the public with regard to the development of tumescent horns and bovine excrescences as shown by Gillray may have been fuelled by Rowley's concern over the fate of the Ox-faced Boy.

In the same year, an engraving by Williams entitled *Vaccination* (BM 9925), demonstrates the controversy which ensued between factions in the medical profession. In this print the names of anti-vaccinators are provided – Dr Mosley [*sic*] who had written many tracts and published letters against cowpox, Drs Squirrill, Rowley, Birch and Lipscomb – each identified by their initialled swords, and by their names on an adjacent obelisk. A monster made up of different parts of animals including a cow-like body and with horns and a tail like those of a cow and representing 'Vaccination' is covered with sores labelled 'Pestilence, Plague, Foetid ulcers, Leprosy, Pandoras Box'. This monster is being fed with normal babies by three doctors who each have horns (associated with both devilry and with the bovine species) and a cow's tail. One of these doctors, Jenner, has a printed paper, '£10,00[o]', protruding from his pocket. From the rear end of the monster, the babies – having developed horns and tails – are being shovelled up and placed on a dung cart. The doctor engaged in this activity is Dr Woodville. He is identified by a book underneath his foot bearing the title 'Lectures on Botany'. Dr Woodville had written a book on *Medical Botany* (1799) containing descriptions of medicinal plants. He was also Physician to the Smallpox Hospital at St Pancras where he supported Jenner's work. It has been said that Woodville supplied Jenner with his 'original' attenuated vaccine and that this may have been contaminated, resulting in secondary infections to which this print alludes.[30] Anti-vaccine representatives with

swords and shields and proclaiming 'Truth' are seen descending a mountain on which is the Temple of Fame.

It took ten years for the practice of vaccination to become generally accepted. Jenner had to contend with antagonism from some of his own profession, for whom a lucrative trade in inoculation was threatened, from clergymen and others who denounced the practice of transferring disease from beasts to man, and from those who feared the transmission of other diseases during the process. Rowley had described how

> it would be cruel, for the world to know, who had laboured under the Cow-Pox Mange, evil, ulcer, or any other beastly disease, it might infallibly injure their fortune in life, particularly in matrimonial alliances. Who would marry into any family, at the risk of their offspring having filthy beastly diseases?[33]

Although Rowley admitted that many vaccinators were not masters of the technique which could thus cause adverse effects, he still felt strongly that diseases of 'brutes' would be incorporated into the human constitution however the vaccinations were performed.

In contrast to the antagonism displayed in the previously described prints, Isaac Cruikshank supported Jenner in his print *Vaccination against Small Pox, or Mercenary & Merciless spreaders of Death and Devastation driven out of Society* [86]. This was published in 1808 (BM 11093). It shows Jenner accompanied by two colleagues, holding his scarifier or vaccination knife inscribed with the words 'milk of human kindness'. Retreating from his advance are three out-dated practitioners who still continue the old practice of inoculation. They are holding up large scarifiers dripping with purulent matter and inscribed 'The curse of human kind'. One of the three is saying, 'Curse on these Vaccinators. We shall all be starved, why Brother I have matter enough here to kill 50.' The second one adds, 'And these would communicate it to 500 more.' 'Aye, Aye', states the third, 'I always order them to be constantly out in the air, in order to spread the contagion.' Jenner says 'Oh, Brothers, Brothers, suffer the Love of Gain to be Overcome by compassion for your fellow creatures, & do not delight to plunge whole Families in the deepest distress, by the untimely loss of their nearest and Dearest relatives.' Such distress is illustrated by dead and dying pock-marked individuals strewn all round, and by a mother holding her dying baby and crying out for assistance.

A cherub is about to place a laurel wreath on Jenner's head, proclaiming him 'The Preserver of the Human Race'. Jenner's colleagues are carrying rolled documents on which the words 'Bill to', can be distinguished. These refer to government support which had resulted in the establishment of a National Vaccine Institute in 1808, following a report on vaccination submitted by the Royal College of Physicians the previous year. This Institute

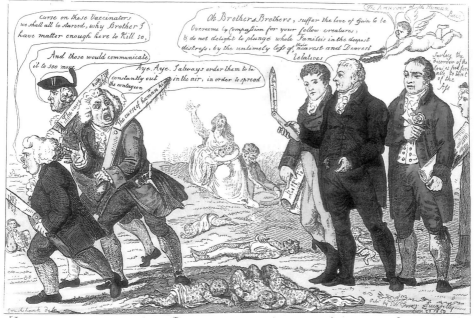

86. ISAAC CRUIKSHANK: *Vaccination against Small Pox, or Mercenary &
Merciless spreaders of Death and Devastation driven out of Society*

replaced the Royal Jenner Society and its inception had occasioned renewed
antagonism from the opponents of vaccination. A figure behind Jenner says,
'Surley [*sic*] the disorder of the Cow is preferable to that of the Ass.'

Anti-vaccination campaigns continued. Isaac Cruikshank's son, George,
had views which differed from those of his father. He offered support to the
anti-vaccinators in the form of a print, *The Cowpox Tragedy*, which was
published in 1812 in the journal *Scourge*. This was an attack on vaccination
and on the Royal College of Physicians, which, in 1806, had reported strongly
in favour of vaccination and the merits of Jenner. It is a complicated and
detailed print (described in the *British Museum Catalogue of Personal and
Social Satires*, No. 11953). The main section contains a funeral procession for
'Vaccina aged 12 years'. On top of the coffin stands an image of a garlanded
golden calf inscribed 'the Brazen Image'. The pall bearers (or undertakers),
whose torches bear the words 'Harveian Oration', are physicians from the
Royal College of Physicians, and a reminder of Hogarth's allusions to doctors
and undertakers in *The Company of Undertakers*. A motley collection of
mourners emerges from the collapsing building of the Royal College of
Physicians to accompany the procession, led by parson Rowland Hill who

vaccinated thousands of people himself. (The Methodist Chapel at which he preached was in Blackfriars Road.) A small cow with the distressed and horned head of Jenner falls from behind a curtain on which appear the words, "'tis Conscience that makes Cow-herds of us all'.

By 1839, however, popular and professional hostility to vaccination was muted. Inoculation (variolation) was forbidden by law in England in 1840 and vaccination of infants was made compulsory in 1853 in England and the law extended to Scotland and Ireland in 1863. Those opposed to compulsory vaccination continued to campaign: their activities can be seen, for example, in hand-drawn and printed designs on envelopes and postcards.[30]

The prints described in connection with vaccination show how artists could be involved in contemporary controversies. They also illustrate what, in the twentieth century, appears to be the continuing naïvety of thought amongst some members of the medical profession who were supposed to advise members of the general population about matters of health. Some of these thought patterns were associated with current ideas of physiognomy, humoral theory and man's association with 'brutes', themes apparent in a number of prints which have already been discussed. These ideas in turn help to explain the fear and scepticism of the general population with regard to the practice of vaccination. At the time of publication, some aspects of the standpoint of those responsible for the prints would have seemed entirely credible.

CHAPTER 9
. . . To the Tomb

I. DENTISTRY: A BIG SMILE

a maiden of forty-five . . . her teeth straggling and loose, of various colours and conformation.[1]

THIS was how Smollett described Tabitha Bramble in *The Expedition of Humphrey Clinker*. The condition of her teeth was probably similar to that of many people at the time. The general state of teeth during the eighteenth century was poor. Lack of cleanliness, inadequate and inappropriate diet and, in the upper and middle classes particularly, a surfeit of sweetmeats, contributed to the decay. The use of fans was not merely a coquettish affectation. It was often a protection from the foetid breath of associates or a means of hiding a blemished smile.

English dentistry was not as far advanced as French dentistry at this time. Following separation of the barbers and surgeons in 1745, some dental practitioners wished to improve their status and associated with the surgeons, receiving further training in anatomy and surgery. One practitioner who had received such training was Martin van Butchell. He, along with some other practitioners, did not confine himself to dentistry. He was the son of a tapestry maker to George II and was a colourful character. He was born in Flanders in 1736, and when his family moved to England, he received a good education and became a Groom of Chambers, a post which enabled him to earn sufficient money to pursue his interests in mechanics, medicine and anatomy. Human teeth became of special interest to him after breaking one of his own, and he engaged himself as a pupil of John Hunter. This led to a career in dentistry, and some success.[2] He practised as a dentist for many years, and as part of his practice made artificial teeth fitted with gold pivots and springs. He professed to be able to fit these complete with gums, sockets and palate without 'drawing stumps or causing pain'. He suggested that these were 'useful ornaments' and 'most helpful to enunciation'.[3]

An advertisement in the *St James's Chronicle* of 1 March 1777 stated that,

Van Butchell, Surgeon-Dentist, attends at his House, the upper part of Mount-Street, Grosvenor Square, every day in the Year, from Nine to One o' clock, Sundays excepted.

Name in Marble on the Door. Advice, £2.2s. Taking out a Tooth or Stump, £1.1s. each. Putting in artificial Teeth, £5.5s. each. A whole under Row, £42. Upper Row £63. An entire set, £105. Natural Teeth, £10.10s. each. The Money paid first.[4]

The price of his artificial teeth was considerable, a fact which reflects the scarcity of such dentures at the time and their perceived worth. His use of 'Natural Teeth' was in line with the practice advocated by his teacher, John Hunter – a development which is discussed later.

Van Butchell also achieved some eminence as a maker of trusses, and in the treatment of fistulae. According to a biography of him written in 1804,[5] he: 'has been very long, in the habit of, curing Fistulas, Piles, Wens, Carbuncles; Mattery Pimples, Inflammations, Boils, Ulcers, Aching Legs; Tumours, Abscesses, Strictures, and Ruptures, without Confinement; Burning or Cutting.' This biography also described him as: 'the Inventor, of Elastic-bands; (Gentlemen wear them, to keep up small-cloathes) Also, Cork-bottoms, to Iron-stirrups; Spring-girths for Saddles; and many like things.' He advertised a 'Spring band' 'by the King's patent' for the treatment of ruptures in a hand-bill dated 5 June 1788, and in November of that year the *Morning Herald* contained an advertisement announcing his 'newly-invented Spring band Garters . . . will help to make [the ladies] (as they ought to be!) – superlatively happy!'. On 3 October 1791 Gillray published a print in which he portrays the fashionable but ageing actress, Mrs Hobart, trying on one of the garters. The picture on the wall behind this lady alludes to one of her roles in her hey-day, a scene from *Nina or the Madness of Love*, a popular play which she had commissioned George Monck Berkeley to translate from the French. The whole print satirically suggests that with the aid of the garters, she might yet be rejuvenated. The print is entitled *La derniere ressource; – or – Van-Buchells Garters* [87].

Van Butchell attracted attention to himself by his appearance in public with long white beard and strange costume – shirt, waistcoat, breeches and stockings all in one piece, everything in white – complete with a large bone in his hand attached to his wrist by a string. This defensive weapon, reminiscent of Samson, was sometimes satirically referred to as 'the jaw-bone of an ass'.[6] No less striking was his habit of riding through London on a white pony which was painted with large black or purple spots. This sometimes had a curious bridle attached to its head, fixed with a blind which Butchell could let down over the horse's eyes if it took fright, or if its owner thought some object was unfit for it to see.

Even more eccentric was his behaviour following the death of his wife.

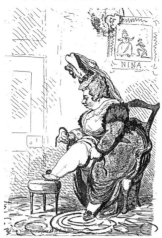

87. Attributed to Gillray: *La dernière ressource; – or – Van-Buchell's Garters*

Butchell persuaded Dr William Hunter and Mr Cruikshank to embalm her body. This they did, by injecting oil of turpentine and camphorated spirit of wine into her blood vessels and packing camphor into the abdominal cavity. With the addition of carmine dye to ensure a rosy complexion, glass eyes, and a fine lace gown, she continued to preside over his drawing-room in a case with a glass lid and was usually introduced to visitors as his 'dear departed'.[7] It was said that this sequence of events was occasioned by a clause in the marriage settlement with regard to the non-disposal of certain property 'while she remained above ground'. Her presence was, however, no longer welcome on Butchell's re-marriage, and the lady was banished to the Museum at the College of Surgeons and finally cremated there by a German bomb in 1941.[8]

Dentistry had been practised from ancient times, treatment generally involving extraction of teeth or the relief of toothache by local application of a red-hot iron for cauterisation, or by the use of opiates or other general sedatives. Attempts at filling cavities with various compounds had been tried, as had the fitting of artificial teeth. Ivory was the usual medium for the latter by the end of the seventeenth century, but there was a tendency for it to turn yellow. Other suitable substitutes for the originals were tried, including animal bone and human teeth, but progress was slow until the celebrated French dentist, Pierre Fauchard, brought about many improvements. He was born in Brittany in 1678 and trained as a military surgeon. He settled in Paris about 1719, and in 1723 completed a comprehensive treatise *Le chirurgien dentiste, ou, traité des dents* which was published in 1728, and remained an authoritative work on dentistry throughout the eighteenth century.[9] One of his practices entailed wiring artificial teeth together with silk or fine gold wire

and making them into a block which he then wired to the adjacent natural ones. He devised a method of fitting crowns to teeth, and attempted to make full sets of artificial dentures. The lower sets remained in position quite well, but there was some problem in keeping upper sets in position, particularly during mastication. He overcame these problems in double sets by hinging the upper and lower dentures with steel springs. The pressure from the springs ensured that the teeth stayed in place against the upper and lower jaws. He used an enamel coating over the teeth to give them a more natural appearance with pink coloured enamel over the base.

A French apothecary, Duchateau, tried to produce a mineral base for the artificial teeth which would not discolour or decay with use, with unpleasant consequences, but his attempts proved unsuccessful. The porcelain paste which he used shrank when fired and the resulting teeth were abnormally white. He sought the help of a dentist, Dubois de Chemant – whom Rowlandson portrayed – and they tried out various modifications. A set was eventually produced for Duchateau himself which was satisfactory, and the apothecary tried to supply similar sets for other toothless clients. He had no dental experience and this venture failed, causing him to abandon the idea. De Chemant, however, persevered with the experiments and produced a mineral paste with important modifications from which he made a number of successful dentures. These consisted of a single block in which were moulded teeth and gums. He publicised these in pamphlets in 1788, and Louis XVI granted him a patent. The Paris Faculty of Medicine praised his dentures, and testimonials and poems were written in his praise, but he attracted some hostility from those who claimed that he had usurped Duchateau's invention. De Chemant was sued for this, but the action failed. He left Paris for England and established himself in London in 1792, where he obtained exclusive rights to produce the dentures for a period of fourteen years. The Wedgwood factory supplied the porcelain paste for these.[10] In 1804 he was charging 60, 70, and 80 guineas for a set. The vogue for the teeth lasted for about twenty years, after which improvements in other models ensured their decline.

Rowlandson's print of the French dentist Dubois de Chemant was published in 1811. In this, *A French Dentist shewing a Specimen of his Artificial Teeth and False Palates* [88], de Chemant is proudly showing off the teeth of a woman patient who is equally proudly demonstrating the full set of dentures – including the attached springs – in a broad smile. A man also in need of some dental attention is peering at the teeth through his lorgnette. A notice on the wall reads: 'Mineral Teeth. Monsieur De Chemant from Paris engages to offer from one tooth to a whole set without pain. Monsieur D . . . can also offer an artificial Palate or a glass Eye in a manner peculiar to himself he also . . .'. There does not seem to be any evidence with regard to the supply of 'glass eyes' referred to in the print. This may be an allusion to the inability

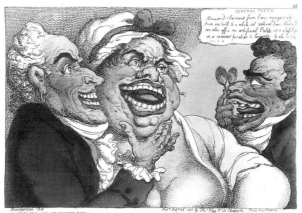

88. THOMAS ROWLANDSON: *A French Dentist shewing a Specimen of his Artificial Teeth and False Palates*

to 'see' the falsity of the dentures. It is not known whether Rowlandson was commissioned to produce this print by de Chemant for publicity purposes, but it is a possibility. At this time, the use of his dentures may have been declining and such publicity would have been welcome.

Some dental practitioners, especially in country areas, retained their practice of barbering and tooth-drawing. One such was illustrated by Rowlandson as late as 1823 in *The Toothache, or Torment and Torture*. This representation satirically depicts 'Barnaby Factotum' in his establishment where he combines the activities displayed on the poster on the wall: 'Draws Teeth, Bleeds & Shaves: Wigs made here; also sausages. Wash Balls, Black Pudding, Scotch Pills, Powders of the Itch, Red Herrings, Breeches Balls and Small Beer by the maker. *In utrumque Paratus*.' A small boy is holding up a pair of forceps with which to remove the offending tooth, and a bowl to receive it, whilst an old lady looks on with apprehension as she holds her own painful jaw. The practice of approaching the patient from the rear was not universal, but became more common throughout the eighteenth century.

Other tooth-drawers visited markets and fairs in the old established way, as Rowlandson's prints of Dr Botherum and other itinerants at the fairs illustrate. Many of them were totally untrained in their art, but they were often the only practitioners available for most of the population. In an emergency, other stalwart members of the community might oblige by removing a tooth. Only the rich could afford the services of an adequately trained 'dentist' (the word came from the French late in the eighteenth century).

Two contrasting prints after Dighton (*c*.1785) show this state of affairs. In

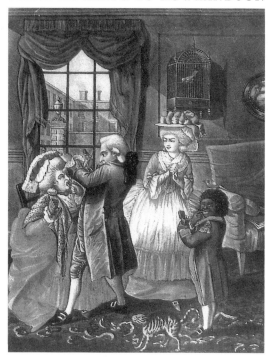

89. ROBERT DIGHTON: *The London Dentist*

the first, *The Country Tooth Drawer*, the local farrier is extracting a tooth with a large pair of forceps. His strong arms are probably his only qualification for the job. He is being assisted by his sturdy workmates, and the venue is the smithy. The second print, *The Town Tooth Drawer*, shows how a rich lady may have a similar extraction in her own home. The fashionably dressed dentist is accompanied by a small black boy who is employed to carry his box of instruments, and the dentist is using a 'modern' instrument – a tooth key – for the operation. The original engraving of the latter by Robert Dighton is *The London Dentist*, 1784 [89]. The operator in this is said to bear a marked resemblance to Bartholomew Ruspini[11] who was a well-known dentist in London, an Italian by birth, who had trained as a surgeon before specialising in dentistry in Paris. He arrived in England in 1759 and as a 'surgeon-dentist' set up practice initially in Bath. He subsequently settled in London in 1766, under the patronage of the Dowager Princess of Wales, and established a fashionable practice.

Even the more privileged members of society could not always obtain the services of a proficient practitioner. Parson Woodforde of Norwich, a well-known diarist, wrote in his diary on 4 June 1776:

My tooth pained me all night, got up a little after 5 this morning, and sent for one Reeves a man who draws teeth in this parish, and about 7 he came and drew my tooth, but shockingly bad Indeed, he broke one of the fangs of the tooth, it gave me exquisite pain all the day after, and my face was swelled prodigiously in the evening and much pain. Very bad and in much pain the whole day long. Gave the old man that drew it however 0.2.6. He is too old, I think, to draw teeth, can't see very well.[12]

Rowlandson drew attention to another dental practice which was fashion-able in the late eighteenth century, namely the *Transplanting of Teeth*. His painting is so-named [90]. John Hunter described this practice in his publication *The Natural History of the Human Teeth* in 1771, and his name gave it a seal of approval.

We can actually transplant a Tooth from one person to another, without great difficulty, nature assisting the operation, if it is done in such a way that she can assist; and the only way in which nature can assist, with respect to either size or shape, is by having the fang of the transplanted Tooth rather smaller than the socket. The socket, in this case grows to the Tooth. If the fang is too large, it is impossible indeed to insert it all in that state; however, if the fang should be originally too large, it may be made less; and this seems to answer the purpose as well.

. . . a fresh Tooth, when transplanted from one socket to another, becomes to all appearance a part of that body to which it is now attached, as much as it was of the one from which it was taken; while a Tooth which has been extracted for some time, so as to lose the whole of its life, will never become firm or fixed; the socket will also in this case aquire the disposition to fill up, which they do not in the case of the insertion of a fresh Tooth.[13]

He stressed that parts taken from young 'animals' were better and would last longer.

In a later edition of his book (1778),[14] Hunter said that the operation was not a difficult one, but one which required more surgical and physiological knowledge and care than any other dental practice. He advised caution, especially with a living tooth because it was meant to retain its life: 'the Patient should apply early, and give the dentist all the time he thinks necessary to get sufficient number of Teeth that appear to be of a proper size etc. Likewise he must not be impatient to get out of his hands before it is advisable.' Single fanged teeth, incisors, cuspids and bicuspids transplanted best, according to Hunter, whilst a dead tooth might be fitted in place of one of the 'grinders'. Attention had to be paid to the socket and gums of the recipient and only when the appearance was favourable should the 'scion' tooth be introduced.

No person should have a Tooth transplanted, while taking mercury, even although the Gums are not affected by it at the time; for they may become affected by that mercury before the Tooth is fixed. For this reason, those who have Teeth transplanted, ought particularly to avoid for some time the chance of contracting any complaint, for the cure of which mercury may be necessary.

Mercury was used in the treatment of syphilis, when it often caused the gums to swell and sometimes to become ulcerated. Salivation was increased and loosening of teeth occurred, as was suggested by Hogarth in Plate 5 of *The Harlot's Progress* [27].

Hunter stressed that the age of the recipient should be at least 18 to 20 years, so that the teeth on either side of the fitted tooth would be full grown. He again emphasised that teeth from the young were best, and female donors were often used because the 'scion' teeth were generally smaller than those of men and would fit more readily into the vacated sockets: 'The best remedy is to have several people ready, whose Teeth in appearance are fit; for if the first will not answer, the second may . . . the sooner the scion Tooth is put into its place the better . . .'.

This recommendation forms the basis of Rowlandson's satirical painting on this topic, and the dental practitioner in his painting is based on Ruspini,[15]

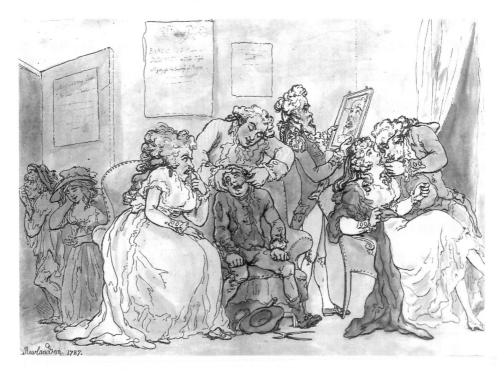

90. THOMAS ROWLANDSON: *Transplanting of Teeth*

although a diploma on the wall describes the occupant of the premises as 'BARON ROH– DENTIST to Her High Mightyness Empress of Rusia'. This gentleman is in the process of removing a 'scion' tooth from a young chimney-sweep for the benefit of the fashionably dressed middle-aged lady on his right, who evidently feels the need for her smelling-salts, which she is holding to her nose. Another fashionably dressed, younger lady is undergoing a dental inspection by an assistant. Behind her, a client looks at the result of his operation in a mirror. Two poorly clad young people are leaving the room with aching jaws and the monetary proceeds of their transaction. A notice on the door above the couple informs readers that 'Most money given for Live Teeth'.

Examples of a surgeon-dentist's charges for such operations in 1781 are provided by Paul Euralius Jullion of 4 Gerrard Street, Soho, London:

Transplanting a live tooth £5 5s.
Transplanting a dead tooth £2 2s.
Engrafting the crown or body of a
sound human tooth on the root of a
decayed one £2 2s.[16]

Not all surgeon-dentists approved of the practice. One London practitioner who advertised his services with appropriate fees for each item, added the information, 'To transplant a Tooth with Success, a Folly.'[17]

After transplantation the 'scion' tooth was fixed to two neighbouring teeth by means of silk or sea-weed, and the patient was advised to take care to avoid disturbing it. Hunter commented that transplantation of a dead tooth might be preferable because there was more certainty of matching the teeth, but these did not always retain their colour. However, they could last for years.

The fashion for transplantation declined for various reasons: the avail-ability and improvement of artificial dentures, the failure of the transplanted tooth to remain secure, the fear of introducing disease, and the general distaste occasioned by the practice and highlighted by people such as Rowlandson.

Rowlandson's painting demonstrates the extent to which the class system contributed to the dental health of the better-off or élite in society who could thus exploit its poorer members. His message seems to have provided some effective 'propaganda' against the practice in this instance, at least in Britain. The practice did however spread to Europe and America and continued in some cases well into the nineteenth century.

II. LICENSED TO KILL?

You recall to my mind that cruel separation of the united fraternities, so much to the prejudice of both bodies . . . What a blow was this to me who unite both in my own person.[18]

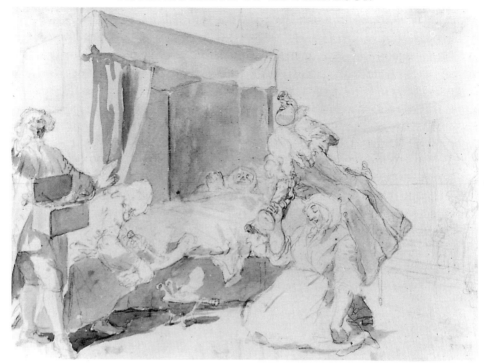

91. WILLIAM HOGARTH: *An Operation Scene in a Hospital*

The Company of Barber-Surgeons divided into two separate entities in 1745, the surgeons considering that their interests and status would be better served by such separation (see Chapter 1). This separation was neither universally popular nor universally practised. Tom Jones, in Fielding's novel of that name, referred to Benjamin as 'Mr Barber, or Mr Surgeon, or Mr Barber-Surgeon'. Benjamin's response is quoted above.

The surgeons, like the physicians, became increasingly involved in the developing hospitals. A drawing by Hogarth executed about this time, shows an operation scene in such a hospital [91]. The drawing was apparently intended for engraving because the surgeon is using his left hand for the operation, and the proceedings would have been reversed in subsequent prints. The operation is being performed on a patient's leg – apparently cauterisation, and probably of an ulcer.[19] The surgeon is bending over the affected limb, holding it still with one hand and applying the cauterising iron to the lesion with the other. On the floor by his side is a pan raised on a stand containing instruments and some combustible material with which to heat them. Other instruments, with dressings, are contained in a box held by an

assistant who holds out a hand in horror as if to halt the proceedings as signs of burning appear.

Every surgeon had one or more apprentices who were bound to him for seven years at Surgeons' Hall. They had to pay a fee to their Master and expected to be offered a vacancy on the staff of the hospital when trained. At some hospitals such as St Bartholomew's and St Thomas's in London, the surgeons also had 'skellet carriers' or 'dressers', who ranked below the apprentices and were chosen from amongst the surgeon's pupils. Their duty was to walk round behind the surgeon carrying the 'skellet' or box containing the necessary equipment for dressings. Each surgeon had up to four of these dressers who had to pay double premium to their Master. They were required to stand round the operating table whilst other pupils were ranged further away.[20] The assistant holding such a box in this scene seems to fit into this category and as Hogarth had connections with St Bartholomew's Hospital, this was the likely scene of operation.

A careless or intoxicated nurse kneeling by the bed is holding a candlestick and lighted candle with which she has set fire to the wig of the physician on her right-hand side. A parallel incident is said to have occurred on Queen Caroline's deathbed, when the Queen's curtains were similarly inflamed.[21] Sterne later describes a comparable scene in *The Life and Opinions of Tristram Shandy* in which the servant girl, Susannah, assists Dr Slop at a minor operation on the unfortunate young Tristram, an argument ensuing:

> Slop snatched up the cataplasm, – Susannah snatched up the candle; – a little this way, said Slop; Susannah looking one way, and rowing another, instantly set fire to Slop's wig, which being somewhat bushy and unctuous withal, was burnt out before it was well kindled.[22]

The 'inflamed' physician in Hogarth's drawing inspects a flask of urine and palpates the patient's pulse. Physicans expected to supervise the surgeons' activities, but this physician's interest in the patient and the surrounding circumstances seems limited. This was often perceived as the actuality.

The scene is another example of how Hogarth combined realism with known contemporary events. Queen Caroline's death occurred in 1737 as the result of an operation. Hogarth may have been making some allusion to this as an indication of the hazards associated with operations.

Most operations *were* hazardous procedures in the eighteenth century and were not undertaken lightly. Surgical techniques were often crude, anaesthesia and asepsis were non-existent and sedation with brandy or opium was probably the best that could be expected. In the operation scene described, the surgeon is wearing special sleeves over his cuffs for their protection, but cleanliness was not an over-riding consideration and the sleeves would not necessarily be changed between operations.

III. A PUBLIC ANATOMY

Surgeons were also anatomists, and the activities associated with the two branches of the profession were often fearfully combined in the mind of the general population. Surgery seemed only a short step away from 'anatomisation' and the perceived cruelty of the surgeon was magnified through this association. Hogarth illustrated these perceptions in the dissection scene in his engraving *The Reward of Cruelty* [93]. This is the final scene of the series *The Four Stages of Cruelty*, which he produced in 1751 'in hopes of preventing in some degree that cruel treatment of poor Animals which makes the streets of London more disagreeable to the human mind than any thing what ever, the very describing of which gives pain . . .'.[23]

Hogarth's art owes a great deal to his artistic predecessors and to his professed aim of making it live for his own time. Both these influences are apparent in this scene. Prints of this series of engravings were produced in a cheaper, simpler and more popular form than those of the previous 'Modern Moral Histories' and were intended for a less sophisticated audience, although the background from which Hogarth may have drawn inspiration for the anatomical dissection portrayed would have been appreciated by the cognoscenti. The series supported Fielding's campaign against the increase in the amount of crime, especially those of murder and robbery, which were prevalent in London. Fielding had issued a pamphlet *Enquiry into the Causes of the late Increase of Robbers* in which he considered that public executions were often considered as popular entertainment and even led to glorification of the chief participant. He felt that capital punishment should be swift and certain and that public executions were bad and turned the mob in favour of the criminal and, in fact, had no deterrent effect.[24]

In the final scene, *The Reward of Cruelty*, Tom Nero is the heartless young man (literally so in this portrayal, as the dog devours his heart), who began his life of crime by cruelly taunting defenceless animals in the streets of London and was eventually hanged for the murder of his mistress – a typical scenario in which petty crime led inexorably to the ultimate degradation, and exemplified again by Hogarth in his *Industry and Idleness* series.

In the first scene of the cruelty series, Nero is seen wearing a badge on his arm bearing the letters 'S.G.' indicating that he is a St Giles-in-the-Fields charity school boy. By 1765, social reformers were reflecting upon some of the poor standards of apprenticeships available for such children and a committee was appointed to look into the 'enormous misbehaviour of the boys'. Apprentices were 'riotous, turbulent and very rarely good citizens'.[25] Hogarth's allusion to Nero's charity school background supports this theory. Ultimately, Nero's body is handed over to the College of Surgeons for

dissection. The dissection is a 'Public Anatomy' and the assembled audience watch with varying degrees of interest, dismay and contempt.

Hogarth seemed to share the popular belief that surgeons were, on the whole, disreputable, insensitive to human suffering and prone to victimise people in the same way that criminals victimised their prey. He demonstrates this victimisation in the scene, which, in spite of its gruesome subject matter, contains elements of humour, realism and satire.

Some information about the circumstances surrounding 'Public Anatomies' will help to put the scene into the context of its time. Some knowledge of the artistic background from which Hogarth may have drawn his inspiration for the scene indicates how in this print, as in others, he combined tradition and topicality in his art.

'Public Anatomies' were performed on malefactors at the Barber-Surgeons' Hall until the time of the separation of the two companies in 1745. They usually took place four times a year, as laid down by the Act of 1540 (see Chapter 1). In addition, an indefinite number of 'Private Anatomies' were held with the Company's permission. To these, the surgeon invited his own friends and pupils, and the Court of the Barber-Surgeons could invite guests. Two Masters and two Stewards of Anatomy were appointed; the Stewards usually dissected and prepared the body and the Masters read the lectures on dissection to the assembled audience.[26] A dinner often followed to complete the social occasion.

An entry in the Annals of the Barber-Surgeons for 20 October 1631 refers to the facilities (or lack of facilities) available then for undertaking such a dissection:

> This Court taking notice of the lack of a Private dissection Roome for anatomicall employemente and that hitherto those bodies have beene a greate annoyance to the tables dresser boardes and utensils in o[r] upper Kitchin by reason of the blood filth and entrailes of these Anathomyes and for the better accommodating of these anatomicall affaires and preserving the Kitchin to its owne prop[r] use, Doe nowe order that there shallbe a faire convenient roome built over the greate staire case next to the back yard to be imployed onely for dissection of private Anatho-myes . . .[27]

What would thus appear to have been a necessary extension to the Barber-Surgeons' Hall was opened in 1638. This was the first building in Britain designed as a specific anatomy theatre, the design of which has been attributed to Inigo Jones, and it remained in use as such until 1745. It was demolished in 1784, the Barbers and Surgeons having failed to come to any agreement concerning its use. The Surgeons built a new hall close to Newgate Gaol, but this was not in use until August 1751. At the time of Hogarth's print (engraving dated 1 Feb. 1751), the Barber-Surgeons' theatre was no longer in

use for dissections. The print contains elements of the Barber-Surgeons theatre, the Cutlerian theatre of the Royal College of Physicians – built in Warwick Lane after the old College had been burnt down in 1666 – and of the new but as yet unused Surgeons' Hall.[28]

Artistic precedences for studies of 'Public Anatomies' exist and may have influenced Hogarth in his design. These were based on actual situations.

Autopsies for forensic purposes were held in the latter part of the thirteenth century at the medical school in Bologna. A few decades later public dissections were well recognised, but the purpose of these was to verify the accounts given by the ancient authorities such as Galen and Avicenna and to provide some visual *aides-mémoires* for the students. In the absence of preservatives, dissections were conducted with some haste. Dissection illustrations by artists were not common and even a well-known anatomical treatise such as that of Mundinus's *Anathomica* (1316) was not originally illustrated. Mundinus (Mondino de Luzzi *c*.1270–1326) aimed to demonstrate the old texts. He did perform the dissections himself, although most of his successors declined to do so. Professors retained their 'chairs' and their dignity, thus symbolised. This 'chair' was usually elevated in the manner of a pulpit from which the occupant declaimed previous works. The dissection was performed by a menial demonstrator under the direction of an 'ostensor' who indicated the necessary lines of incision by means of a wand or pointer. The frontispiece of the Mundinus text of the *Fasciculo di Medicina* (1493 edition) edited by Johannes de Ketham, a German physician, is from a woodcut of a scene representing such a procedure in Padua at that date and is recognised as 'the best early presentation of an academic anatomy'.[29]

The famous anatomical theatre at Leiden was an early and important venue for 'Public Anatomies'. Anatomy lessons were part of the medical school curriculum at Leiden, and these were heralded by public announcements and advertisements inviting the general public to attend. Andries Jacobsz Stock (1572–1648) made a print known as *The Anatomy Lesson of Dr Pieter Paaw* (1615), which was first inserted in Pieter Paaw's *Primitiae Anatomicae De Humani Corporis Ossibus*. It illustrates the anatomist Dr Paaw, who founded the anatomy theatre at Leiden and was the Professor of Anatomy and Botany at the University, presiding over a dissection and pointing out the relevant parts of anatomy to the assembled audience, which in this case includes foreigners and important figures from the past. Galen is posed as the praelector reading from his text. In this print, an animated skeleton is seen wielding a banner which bears the inscription 'Death is the line that marks the end of all'.[30] The floor and table are strewn with sprigs of rosemary or yew which were supposed to have disinfectant properties. Two dogs sit patiently awaiting their fate, which is to provide a study of comparative anatomy.

Hogarth's theatre and the scene depicted in the *Reward of Cruelty* bear a

striking resemblance to Stock's print and to the earlier 'Frontispiece' or title-page to Vesalius' works *De Humani Corporis Fabrica* and *Epitome* (a small twelve-page version of *De Fabrica*), both published in 1543. Vesalius' works contain beautifully executed anatomical plates which provided a basis for the scientific study of anatomy. Vesalius, the most eminent anatomist of the Renaissance period, found during the course of his dissections that the current teaching, which was based on Galen's work, was full of errors. Galen's work had been based mainly upon animal dissections and their similarity to human anatomy had been assumed. (The Renaissance title-page of Galen's *Opera omnia* portrayed the dissection of a pig.) The artist Jan Steven van Kalkar (or Calcar) – or Titian, according to some historians – provided the expert draughtsmanship which led to the production of the plates in *De Fabrica*, in which skeletons and muscle-men are depicted in action and in intricate detail. The introduction to the first plate indicated that the early illustrations of the muscle-man in the plates showing superficial dissections were intended to display a total view of the major muscles such as only painters and sculptors would normally consider.[31] The first anatomical drawing books for artists were based on Vesalian figures. In 1706, the Augsburg bookseller Maschenbaur published prints from the original Vesalian plates.[32] This made the detailed anatomical drawings more widely available, but Vesalius' work was plagiarised and inferior copies were produced. Amongst these are drawings in a manuscript volume now in the Hunterian Library at Glasgow – though the title-page may be genuine[33] – which were purchased by William Hunter in 1755, and the copy of the *Epitome* on vellum in the British Museum Library, which is said to be the example included in the sale of Dr Richard Mead's books in November 1754 and 1755 and purchased for £8 12s. 6d.[34] Dr Mead's art collections had been available for artists to copy until his death, and it is possible that Hogarth had seen the *Epitome* there, and used this as a model for his own 'Public Anatomy', though he may also have known the famous printed volumes.

Vesalius' 'Frontispiece' [92] was a fashionable decorative title-page to his work intended to adorn the title *De Humani Corporis Fabrica*. Below this title a crowd of people are gathered around a central figure who is the focus of attention in a 'Public Anatomy' demonstration. Vesalius himself is standing on the right-hand side of the central figure – a female cadaver – with one hand raised as if to emphasise a point which he is demonstrating. Above the body an animated skeleton is sitting on a desk-top pointing with a pole towards the partially dissected body. By this means, Vesalius may be indicating his attitude towards the practice of the lecturer declaiming from above. A naked model peers from behind a pillar. The skeleton and the nude indicate the importance that Vesalius laid upon the study of osteology and surface anatomy in articulated and living fashion as well as in the inanimate. Two

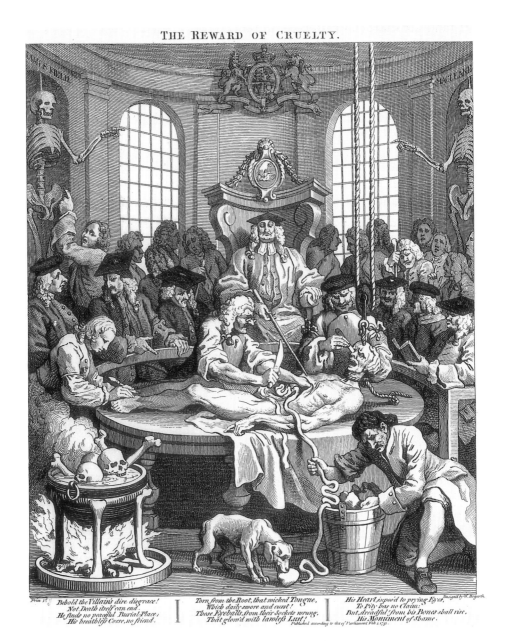

92. JOHN STEPHEN CALCAR: *Anatomical Lesson* frontispiece of *De Humani Corporis Fabrica*, by Vesalius, 1543.

assistants are sharpening tools for the great man, who performs the dissection himself as Mundinus had done. Two other attendants are holding a monkey and a goat on which vivisection will be performed. Vesalius and his contemporaries usually concluded their public anatomies in this way.[35] The spectators are arranged in tiers in a semi-circle around the dissecting table. At the front are the professional men and students, one of whom is consulting a text – possibly a Galenic text – indicating the Vesalian view that what has been written should be checked against what is seen in order to ascertain the true facts. Nuns and monks standing behind Vesalius show a keen interest in the proceedings, a circumstance which has been attributed to their curiosity regarding the anatomy of female genital organs.[36] Further back, members of the public are gathered, including a fashionably dressed young man peering down on the right-hand side. The shield at the top of the print bears Vesalius' family coat-of-arms.

In the print *The Reward of Cruelty*, Hogarth places John Freke, surgeon (1688–1757), in the President's Chair in place of Vesalius' skeleton in his 'Public Anatomy'. Freke points in similar fashion to the body undergoing dissection. John Ireland says, 'The president much resembles old Frieke who was the master of Nourse Surgeon and Lithotomist to St Bartholomew's Hospital to whom the late Mr Potts was a pupil. Mr Frieke was originally a member of the Barber-Surgeons' Company . . .'.[37] Freke was also Curator of the 'Repository for Anatomical and Chirurgical Preparations' at the Hospital,[38] a position which may have earned him his place in Hogarth's print.

The Company of Surgeons hired a house in Cock Lane, close to St Bartholomew's Hospital, where the bodies of criminals were delivered for dissection. The President of the Company, in full court dress, awaited the arrival of each malefactor on the first floor where the executioner placed it on the table. The President then made a small incision over the sternum.[39]

Hogarth's 'President', suitably attired, sits in his chair of dignity in its elevated position, as if in judgement, beneath the coat-of-arms bearing the royal crest. (The Surgeons did not receive their royal recognition until 1800, although the Physicians had this distinction as early as 1551.) The chair bears arms (or hands) based on those of the physicians – namely, the palpation of the pulse. Hogarth indicates in this way that dissections took place under the auspices of the Royal College of Physicians. Mr Walpole observed:

> how delicate and superior is Hogarth's satire, when he intimates, in the College of Physicians and Surgeons that preside at a dissection, how the legal habitude of viewing shocking scenes hardens the human mind, and renders it unfeeling. The President maintains the dignity of insensibility over an executed corpse, and considers it but as the object of a lecture.[40]

By depicting such insensitivity and callousness on the part of participants in a

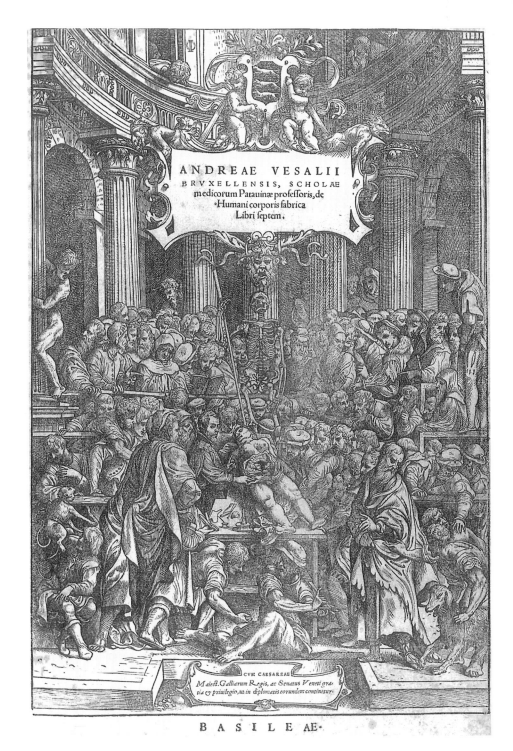

ANDREAE VESALII
BRVXELLENSIS, SCHOLAE
medicorum Patauinæ profefforis, de
Humani corporis fabrica
Libri septem.

CVM CAESAREAE
Maieft.Galliarum Regis, ac Senatus Veneti gra-
tia & priuilegio, ut in diplomatis eorundem contineatur.

BASILEAE·

93. WILLIAM HOGARTH: *The Reward of Cruelty* from *The Four Stages of
Cruelty*

dissection scene Hogarth presents the operation as a suitable and fitting punishment to fit Nero's crime – a fate worse than death. Execution, mutilation and dismemberment were terrifying punishments to all believers in the resurrection of the body. Dismemberment was thought to deny the possibility of resurrection at the Day of Judgement. Hogarth probably attended dissections performed by William Hunter, who was the leading anatomist of the day, and by Cheselden, and would have witnessed what was regarded as insensitivity displayed on these occasions.[41]

In similar fashion to Vesalius or Dr Paaw, a surgeon in Hogarth's scene wields his knife. He and his two assistants are seen wearing carpenter-type aprons and sleeve protectors similar to those worn by surgeons during operations on live subjects.[42] The surgeon's knife appears to be especially vindictive compared with the scalpels used by his subordinates, one of whom goudges out one of Nero's eyes. Such 'weapons' were from amongst the surgeons' tools and emphasised by Hogarth for special effect.

The pulley and rope attached to Nero are similar to those used by artists in order to position skeletons and muscle-men in suitably realistic poses for life studies. Hogarth uses this effect in his print in order to convey the impression of a live body and also to make the point that Nero had arrived in that position via the rope, the hangman's rope at Tyburn. As Walpole continued in his observation, 'the wretch who has been executed seems to feel the subsequent operation'. There are numerous artistic precedents for bodies appearing to be alive during dissection, and it was not unknown for a client of the executioner to recover from the latter's ministrations. An entry in the rough Minute Book of the Company of Barber-Surgeons 1738–42 reads:

> November the 23[d], 1740.
> This day W[m] Duell (who had been indicted at the Old Bayley for a Rape and had received sentence of Death for the same) was carried to Tyburne in order to be executed where having hung some time was cutt down and brought to this Company's Hall in order to be dissected where he had not been five minutes before Life appeared in him & being let blood and other means used for his recovery in less than two hours he sat upright drank some warm wine and look'd often round him before he was carried back to Newgate . . . He afterwards obtained a reprieve in order to be transported for life which he was accordingly in the 16th year of his age.[43]

This kind of mishap was an occurrence contemplated with dread and fearful anticipation by criminals. Tom Nero in Hogarth's print appears to be suffering from this fate during his autopsy. The surgeons are subjecting his body to brutality and callousness to be compared only with the extent of brutality displayed by Nero in the earlier stages of the series. Nero's bones, the audience are led to believe, may find their resting place alongside such

notorious felons as James Field, an eminent pugilist who was hanged at Tyburn on 11 February 1751, and Macleane, a highwayman and robber, who was hanged on 3 October 1750, and whose skeletal remains hang on display in the wall niches at each side of the theatre as a warning to would-be criminals. Nero's finger points to the bones which are being prepared for their ultimate destiny.

Hogarth, as usual, took full advantage of notorious recent incidents to obtain the maximum effect and appeal for his work. Field and Macleane had been discussed in the journals and their names would have been familiar to his audience.[44] Although there was popular conviction that criminals should be hanged, dissection was not universally welcomed. Nero bears a 'mark of infamy' in the form of branded initials on his forearm. Malefactors were usually branded with an 'M' on the palm of their hands.

Hogarth's audience at the scene of crime, as the law and the surgeons take their gruesome course, consists of academics wearing mortar-boards or birettas in the first row (as in the previous 'anatomies'), and a miscellaneous assortment of men behind, including a worried-looking youth who is pointing to the skeleton hanging near to him. Some physicians, recognisable by their hall-marks of wigs, canes and superior aspects, are 'consulting' together in the background with contemptuous disregard of the proceedings. Their theoretical knowledge of anatomy was usually good, although few undertook dissections, preferring to leave them to the manual skills of the surgeons. Many considered that such work was beneath their dignity; their presence was to oversee the surgeons' activities.

The dog in the foreground repays Nero for his previous treatment to its kind and represents a reversal of the vivisection role allotted to the dog in the Vesalian scene. It was, however, customary to provide specimens of parts of animals at the Demonstrations of Anatomy for comparative anatomical purposes. For example, in 1732, the following expenses were incurred by the Barber-Surgeons' Company:

To a sheeps hart & kidney	£0.0.6
A sheeps hart and lights	£0.0.4
2 Bullocks eyes	£0.0.4[45]

The 'Frontispiece' of De Fabrica is not the only part of the work which finds an echo in Hogarth's print. The initial letters for the first edition of De Fabrica each contain vignettes representing medical incidents. These are portrayed by students in the guise of infants or putti. The letter 'O' depicts infants boiling bones in a cauldron over a wood fire. The boiling was to clean the bones prior to mounting them in articulated form. 'P' shows the infants setting up such skeletons, and 'L' indicates the method of obtaining anatomical specimens from the gallows for dissection. Hogarth's print also

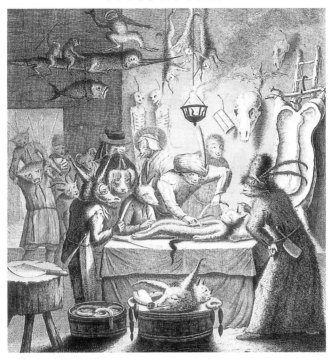

94. EGBERT VAN HEEMSKIRK: *The Quack Physicians' Hall*

displays a cauldron containing denuded skulls and femurs being cleaned over a wood fire. His cauldron is supported by femurs. The table in the anatomy theatre at Leiden has feet carved in the shape of skulls. A similar tub for entrails is present in both theatres, as are the representatives of the canine species, although in a seemingly different capacity.

A different influence on Hogarth may have come from the work of Egbert van Heemskirk, a Dutch painter who emigrated to England, and whose popular style of work was admired by Hogarth. He died in 1704 but a particular work of his which Hogarth may have had in mind was engraved by Toms c.1730, known as the *Quack Physicians' Hall* [94]. In this, animals behave as humans performing a public anatomy, providing an allusion to what was perceived as the animal-like behaviour of the surgeons. This was in line with the physiognomical beliefs exemplified by LeBrun that if any part of a man's body resembled that of a beast, similar conclusions with regard to his nature and behaviour could be drawn. Similarities between Hogarth's and Heemskirk's scenes are apparent in connection with the anatomists, audience, hanging skeletons, body in the process of dissection and tubs containing heads and entrails. The allusion to the butchers' trade is present in the chopping block and the hanging carcase. Surgeons were often regarded as

butchers. Both groups were excused jury service, possibly on the grounds of their supposed insensitivity to suffering.[46] The following lines appear below Heemskirk's print:

> Behold a Quack Physician's Hall,
> Adorn'd with Beasts like Butcher's Stall;
> The various Figures which you see,
> Shew Mankind in Epitome;
> Where Ignorance, instead of Art,
> Supplys the Place of true Desert:
> How hard the Fate of Humankind
> When Blind Men only lead the Blind.

Hogarth, as in previous works, used his knowledge of contemporary practices and topical events, to popularise his work. In addition to the popular references, his allusions to previous anatomical illustrations elevated his scene to a more intellectual level which would have been appreciated by his colleagues. His moral message, delivered at a time when Parliament was considering additional deterrents against the crime of murder[47] and when Fielding was waging his campaign against the increase of crime, offered him the opportunity to provide support in the way he knew best. Popular suspicion of surgeons and distaste for anatomisation are clearly demonstrated.

IV. KILL OR CURE

Blood-letting

Anatomisation epitomised the extreme form of the surgeons' involvement in blood-letting. Blood was a vital life-force and the letting of blood in different circumstances was seen either to kill or cure. One form of blood-letting was 'cupping'.

An excess of blood had been considered as a cause of disease from ancient times, the site of the plethora determining the type of disease resulting from it. Cupping was regarded as beneficial to health and as a means of balancing the body humours by drawing the humours of the underlying structure into the skin, thus relieving congestion. Cupping was prescribed for practically every symptom or disease. Glass or brass cups were popular for this purpose, and a spirit lamp and a lancet usually completed the apparatus. Air was extracted from the cup by means of a lighted lamp or piece of wool or tow used as a wick and soaked in spirit. An incision was made in the skin at a selected site or sites with a lancet or scarificator, which was sometimes spring-loaded so that release of a trigger led to penetration of the skin by the sharp point to a depth

of about an eighth of an inch. The cup or cups were then pressed over the site(s) to collect the blood that exuded as the cup cooled and a vacuum formed. Dry cupping was a similar process without scarification, a bruise or blister resulting.

Cupping was often practised at public bagnios or sweating houses which began to be established in London about the end of the seventeenth century. These establishments were commonly used as retreats or places of rendezvous for lovers, such as the countess and the lawyer in *Marriage-à-la-Mode*, as well as for bathing purposes and many were places of ill-repute. Hogarth drew attention to one of these bagnios, 'The New Bagnio', in his painting *Night* from *The Four Times of the Day* [95]. The sign outside this bagnio illustrates a glass of the type known as a 'rummer'. Hogarth may be using this in its dual role as a container for liquor and as a cupping glass, both benefits to be obtained on the premises. He juxtaposes the bagnio with a barber-surgeon's establishment, the perspectival intermingling of signs indicating a combination of activities. The apparently intoxicated barber is seen through the window shaving a customer. His sign illustrates his other accomplishments, namely as Bleeder and Tooth-drawer, and as proof of the former, six dishes containing 'blood' lie on a table outside the window. The Act of 1540 stated that:

> no manner of psonne within the cittie of London, subburbes of the same and one myle compas . . . using barbery or shaving . . . shall occupy any surgery letting of bludde or any other thing belonging to surgery, drawing of teeth onely except . . . and furthermore in like manner whosoever that usith the mystery of crafte of surgery within the circuits aforesaid . . . shall in no wise occupye nor exercise the feate or crafte of barbarye or shaving.

According to this, the barber should not carry out the operation of bleeding. Even being shaved by the drunken barber would seem to be a hazardous procedure, with inadvertent blood-letting a real danger. The lawlessness on this particular barber's part may be a deliberate demonstration by Hogarth to fit in with the lawless activities proceeding outside the shop, where chaos is seen to reign. Blood-letting apparently went on both inside and outside the establishment. Hogarth wished to draw attention to the hypocrisy, drunkenness and corruption which were perpetrated in society under the cloak of darkness (Night), not least by those who were supposed to uphold recognised values. The figure in the foreground wearing an apron and with set-square on a ribbon round his neck was a Freemason and Bow Street Magistrate, said to represent Sir Thomas de Veil. He had vigorously condemned drunkenness and had his house burnt down as a result, but he could not escape from the charge of corruption in some of his own dealings nor from Hogarth's satirical references in this picture.[48]

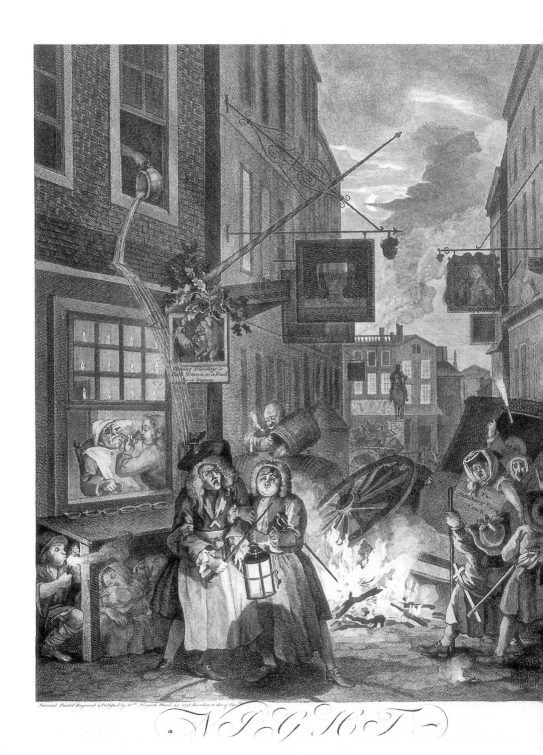

95. WILLIAM HOGARTH: *Night* from *The Four Times of the Day*

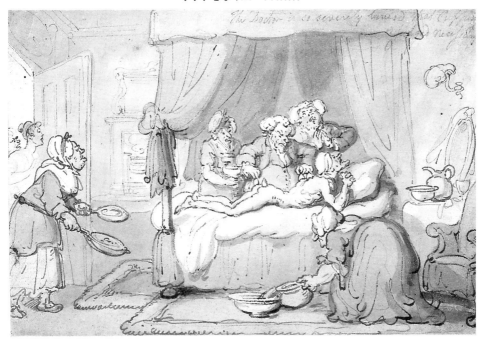

96. THOMAS ROWLANDSON: *The Doctor is so severely bruised that cupping is judged necessary*

Rowlandson employs the practice of cupping for the benefit of ' Dr Syntax' in his drawing *The Doctor is so severely bruised that cupping is judged necessary* [96]. This drawing was sent to Ackermann, a noted London publisher and friend of Rowlandson, who sent an etching or drawing to William Combe, a hack writer whom he employed to write verses for his *Poetical Magazine*. Publication of three series of 'Tours' resulted, describing and illustrating the exploits of the doctor – an eccentric parson and schoolmaster. Many of these were loosely based on the journeyings of William Gilpin and his 'Picturesque Travels'. This particular illustration however, was not published in the *Syntax* series. The naked doctor is shown with cupping glasses being placed on various parts of his anatomy by the surgeon, while three elderly nurses administer to his needs with warming pans, gruel and hot water. A colleague prays fervently for his recovery.

Cupping was one way of relieving 'congestion', but phlebotomy or venesection provided more immediate effects. Although physicians such as Sydenham used the practice of blood-letting with circumspection, it was still a remedy commonly used throughout the eighteenth century. For example, a *Medical Guide for the use of the Clergy, Heads of Families, and Practitioners in Medicine and Surgery* (1812) contains a section on Phlebotomy, or Blood-

Letting. According to the *Guide*, in certain circumstances such as 'severe falls with internal bruises', the operation should take place immediately and, 'In sudden attacks of apoplexy, inflammation of the lungs, pleurisy, and all internal inflammations and inflammatory fevers, attended with determination of blood to the head or lungs, the *speedy* loss of blood is often of considerable importance'.[49] The *Guide*, however, gives some warning with regard to its execution and to the dangers which might ensue from the misguided services of such practitioners as blacksmiths, farriers and barbers and, perhaps, men like Corporal Trim in Sterne's *The Life and Opinions of Tristram Shandy*, who, 'to the character of an excellent valet, groom, cook, sempster, surgeon, and engineer, superadded that of an excellent upholster too.'[50]

A barber-surgeon (the title given to the operator in the accompanying verse) is performing the task in the first print of Hogarth's 'Election' series, *The Humours of an Election* (1755–8), the title of which contains a medical allusion [1]. This series was based on the notorious Oxfordshire election of 1754, in which ambition among politicians and the ensuing competition for votes led to scenes such as those portrayed in satirical fashion by Hogarth. The first scene is set in a room in a public house which the Whig candidates have hired for *An Election Entertainment*. Amongst the activities going on in the room, feasting has played a major role, and for the Mayor, a surfeit of oysters seems to have caused a fit of apoplexy. The barber-surgeon is mopping his patient's brow; he has placed a tourniquet round his arm and is in the process of bleeding him whilst holding a basin in which to catch the blood. The barber-surgeon has a lancet in his mouth, of the kind usually used for venepuncture or 'breathing' a vein.

The tri-partite division of medical services which was evident in London was not so apparent in the countryside. Part of the 'Poetical Description' of Hogarth's scene, written under his 'sanction and inspection' and published in 1759, contains the words:

> The Mayor with oysters dies away!
> – But softly, don't exult so fast,
> His spirit's noble to the last;
> His mouth still waters at the dish;
> His hand still holds his favourite fish;
> Bleed him the Barber-surgeon wou'd;
> He breathes a vein, but where's the blood?
> No more it flows its wonted pace,
> And chilly dews spread o'er his face.[51]

The barber-surgeon apparently still operated in this part of the country, although in this case his ministrations appear to be in vain. The practice of

surgery alone was not always customary or sufficiently rewarding financially to earn a living by this means away from the metropolis.

The practice of bleeding or letting of blood had been long-established and was considered by many as a prophylactic measure to ensure good health. A friend of Dr Samuel Johnson, clergyman Dr John Taylor, attributed a nose bleed to the fact that he had omitted to have himself blooded 'four days after a quarter of a year's interval'.[52] Dr Johnson disapproved of this measure, but many people from different social strata felt that it was essential to their well-being. James Adair wrote in 1790:

> The idea of bleeding and purging every spring and fall, to prevent fevers and other diseases was formerly very general in the country; owing to the ignorance or knavery of barbers and medicasters, who derived no small benefit from thus disciplining whole parishes. Many of the lower ranks do still submit, with implicit faith . . .[53]

Samuel Richardson's 'Pamela' made reference to the supposedly prophylactic measure of bleeding for herself when her baby son had contracted smallpox: '– But I am living very low, and have taken proper precautions by bleeding, and the like, to lessen the distemper's fury if I should have it . . .'.[54] The Revd Penrose described the treatment accorded to a friend of his who had 'dropp'd in a Paralytic Fit, or something of that kind': 'The Physician and Apothecary were sent for, who ordered him into a Bath Chair, put him to his House, let him blood, put a Blyster on his Back, gave him a Vomit . . .'.[55]

Rowlandson portrays a typically robust scene in an appropriately named print, *Bleeding a Fat Woman* [97]. The operation is being carried out by a surgeon, who is supporting the lady's arm with one hand and holding up a lancet or scarifier with the other. In keeping with her size, the assistant is holding a bucket rather than a bowl in which to catch the vital fluid. A nurse in the background is tying a bandage on another lady's arm to act as a tourniquet in preparation for her operation. Others stoically await their turn.

In contrast, an oil-painting by an anonymous English artist of the late eighteenth century illustrates an unidentified surgeon with his little black assistant letting blood from the arm of a fashionable lady. She has her sleeve rolled up and a tourniquet tied round her upper arm and is holding a cane in order to help the blood distend the vein at the venepuncture site.[56] This accords with the directions given in the *Practical Dispensatory . . .*:

> The person being properly seated in a good light, a bandage should be tied round the upper arm about three fingers breadth above the elbow, sufficiently tight to compress the veins so as to prevent the return of blood, but not so tight as to prevent its passage to the brachial artery . . . A vein of moderate size . . . should be chosen. The arm should be extended, and if the vein do not rise well, the patient should shut his hand or grasp a stick.[57]

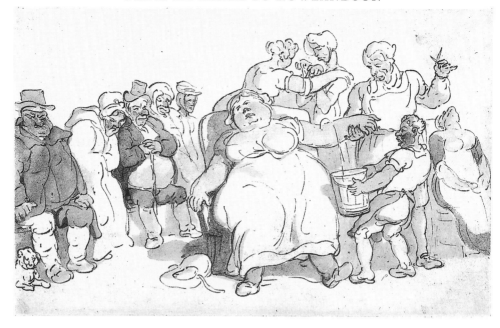

97. THOMAS ROWLANDSON: *Bleeding a Fat Woman*

Politically speaking, blood-letting could represent the draining of the blood of the nation at times of riots and revolution. John Bull and Britannia frequently and patriotically underwent the operation for the good of the nation. Evacuations in the form of vomits, purges and blood-letting were a constant theme.

Operations in operation

Methods of stemming the flow of blood could be quite primitive. For example, a character seated in the foreground in *The Election Entertainment* who has sustained a head wound has gin applied both externally and internally, spirit providing both panacea and antiseptic properties and helping to dry and clean the wound – a variation of the 'vinegar and brown paper' remedy in the nursery rhyme. For head injuries, pieces of lint dipped in spirit of wine were often used. Different forms of alcohol – wine, brandy, spirits of wine, or compresses soaked in warm wine – were used according to availability: Hogarth supplied gin in his scene. The healing effects of such treatment, although not understood, were thus acknowledged. Fresh cuts and bruises or grazes of the skin on other sites of the body were usually treated by means of a 'Diachylon' plaster, that is a concoction of plant juices which was spread on to leather or black silk and applied to the wound. Hogarth's

[272]

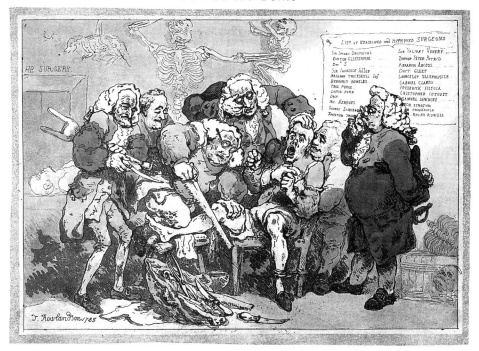

98. Thomas Rowlandson: *The Amputation*

illustration of Don Quixote being cared for by the Inn-Keeper's wife and daughter demonstrates the application of such a plaster to the traveller's injured back.

The risks attached to operative surgery led to the popular perception that such procedures were closely associated with anatomisation and they were portrayed by artists accordingly. Rowlandson's scene of an operation for amputation of a limb, published in 1785, offers no compromise with regard to the opinion of a surgeon's practice and of its probable outcome [98]. An unfortunate patient or victim is being held firmly in place by a strong attendant and by a rope tied to his left leg and to the leg of his chair. The surgeon, who has removed his coat and is wearing protective sleeves and a carpenter's apron in similar fashion to that of the anatomist, has placed his own right knee and left hand on the doomed leg to keep it in position, whilst he saws through this seemingly healthy limb below the knee joint. The surgeon's bag of assorted tools, similar to that of a carpenter and anatomist, but including a forgotten or misplaced femur, spills its contents over the floor, and a bowl placed strategically to catch the blood as it pours from the wound lies nearby. No tourniquet has been applied, thus carrying the 'blood-letting' to extremes. It has been said that the operator was meant to represent Robert

Liston, a famous Scottish surgeon who did not bother to use a tourniquet, but Liston was not born until 1794, after the print was published.[58] It seems unlikely that Rowlandson would have omitted a tourniquet by accident. Such an omission would have been noted by observant 'readers'. Its absence, therefore, would have had some purpose. This may have been in connection with the subsequent loss of life by this means – the ultimate 'blood-letting' – or the perceived hastiness on the part of surgeons to amputate without due care and consideration for the outcome.[59] None of the assembled audience shows any concern for the patient. The gentleman at the back of the group around the 'victim' uses his head for support so that he can obtain a better view of the operation at which he peers through his spectacles. Likewise, the portly physician on the right with tricorn hat, periwig and sword indicating his profession, stands and watches with no sign of concern. The assistant on the left holds a knife for the next stage of the proceedings and a crutch under his arm for the patient's use on completion of the operation. This seems to offer his only hope of support. No anaesthetic or antiseptic procedures were available at the time, and this patient does not seem to have been offered any form of sedation. Thomas Percival MD writes in his *Medical Ethics*, that during an operation

> It may be humane and salutary, however, for one of the attending physicians or surgeons to speak occasionally to the patient, to comfort him under his sufferings; and to give him assurance, if consistent with truth, that the operation goes well, and promises a speedy and successful termination.

He goes on to state that,

> When several operations are to take place in succession, one patient should not have his mind agitated by the knowledge of the suffering of another. The surgeon should change his apron, when besmeared; and the table or instruments should be freed from all marks of blood, and everything that may excite terror.[60]

The 'surgery' in Rowlandson's scene seems to act as both dissecting room and operating room, emphasising the similarity between the two procedures – almost certain to 'excite terror'. A cadaver and gesticulating skeletons behind the group, one of which seems to empathise with the patient, feeling similar agonies, and a tub with torso and skull on the right of the picture, provide evidence of this. A list of names of 'approved surgeons' is shown on a poster on the wall. These names include 'Christopher Catgut, Samuel Sawbone, Launcelot Slashmuscle, Dr Glisterpipe, Paul Purge, Sir Valiant Venery and Sir Jaundice Jollop', appropriate names to accompany their activities.

An oil-painting by an unknown artist c.1775, of *An Eighteenth Century amputation scene in the men's operating theatre of old St Thomas's Hospital* [99], was acquired by the Royal College of Surgeons in 1965, and has been

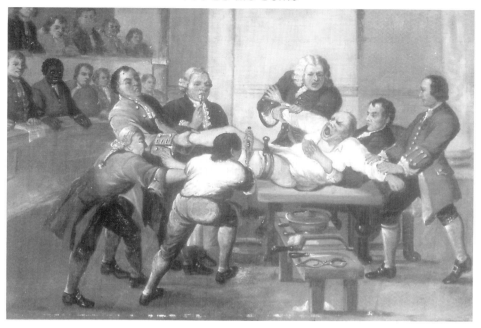

99. ARTIST UNKNOWN: *An Eighteenth Century amputation scene in the men's operating theatre of the old St Thomas's Hospital*

described by Lord Brock.[61] Unfortunately, the painting is now missing, but prints remain. This painting lends credence to some of Rowlandson's satirical observations and portrays the horrifying experience of such an operation for both patient and observer. Only the physician, with cane to nose, seems unmoved by the proceedings. The surgeon has removed his frock-coat and is wearing a carpenter's apron. He is sawing off the patient's left leg below the knee and distal to a screw-type tourniquet, whilst the attendants are firmly holding down the screaming sufferer. The screw-type tourniquet was invented by Frenchman Jean Louis Petit (1674–1750). Similar types can be seen in boxes of surgical instruments used in the eighteenth century especially by the army and navy.[62] The low operating table is placed at right angles to another table on which are ranged the instruments which were in use at that time for such an operation. These include a long curved knife, saw and bone-forceps. Similar instruments from the eighteenth century are on display at the College. A large bowl of water is placed underneath the table ready to receive the amputated limb. Students are ranged in tiers watching the operation in the theatre which has been identified as that of the old St Thomas's Hospital when it was in the 'Borough' and formed one of the 'United Borough Hospitals' with Guy's Hospital.[63]

Although Rowlandson's operation scene was intended primarily for amusement, its accuracy and that of the oil-painting can be corroborated to a certain extent by referring to a text-book illustration from a contemporary book of surgery.[64] In this, amputation is being demonstrated by frock-coated surgeons and attendants who are sawing off a lower limb below the knee joint. A tourniquet is not visible in the operation field, but one is shown in the inset. This, the saw and the large bowl appear in both scenes.

CHAPTER 10 .

The End

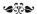

I. DEATH COMES AT THE END

> . . . the end crowns all,
> And that old common arbitrator, Time,
> Will one day end it.
> Shakespeare, *Troilus and Cressida*, IV.v.223

TO be a victim of 'anatomisation' or even of its ally 'surgery' was a very real fear in the eighteenth century. The attitudes of the artists and their perceptions of practitioners engaged in these fields and the results of their ministrations – in accordance with those of many ordinary citizens – are brought clearly into focus through the artists' works.

The need for more surgical and physiological knowledge was recognised increasingly, not only by John Hunter in connection with dentistry,[1] but in other spheres of medical practice. Knowledge of anatomy was essential. Surface anatomy and the study of the actions of muscles were also recognised as valuable for the artist, and had been so recognised since Leonardo's and Michelangelo's time. William Hunter, in his lectures to the Royal Academy, fostered a new approach to this aspect of art. Johann Zoffany painted two 'group' portraits of the Royal Academy, the first of these entitled *The Life School at the Royal Academy of Arts* and the second, *Dr William Hunter lecturing at the Royal Academy of Arts* [104]. These provide interesting group portraits of academicians who did not require instruction, but were chosen to be present for 'formal gatherings' at the Academy. The contrived grouping in the former portrait was not a 'life-like' scene, but was meant to represent the ideals espoused by the Royal Academy within a conventional framework. Women were not present because it was considered indecorous for them to be in the presence of a male model. They are therefore represented by portraits on the wall. The academicians assembled for the scene include William Hunter in his capacity as lecturer in anatomy at the Academy. His presence represents a rare privilege, acknowledging his special status there.[2] Hunter played an important role in connection with the teaching of anatomy to art

[277]

students at a time when it was recognised that such knowledge was invaluable for the correct portrayal of life studies.

In addition to benefiting from the practical knowledge the anatomists imparted, an artist such as Rowlandson found material for his drawings in the practices and surroundings of the practitioners. The anatomy theatre provided a new arena in which to work and the activities taking place there had a theatrical element which could be usefully exploited. Again, social, moral and political messages could be conveyed through this medium. However, as in previously described prints, these messages would only be effectively conveyed if elements of truth or of truly held beliefs could be recognised as part of the scene.

Hogarth had illustrated his feelings and those of many of his contemporaries towards the surgeons and their practices most effectively in *The Reward of Cruelty*. This was in 1751. Rowlandson illustrated views from later in the century in such prints as *The Dissecting Room*, *The Lancett Club at a Thurtell Feast*, *The Anatomist* and *The Persevering Surgeon*, which are amongst those described below. There seems to have been little change in perception.

As described previously, the establishment of private schools of anatomy was made possible following the separation of the Surgeons from the Barber-Surgeons' Company in 1745. William Hunter started a series of anatomy lectures in 1746 and for several years collected and prepared suitable specimens for demonstration purposes. He spent a winter in Paris and became familiar with the French method of dissection whereby each student 'had' a body. John Hunter joined his brother in 1748. William hoped to establish a national school of anatomy, with a museum containing normal and pathological specimens in addition to biological and anthropological specimens for comparative anatomical studies, but his plans were thwarted. However, the nucleus of 'The Windmill Street Museum and School' was established.[3] William moved to live in Great Windmill Street in 1768, and his museum opened there in 1770.

Rowlandson visited this establishment where he sketched William at work. The original drawing of this, *The Dissecting Room* [100], is at the Royal College of Surgeons in London. It displays an attic room with sky-light windows. William, wearing spectacles, is standing amidst a group of students, pointing out some feature to which they have directed their attention. Another interested viewer, Tobias Smollett, is standing over a busily occupied student at the right-hand side. Their attentions are focused on two cadavers in the throes of 'anatomisation'. Another body is lying partly inside and partly overflowing a box on the floor, on the left of the picture. The pupils include some well-respected medical men who have been identified as John Hunter, Howison, Cruikshank, Hewson, Pitcairn, Matthew Baillie – nephew of the

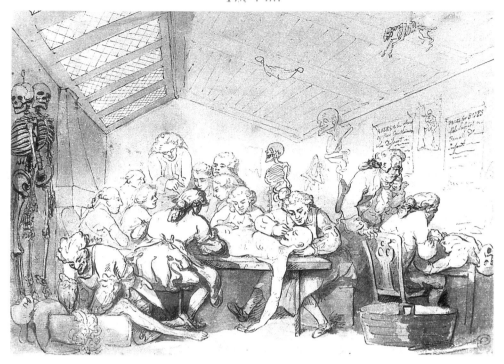

100. THOMAS ROWLANDSON: *The Dissecting Room*

Hunters – Howe, Sheldon and Camper.[4] These gentlemen could not all have been present at the same time because Smollett left England in 1763 and Hewson died in 1774, when Cruikshank was aged nineteen, and Baillie aged thirteen was still in Scotland,[5] but Rowlandson incorporated them all into one picture as a composite portrait of some of Hunter's pupils and colleagues, a practice which was not unusual at the time.

On the wall are two posters with an anatomical drawing between them. One poster reads 'Rules to be observed while dissecting' and the other lists the prices offered for cadavers, according to whether the subject were male, female or infant. Three articulated skeletons stand on the sidelines, and a bust, possibly representing Galen's presence, overlooks the scene. Comparative anatomical specimens hang from the ceiling in similar fashion to those seen in the 'Cabinets of Curiosities'. The dissectors are wearing protective aprons and sleeves, such as were worn by surgeons whilst operating, and a saw and pair of bone-forceps lie on the floor, representing tools of the trade. A tub in the right foreground, and entrails overflowing from the box and cadaver in the left foreground, add to reminiscences of Hogarth's dissection scene in *The Reward of Cruelty*, whilst the cadaver on the right seems to be

feeling pain similar to that experienced by Tom Nero. Rowlandson combines reportage with satire in his picture.

A view of the Museum in Windmill Street, which has been attributed to Rowlandson, is named *The Resurrection, or an Internal View of the Museum in W—d-m-ll Street on the last Day* (BM 6127). It seems unlikely to be one of Rowlandson's drawings. It lacks his style with its curving lines and vigorous characterisation, but when in low funds Rowlandson often etched the drawings of some of his friends, and he may have been associated in some manner with the production of this print. In this scene various 'resurrected' cadavers are searching for their lost or correct members (one – her virginity) amongst the specimens in the museum. Dr Hunter in their midst, bewails this outcome, with the words: 'Oh, what a smash amongst my Bottles and Preparations! never did I suppose such a day would come.' The anxiety displayed amongst those searching for their missing parts reflects the anxiety felt about a compromised physical state for resurrection at the Day of Judgement. This anxiety was similar to that associated with being hung, drawn and quartered, after which parts of the criminal's body would be placed on spikes in various parts of the city. Anatomisation posed an equal threat. To be denied full resurrection transcended mere execution.

A drawing which is by Rowlandson, *The Dissection*, was executed in about 1775–80. This macabre scene represents a mixture of reportage and carica-ture, with an element of eroticism provided in the background where two surgeons view a female cadaver with undue interest. This feature remains unfinished. Such lascivious interest was popularly thought to be associated with dissection by an exclusively male fraternity.

Bodies for dissection were scarce and it became increasingly difficult to obtain enough subjects for lecture and demonstration purposes. The surgeons obtained their limited quota at the Surgeons' Hall, so that private anatomists went to great lengths to get material and interesting subjects for their own use. The surgeons' quota came from the gallows at Tyburn, but others had recourse to the graveyards. A letter to the *Gentleman's Magazine* in 1747 referred to 'The affair which lately happened to the vaults at St Andrew's, Holbourne . . . [the] body was taken away by the sexton, the very night of its interment, and sold to a surgeon . . .'; the writer was 'informed that it is a common practice with these fellows, and their comrades, to steal dead bodies and sell them . . .'.[6]

In 1762, another letter to the same magazine read:

A man going to take up a load of dung in St George's fields, found at the dunghill the bodies of a woman and eight children, cut and mangled in a shocking manner, the handywork probably, of some young anatomist, who deserves a rigorous punishment for his carelessness and indiscretion.[7]

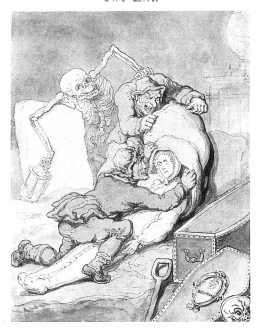

101. THOMAS ROWLANDSON: *Resurrection Men*

The procurers of these bodies were named 'Resurrectionists'. The Hunter brothers were amongst those who would go to great lengths in order to obtain specimens, including those from the graveyards. *The Anatomist overtaken by the Watch . . . carry'ng off Miss W— in a Hamper* by W. Austin, illustrates this practice in 1773 (BM 5119). The anatomist is running away from the scene, but has dropped a vital clue to his identity, a paper bearing the words 'Hunter's Lectures'. The print of the 'Resurrection' at Windmill Street, previously mentioned, is an allusion to this practice.

Another scene named *Resurrection Men* [101] – a pen and ink and water-colour by Rowlandson – shows an exhumed shrouded body being put into a sack by two such men. An animated skeleton with a lamp in its right hand looks over the shoulder of one of the body-snatchers and clutches his back with its left hand. The coffin lid from the empty casket lying on the ground, bears the word 'RESURGAM' – 'I will rise again'. 'Sack-em-up-men' was another pseudonym for those poachers who assisted the bodies to 'rise again'.

Rowlandson's drawing of *The Dissection* contains a hamper similar to that shown in *The Anatomist overtaken by the Watch* and the body is in a similar attitude. In this drawing it is in the dissection room awaiting autopsy. The anatomist (William Hunter again?), is engrossed in his work whilst others look on. A gross character on the right takes snuff during a pause from his own exertions involving a body whose legs are the only visible features in the

picture. Other accompaniments such as the discarded skeleton underneath the table, and a tub for the entrails, set the scene.

John Hamilton Mortimer produced a pen drawing of *Doctors Dissecting* at about this time and his drawing may have given Rowlandson ideas for his *Dissection.*[8] Rowlandson was impressed by Mortimer's style and subject matter and may have sought to emulate him. Mortimer's drawing shows the anatomists concentrating on their work with vultures on their heads. Mice, a crow, worms and even a dog, await their turn. He places the anatomists on a par with such creatures. A bloodied, partially dissected head stares in life-like fashion from protruding eyeballs as it is shovelled away – perhaps to be buried alive! This drawing lacks the humour that Rowlandson was able to incorporate into even such a macabre subject as dissection, but it conveys some of the horror associated with the topic. The life-like stare from the decapitated head bears some resemblance to Hogarth's Nero in *The Reward of Cruelty.*

Rowlandson demonstrates the fear of not being dead before dissection took place in a drawing published in 1811, entitled *The Anatomist* (BM 11800), in which a surgeon/anatomist is preparing to dissect a young gentleman. The latter has hidden from the wrath of a young lady's father or elderly husband. Unfortunately, he has chosen the anatomy table on which to hide, but his healthy state does not seem to deter the surgeon from his purpose, which might be intended as punishment for the young man's supposed crime. This scene may be intended to portray an attempt to suppress youthful vigour and energy and to maintain control, but the dependent phallic knife in the hand of the surgeon infers the latter's impotence on this score. The ubiquitous skeleton and the bust over the doorway possibly representing Galen overlook the activities in familiar fashion. A poster on the wall advertising a course of anatomical lectures by Professor Sawbones identifies the operator and draws attention to the fact that private anatomy courses were held.

The notion that the anatomist/surgeon never gives up is presented in Rowlandson's drawing *The Persevering Surgeon* [102]. Here the practitioner is dissecting a female cadaver. His lascivious expression and raised phallic scalpel whilst thus 'ravishing' the body in his possession again expresses prevalent ideas as to the activities of these gentlemen. Rowlandson cannot be absolved from the accusation of using such naked female bodies for the purpose of voyeurism and, in some instances, for pornography.[9] The articulated human and animal skeletons, bottles of specimens, and tub for entrails in this print complete the recognisable venue.

An anatomical lecture is in progress in another of Rowlandson's drawings by that name, *An Anatomical Lecture* [103]. The actual venue is unspecified, but the drawing bears some resemblance to Johann Zoffany's unfinished oval canvas entitled *Dr William Hunter lecturing at the Royal Academy of Arts,*

The End

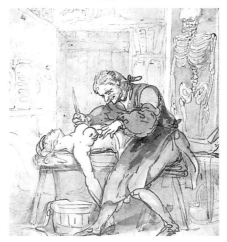

102. THOMAS ROWLANDSON: *The Persevering Surgeon*

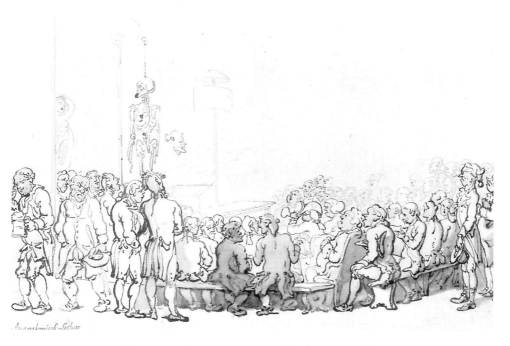

103. THOMAS ROWLANDSON: *An Anatomical Lecture*

*c.*1773 [104]. This portrays William Hunter performing his statutory duties as lecturer at the Academy, where he had been appointed to the Chair of Anatomy in 1768. Hunter is demonstrating surface anatomy on a live human model to his audience, which includes the partially deaf President of the

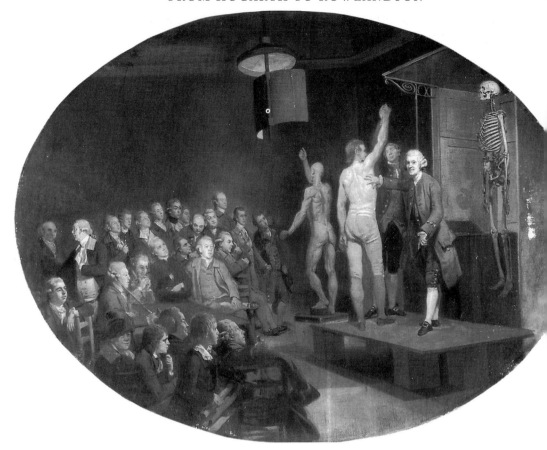

104. JOHANN ZOFFANY: *Dr William Hunter Lecturing at the Royal Academy of Arts*

Academy, Sir Joshua Reynolds, who can be seen in the front row listening through his ear trumpet. In Rowlandson's drawing, the head of the lecturer, possibly Hunter, can be seen over the lectern. A skeleton hanging from a curved hook is present and also a 'model' figure draped in classical style. A shaded lamp which enables light to be cast upon the model to be drawn, a sketch of whom can be seen lightly drawn in behind the lamp, resembles that in Zoffany's painting. Rowlandson's audience also includes a bewigged gentleman who is listening with the aid of his ear trumpet. This could be an allusion to Reynolds and the location that of the Royal Academy of Arts. Such lectures were popular and attended by a variety of people.

Lectures by surgeons were apparently not always so well received. Rowlandson's water-colour drawing of *John Heaviside lecturing at Surgeons' Hall* illustrates some lack of respect and attention shown to the lecturer by his

contemporaries. John Heaviside was a member of the Council of the College of Surgeons 1800–28, and had been a member of the Company of Surgeons from 1793 to 1800. He is drawn standing on the right-hand side of the table, reading from his notes, while around him colleagues seem to be involved in their own activities including drinking tea or coffee, talking, reading, examining specimens on the balcony, 'consulting', or merely day-dreaming by the fireside. Above the latter are arranged trophies from foreign countries, with a primitive medical man having the place of honour in the centre. Rowlandson satirically depicts the skeleton hanging over them and the comparative anatomical specimens, one of which appears to be in the process of decapitating one gentleman whose colleague is glancing fearfully towards the specimen jars to his right. Some of the exhibits are reminiscent of those allied to quackery and are possibly intended as an allusion to such by Rowlandson, but may also allude to Heaviside's own museum of anatomy and natural history which he built up at his house in Hanover Square and which attracted a good deal of professional and public interest. There he held weekly meetings of medical men.[10] The Surgeons' Hall illustrated in this drawing is that of the Company of Surgeons in the Old Bailey before its demolition in 1797.

John Hunter was particularly keen to obtain varied human and animal specimens for his collection of comparative anatomical exhibits, and with this aim made arrangements with the keeper of wild animals at the Tower of London to obtain their bodies after death. Circus managers received similar requests. Hunter was particularly interested in the Irish giant, Charles Byrne (or O'Brien, as he was sometimes called, 1761–83) and expressed a wish to have his body in his collection after the giant's demise. The ailing giant was aware of this and may already have been paid by Hunter, but was horrified at the prospect. He therefore arranged for his remains to be thrown into the sea. Hunter bribed the bodyguards and is said to have paid £500 for the body, which he duly obtained.[11] The skeleton of Byrne is on view in the Hunterian Collection at the Royal College of Surgeons in London. It is 7 ft 7 in. tall. The skull was opened by Sir Arthur Keith in 1911, when it was found that the *sella tursica* (the site which contains the pituitary gland) was greatly enlarged. Excessive action of the pituitary gland causes gigantism before the bone epiphyses have united. This effect was not finally recognised until Harvey Cushing completed his studies on the pituitary gland and its disorders in 1912.[12] Rowlandson made a water-colour drawing of the giant in which he compares his size with that of normal individuals who view him with curiosity. A youth is trying on one of the giant's boots and a young lady is comparing one of her dainty feet with his larger version. One curious gentleman is standing on a chair and looking at the giant through an eye-glass. These curious viewers were not the only ones to seek such oddities. The

giant had been exploited previously and had been the object of exhibitions in his home country of Ireland before coming to London, where for a short time his appearance attracted large numbers of spectators. The original painting is at the Royal College of Surgeons, and a boot, shoe, stocking and a glove belonging to the giant are also in the Museum there.

Sir Joshua Reynolds made use of the giant in his portrait of John Hunter: the bones of the giant's feet and lower limbs are included with the subject. There is also an accompanying book opened at a page showing drawings of comparative anatomical specimens. A copy of this painting by Henry Bone can be seen in the Hunterian Museum at the Royal College of Surgeons in London.

Topicality entered into the theme as occasion arose. The title of a dissection scene drawn by Rowlandson in 1823, *Struggling with Death or The Lancett Club at a Thurtell Feast* related to a gruesome murder which had been perpetrated on 24 October 1823 and had been widely reported in the newspapers. The crime was pre-meditated and involved two collaborators, Thurtell and Hunt, who had invited a man named Weare to spend a few days in the country for some shooting. Weare set out for the cottage venue near Elstree, but was waylaid by Thurtell who fired bullets at him but without killing him. As Weare tried to escape, Thurtell followed, cut his throat, and 'ran the pistol into his skull, turned it through his brains'.[13] The body was enveloped in a sack, thrown across a horse and dragged to a pond where stones were added to the sack and it was thrown into the water. The seemingly unconcerned guilty pair later ordered pork chops for their supper and spent a convivial evening.

The words 'Lancett Club' may have been a reference to the founding of a journal, the *Lancet*, the first edition of which appeared in October 1823. This radical journal was started by surgeon Thomas Wakeham, who intended to attack complacency in the profession and to expose episodes of malpractice and of nepotism. A number of small medical societies had been set up in the late eighteenth century, some of which developed into clubs where members could share their scientific and social interests.[14] In this print, Rowlandson demonstrates the interest provoked by a gruesome dissection, which would probably have been followed by a 'Feast' – a meal which often succeeded private dissections. The practice was thus equated with that of the two notorious murderers. In this scene, a basket with open lid, similar to those in *The Dissection* and *The Anatomist Overtaken by the Watch*, reveals another body, whilst that of a baby lies close by. Such baskets or hampers with handles on the sides were convenient receptacles in which grave-robbers could transport their victims. From their presence in these drawings, we are probably to understand that the bodies being dissected have been obtained in this way.

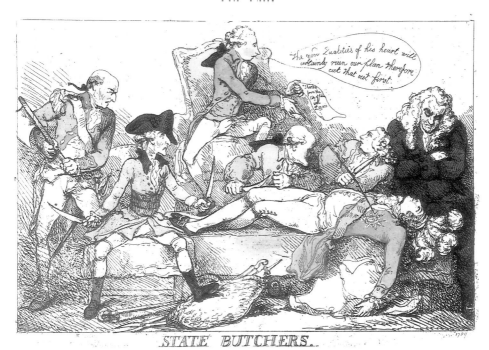

105. Attributed to Rowlandson: *State Butchers*

The political arena did not escape 'anatomisation'. Corruption at the centre of power could be seen to have results equivalent to the putrefaction of the body after death. In the print *Dissection of a dead Member* (BM 3271) one dead MP is noted to be so corrupted at autopsy that his organs bear witness to signs of bribery and his heart has 'not a drop of good blood' in it.

Dissection formed the theme for one of Rowlandson's political satires, *State Butchers* [105], published in December 1788 or January 1789, a hand-coloured etching based on a drawing by Wigstead. This is a satire on the Regency crisis. The Prince of Wales had been criticised following attempts to assume power in place of his mad father, George III. He became an ally of Fox, the leader of the Opposition Party in Parliament, and the public resented his behaviour. In this print, however, Rowlandson criticises Pitt, the Prime Minister, and the king's ministers for keeping the prince from the throne. Pitt had been offered £50,000 by the City of London if he would resign from office; the offer was doubled within two days but was refused by the minister. Here, Pitt is placed in the chair of the President of the Company of Surgeons – in similar fashion to that in which Hogarth placed his surgeon in *The Reward of Cruelty* – with his wand or pointer directed towards the prince's heart, indicating that this should be removed: 'the good qualities of his heart will

utterly ruin our plan therefore cut that out first', are the words issuing from Pitt's mouth. Other ministers have their knives ready; amongst them, Grafton, at the prince's feet, with a knife in each hand. He has one foot placed on a bag of surgeons' tools from which a saw and pair of shears are falling. The implements are familiar as are the determined features of the 'dissectors', apart from the one at the prince's head: he represents Thurlow and his attitude epitomises his temporising nature.

Such words as 'corrupt' and 'putrid' were often felt to be appropriate when applied to aspects of government and of ministers and members of parliament. Visual puns from the field of anatomy were not lost to the designers of popular prints.

II. REMEMBER THOU SHALT DIE

> And come he slow, or come he fast,
> It is but Death who comes at last.
> Sir Walter Scott, *Marmion*, c.II.xxx

The fine line between life and death, which seems to be epitomised by the surgeons' practices, has been depicted traditionally by artists in 'Dance of Death' scenes.

Death as a topic of social conversation seems to be taboo in many parts of Britain in spite of the fact that it is an ever-present feature of our collective lives. When death occurs, it must be unobtrusive, clinical and tidy, and impinge as little as possible on the rest of society.

It was not always so. Attitudes have changed since early modern times, when contemplation of, or, in some cases, celebration of death as part of life was aided by means of paintings of the deceased, the use of mourning rings and jewellery, the sending of black-bordered cards and invitations to the funeral. The practising of such funeral rites conferred some therapeutic benefit upon the bereaved, helping to release pent-up emotions of grief, guilt, love and fear. Underlying all was a potent reminder or *memento mori* – remember thou shalt die. The corollary of this was 'repent of your sins while you have time'. This didactic theme has been at the heart of the matter in both religious and secular spheres for centuries. In early modern times a cadaverous figure or skeleton spelled out the message to those who could not read. In the late twentieth century, the image of skull and cross-bones needs no explanation. The certainty and proximity of death, especially at times of great epidemics, were demonstrated so that everyone would be prepared and work out their own salvation to attain eternal life by leading a better life on earth and passing through a 'good' death.[15]

For centuries the terms 'Dance of Death' and *Danse Macabre* have been

used to describe artistic representations in which a number of people, portrayed as both living and dead, play a part. The participants are traditionally arranged in some kind of order of social rank or hierarchy, starting with those at the top such as a pope, cardinal and archbishop, or emperor, king and duke, and ending with the more lowly members of society, with members of the clergy and the laity alternating.

The earliest known representation of this kind is a cycle of forty pictures, produced in 1424–5, which decorated the walls of the cemetery of the Holy Innocents in Paris, in which the figures – all male – were arranged in their social order of precedence forming a kind of dance or procession round the cemetery. The figures were usually arranged in pairs, each pair representing the living and the dead, the latter being depicted as cadaverous figures, partly skeletal and partly mummified, with grinning skulls and worm-infested gaping abdomens – as they would become after death. Sometimes the dead individual would be naked and sometimes draped in a shroud; invariably he would be leading a reluctant partner by the hand in an attempt to persuade him to join him in the dance, presumably to the grave. The paintings were accompanied by apt verses written as a dialogue between the living and the dead.

Around the inside of the cemetery walls were cloisters consisting of about eighty arches in which were tombs of many wealthy and distinguished citizens. Above the cloisters were a number of garrets. Space in the burial ground was scarce, and as graves became filled, skulls and other bones were exhumed and placed in the garrets. In time, a vast number of skulls and other bones accumulated and these could be viewed by the citizens of Paris, many of whom used the cemetery as a place of recreation or even as a place in which to conduct their trade or business affairs.[16] It was clear to all that death reduced everyone, of whatever social class, to a similar state, often without warning.

The theme of the *Danse Macabre* was repeated in other parts of Europe, including Britain. At Hexham Priory in Northumberland, four painted panels have survived from a series painted in the fifteenth century; they represent a pope, emperor, cardinal and king, each accompanied by his dead counterpart. The dead are partly skeletal and partly mummified with grinning skulls, as in the Paris scenes, and they seem to be taunting the living, one attempting to remove a hat and another brandishing a scythe – Death's fatal weapon in allegory.

By the sixteenth century when Hans Holbein produced his famous woodcuts, *The Dance of Death*, the cadaverous figure accompanying his live partner had been replaced by a skeleton personifying Death itself. Free of skin and mummified flesh, he seemed to have found a new freedom of movement; he leapt and danced and took perverse and sometimes erotic pleasure where he liked, taunting his victim and usurping any powers that the latter may have

had.[17] 'Death' led the dance and enticed his reluctant victim. His image was still used in a didactic way to emphasise the transient nature of the human body and of all earthly things. One never knew when Death might appear. Even those who could not read understood the underlying message. Holbein did not adhere strictly to an order of precedence for his characters, who could be viewed separately or in pairs of prints, as opposed to processing round the walls of a cemetery or in panels in a church, but all classes of society were included in his images and, as previously, nobody could escape Death's clutches. Holbein completed his series in 1526, and by the time of his death in 1543 his 'Dance of Death' scenes were famous throughout Europe.

Since Holbein's day there have been many portrayals of Death as a skeleton. Single prints portraying him claiming his victim cannot be described as traditional 'Dance of Death' images, but they were loosely based on the original concept. Scenes entitled 'Dances of Death' were still being published in Britain in the late eighteenth and early nineteenth century. Newton's *Dances of Death* was published in 1796, and one designed by G. M. Woodward and etched by Isaac Cruikshank, *The Dance of Death Modernised* (BM 11125), was probably published at about the same time. The latter comprises twenty-four stereotyped individuals arranged in four rows of eight figures, each being accosted and sometimes taunted by Death as he or she – as in this series, females take part in the dance – is led to the grave. The characters range from a king to a beggar and include a bishop, a lawyer, a clergyman, a bawd and a young lady, in no particular order of precedence, although all ranks of society, both lay and secular, are included in the procession in traditional fashion. Each individual offers some reason for his or her reluctance to accompany Death. The doctor, with cane held to his nose, complains, 'Here's fine encouragement for the Faculty'. One participant refers to the quack, Dr Buzaglo, complaining that his exercises were 'nothing to this' (see p. 191). Above the last of the series, Death and a beggar dancing hand in hand, are the words, 'This is the Universal Dance from a King to a Beggar!'

At this time anatomical dissections, proceedings which were often open to the public, enhanced the impact of the gruesome images that artists used. The live body and the skeleton were no longer completely separated as they had been in mere images; the skeleton could be seen to be part of the living body. Artists used the symbolism as a powerful ally in order to convey a social, political or moral message, or used it in a traditional way to add meaning to a painting. Rowlandson, as has already been shown, produced many drawings using this feature in relation to anatomisation and surgery. He also used it in association with such practices as debauchery, prostitution, quackery and gin-drinking, which were all seen as allies of Death. Popular perceptions of the ineffectiveness of doctors and of their dubious practices did not escape

from the relationship and received similar treatment at his hands. Whereas artists such as Hogarth hoped to convey a moral message by this means, as in *The Reward of Cruelty* and in 'The Consultation' scene from *Marriage-à-la-Mode*, Rowlandson's portrayals were more likely to satisfy his propensity for tragi-comic humour and public entertainment. They do, though, reflect some of the social and medical activities that were taking place.

A popular series of such prints by Rowlandson was published in 1815–16 by Ackermann, entitled an *English Dance of Death*. This again is based on the original concept of the *Danse Macabre* and is described on the title-page as the 'representation of one or more Skeletons, sometimes, indeed in Grotesque Attitudes, and with rather a comic effect, conducting Persons of all ranks, conditions and Ages, to the Tomb.' Each scene is accompanied by a verse which was provided independently by William Combe (who produced the verses to accompany Dr Syntax on his 'Travels'), who spent some years in prison. Ackermann provided the link between the two men who never met each other. The original series consisted of 74 full-page colour prints. Three prints appeared each month from 1 April 1814 to 1 March 1816.[18] Members of the medical profession did not escape censure in this series.

One of these prints was aimed at the apothecaries, many of whom cheated their clients with adulterated drugs and cheap substitutes. Roderick Random laid this charge against his master, Mr Lavement, a French apothecary to whom he acted as journeyman in Smollett's *Adventures of Roderick Random*. He said of this gentleman:

> his expence for medicines was not great, he being the most expert man at a succedaneum, of any apothecary in London, so that I have sometimes been amaz'd to see him without the least hesitation, make up a physician's prescription, though he had not in his shop one medicine mention'd in it.[19]

Rowlandson's print *Death and the Apothecary* or *The Quack Doctor* [106], shows a benevolent-looking, well-nourished apothecary in his shop filling up medicine bottles from one of his recipes, whilst an assortment of ailing clients wait for his attention. A gouty individual seated on the right is looking over his shoulder in horror to see a skeleton wearing an apron and turning a pestle in a mortar labelled 'SLOW POISON'. It is leering at him through a mirror in front of it. Hanging from the ceiling is the ubiquitous dried fish or quack emblem, and various tools of the trade line the shelves and occupy the curtained-off area near the skeleton. Accompanying words from the Apothecary state: 'I have a secret Art, to cure / Each Malady, which men endure.' He gives this advice to the ladies,

> These Pills within your chamber keep,
> They are decided friends to sleep,

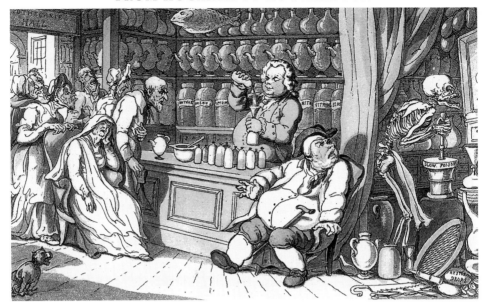

106. THOMAS ROWLANDSON: *Death and the Apothecary*, or
The Quack Doctor

And, at your meals, instead of wine,
Take this digestive Anodyne.
Should you invigoration want,
Employ this fine Corroborant.
These curious Panaceas will
If well applied, cure every ill.
So take them home; and read the bill,
Which with my signature at top,
Explains the medicines of my shop.
On these you may have firm reliance;
So set the college at defiance.
And should they not your health restore,
You now know where to send for more.

Reference has already been made to *Death in the Nursery* [44], another
scene from the series, which portrays a skeleton with a tender expression on
his face as he regards his small victim and rocks the cradle. The nurse in
charge sleeps nearby in a drunken stupor. Yet another scene illustrates a
quack doctor in partnership with the undertaker. The latter bemoans his fate
at the doctor's demise:

A Doctor, who the art had found,
Sometimes, to make a sick man sound;
And also had a cunning trick,
As often to make sound men sick;
While his Specific, Sov'reign Pill,
To cure all ails – would sometimes kill;
As he was one day riding home,
Death fancied to be frolicsome;
And leaping on this Doctor's back,
Sat close and snugly, at his back;
And, as they reach'd NED SCREWTIGHT's door,
Death sneez'd – and NOSTRUM was no more.
NED bellow'd, as he view'd the sight,
Which put the street into a fright.
This day I never wish'd to see –
Unlucky for my trade, and me –
His wife exclaim'd – what's all this rout?
Here, bring him in and lay him out.
What's got into your foolish Nob?
The man is dead – and you've a Job –
SCREWTIGHT hung down his head and sigh'd.
– You foolish woman, he replied,
– Old Nostrum, there, stretch'd on the ground,
Was the best friend I ever found.
The good man lies upon his back;
And trade will now, be very slack.
– How shall we Undertakers thrive
With Doctors who keep folks alive?
You talk of jobs – I swear 'tis true,
– I'd sooner do the job for you.
We've cause to grieve – say what you will;
– For, when Quacks die, – they cease to kill.[20]

In the same scene a young lady beckons to Death to assist her with her elderly infirm partner, who makes his way towards the shop labelled 'Deadus Best/ Cordial Gin'.

These scenes convey in light-hearted fashion the prevalence of death in many situations. The artist's unconventional style emphasises the social disorder and unruliness that was present in life, and his skeletal figure of Death contributes to the ultimate disruption of the established order. Death could 'cock a snook' at anyone at any time in any place and none could say him nay. He was the perfect reactionary figure, who might be envied by all: he

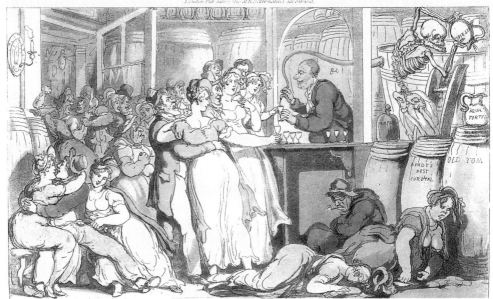

107. THOMAS ROWLANDSON: *The Dram Shop*

could overthrow monarchy, defeat enemies, carry off young ladies, creep unnoticed into any nook and cranny, perform unseemly or lewd acts, and hide all his secrets in the grave.

Some of Rowlandson's single prints contain this skeletal symbol, for example, *The Dram Shop* [107], in which the evils of drink are displayed. This is a topic portrayed also by George Cruikshank in less humorous style in *The Gin Shop* (described on p. 131). A doctor keeping Death at bay by means of a clyster pipe or rectal syringe is the subject of the print *The Doctor Dismissing Death*, published in 1782. Here, a skeleton is entering a room through a cottage window and receiving the contents of the doctor's syringe. The print seems to be indicating the paucity of the doctor's defences on behalf of his patient in the face of Death. As an indication that a doctor's defences may be hopeless, and may even assist the enemy, a skeletal figure holds aloft a box of pills to greet the doctor as he visits a patient in another illustration on this theme.

The skeletal figure of Death pervaded the thoughts of patients in many circumstances. As was shown in Chapter 6, the hypochondriac's imagination could play deathly tricks, but death was close in reality and perhaps just accepted as 'part of life'. Certainly Rowlandson included it in his panoply of life, and his tragi-comic portrayals may have helped to 'take the sting out of death'.

Many factions could appropriate Death's symbolic figure. An anonymous

[294]

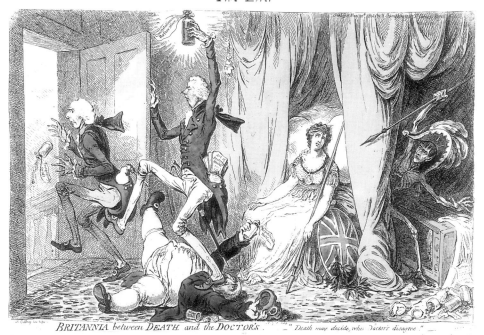

BRITANNIA *between* DEATH *and the* DOCTORS . _ " *Death may decide, when Doctors disagree* " _

108. JAMES GILLRAY: *Britannia between Death and the Doctors*

print entitled *The Siege of Warwick lane or The Battle between Fellows and Licentiates*, *c.*1768, portrays the President of the Royal College of Physicians as a bewigged, skeletal figure representing 'Death'. He and his 'Fellows' are being subjected to an invasion of tartan-clad Scottish medical practitioners firing clyster pipes and verbal abuse and wielding traditional Scottish weapons. These 'warriors' led by 'Folly' are seen invading the exclusive sanctity of the rooms at the College in Warwick Lane, where the skeleton and his elderly colleagues are being used to symbolise the old and obsolete ideas prevailing there. Medical practitioners from outside the traditional training grounds of Oxford and Cambridge could only become Licentiates of the College. Graduates of the increasingly enlightened Scottish universities – as far as clinical medicine was concerned – demanded the right to become Fellows (see Chapter 1).

The skeleton was a useful figure politically. In different guises he could be a powerful ally for polemicists. One role in which he was frequently cast in the early nineteenth century was that of Napoleon. For example, a skeletal Napoleon is threatening a bed-ridden Britannia as politicians squabble about effective means of resuscitation for the country in *Britannia between Death and the Doctors* [108] William Pitt, as one of a triumverate of disagreeing doctors, holds up his own medicine, 'Constitutional Restorative', as he kicks

the outgoing prime minister, Henry Addington, with his 'Composing Draft', out of the door and tramples upon his political rival, Fox, with his remedies of 'Whig Pills' and 'Republican Balsam'. Ailing Britannia, for whom the remedies are intended, is shown being threatened by an arrow wielded by a skeletal Napoleon.

Addington was nicknamed 'The Doctor' because he was supposed to have gleaned some medical knowledge from his father, who was a medical man. The accoutrements of his 'profession' accompanied him in many caricatures and it has been estimated that he appeared in more than 130 political prints in some form of medical role.[21] The political or social message conveyed would have meant little if the medical symbolism were not clear.

Examples of the skeleton on tombstones, sometimes with an hour-glass as a symbol of the passing of time, with a scythe as his weapon, a dart or arrow as a symbol of disease, or with some symbol of mortality, can be seen in churches and graveyards throughout the British Isles. St Magnus Cathedral in Kirkwall in the Orkneys contains some particularly well-preserved examples. Here also, hanging in the north aisle of the nave, is a seventeenth-century wooden memorial sign, known as the 'Mort Brod'. This bears a rhyming inscription on one side and a shrouded skeleton holding an hour-glass on the other, and the words *Memento Mori*. An eighteenth-century plaque in St Oswald's Church in Cumbria reads, 'One eye on death, the other fixed on high / Will teach thee reader both to live and die.'

Not until the second half of the nineteenth century was the doctor dissociated from Death in caricatures. This change was partly due to the changing perception of the doctor's worth and acknowledgement of his increasing skill and knowledge.[22] Until then, the words in Hogarth's print of *The Company of Undertakers* still rang true in many people's thoughts: *Et Plurima mortis imago*.

References

PREFACE

1. M. Dorothy George, *Hogarth to Cruikshank: Social Change in Graphic Satire* (London: Allen Lane, 1967), p. 13.

INTRODUCTION

1. Quoted from Hogarth's original MSS, compiled by John Ireland and John Nichols, *Hogarth's Complete Works* (London, n.d.), III, p. 30. Henceforth cited as Ireland & Nichols.
2. Ronald Paulson, *Representations of Revolution, 1789–1820* (New Haven and London: Yale University Press, 1983), p. 184.
3. Roy Porter, 'Past and Present; Seeing the Past', *Journal of Historical Studies*, 118 (February 1988), p. 190.
4. Ibid.
5. Paulson, *Representations of Revolution*, p. 187.
6. William C. Butterfield, 'The Medical Caricatures of Thomas Rowlandson', *Journal of the American Medical Association*, 224:1 (April 1973), p. 113.
7. Diana Donald, 'Characters and Caricatures: The Satirical View', in Nicholas Penny (ed.), *Reynolds* (London: Royal Academy of Arts, 1986), p. 248.
8. Roy Porter, *English Society in the Eighteenth Century* (Harmondsworth: Penguin, 1982; revised edn 1990), p. 248.
9. Paulson, *Representations of Revolution*, pp. 158–160.

1: SETTING THE MEDICAL SCENE

1. Two copies of this Act of 1511 are entered on the roll – nos 18 & 22. The text is printed from the former *An Act concerning Phesicions & Surgeons*, the third year of the reign of Henry VIII. *Statutes of the Realm* 1511, ch. II.
2. R.M.S. McConaghay, 'The History of Rural Medical Practice in Britain', in F.N.L. Poynter (ed.), *The Evolution of Medical Practice in Britain* (London: Pitman, 1961), p. 124.
3. Act of 1540 *conc'ning Barbers and Chirurgians Statutes of the Realm*, ch. XLII, p. 794.
4. Sir George Clark, *The History of The Royal College of Physicians of London* (Oxford: Clarendon Press, 1966), 1, p. 122.
5. *Statutes of the Realm* 1542, p. 906.

6. Juanita G.L. Burnby, 'A Study of The English Apothecary from 1660–1760', *Medical History* (London: Wellcome Institute, 1983), Supplement No. 3, p. 5.
7. Clarke, *History*, 2, pp. 476–9.
8. Derek Jarrett, *England in the Age of Hogarth* (St Albans: Paladin, 1974), p.192,
9. Ivan Waddington, 'The Struggle to Reform the Royal College of Physicians 1767–1771', *Medical History*, 17 (April 1973), p. 116.
10. Roy Porter, 'Disease, Medicine and Society in England 1550–1860', *Studies in Economic and Social History* (London: Macmillan, 1987), pp. 35–9; for a brief survey of hospital development, see also Joan Lane, 'The role of apprenticeship in eighteenth-century medical education in England' in Bynum & Porter (eds), *William Hunter and the eighteenth-century medical world*, p. 82.
11. J. S. Purvis, *An Introduction to Ecclesiastical Records* (London: St Anthony's Press, 1953), p. 49.
12. Irvine S. Loudon, 'The Nature of Provincial Medical Practice in Eighteenth-Century England', *Medical History*, 29 (1985), 1–32.
13. *British Encyclopaedia*, Ninth Edition, Vol. XIV, p. 821.
14. N. Jewson, 'Medical Knowledge and the Patronage System in Eighteenth Century England', *Sociology*, XIII (1974), pp. 369–85.
15. Douglas Guthrie, *A History of Medicine* (London: Nelson, 1945), p. 239.
16. W. F. Bynum, 'Treating the Wages of Sin', in Bynum & Porter (eds), *Medical Fringe and Medical Orthodoxy*, pp. 9–12.
17. Early Greek philosophers had recognised four natural elements – hot, cold, dry, moist – with associated qualities, and these combinations made up the four humours: hot and moist = blood; cold and moist = phlegm; hot and dry = yellow bile; cold and dry = black bile. These became associated with human temperaments: sanguine, phlegmatic, melancholic and choleric. Disease was thought to be caused by imbalance of humours, and treatment was designed to restore the correct balance.
18. An issue was an artificially produced ulcer or wound which was kept open and discharging by means of inserting small objects such as pieces of thread. The resulting discharge was supposed to be the bad humours from the blood draining out.
19. Quoted in Loudon, 'The Nature of Provincial Medical Practice', p. 21.
20. Roy Porter, 'Disease, Medicine and Society in England 1550–1860', p. 34.
21. Ibid. p. 35.
22. M. Dorothy George, *London Life in the Eighteenth Century* (Harmondsworth: Penguin, 1985), p. 62.
23. Ruth McClure, *Coram's Children* (New Haven and London: Yale University Press, 1981).
24. Jewson, 'Medical Knowledge and the Patronage System', p. 379.
25. Samuel Johnson, *Dictionary of the English Language*, 1785.
 'Quack' = (v.) To chatter boastingly; to brag loudly; to talk ostentatiously.
 (n.)1. A boastful pretender to arts which he does not understand.
 2. A vain boastful pretender to physick; one who proclaims his own medical abilities in publick places.
 3. An artful tricking practitioner in physick.
 (to physick = to purge; to treat with physick; to cure.)
26. Roy Porter, *Health for Sale: Quackery in England 1660–1850* (Manchester: Manchester University Press, 1989), p. 116.

27. Bynum, 'Treating the Wages of Sin', p. 18.
28. Porter, *Health for Sale*, p. 187.
29. Roy Porter, 'Before the Fringe', *History Today* (November 1986), pp. 17–18.
30. The advertisement of patent medicines was noted also by William Rowley in his pamphlet *Cow-Pox Inoculation*, where he mentions that public papers carried advertisements for 'Velno's Syrup' as a cow-pox cure.

 It was widely thought that doctors welcomed any increase in their workload, without regard to their patients' discomfort or their purses, as long as their own revenues increased. This is the theme of a print entitled *Address of Thanks to Influenza* (1803), in which several medical practitioners are presenting an address of thanks to a flu-ridden patient. They hope that on his recovery he will have left some of its 'relics' or infection behind. Each doctor is claiming unique benefits from his favourite medicament, such as 'James's Powders' and 'Peruvian Bark'. One doctor states: 'My friend Mr Newberry made me a very handsome present for my recommendation of his James's powders in the newspapers.'
31. Charles E. Rosenberg, 'Medical Text and Social Content: Explaining William Buchan's "Domestic Medicine"', *Bull. Hist. Med.* 57 (1983), pp. 22–42.
32. Ireland & Nichols, II, p. 264.
33. Oliver Goldsmith, *She Stoops to Conquer*, Act 2, Scene i, ll. 590–4.
34. Jarrett, *England in the Age of Hogarth*, p. 149.
35. Quoted from Rosenberg, 'Medical Text and Social Content', p. 27.
36. Guthrie, *A History of Medicine*, p. 260; see also: F. F. Cartwright, *A Social History of Medicine* (London: Longman, 1977).

2: MEDICAL IMAGES IN HOGARTH'S LONDON

1. Oliver Goldsmith, *The Vicar of Wakefield* (1766; Harmondsworth: Penguin, 1985), p. 116.
2. BM 1779. This and all subsequent BM numbers refer to M. Dorothy George's *Catalogue of Political and Personal Satires* (London: British Museum, 1935).
3. 'The Weekly Journal' London, 19 November 1726, from *The Caledonian Mercury* (Edinburgh), No.1036, 5 December 1726.
4. 'In a letter from a Gentleman at Guildford, to his friend a Physician in Ipswich, Suffolk, The Wonder of Wonders: or, a True and Perfect Narrative of a Woman near Guildford in Surrey, who was delivered lately of Seventeen Rabbits and Three Legs of a Tabby Cat, etc.', Ipswich, 1726. From *Tracts Relating to Mary Toft* in the British Library.
5. John Pechey, *The Compleat Midwife's Practice Enlarged* (fifth revised edn, London, 1698), p. 58; quoted in Paul-Gabriel Boucé, 'Imagination, pregnant women, and monsters, in eighteenth-century England and France', in Rousseau & Porter (eds), *Sexual Underworlds of the Enlightenment*, p. 92.
6. Boucé, ibid., p. 86.
7. C. Ahlers, *Some Observations concerning the Woman of Godliman in Surrey, made at Guildford on Sunday, November 20, 1726. Tending to prove her extraordinary Deliverance to be a Cheat and Imposture.*
8. J. Howard, 'An Abstract of the Letter from Mr. Howard, the Man Midwife and Surgeon at Guildford dated November 22th, 1726', from *Tracts Relating to Mary Toft*.

9. S.A. Seligman, 'Mary Toft the Rabbit-Breeder', *Medical History*, 5 (1961), p. 358. This paper is mainly a narrative account of the affair. Brief reference is made to popular publications in the aftermath. See also L. Lewis Wall, 'The Strange Case of Mary Toft (Who was Delivered of Sixteen Rabbits and a Tabby cat in 1726)', *Medical Heritage*, 1:3 (May/June 1985), pp. 199–211; also Dennis Todd, 'Three Characters in Hogarth's "Cunicularii" – and some implications', *Eighteenth Century Studies*, 16 (1982), pp. 26–46.

10. Sir R. Manningham, *An exact Diary of What was Observed during a Close Attendance upon Mary Toft, The Pretended Rabbet Breeder of Godalming in Surrey from Monday, November 28th., to Wednesday, December 7th., following, Together with An Account of her Confession of the Fraud*, 1726.

11. Robert Halsband, *Lord Hervey, 18th Century Courtier* (Oxford: Clarendon Press, 1973), p. 16.

12. *Whitehall Evening Post*, London, 6 December 1726, in *The Caledonian Mercury*, No. 1036.

13. For example, James Douglas, *Remarks on some Passages in Sir R. Manningham's Diary* (London, 16 December 1726), in which he writes 'I begin by declaring it to have been always my firm opinion that the report was false.' In the draft MS for the printed version of his *Remarks*, he states that 'people may be led to believe that for some time at least I was of the same opinion, of which he [Manningham] candidly enough acknowledged himself to have been. . .' (12 December 1726; Glasgow University, Special Collections, Hunterian Library.) See also C. Ahlers, *Some Observations. . ..*

14. J. Ireland, *Biographical Anecdotes of William Hogarth* (London, 1781), p. 16.

15. John Nichols & George Steevens, *The Genuine Works of William Hogarth*, II (London, 1810), p. 52.

16. Keith Thomas, *Man and the Natural World* (London: Allen Lane, 1983), pp. 35–9 in particular.

17. Laurence Sterne, *The Life and Opinions of Tristram Shandy* (1759–67; Harmondsworth: Penguin, 1987), pp. 35–7.

18. John Maubray, *The Female Physician* (London, 1724), p. 375.

19. J.A. Blondel, MD, *The Power of the Mother's Imagination over the Foetus Examin'd*, first published 'upon the occasion of the Cheat of Godalming' (London, 1729).

20. Daniel Turner, *De Morbis Cutaneis* (London, 1723), ch.12.

21. Henry Fielding, *Joseph Andrews* (1742; Harmondsworth: Penguin, 1988), p. 216.

22. Tobias Smollett, *The Adventures of Peregrine Pickle* (1751; Oxford University Press: World's Classics, 1983), p. 21.

23. Paul-Gabriel Boucé, 'Imagination, pregnant women, and monsters, in eighteenth-century England and France', pp. 86–99.

24. *Apocrypha*, 2 Esdras 5:8.

25. Charles LeBrun, 'Conférence de M.LeBrun sur l'expression générale et particulière' (Paris, 1698), trans. John Williams, 1734; Augustan Reprint Society 200–201 (Los Angeles: William Andrews Clark Memorial Library, 1980).

26. Grose's *A Classical Dictionary of the Vulgar Tongue*.

27. Fielding, *Joseph Andrews*, p. 158.

28. Seligman, 'Mary Toft the Rabbit-Breeder', p. 359. In another publication

Much Ado About Nothing (? by Jonathan Swift) – supposedly a 'confession' made under the pseudonym 'Merry Tuft', 'in her own words' – Manningham is described as 'an ugly old gentleman in a grate blak wig'.

29. Todd, 'Three Characters in Hogarth's "Cunicularii" ', p. 43.
30. Ronald Paulson, *Hogarth's Graphic Works* (New Haven & London: Yale University Press, 1989) p. 69.
31. Thomas, *Man and the Natural World*, p. 98.
32. Samuel Butler, *Hudibras*, Part III, Canto I, lines 365–6.
33. Nichols & Steevens,*The Genuine Works of William Hogarth*, I, p. 37.
34. Ibid., p. 51.
35. Nichols & Steevens, *The Genuine Works. . .*, II, p. 49.
36. Ronald Paulson, *Hogarth. His Life, Art and Times* (New Haven & London: Yale University Press, 1971), II, p. 354.
37. 'W—lk—r' may refer to Middleton Walker, a surgeon and man-midwife who was summoned before the censors of the Royal College of Physicians c.1728 because he was not a Licentiate of the College. See Clark, *History of The Royal College of Physicians of London*, 2, p. 502.
38. George, *Catalogue*, p. 637.
39. Nichols & Steevens, *The Genuine Works. . .*, I, pp. 28–30; Shearer West, 'The Theatrical Portrait in Eighteenth-century London' (Ph.D. thesis, St Andrews University, 1986), pp. 22–3. In 1724 Hogarth issued a satirical print, *A Just View of the British Stage*, in which he ridiculed Cibber, Booth and Wilkes at Drury Lane for their obsession with profitable but soulless pantomimes; Ben Jonson's ghost rises in horror. In Hogarth's print *Masquerades and Operas*, the plays of Congreve, Shakespeare and Jonson are consigned to the waste-paper basket as the public flock to see *Harlequin Dr. Faustus*.
40. The 'Anodyne Necklace' was advertised, as in the *Craftsman* of 2 December 1732 in which it was said to have 'curative powers for Children's Teeth, Fits, Fevers, Convulsions etc. and the great specific remedy for the Secret Disease'. See Francis Doherty, 'The Anodyne Necklace: A Quack Remedy and its Promotion', *Medical History*, 1:3 (1990), pp. 268–93. See also Hogarth's print *The Death of the Harlot*, Plate 5 of the series *A Harlot's Progress*.
41. K. Bryn Thomas, *James Douglas of the Pouch and his pupil W. Hunter* (London: Pitman, 1964), p. 198, refers to Douglas's presentation of 'The Natural History of the Flamingo' to the Royal Society and the publication of this lecture in *Phil. Trans.*, xxix, 523, 1714/16.
42. British Museum pamphlet 1178, h, 4 ; Special Collection of Douglas's writings in Glasgow University Library, MS D336(2). See also Denis Todd, 'New Evidence for Dr. Arbuthnot's Authorship of "The Rabbit-Man-Midwife" ', *Studies in Bibliography*, 41 (1988), pp. 257–67.
43. [Swift, Jonathan], *The Anatomist dissected or the Man-Midwife finely brought to Bed. Being an Examination of the Conduct of Mr. St. André Touching the late pretended Rabbit-bearer as it appears in his own Narrative,* by Lemuel Gulliver, Surgeon and Anatomist to his Majesty with a proper Regard to his intended Recantation (London, 1727). 'Touching' refers to the clinical vaginal examination of a woman by "introducing the forefinger lubricated with pomatum into the vagina, in order to feel the Os Internum and neck of the uterus; and sometimes into the rectum to discover the stretching of the Fundus

. . ." – William Smellie, *A Treatise on the Theory and Practice of Midwifery* (London, 1752). See also Porter, 'A Touch of Danger: The Man-midwife as sexual predator' in Rousseau & Porter (eds), *Sexual Underworlds of the Enlightenment*, pp. 206–32.

44. William Rowley, *Cow-Pox Inoculation No Security Against Infection* (1805).

45. Thomas Braithwaite, *Remarks on A short Narrative of an Extraordinary Delivery of Rabbets, perform'd by Mr.John Howard, Surgeon at Guildford. As publish'd by Mr. St. André Anatomist to His Majesty with a proper Regard to his intended Recantation* (London, 1726).

46. *The Craftsman*, Vol.I, No.III, 'Being a Critique on the Times', ed. Caleb D'Anvers (London, 1727). 'Caleb D'Anvers' was a fictitious name for Nicholas Amhurst; he was part of an anti-Walpole faction and an associate of Hogarth's (see Paulson, *Hogarth. His Life, Art and Times*, I, p. 173).

47. Nigel Llewellyn, *The Art of Death: Visual Culture in the English Death Ritual c.1500–1800* (London: Reaktion Books in association with the Victoria and Albert Museum), p. 61.

48. Ibid. p. 74.

49. Charles Mackinnon, *The Observer's Book of Heraldry* (London: Warne & Co., 1966), p. 30.

50. Quoted from Paulson, *Hogarth's Graphic Works*, p. 173; the phrase comes from the *Aeneid* II, l.369.

51. Jonathan Swift, *Gulliver's Travels* (1726; Harmondsworth: Penguin, 1987), pp. 301–2.

52. Norman B. Gwyn, 'An Interpretation of the Hogarth Print "The Arms of the Company of Undertakers" ', *Bull. Hist. Med.* (1940), pp. 115–27.

53. George, *From Hogarth to Cruikshank*, p. 92.

54. Gwyn, loc. cit.

55. Paulson, *Hogarth's Graphic Works*, p. 174.

56. F. Foster, 'William Hogarth and the Doctors', *Bulletin of the Medical Libraries Association*, 32 (1944), p. 363.

57. *Munk's Roll*, Royal College of Physicians, 1878.

58. Foster, loc. cit.

59. Johannes de Ketham, *Fasciculus di Medicinae* (Basel, 1493).

60. J. Ireland, *Hogarth Illustrated* (London, 1812), II, p. 301.

61. Hogarth's footnote refers to Guillim, a famous English writer on heraldry.

62. Leslie G. Matthews, 'Day Book of the Court Apothecary in the Time of William and Mary, 1691', *Medical History*, 22 (1978), p. 173.

63. Eric Jameson, *The Natural History of Quackery* (London: Michael Joseph, 1961), p. 168.

64. *The London Stage 1660–1800; A Calendar of Plays, Entertainments and Afterpieces . . . with contemporary comment*, Part 3: 1729–1747, ed. A.H. Scouten, II, p. 607.

65. 'Grubstreet Journal', *Gentleman's Magazine*, 22 December 1737.

66. 'Grubstreet Journal', *Gentleman's Magazine*, 19 December 1734, p. 665: 'The Drop.Recip.Butyr.Antimon.Unc.2.Crem.Tartar. Unc.4.M.et Coq.in Aq.Com.q.s.per octo horas.deinde adde gradatim Ol.Tart.p.Deliq.Unc.4.Cola & Evapora ut paretur Sal.quod Fluat. p. Deliq.Capiat hujus a gut.j.ad plures, in hansiulo vini albi cujuslibes mollioris.' 'The Pill is said to be no other than

the Vitrum Antimonii, formed with the Drop into small Pills, each of a Grain weight.'

67. 19 December 1734, p. 665.
68. Ibid., p. 670.
69. Roy Porter, 'Before the Fringe: Quack Medicine in Georgian England', *History Today* (November 1986), p. 18. Radcliffe had left a 'Foundation' to promote the search for knowledge among aspiring young practitioners.
70. Rupert Gunnis, *Dictionary of British Sculptors: 1600–1851* (London: Odhams Press, 1968), p. 81.
71. Jameson, *The Natural History of Quackery*, pp. 81–94.
72. William Feaver, *Masters of Caricature* (London: Weidenfeld and Nicolson, 1981), p. 41.
73. Charles John Samuel Thompson, *The Quacks of Old London* (London: Brentano's, 1928), pp. 303–6.

3: THE ITINERANT QUACK

1. Ronald Paulson, *Hogarth's Graphic Works*, p. 154.
2. *The London Stage*, Part 2: 1700–1729, ed. E.L. Avery, Introduction, p. lxxxviii.
3. M. Dorothy George, *English Political Caricature to 1792*, p. 83.
4. P. Hartnell & P. Found, *The Concise Oxford Companion to the Theatre* (Oxford University Press, new edn, 1992), pp. 101–3.
5. *B.M. Catalogue*, Vol.II: 1689–1733, p. 840.
6. Quoted in David Bindman, *Hogarth* (London: Thames and Hudson, 1988), pp. 88–9.
7. H.W. Janson, *Apes and Ape-Lore in the Middle Ages and the Renaissance* (London: Warburg Institute, 1952); chs 1, 2, 4 and 7 describe the evolution from 'simian sinner' to 'simian fool'.
8. *Gentleman's Magazine*, XVIII (1748), 'Pharmocopoeia Empirica', pp. 348–50.
9. Sean Shesgreen, *Hogarth and the Times-of-the-Day Tradition* (Ithaca and London: Cornell University Press, 1983), pp. 89–133.
10. Ibid., p. 125.
11. Oliver Goldsmith, 'Letters from a Citizen of the World to his Friends in the East', Letter XXIV c.1761, from *The Works of Oliver Goldsmith* (Edinburgh, 1872), p. 202.
12. Daniel Defoe, *Journal of the Plague Year* (1722; London: Dent/Everyman, 1969), p. 33.
13. Thomas Wright, *Caricature History of the Georges* (London: Chatto and Windus, 1904), p. 229.
14. Paulson, *Hogarth. His Life, Art and Times*, II, pp. 145–52.
15. Samuel Johnson, *Dictionary of the English Language*, 1785.
16. Paulson, see n.14 above.
17. Ireland & Nichols, III, p. 41.
18. Tobias Smollett, *The Life and Adventures of Sir Launcelot Greaves* (1760–1; London: Oxford University Press, 1973), p. 30.
19. Joseph Grego, *Rowlandson: The Caricaturist* (London: Chatto & Windus, 1880), II, p. 5.
20. Rowlandson produced an album entitled 'Comparative Anatomy,

Resemblances Between the countenances of Men and Beasts'. See Robert Wark, *Drawings of Thomas Rowlandson in the Huntington Collection* (San Marino, California: Huntington Library, 1975), p. 116.

21. Jan Steen produced many paintings of the physician with his patient. The physician was usually depicted as a learned, well-dressed gentleman, complete with urine flask, and sometimes palpating his wealthy patient's pulse.

22. J.M. Adair, *Essays on Fashionable Diseases* (London, 1790), Essay IV 'On Empiricism, or Quackery', p. 185.

23. Roy Porter, 'I think ye Both Quacks', in Bynum & Porter (eds), *Medical Fringe & Medical Orthodoxy 1750–1850*, p. 77 n. 15.

24. Ibid., p. 56.

25. Donald Posner, 'Watteau's Reclining Nude and the "Remedy" Theme', *Art Bulletin*, 54 (December 1972), pp. 383–9.

26. For assessment of the political situation with regard to Bute's policy and influence, see J.H. Plumb, *The First Four Georges* (London: Collins/Fontana, 1967).

27. 'Horace Walpole's Correspondence with Sir Horace Mann', 21 October 1764. W. S. Lewis (ed.), *Horace Walpole's Letters*, VI (London: Oxford University Press, 1960), p. 257.

28. Wright, *Caricature History of the Georges*, p. 230.

29. See *Hudibras* Plate IX, 'The Committee', from Revd J. Trusler & E.F. Roberts (eds), *The Complete Works of William Hogarth* (London: Mackenzie, n.d.).

30. Swift, *Gulliver's Travels*, pp. 232–34.

4. A POX ON YOU ALL

1. Michael Godby, 'The First Steps of Hogarth's *Harlot's Progress*', *Art History*, 10:1 (March 1987), pp. 23–7.

2. Ireland & Nichols, I, p. 102.

3. Ibid., p. 115, and Paulson, *Hogarth's Graphic Works*, p. 148. One of the doctors is sometimes named as Dr Ward, but he did not appear in London until 1733.

4. Henry Fielding, *The History of Tom Jones* (1749; Harmondsworth: Penguin, 1987), p. 609. Dr Misaubin in the same novel is said to comment, 'Bygar, me believe my pation take me for de undertaker: for dey never send for me till de physician have kill dem' (p. 225).

5. *Gentleman's Magazine* (April 1734), Obituary, p. 218.

6. From the eighteenth-century medical herbalist S. Gould's *Special Ailments* (London: n.d.).

7. Dr Thomas Sydenham, *The Whole Works of that Excellent Practical Physician Dr. Thomas Sydenham* (London, 1705), p. 258. For further information on the treatment of venereal disease, see Bynum, 'Treating the Wages of Sin: Venereal Disease and Specialism in Eighteenth Century Britain', in Bynum & Porter (eds), *Medical Fringe and Medical Orthodoxy 1750–1850*, pp. 5–28.

8. J. Friedenwald & S. Morrison, 'History of the Enema', *Bull. Hist. Med.*, 8 (1940), part I, p. 68; part II, p. 239.

9. Porter, 'Before the Fringe: Quack Medicine in Georgian England', p. 19.

10. *Gentleman's Magazine*, V (January 1735), p. 11.

11. Ireland & Nichols, I, p. 119.
12. Sydenham, *Whole Works. . .*, p. 263.
13. Paulson, *Popular and Polite Art in the Age of Hogarth and Fielding* (Chicago & London: University of Notre Dame Press), p. 34.
14. Ireland & Nichols, I, p. 119.
15. Ibid., II. p. 7.
16. See Robert Cowley, *Marriage-à-la-Mode: a re-view of Hogarth's narrative art* (Manchester University Press, 1983), for detailed descriptions of the picture analogies.
17. This series was announced in the *London Daily Post* of April 1743 as 'representing a variety of modern occurrences in high life'.
18. Sydenham, 'A Treatise of the Gout and Dropsie' from *The Whole Works. . .*, p. 340.
19. Cowley, *Marriage-à-la-Mode*, p. 59.
20. John Freke, 'Venereal Disease of the Bones', *An Essay on the Art of Healing* (London, 1748).
21. G.C. Lichtenberg, *Hogarth on High Life* (Connecticut: Wesleyan University Press, 1970), p. 47.
22. Paulson, *Hogarth's Graphic Works*, p. 271.
23. Ireland & Nichols, II, p. 28.
24. Dr Samuel Garth, a physician, wrote this 'mock-heroic' poem about the College of Physicians in 1699. According to the preface, it was 'grounded on the Feud that happened in the Dispensary betwixt a Member of the College with his Retinue, and some of the Servants that attended there to Dispense the Medicines'. It made the College the talk of the town. See Clark, *The History of the Royal College of Physicians*, 2, p. 472.
25. O. Impey & A. Macgregor (eds), *The Origins of Museums: Cabinets of Curiosities in the Sixteenth and Seventeenth Century* (Oxford: Clarendon Press, 1985), p. 185.
26. William Shakespeare, *Romeo and Juliet*, V.i.37ff.
27. Cowley, *Marriage-à-la-Mode*, p. 91.
28. Howard Haggard, *Devils, Drugs and Doctors* (London: Heinemann, n.d.), p. 328.
29. J.C. Cooper, *An Illustrated Encyclopaedia of Traditional Symbols* (London: Thames and Hudson, 1982).
30. Haggard, *Devils, Drugs and Doctors*, p. 325. The Royal Society was requested by Charles II to investigate the properties of a cup made from rhinoceros horn, which they then pronounced useless.
31. Cowley, *Marriage-à-la-Mode*, p. 89; Matthews, 'Day Book of the Court Apothecary. . .', p. 172.
32. Lichtenberg, *Hogarth on High Life*, p. 54.
33. Dr James Parsons, *Mechanical and Critical Enquiry into the Nature of Hermaphrodites* (1741), and 'An account of some very extraordinary Tumours upon the head of a young Labouring Man in Bartholomew's Hospital, with Figures drawn from the Life', *Phil. Trans.*, 1 (1746), p. 396.
34. Michael Levey, *Marriage-à-la-Mode* (London: National Gallery, 1970).
35. R. Campbell, *The London Tradesman* (London, 1747), p. 52.
36. Michael Rein, 'History of Syphilis', in King Holmes (ed.), *Sexually Transmitted Diseases* (New York: McGraw Hill, 1990), p. 374.

37. Matthews, 'Day Book', p. 169 ref. Sydenham's 'Laudanum' was 'the first liquid generally designated Laudanum' consisting of opium, saffron, cinnamon, cloves and Canary Wine.
38. Juleps were diluted sweetened mixtures of various medicaments.
39. Cowley, *Marriage-à-la-Mode*, p. 149.
40. Daniel Defoe, *Moll Flanders*, p. 219.
41. Alexander Pope, *An Essay on Man*, Epistle IV, l.120.
42. Henry Fielding, *Amelia* (1751; Harmondsworth: Penguin, 1987), p. 21.
43. J. Ireland, *Hogarth Illustrated*, 1791.
44. T.G. Coffey, 'Beer Street: Gin Lane: Some Views of 18th-Century Drinking', *Quarterly Journal of Studies on Alcohol*, 27 (1966), p. 674.
45. Wright, *Caricature History of the Georges*, p. 114.
46. *An Act for laying a duty upon the Retailers of Spirituous Liquors, and for licensing the Retailers thereof to be enacted after 29 September 1736*.
47. Wright, *Caricature History*, p. 116.
48. Ibid., p. 115.
49. *An Act for repealing certain Duties on Spirituous Liquors, and on Licences for retailing the same, and for laying other Duties on Spirituous Liquors and on Licences to retail the said Liquors*, Act of Parliament, 1743.
50. Paulson, *Popular and Polite Art in the Age of Hogarth and Fielding*, p. 6.
51. Corbyn Morris, *Observation on the Past Growth and Present State of London* (1751), quoted by Coffey, 'Beer Street: Gin Lane', p. 671.
52. J. Ireland, *Hogarth Illustrated*, II, p. 345.
53. *A Dissertation on Mr. Hogarth's Six Prints Lately Publish'd inscrib'd to the Lord Mayor, City of London and Worshipful Court of Aldermen*, 1751.
54. George, *London Life in the Eighteenth Century*, p. 54.
55. *Gentleman's Magazine*, XIII (20 January 1743), p. 38.
56. Alvin E. Rodin, 'Infants and Gin Mania in 18C. London', *Journal of the American Medical Association*, 245:12 (March 1981), pp. 1237–9.
57. George, *London Life in the Eighteenth Century*, p. 39.
58. A report from the Middlesex Sessions Committee in 1735.
59. In 1739, Capt. Coram got the support of a number of ladies of rank who signed a memorial to the Government. A Charter was granted in 1739 which led to the establishment of the Foundling Hospital, and the Foundation stone of the main building was laid in 1742. See George, *London Life in the Eighteenth Century*, p. 56.
60. William Buchan, *Domestic Medicine*, p. 31.
61. Ireland, *Hogarth Illustrated*, II, p. 330.
62. William Combe, *The English Dance of Death, from the Designs of Thomas Rowlandson, with Metrical Illustrations by the Author of 'Dr Syntax'* (London, 1816).

5: HOGARTH AT ST BARTHOLOMEW'S HOSPITAL

1. E.H. Gombrich, *The Story of Art* (Oxford: Phaidon, 1984), p. 364.
2. J. Ireland, *Hogarth Illustrated*, III, ch. 2. See also M. Godby, 'The First Stage of Hogarth's *Harlot's Progress*', with regard to retrospective autobiographical thinking.

3. Sidney C. Hutchinson, *The History of the Royal Academy 1768–1968* (London: Chapman & Hall, 1968), p. 28.
4. N. Pevsner, *Academies of Art, Past and Present* (Cambridge University Press, 1940), p. 125.
5. Hogarth, Autobiographical Notes from *The Analysis of Beauty*, ed. Joseph Burke (Oxford: Clarendon Press, 1955); see also Hogarth's *Apology for Painters*, ed. Michael Kitson, Walpole Society 1966–1968, 41 (Glasgow: The University Press, 1968), p. 103.
6. 'An Abridgement of the Conference of M. Le Brun on Physiognomy' (London, 1734), p. 52.
7. Hogarth, *The Analysis of Beauty*, pp. 138–9.
8. J. Ireland, *Biographical Anecdotes of William Hogarth*, p. 30.
9. Twentieth-century diagnoses of the afflicted (reading from left to right across the painting) would be: cretinism (hypothyroidism); chlorosis (severe iron deficiency anaemia); blindness; jaundice; gout; mastitis (breast inflammation); rickets; myotonia congenita; congenital syphilis (baby affected before birth); gonorrhoea – gonococchal arthritis; carcinomatosis (disseminated malignant disease).
10. Francis Glisson, *De Rachitide*; *Glisson on Rickets*, trans. Nicholas Culpepper (London, 1668).
11. John Freke, 'Of the Rickets', Section II of *An Essay on the Art of Healing*.
12. Freke, 'Of Tumours proceeding from the Melancholy', Section XIII of *An Essay on the Art of Healing*.
13. Minute from the *Hospital Journal* of St Bartholomew's, 1727.
14. V.C. Medvei & J.L. Thornton (eds), *The Royal Hospital of Saint Bartholomew 1123–1973* (Ipswich: Cowell Ltd, 1974), p. 350.
15. Charles Singer & E. Ashworth Underwood, *A Short History of Medicine*, 2nd edn (Oxford: Clarendon Press, 1962), p. 644.
16. Dr Thomas Sydenham, *The Whole Works. . .*, p. 322.

6: A QUESTION OF TASTE

1. Henry Fielding, *Joseph Andrews*, pp. 196–7.
2. Iain Pears, *The Discovery of Painting: The Growth and Interest in the Arts in England, 1680–1768* (New Haven & London: Yale University Press, 1988), Introduction.
3. David Bindman, *Hogarth*, p. 67.
4. Hogarth asked his friend, Dr Hoadley, to write a poetic explanation of the *Rake's Progress*. The resultant verses were added to the appropriate prints.
5. Richard Reece, *The Medical Guide for the Use of Clergy, Heads of Families, and Practitioners of Medicine and Surgery* (London, 1812), p. 315.
6. Samuel Richardson, *Pamela* (1740; Harmondsworth: Penguin, 1985), p. 64.
7. Reece, *Medical Guide*, p. 18.
8. *Gentleman's Magazine*, V (March 1735), p. 122.
9. Alexander Pope, *The Dunciad*, 1743, Book I, ll.29–32.
10. See Richard Hunter & Ida Macalpine, *Three Hundred Years of Psychiatry 1535–1860* (London: Oxford University Press, 1963), p. 402 re. 'A Treatise on Madness' by William Battie MD (1758), and p. 411 re. 'Remarks on Dr. Battie's Treatise on Madness' by John Monro MD.

11. From 'Fog's Journal', No.443, 14 May, *Gentleman's Magazine*, VII (May 1737), pp. 289–90.
12. *Gentleman's Magazine*, XXV (1755), p. 43.
13. Quoted by Max Byrd, *Visits to Bedlam: Madness and Literature in the Eighteenth Century* (Columbia: University of South Carolina Press, 1974), p. 24. Ned Ward was a journalist who produced *London Spy* in 1699 in monthly instalments. It was published in volume form in 1703, including the section on the visit to Bedlam.
14. Anon. *An Historical Account of the Origin, Progress, and Present State of Bethlem Hospital Founded by Henry the Eighth for the Cure of Lunatics, and Enlarged by Subsequent Benefactors, for the Reception and Maintenance of Incurables*, London, 1783 (Bethlem Hospital Archives).
15. Cesar de Saussure, *A Foreign View of England*, quoted from Porter, *Mind Forg'd Manacles*, p. 126.
16. Thomas Tryon, 'Treatise of Dreams and Visions', 1698, quoted from Michael V. DePorte, *Nightmares and Hobbyhorses: Swift, Sterne, and Augustan Ideas of Madness* (San Marino, California: Huntington Library, 1974), pp. 108–9.
17. Paulson, *Hogarth. His Life, Art and Times*, I, p. 333. (A *pietà* is a representation of the Virgin Mary with the dead Christ across her knees.)
18. See Denis Leigh, *The Historical Development of British Psychiatry* (Oxford: Pergamon Press, 1981), I, pp. 136–9 concerning claims for the first description of GPI. For eighteenth-century treatments of the insane and perceptions of insanity, see also Porter, *Mind-Forg'd Manacles*.
19. Thomas Willis, *Two discourses concerning the soul of brutes which is that of the vital and sensitive of man* (1672), quoted from Hunter & Macalpine, *Three Hundred Years of Psychiatry*, p. 191.
20. J. Kromm, 'Studies in the Iconography of Madness, 1600–1900', Ph.D. thesis, Emory University, 1984.
21. James Parsons, *Human Physiognomy Explained* in the Crounian Lectures on Muscular Motion for the year 1746 (London, 1747).
22. *Gentleman's Magazine*, XVIII (1748), p. 199.
23. *The World*, No. XXIII (7 June 1753), p. 138.
24. Quoted from Haggard, *Devils, Drugs and Doctors*, p. 372.
25. Tryon, 'Treatise of Dreams and Visions', quoted from DePorte, *Nightmares and Hobbyhorses*, pp. 108–9.
26. Smollett, *The Life and Adventures of Launcelot Greaves*, p. 52.
27. Paulson, *Hogarth. His Life, Art and Times*, II, p. 354.
28. Ibid., pp. 144–52.
29. Keith Thomas, 'Other Modes of Thought', *Times Literary Supplement* (4–10 December 1987), p. 1339.
30. Porter, *Mind-Forg'd Manacles*, p. 24.
31. Ibid., pp. 178–9.
32. Smollett, *The Life and Adventures of Launcelot Greaves*, p. 187.
33. Porter, *Mind-Forg'd Manacles*, p. 280.
34. Adair, *Essays on Fashionable Diseases*, p. 94.
35. Christopher Anstey, *The New Bath Guide* (1766; reprinted London: Redwood Press, 1970), p. 5.
36. Sander L. Gilman, *Seeing the Insane* (New York: John Wiley, 1982), pp. 58–71 and pp. 90–1.

37. Hunter & Macalpine, *Three Hundred Years of Psychiatry*, p. 402.
38. Ibid., p. 408.
39. *Gentleman's Magazine*, No.33 (January 1763), p. 25.
40. Smollett, *The Life and Adventures of Sir Launcelot Greaves*, p. 187.
41. *An Act of Parliament for Regulating Madhouses, 1774*. Geo.III, c.49.
42. Quoted from Porter, *Mind-Forg'd Manacles*, p. 10.
43. David Macbride MD, *A methodical introduction to the theory and practice of Physick* (1772) quoted from Hunter & Macalpine, pp. 449–50.

7: FASHIONS IN HEALTH AND TREATMENT

1. J.M. Adair, *Essays on Fashionable Diseases*, p. 4.
2. Ibid., p. 7.
3. Richard Steele, 'On the Manners of the Bath Visitors', *Guardian*, 30 September 1713, in Revd R. Lynham (ed.), *The British Essayists: the Guardian* (London, 1827), p. 296.
4. Tobias Smollett, 'An Essay on the External Use of Water. . .' (1752), edited by Claude E. Jones, *Bull. Hist. Med*, 3 (1935), pp. 31–82.
5. Lewis M. Knapp (ed.), *The Letters of Tobias Smollett* (Oxford: Clarendon Press, 1970): for instance letters to William & John Hunter, 11 August 1734 (no. 94), 2 October 1762 (no. 88), 9 January 1771 (106); to Pitcairn, physician at St Bartholomew's Hospital (1750–85) and President of the RCP (1775–85); to surgeon John Moore in Glasgow, 13 November 1765 (no. 97).
6. Anstey, *New Bath Guide*, Introduction.
7. Revd John Penrose, *Letters from Bath 1766–1767*, with introduction and notes by Brigitte Mitchell & Hubert Penrose (Gloucester: Alan Sutton, 1983), p. 108.
8. *Gentleman's Magazine*, V (March 1735), p. 122.
9. George Cheyne, MD, FRS, *Observations concerning the Nature and due Method of Treating the Gout. . . together with an Account of the Nature and Qualities of Bath Waters* (London, 1720).
10. Tobias Smollett, *The Adventures of Ferdinand Count Fathom* (1753; London: Oxford University Press, 1971), pp. 258–9.
11. Knapp (ed.), *The Letters of Tobias Smollett*, no. 88.
12. Philip Thicknesse, *The New Prose Bath Guide, for the Year 1778* (n.p., n.d.).
13. Ibid., pp. 43–4.
14. Smollett, *Humphrey Clinker*, p. 38.
15. Penrose, *Letters from Bath*, p. 55.
16. Anstey, *New Bath Guide*, p. 16.
17. Horace Walpole, who frequently suffered from gout, advised the Hon. Mrs Grey as to the best way of treating an acute attack: 'If she does not encourage the swelling by keeping her foot wrapped up as hot as possible in flannel, she will torment herself and bring more pain.' *Letters of Walpole Earl of Orford* (London, 1886), 6, p. 27.
18. Anstey, *New Bath Guide*, p. 6.
19. Christopher Anstey, *An Election Ball in Poetical Letters. . .* (2nd edn, 1776), p. 26.
20. Abraham Buzaglo, *A Treatise on the Gout. . .* (3rd edn, London, 1778), p. 4.

21. Francis Grose, *A Guide to Health, Beauty Riches and Honour* (London, 1783), no. IX, p. 7.
22. *The Dance of Death Modernised*, engraving by G.M. Woodward, 1808 (BM 11125).
23. Walpole, *Letters of Walpole*, V, p. 132: to George Montagu Esq., 10 November 1768.
24. William Cowper, *Retirement* (1782) ll.515–24, *The Poems of William Cowper* (Oxford: Clarendon Press, 1980), I, p. 385.
25. Smollett, *Humphrey Clinker*, p. 166.
26. Ibid., p. 162.
27. Knapp (ed.), *The Letters of Tobias Smollett*, letter written from Boulogne, 11 August 1763, no.94, p. 119.
28. Smollett, *Humphrey Clinker*, p. 162.
29. George, *Hogarth to Cruikshank*, p. 134.
30. Goldsmith, 'Letters from a Citizen of the World to his Friends in the East', xxiv, p. 202.
31. Porter, 'Before the Fringe: Quack Medicine in Georgian England', and see also Porter, *Health for Sale*.
32. Quoted from Stuart Andrews, *Methodism and Society* (London: Longman, 1970), p. 51.
33. Thicknesse, *The New Prose Bath Guide*, p. 75.
34. Clark, *The History of the Royal College of Physicians of London*, I, pp. 69, 71–2, 85.
35. Jameson, *The Natural History of Quackery*, p. 117.
36. James Graham MD, *The Guardian of Health, Long Life, and Happiness!. . .* (London, 1784).
37. Jameson, *The Natural History of Quackery*, p. 128.
38. *Dictionary of National Biography* (London, 1907), p. 325.
39. Ibid., p. 324.
40. *The London Stage*, Part 5: 1776–1800, ed. C.B. Hogan, p. 358.
41. Eugene R. Page, *George Colman the Elder* (Columbia University Press NY, 1935), pp. 267–8.
42. Jameson, *The Natural History of Quackery*, p. 130.
43. BM 6324,*The Doctor Himself* from *The Rambler*, February 1783, p. 65.
44. Jameson, *The Natural History of Quackery*, p. 62.
45. Grose, *A Guide to Health, Beauty Riches and Honour*, no. XCV, p. 59.
46. David Gadd, *Georgian Summer: Bath in the Eighteenth Century* (Bradford-on-Avon, Wiltshire: Moonraker Press, 1977), p. 80. Rowlandson provided an illustration of the use of such a gaming table in *E, O, or the Fashionable Vowels* (1781).
47. Ibid., p. 80.
48. Henry Angelo, *Reminiscences of Henry Angelo, with Memoirs of His Late Father and Friends* (London, 1828), p. 127.
49. Wright, *Caricature History of the Georges*, p. 544.
50. 'Hebe Vestina's Celebrated Lecture . . .' appeared in a list of publications by Graham in his pamphlet *The Guardian of Health, Long Life and Happiness!*
51. Grose, *A Guide to Health. . .*, no. XL.

52. Horace Walpole, 'Letter to the Countess of Ossory' dated July 1789, quoted from *British Medical Journal* (30 January 1909), p. 293.
53. BM 7748 and Angelo, *Reminiscences*, p. 125.
54. Rousseau & Porter (eds), *Sexual Underworlds of the Enlightenment*, p. 214.
55. 'Animal Magnetism', *The Attic Miscellany*, no. IV (January 1790), pp. 121–4.
56. Jameson, *The Natural History of Quackery*, p. 147.
57. Charles Cunningham Langworthy, *A View of Perkinean Electricity . . .* (Bath, 1798).
58. *Bristol Mercury*, 21 May 1798. Falconer Pamphlets Vol.1, p. 39.
59. Elisha Perkins, *The Influence of Metallic Tractors on the Human Body in removing various Painful, Inflammatory diseases, such as Rheumatism, pleurisy, some Gout affections etc. etc.* (London, 1798).
60. Langworthy, *A View of the Perkinean Electricity*
61. Draper Hill, *Mr. Gillray: The Caricaturist, A Biography* (London: Phaidon, 1965), pp. 140–1.
62. Adair, *Essays on Fashionable Diseases*, p. 1.

8: FROM THE WOMB . . .

1. Martin Hopkinson, 'William Hunter, William Hogarth and the "Anatomy of the Human Gravid Uterus" ', *Burlington Magazine*, cxxvi (March 1984), pp. 156–9.
2. Laurence Sterne, *The Life and Opinions of Tristram Shandy*, pp. 41–3.
3. William Smellie, *A Treatise on the Theory and Practice of Midwifery* (London, 1752), Preface, p. v.
4. Ibid., p. 180. See note on 'Touching', Ch. 2 n. 43 above.
5. Roy Porter, 'A Touch of Danger: The man-midwife as sexual predator', in Bynum & Porter (eds), *William Hunter and the eighteenth-century medical world*, p. 208.
6. Douglas Guthrie, *A History of Medicine*, pp. 236–7.
7. Count de Buffon, *Natural History, General and Particular*, Notes and Observations by William Smellie (2nd edn, 1785).
8. Bynum & Porter (eds), *William Hunter and the eighteenth-century medical world*.
9. John L. Thornton & Patricia C. Want, 'William Hunter (1718–1783) and his contribution to obstetrics', *British Journal of Obstetrics and Gynaecology*, 90 (September 1983), pp. 792–3.
10. Bynum & Porter (eds), *William Hunter*.
11. Ibid., p. 210.
12. Sterne, *Tristram Shandy*, p. 71.
13. *George Stubbs. 1724–1806* (London: Tate Gallery Publications, 1984), p. 217.
14. Alban Doran, *Burton ("Dr. Slop"): His Forceps and His Foes* (London: Sharratt & Hughes, 1913).
15. M. Dorothy George, *London Life in the Eighteenth Century*, pp. 60–1.
16. Ibid., pp. 40–1.
17. *Gentleman's Magazine*, no.13 (1743), p. 430.
18. Charles Singer & E. Ashworth Underwood, *A Short History of Medicine*, p. 650.

19. Samuel Richardson, *Pamela*, 2, p. 382.
20. C. King, 'The Politics of Representation: A democracy of the Gaze', in Bonner et al. (eds), *Imagining Women. Cultural Representations of Gender* (Cambridge: Polity Press in assoc. with Open University, 1992), p. 134.
21. Christopher Anstey, *An Election Ball* (2nd edn, 1776), pp. 42–3.
22. Daniel Defoe, *Moll Flanders*, p. 173.
23. *The Story of The Thomas Coram Foundation for Children*, p. 12; John Brownlow, *Memoranda; or Chronicles of the Foundling Hospital* (London, 1847).
24. 'One of the most common faults of those who nurse for hire, is dosing the children with stupefactives, or such things as lull them to sleep. An indolent nurse. . . will seldom fail to procure for it a dose of laudanum, saffron, or, what answers for the same purpose, a dose of spirits or other strong liquors' – William Buchan, *Domestic Medicine*, pp. 29–30.
25. Lord Byron, 'English Bards and Scotch Reviewers', *The Poetical Works of Lord Byron* (London: John Murray, 1854), p. 423.
26. Lady Mary Wortley Montagu, *Letters from the Levant, during the Embassy to Constantinople 1716–18* (London, 1838), letter no. xxxv, 1 April, to Mrs. S.C-- [Miss Sarah Chiswell].
27. Sir Arthur Salusbury MacNalty, 'The Prevention of Smallpox: From Edward Jenner to Monckton Copeman', *Medical History*, 12 (1968), p. 4.
28. Revd John Penrose, *Letters from Bath 1766–1767*, p. 123.
29. *Gentleman's Magazine*, XL (3 December 1770), p. 585.
30. V. Denis Vandervelde, 'Anti-vaccination Art and Ephemera in the U.K.', monograph written for *Pratique*, 1991.
31. *Physic and Physicians: A Medical Sketch Book*, III, p. 80.
32. George, *London Life in the Eighteenth Century*, p. 329.
33. William Rowley, *Cow-Pox Inoculation. . .* (London, 1805), p. vi.

9: . . . TO THE TOMB

1. Tobias Smollett, *The Expedition of Humphrey Clinker*, p. 56.
2. *The Wonderful and Scientific Museum or magazine of London, Remarkable Characters* (London, 1803) I, p. 191. 'Life and Character of the celebrated Mr. Martin Van Butchell, Surgeon Dentist and Fistula Curer, of Mount-Street, Berkely Square', whose 'singularities and eccentricities have tended rather unfortunately to obscure, than exalt or display the sterling abilities, which even the tongue of Envy has never denied him'.
3. John Woodforde, *The Strange Story of False Teeth* (London: Routledge & Kegan Paul), p. 30.
4. Quoted from J. Menzies Campbell, *Dentistry – Then and Now* (Glasgow: Pickering & Inglis, 1963), p. 226.
5. William Granger, 'assisted by many Valuable Articles commissioned by James Cauldfield & others', *The New Wonderful Museum and Extraordinary Magazine being a complete Repository of All the Wonders, Curiosities, and Rarities of Nature and Art* (London, 1804), II, p. 616.
6. *The Wonderful and Scientific Museum. . .*, I, p. 191.
7. Charles John Samuel Thompson, *The Quacks of Old London*, p. 322.
8. Eric Jameson, *The Natural History of Quackery*, p. 183.

References

9. Malvin E. Ring, *Dentistry: An Illustrated History* (New York: Harry Abrams), p. 160.
10. Dr A. Pearlman, 'Wedgwood & Porcelain Dentures', *Proceedings of the Wedgwood Society*, No.3 (1959), p. 122.
11. Campbell, *Dentistry – Then and Now*, p. 71.
12. Revd James Woodforde, *The Diary of a Country Parson, 1758–1781* (Oxford University Press, 1981), I, p. 183.
13. John Hunter, *The Natural History of Human Teeth* (London, 1771), p. 126.
14. John Hunter, *A Practical Treatise on the Diseases of the Teeth* (London, 1778).
15. Campbell, *Dentistry – Then and Now*, p. 64.
16. Ibid., p. 195.
17. Revd John Penrose, *Letters from Bath 1766–1767*, p. 141.
18. Henry Fielding, *Tom Jones*, p. 381.
19. Advertised in a sale in 1842, Lot 1329 from the 'Horace Walpole Collection', and described as 'an original sketch by Hogarth of a surgeon operating on an ulcerated leg of a woman'.
20. J. Johnston Abraham, *Lettsom* (London: Heinemann, 1933), p. 38.
21. A. P. Oppé (ed.), *The Drawings of William Hogarth*, No. 64.
22. Laurence Sterne, *The Life and Opinions of Tristram Shandy*, p. 400. A 'cataplasm' is a kind of poultice.
23. J. Ireland, *Hogarth Illustrated*, p. 266.
24. Henry Fielding, *Enquiry into the Causes of the late Increase of Robbers etc. with some proposals for remedying this growing evil* (London, 1751).
25. George, *London Life in the Eighteenth Century*, p. 248.
26. Sidney Young, *Annals of the Barber-Surgeons of London* (London: East & Blades, 1890), p. 362.
27. Ibid., p. 334.
28. W. Brockbank & J. Dobson, 'Hogarth's Anatomical Theatre', *Journal of the History of Medicine*, 14 (July 1959), p. 352; Clark, *History of The Royal College of Physicians of London*, i, pp. 328–33.
29. Charles Singer, 'Historical Essay' in Ludwig Choulant, *History and Bibliography of Anatomic Illustration* (New York: Schuman, 1945), p. 21–R.
30. Andries Jacobsz Stock, after Jacques de Gheyn II, *The Anatomy Lesson of Dr Pieter Paaw*, from Pieter Paaw, *Primitive Anatomica De Humani Corporis ossibus*, 1615.
31. M. Kemp, 'Vesalius Andreas. A Drawing for the Fabrica, and some thoughts upon the Vesalian Muscle-men', *Medical History*, XIV:3 (July 1970), p. 282.
32. Choulant, *History and Bibliography of Anatomic Illustration*, p. 37.
33. S.W. Lambert, W. Wiegand & W.H. Ivins, *Three Vesalian Essays* (New York: Macmillan, 1952), p. 125.
34. W.G. Spencer, 'Vesalius: His Delineation of the Framework of the Human Body in the "Fabrica" and "Epitome" ', *British Journal of Surgery*, 10 (1923), pp. 382–402.
35. C. Singer & E.A. Underwood, *A Short History of Medicine*, p. 92.
36. Spencer, 'Vesalius', p. 391.
37. J. Ireland, *Hogarth Illustrated*, II, p. 326 note.
38. Medvei & Thornton (eds), *The Royal Hospital of Saint Bartholomew, 1123–1973*, p. 47.

39. Ibid., p. 210.
40. Nichols & Steevens, *The Genuine Works of William Hogarth*, II, p. 199.
41. M. Kemp (ed.), *Dr William Hunter at the Royal Academy of Arts* (University of Glasgow Press, 1975), p. 16. Quote from an annotation apparently by John Hunter: 'About this time [i.e. early 1750s] he read lectures in Anatomy to the Incorporated Society of Painters at their rooms in St. Martin's Lane, upon a subject executed at Tyburn. . .'. It is suggested that this activity must have taken place at Hogarth's St Martin's Lane Academy, as the Society of Painters was not founded until 1760 and was incorporated in 1765.
42. Rt. Hon. Lord Brock, 'Eighteenth Century Amputation scene in the Men's Operating Theatre of old St. Thomas's Hospital', *Annals RCS*, 59 (1977), pp. 415–19.
43. Young, *Annals of the Barber-Surgeons of London*, p. 359.
44. (i) *Gentleman's Magazine* (1749), p. 89: 'Was fought at Broughton's amphitheatre a very long battle between Slack the famous boxer of Norwich, and one Field, a sailor'.
 (ii) *Gentleman's Magazine* (1751), p. 88: 11 February 1751, 'Were executed at Tyburn, Field. . . Field's legs were chained together to prevent a rescue'.
 (iii) *Gentleman's Magazine* (1749), p. 522: Macleane was said to be involved in an incident reported, in which Horace Walpole had been robbed and almost killed.
45. Young, *Annals*, p. 356.
46. Ireland & Nichols, II, p. 62.
47. The rapid dispatch of criminals was intended to reduce the opportunity for their 'glorification': 'Whereas the horrid Crime of Murder has of late been more frequently perpetrated that formerly and particularly in and near the Metropolis of this Kingdom, contrary to the known humanity and natural Genius of the British Nation: and whereas it is thereby become necessary, that some further Terror and peculiar Mark of Infamy be added to the Punishment of Death, now by Law inflicted on such as shall be guilty of wilful Murder, be executed according to Law, on the Day next but One after Sentence passed, unless the same shall happen to be the Lord's Day . . . and . . . be immediately conveyed by the Sheriff or Sheriffs, his Deputy or Deputies, and his or their Officers, to the Hall of the Surgeons Company, or such other Place as the said Company shall appoint for this Purpose . . . and the Body so delivered to the said Company of Surgeons, shall be dissected and anatomized . . . Provided also, That it shall be in the Power of any such Judge or Justice to appoint the Body of any such Criminal to be hung in Chains: But that in no Case whatsoever the Body of any Murderer shall be suffered to be buried; unless after such Body shall have been dissected and anatomized . . . (At the Parliament begun and holden at Westminster the Tenth Day of November, Anno Dom. 1747 . . .).'
48. Paulson, *Hogarth's Graphic Works*, p. 181.
49. Richard Reece, *The Medical Guide, for the use of Clergy, Heads of Families, and Practitioners in Medicine and Surgery*, pp. 121–2.
50. Laurence Sterne, *The Life and Opinions of Tristram Shandy*, p. 521.
51. Paulson, *Hogarth's Graphic Works*, p. 230.
52. James Boswell, *The Life of Samuel Johnson* (1791; Harmondsworth: Penguin, 1979), p. 228.

53. Adair, *Essays on Fashionable Diseases*, p. 7.
54. Samuel Richardson, *Pamela*, p. 340.
55. Penrose, *Letters from Bath, 1766–1767*, p. 156.
56. An oil-painting on tin, painted by an unknown artist in the late eighteenth century and held in the Wellcome Institute, London.
57. Reece, *The Medical Guide . . .*, p. 121.
58. William C. Butterfield, 'A Caricaturist of the Eighteenth Century Anatomists and Surgeons', *Journal of Surgery, Gynaecology and Obstetrics*, 144 (April 1977), p. 591.
59. Roy Porter, 'Laymen, doctors and medical knowledge in the eighteenth century: the evidence of the *Gentleman's Magazine*', in Porter (ed.), *Patients and Practitioners*, pp. 305–6; Roger Cooter, 'Bones of Contention? Orthodox Medicine and the Mystery of the Bone-setter's Craft', in Bynum & Porter (eds), *Medical Fringe and Medical Orthodoxy 1750–1850*, p. 171 n. 14: 'The mortality rate for amputations in British hospitals prior to the 1870's varied between 25% and 50%'.
60. Thomas Percival MD, *Medical Ethics; or a Code of Institutes and Precepts, adapted to the Professional Conduct of Physicians and Surgeons* (Manchester, 1803), pp. 21–2.
61. Brock, 'An Eighteenth-century amputation scene', p. 417.
62. Ibid., pp. 415–19.
63. Ibid., p. 415.
64. Illustration of below-knee amputation from Heister, *General System of Surgery* (London, 1768), in Ernest Gray (ed.), *Man-Midwife, The Further Experience of John Knyveton M.D. . . . 1763–1809* (London: Robert Hale, 1946), p. 180.

10: THE END

1. John Hunter, *A Practical Treatise on the Diseases of the Teeth*, 1778.
2. Martin Kemp (ed.), *Dr. William Hunter at the Royal Academy of Arts*, p. 14.
3. Stewart Craig Thomson, 'The Great Windmill Street Schools', *Bull. Hist. Med.*, 12, p. 377.
4. 'W.J.', *Annals of Surgery*, 4 (1949), p. 122.
5. William Le Fanu, *A Catalogue of the Portraits . . . in The Royal College of Surgeons of England* (Edinburgh and London: Livingstone, 1960).
6. *Gentleman's Magazine*, 24 October 1747, p. 487.
7. *Gentleman's Magazine*, 14 July 1762, p. 340.
8. Clement Fry Collection, Yale Medical Library, New Haven, USA.
9. Paulson, *Representations of Revolution (1789–1820)*, p. 160.
10. Piper, 'Take the Face of a Physician'.
11. J. Dobson, 'Charles Byrne: The Irish Giant', *Annals of Surgery*, 13 (1953), pp. 63–5.
12. Singer & Underwood, *A Short History of Medicine*, pp. 371, 543.
13. E.R. Watson, 'The Trial of Thurtell and Hunt', *Notable British Trial Series* (Edinburgh: Hodge, 1920). A contemporary broadside ballad described the scene:

> Although his hands were warm with blood,
> He down to supper sat,

And pass'd the time in merry mood,
With drink and songs and chat.

14. F.F. Cartwright, *A Social History of Medicine* (London: Longman, 1977), p. 55.
15. Renate Burgess, 'The Dance of Death. An iconographic interpretation of the popular theme of death through five centuries', *Bulletin of the Society for the Social History of Medicine*, 26 (1980), pp. 25–37.
16. Philippe Ariès, *The Hour of Our Death*, pp. 69–71.
17. James M. Clark, *The Dance of Death in the Middle Ages and Renaissance* (Glasgow: Jackson Son & Co., 1950).
18. Robert R. Wark, *Drawings by Thomas Rowlandson* . . .
19. Tobias Smollett, *The Adventures of Roderick Random*, p. 100. John Quincy defined 'succedaneum' in *Lexicon Physico-Medicum* (5th edn, 1736), as 'anything substituted in the room of another', ibid., p. 447 n.3.
20. Combe, *The English Dance of Death*, 1816.
21. William H. Helfand, 'Medicine and Pharmacy in British Political Prints – the example of Lord Sidmouth', *Medical History*, 29 (1985), pp. 375–85.
22. Alfred Scott Warthin, 'The Physician of the Dance of Death', *Annals of Medical History* (March 1931), p. 148.

Bibliography

I. PRIMARY SOURCES

Adair, J.M. *Essays on Fashionable Diseases*, London, 1790.

Ahlers, C. *Some Observations concerning the Woman of Godliman in Surrey, made at Guildford on Sunday, November 20, 1726. Tending to prove her extraordinary Deliverance to be a Cheat and Imposture*, from Tracts Relating to Mary Toft, British Library.

Angelo, Henry. *Reminiscences of Henry Angelo, with Memoirs of His Late Father and Friends*, London, 1828.

[Anon.] In a letter from a Gentleman at Guildford, to his friend at Ipswich, Suffolk, *The Wonder of Wonders; or, a True and Perfect narrative of a Woman near Guildford in Surrey, who was delivered lately of Seventeen Rabbits and Three Legs of a Tabby Cat*, etc. Ipswich, 1726, from Tracts Relating to Mary Toft, British Library.

[Anon.] *An Historical Account of the Origin, Progress, and Present State of Bethlem Hospital Founded by Henry the Eighth for the Cure of Lunatics, and enlarged by Subsequent Benefactors, for the Reception and Maintenance of Incurables*, London, 1783 (Bethlem Hospital Archives).

Anstey, Christopher. *An Election Ball in Poetical Letters from Mr Inkle, at Bath, to His Wife at Glocester with a Poetical Address To John Miller, Esq. at Batheaston Villa*, 2nd edition, 1776.

Anstey, Christopher. *The New Bath Guide*, 1766. Reprinted by the Redwood Press, London, 1970.

Arbuthnot, John. *Bunny's Dad*, 1726. British Museum Pamphlet 1178, h, 4. also in Special Collection of James Douglas's writings, Glasgow University, Hunterian Collection, M.S. D336(2)

Blondel, J.A. MD. *The Power of the Mother's Imagination over the Foetus Examin'd*, London, 1729.

Blunt, John. *Man-Midwifery Dissected . . .*, London, 1793.

Boswell, James. *The Life of Samuel Johnson*, 1791. Edited by Christopher Hibbert, Harmondsworth: Penguin, 1979.

Braithwaite, Thomas. *Remarks on A short Narrative of an Extraordinary Delivery of Rabbets, perform'd by Mr. John Howard, Surgeon at Guildford, As publish'd by Mr St André Anatomist to His Majesty with a Proper Regard to his intended Recantation*, London, 1726.

Butler, Samuel. *Hudibras*, Alfred Milnes (reprint ed) Macmillan, London, 1895.

Buzaglo, Abraham. *A Treatise on the Gout; wherein The Inefficacy of the usual Treatment in that Dreadful Disorder is demonstrated the Facility of a speedy and*

radical Cure to be effected between the Fits, and prevent their Return, by a peculiar Mode of Muscular Exercise, Is established to Conviction; and A New and Infallible Discovery of sure and certain Relief during the Fit, in every Gouty Case whatever, is offered to the Public, on the indisputable Evidence of many extraordinary Cures, on Persons of the first Rank. Performed by A. Buzaglo of the Strand, London, 3rd edn, 1778.

Byron, Lord. 'English Bards and Scotch Reviewers', from *The Poetical Works of Lord Byron*, collected and arranged with notes and illustrations by John Murray, London, 1854.

[Cadogan, Dr. William.] *An Essay upon the Nursing and Management of Children, From their Birth to Three Years of Age, by a Physician* In a Letter to one of the Governors of The Foundling Hospital, publ. by order of the General Committee for transacting the Affairs of the said Hospital, London, 1748.

Campbell, R. *The London Tradesman*, London, 1747.

Cheyne, George MD,FRS. *Observations concerning the Nature and due Method of Treating the Gout . . . together with an Account of the Nature and Qualities of Bath Waters*, London, 1720. Combe, William. *The English Dance of Death, from the Designs of Thomas Rowlandson, with Metrical Illustrations by the Author of 'Doctor Syntax'*, 2 vols, London, 1816.

Cowper, William, *Retirement*, 1782. From *The Poems of William Cowper*, Vol. 1. 1748–1782, eds John Baird & Charles Ryskamp, Oxford: Clarendon Press, 1980.

Defoe, Daniel. *Journal of the Plague Year*, 1722. London: Dent, Everyman Library, 1969.

Moll Flanders, 1722. Edited by Juliet Mitchell, Harmondsworth: Penguin, 1985.

A Dissertation on Mr. Hogarth's Six Prints Lately Publish'd, inscribed to the Lord Mayor, City of London and Worshipful Court of Aldermen, 1751.

Douglas, James. *Remarks on some Passages in Sir R. Manningham's Diary*, London, 16 December 1726. (Special Collections, Glasgow University Library.)

The English Rogue; or the Life of Jeremy Sharp. To which is added a Narrative of Mary Toft; of an extraordinary Delivery of Eighteen Rabbets . . ., London, 1776.

Fielding, Henry. *Joseph Andrews*, London, 1742. Edited by R.F. Brissenden, Harmondsworth: Penguin, 1988.

The History of Tom Jones, London, 1749. Edited by R. C. P. Mutter, Harmondsworth: Penguin, 1985.

Amelia, London, 1751. Edited by David Blewett, Harmondsworth: Penguin, 1987.

Enquiry into the Causes of the late Increase of Robbers etc. with some proposals for remedying this growing evil, by Henry Fielding Esq. Barrister at Law, & one of His Majesty's J. P.'s for the County of Middlesex and for the City & Liberty of Westminster, London, 1751. To the Rt. Hon. Philip Lord Hardwick, Lord Chancellor of Great Britain.

Freke, John. *An Essay on the Art of Healing*, London, 1748.

Glisson, Francis. *De Rachitide*, trans. Nicholas Culpepper: 'Glisson on Rickets', London, 1668.

Goldsmith, Oliver. 'Letters from a Citizen of the World to his Friends in the East' c. 1761. Letter XXIV in W.P. Nimmo (ed.), *The Works of Oliver Goldsmith*, Edinburgh, 1872.

Bibliography

The Vicar of Wakefield, 1766. Edited by Stephen Coote, Harmondsworth: Penguin, 1985.

She Stoops to Conquer, London, 1773.

Gould, S. *Special Ailments*, London, n. d.

Graham, James MD. President of the Council of Health, in London. *The Guardian of Health, Long Life, and Happiness! or The Whole Art of Preventing and Curing Diseases. General Directions as to the Regimen etc. for the cure of most Diseases, for the preservation of Health, for the Happy prolongation of Life etc.*, Pall Mall, London, 25 May 1784.

A New, Plain, and Rational Treatise on the True Nature and Uses of the Bath Waters: Shewing The Cases and Constitutions in which these Waters are really proper to be used, and the best Methods of using them, and likewise the Cases in which they are hurtful and very dangerous; – and demonstrating the great Errors in which Mankind have hitherto been under, in regard to bathing in, pumping with, and drinking these wonderful and powerful Waters; – and also as to their Regimen of Food, Drink, Airing, Exercising, Etc., Bath, 1789.

Granger, William, 'assisted by many Valuable Articles commisioned by James Caulfield, & others'. *The New Wonderful Museum and Extraordinary Magazine being a complete Repository of All the Wonders, Curiosities, and Rarities of Nature and Art*, London, 1804.

Grose, Francis. *A Guide to Health, Beauty Riches and Honour*, London, 1783.

A Classical Dictionary of the Vulgar Tongue, 1785.

Gulliver, Lemuel [Jonathan Swift], Surgeon and Anatomist to the Kings of Lilliput at Blefescu, and Fellow of the Academy of Sciences in Balnibari. *The Anatomist Dissected: or the Man-Midwife finely brought to Bed. being an Examination of the Conduct of Mr. St. André Touching the late pretended Rabbit-bearer; as it appears from his own Narrative*, Westminster, 1727.

Hill, John, 'Hypochondriasis'. The Augustan Reprint Society, No. 135, 1969.

Hogarth, William. *The Analysis of Beauty*, 1753. With the rejected passages from the manuscript drafts and autobiographical notes, edited and introduced by Joseph Burke, Oxford: Clarendon Press, 1955.

Apology for Painters. Edited by Michael Kitson, Walpole Society, 41, Glasgow: The University Press, 1968.

Howard, J. *An Abstract of the Letter from Mr. Howard, the Man-Midwife and Surgeon at Guildford dated November 22th, 1726*, from Tracts Relating to Mary Toft, British Library.

Hunter, John FRS. *The Natural History of Human Teeth: explaining their Structure, Use, Formation, Growth, and Diseases*, London, 1771.

Hunter, John. *A Practical Treatise on the Diseases of the Teeth*, London, 1778.

Ireland, J. *Biographical Anecdotes of William Hogarth*, London, 1781.

Ireland, J. & Nichols, John. *Hogarth's Complete Works*, 3 vols, London, n.d.

Ireland, John. *Hogarth Illustrated*, 3 vols. London, 1812.

James, Robert (publisher). *Medical Dictionary*, London, 1743–5.

Johnson, Samuel. *Dictionary of the English Language*, London, 1785; 1827.

Ketham, Johannes de. *Fasciculus di Medicinae*, Basel, 1493. (Manchester University, John Rylands Library, Special Collection.)

Kirby, R.S. *The Wonderful and Scientific Museum or Magazine of London. Remarkable Characters*, Vol. 1, London, 1803.

Langworthy, Charles Cunningham. *A View of the Perkinean Electricity, or an*

Enquiry into the Influence of Metallic Tractors, founded on a Newly-Discovered Principle of Nature, and Employed as A Remedy in many painful Inflammatory Diseases . . . , 2nd edn, Bath, 1798.

LeBrun, Charles. 'Conférence de M. LeBrun sur l'expression générale et particulière', Paris, 1698; trans. John Williams, 1734. *A method to learn to design the passions*, introduction by Alan T. McKenzie, Augustan Reprint Society no. 200–201, Los Angeles: William Andrews Clark Memorial Library, 1980.

Locke, John. *Some Thoughts concerning Education*, London, 1693.

Manningham, Sir R. *An exact Diary of What was Observed during a Close Attendance upon Mary Toft, the Pretended Rabbet Breeder of Godalming in Surrey from Monday, November, 28th., to Wednesday, December, 7th., following, Together with An Account of her Confession of the Fraud*, London, 1726.

Maubray, John. *The Female Physician*, Printed for John Holland at the Bible and Bull, St Paul's Churchyard, 1724.

Montagu, Lady Mary Wortley. *Letters from the Levant, during the Embassy to Constantinople 1716–18*. Letter No. xxxv Adrianople, April 1st. to Mrs. S. C – [Miss Sarah Chiswell], London, 1838.

Nichols, John and Steevens, George. *The Genuine Works of William Hogarth*, 3 vols, London, 1808–17.

Parsons, Dr James. *Human Physiognomy Explained* in the Crounian Lectures on Muscular Motion for the year 1746, London, 1747.

'Mechanical and Critical Enquiry into the Nature of Hermaphrodites', 1741; and 'An Account of some very extraordinary Tumours upon the head of a young Labouring Man in Bartholomew's Hospital, with Figures drawn from the Life' in *Philosophical Transactions*, 1, 1746.

Penrose, Revd John. *Letters from Bath 1766–1767*. With introduction and notes by Brigitte Mitchell & Hubert Penrose, Gloucester: Alan Sutton, 1983.

Percival, Thomas MD. *Medical Ethics; or a Code of Institutes and Precepts, adapted to the Professional Conduct of Physicians and Surgeons*, Manchester, 1803.

Perkins, Elisha. *The Influence of Metallic Tractors on the Human Body in removing various Painful, Inflammatory diseases, such as Rheumatism, pleurisy, some Gout affections etc. etc.*, London, 1798.

Physic and Physicians: A Medical Sketch Book, vol. III, London, 1839.

Reece, Richard. *The Medical Guide for the Use of Clergy, Heads of Families, and Practitioners of Medicine and Surgery*, London, 1812.

Reynolds, Sir Joshua. *Discourses on Art*, 1769–90. Edited by Robert Wark, San Marino, California: Huntington Library, 1959.

Richardson, J. 'The Theory of Painting', Part I, *The Works of Jonathan Richardson*, London, 1792.

Richardson, Samuel. *Pamela*, Vols 1 & 2, London, 1740. Edited by Peter Sabor, Harmondsworth: Penguin, 1985.

Rowley, William MD. *Cow-Pox Inoculation No Security Against Infection: To which are added, The Modes of Treating the Beastly New Diseases produced from Cow-Pox as Cow-Pox Mange, Cow-Pox Ulcers, Cow-Pox Evil or Abscess, Cow-Pox Mortification, etc. with the Author's Certain Experienced, and Successful mode of Inoculating the Small-pox which now becomes necessary from Cow-Pox Failure etc.*, London, 1805.

St André's Miscarriage or a Full and True Account of the Rabbet Woman, 1726.

Broadsheet ballad from Tracts Relating to Mary Toft, British Library. *Hospital Journal*, St Bartholomew's Hospital, London, 1727.

Smellie, William MD. *A Treatise on the Theory and Practice of Midwifery*, London, 1752.

 Natural History, General and Particular, notes and observations on Count de Buffon's works, London, 1785.

Smollett, Tobias. *The Adventures of Roderick Random*, 1748. Edited by Paul-Gabriel Boucé, Oxford University Press, 1979.

 The Adventures of Peregrine Pickle, 1751. Edited by James L. Clifford, Oxford University Press, 1983.

 *An Essay on the External Use of Water, in a Letter to Dr **** with Particular Remarks upon the present Method of using the Mineral Waters at Bath in Somersetshire, and a Plan for rendering them more safe, agreeable, and efficacious*, London, 1752. Edited by Claude E. Jones, *Bull. Hist. Med.*, 3(1935), 31–82.

 The Adventures of Ferdinand Count Fathom, 1753. Edited by Damian Grant, London: Oxford University Press, 1971.

 The Life and Adventures of Sir Launcelot Greaves, 1760–61. Edited by David Evans, London: Oxford University Press, 1973.

 The Expedition of Humphrey Clinker, 1771. Edited by André Parreaux, New York: Houghton Miflin, 1968.

 The Letters of Tobias Smollett, ed. Lewis M. Knapp, Oxford: Clarendon Press, 1970.

Statutes of the Realm, the third year of the reign of Henry VIII. 1511, No. 18. ch. II, 'An Act concerning Phesicions & Surgeons'.

Statutes of the Realm, 1540, 'An Act conc'ning Barbers and Chirurgians', ch. XLII.

Statutes of the Realm, 1542, 'Quack's Charter'.

Statutes of the Realm, 'An Act for laying a Duty upon the Retailers of Spirituous Liquors, and for licensing the Retailers thereof to be enacted after 29, September 1736.'

Statutes of the Realm, 'An Act of Parliament for Regulating Madhouses, 1774, George III', c. 49.

Statutes of the Realm, 'An Act for repealing certain Duties on Spirituous Liquors, and on Licences for retailing the same, and for laying other Duties on Spirituous Liquors and on Licenses to retail the said Liquors', 1743.

Steele, Richard. 'On the Manners of the Bath Visitors', *Guardian*, 30 September 1713. Reprinted in R. Lynam (ed.), *The British Essayists: the Guardian*, no. 174, London, 1827.

Sterne, Laurence. *The Life and Opinions of Tristram Shandy*, London, 1759–67. Edited by Graham Petrie, Harmondsworth: Penguin, 1987.

The Strangers' Assistant and Guide to Bath: Containing an Account of the Place: Of the Hot Springs there, Their several Qualities and Impregnations, Use, as taken Internally, or used as Baths . . . , Bath, 1773.

Swift, Jonathan. *Gulliver's Travels*, London, 1726. Edited by Peter Chapman & John Chalker, Harmondsworth: Penguin, 1987.

[Swift, Jonathan.] *The Anatomist Dissected: or the Man-Midwife finely brought to Bed. Being an Examination of the Conduct of Mr. St. André Touching the late pretended Rabbit-bearer as it appears in his own Narrative*, London, 1727.

Sydenham, Dr Thomas. *The Whole Works of that Excellent Practical Physician Dr. Thomas Sydenham*, London, 1705.

Thicknesse, Philip. *Man Midwifery Analysed*, London, 1764.

Thicknesse, Philip. *The New Prose Bath Guide, for the Year 1778. Dedicated to Lord N____*

Trusler, Revd J. & Roberts, E.F. *The Complete Works of William Hogarth*, London: Mackenzie, n. d.

Turner, Daniel MD. *De Morbis Cutaneis*, London, 1723.

Walpole, Horace. *Letters of Walpole. Earl of Orford*, edited by Peter Cunningham, London: Richard Bentley & Son, 1886.

Woodforde, Revd James. *The Diary of a Country Parson 1758–1781*, edited by John Beresford, Oxford University Press, 1981.

Woodville, William. *Medical Botany: containing systematic and general descriptions with plates, of all the medicinal plants, indigenous and exotic*, 2nd edn ed. W. Phillips, 1810.

Reports of a series of inoculations for the variolae vacciniae, or cow-pox, with remarks and observations on this disease, considered as a substitute for the small-pox, J. Phillip & Son [1799].

Horace Walpole's Correspondence, edited by W. S. Lewis, VI, London: Oxford University Press, 1960.

II. SECONDARY SOURCES

Abraham, J. Johnston. *Lettsom*, London: Heinemann, 1933.

Allderidge, Patricia. 'Bedlam: fact or fantasy?' in *The Anatomy of Madness*, Vol. II. of W. F. Bynum, Roy Porter & Michael Shepherd (eds), *The History of Psychiatry*, London: Tavistock, 1985

Andrews, Stuart. *Methodism and Society*, London: Longman, 1970.

Antal, Frederick. *Hogarth and his Place in European Art*, London: Routledge & Kegan Paul, 1962.

'Ars Medica': Art, Medicine and the Human Condition, Philadelphia Museum of Art, 1986.

Aries, Philippe. *The Hour of Our Death*, trans. Helen Weaver, Harmondsworth: Penguin, 1987.

Atherton, Herbert M. *Political Prints in the Age of Hogarth*, Oxford: Clarendon Press, 1974.

Avery, E. L. (ed.). *The London Stage, 1660–1680; a calendar of plays, entertainments & afterpieces . . .*; Part 2: 1700–1729, Carbondale: Southern Illinois University Press, 1965.

Baker, J.H. 'The Legal Profession and the Common Law', *Historical Essays*, London: Hambledon Press, 1986.

Baskett, John & Snelgrove, Dudley (eds). *The Drawings of Thomas Rowlandson in the Paul Mellon Collection*, London: Barrie & Jenkins, 1977.

Bennett, H. Selfe. 'Joshua Ward, 1685–1761', *Proc. Roy. Soc. Med*, 9:II (1916), 100–12.

Bettmann, Otto. *A Pictorial History of Medicine*, Springfield, Illinois: Charles C. Thomas, 1979.

Bindman, David. *Hogarth*, London: Thames & Hudson, 1985.

Bibliography

Bishop, W. J. *A History of Surgical Dressings*, Chesterfield: Robinson & Sons Ltd, 1959.

Boucé, Paul-Gabriel. 'Imagination, pregnant women, and monsters, in eighteenth-century England and France' in G. S. Rousseau & Roy Porter (eds), *Sexual Underworlds of the Enlightenment*, Manchester: Manchester University Press, 1987.

British Encyclopaedia, Ninth Edition, Vol. XIV, Edinburgh: Adam & Charles Black, 1880.

Brock, Rt. Hon. Lord. 'Eighteenth Century Amputation Scene in the Men's Operating Theatre of old St. Thomas's Hospital', *Annals RCS* 59 (1977), 415–19.

Brockbank, W. & Dobson, J. 'Hogarth's Anatomical Theatre', *J. Hist. Med.*, 14 (July 1959), 351–3.

Brownlow, John. *Memoranda: or Chronicles of the Foundling Hospital*, London: Sampson Low, 1847.

Burgess, Renate. 'The Dance of Death: An Iconographic interpretation of the popular theme of death through five centuries', *Soc. Social Hist. Med. Bull.*, 26 (1980), 25–37.

Burke, Joseph & Caldwell, Colin. *Hogarth – the Complete Engravings*, London: Thames & Hudson, 1974.

Burnby, Juanita G. L. 'A Study of The English Apothecary from 1660–1760', *Medical History*, Supplement No. 3, London: Wellcome Institute, 1983.

Bury, Adrian (ed.). *Rowlandson's Drawings*, London: Avalon Press, 1949.
'Thomas Rowlandson, Historian of English Social Life', *History Today*, vi (July 1956), 466–76.

Butterfield, William C. 'The Medical Caricatures of Thomas Rowlandson', *Journal of the American Medical Association*, 224 (April 1973), 113–17.
'A Caricaturist of the Eighteenth Century Anatomist and Surgeons', *Journal of Surgery, Gynaecology and Obstetrics*, 144 (April 1977), 587–92.

Bynum, W.F. 'Health, disease and medical care' in G. S. Rousseau & Roy Porter (eds), *Ferment of Knowledge: studies in the historiography of eighteenth-century science*, Cambridge: Cambridge University Press, 1980, pp. 211–54.
'Treating the Wages of Sin: Venereal disease and Specialism in Eighteenth Century Britain', in W. F. Bynum & Roy Porter (eds), *Medical Fringe and Medical Orthodoxy*, London: Croom Helm, 1986.

Bynum, W. F. & Porter, Roy (eds). *William Hunter and the eighteenth-century medical world*, Cambridge: Cambridge University Press, 1985.

Byrd, Max. *Visits to Bedlam: Madness and Literature in the Eighteenth Century*, Columbia: University of South Carolina Press, 1974.

Campbell, J. Menzies. *Dentistry – Then and Now*, Glasgow: Pickering and Inglis Ltd, 1963.

Cartwright, F. F. *A Social History of Medicine*, London: Longman, 1977.

Choulant, Ludwig. *History & Bibliography of Anatomic Illustration*, trans. Frank Mortimer, New York: Schuman, 1945.

Clark, Sir George. *The History of The Royal College of Physicians of London*, 2 vols, Oxford: Clarendon Press, 1966.

Clendening, Logan. *Source Book of Medical History*, London: Paul B. Hoeber Inc., 1942.

Coffey, T.G. 'Beer Street: Gin Lane: Some Views of 18th-Century Drinking', *Quarterly Journal of Studies on Alcohol*, 27 (1966), 669–92.

Cooper, J.C. *An Illustrated Encyclopaedia of Traditional Symbols*, London: Thames and Hudson, 1982.

Cooter, Roger. 'Bones of Contention? Orthodox Medicine and the Mystery of the Bone-setter's Craft', in W. F. Bynum & Roy Porter (eds), *Medical Fringe and Medical Orthodoxy 1750–1850*, London: Croom Helm, 1987.

Cope, Sir Zachary. *William Cheselden (1688–1752)*, Edinburgh: E. & S. Livingstone Ltd, 1953.

 ——— *The History of the Royal College of Surgeons of England*, London: Anthony Blond, 1959.

Copeman, W. S. C. *A Short History of the Gout*, Berkeley & Los Angeles: University of California Press, 1964.

'Coram, Thomas'. *The Story of The Thomas Coram Foundation for Children*, London: Printed for the Foundation by White Bros. Ltd, n.d.

Cowley, Robert L. S. *Marriage-à-la-Mode: a re-view of Hogarth's narrative art*, Manchester: Manchester University Press, 1983.

 ——— 'Hogarth and his Dogs', *The Antique Collector* 58:10 (October 1987), 73–82.

Dabydeen, David. *Hogarth's Blacks: Images of Blacks in Eighteenth Century English Art*, Manchester: Manchester University Press, 1987.

DePorte, Michael V. *Nightmares and Hobbyhorses: Swift, Sterne, and Augustan Ideas of Madness*, San Marino, California: Huntington Library, 1974.

Dictionary of National Biography, London: 1907 edn.

Dobson, J. 'Charles Byrne: The Irish Giant', *Annals of Surgery*, 13 (1953), 63–5.

Doherty, Francis. 'The Anondyne Necklace: A Quack Remedy and its Promotion', *Medical History*, 1:3 (1990), 268–93.

Donald, Diana. 'Characters and Caricatures: The Satirical View' in Nicholas Penny (ed.), *Reynolds*, catalogue of exhibition at the Royal Academy of Arts, London, 1986.

Donnison, Jean. *Midwives and Medical Men*, London: Heinemann, 1977.

Doran, Alban. *Burton ("Dr. Slop"): His Forceps and His Foes*, London: Sharratt & Hughes, 1913.

Drake, T. G. H. 'The Medical Caricatures of Thomas Rowlandson', *Bull. Hist. Med.* 323–35.

Falk, Bernard. *Thomas Rowlandson: His Life and Art*, London: Hutchinson & Co. Ltd, 1949.

Feaver, William. *Masters of Caricature*, ed. Ann Gould, London: Weidenfeld & Nicolson, 1981.

Foster, F. 'William Hogarth and the Doctors', *Bulletin of the Medical Libraries Association*, 32 (1944), 356–68.

Friedenwald, J. & Morrison, S. 'History of the Enema', *Bull. Hist. Med.*, 8 (1940), 239–76.

Furst, Herbert. *Portrait Painting*, London: John Lane, The Bodley Head 1927.

Gad, David. *Georgian Summer: Bath in the Eighteenth Century*, Bradford-on-Avon, Wiltshire: Moonraker Press, 1977.

Garrison, Fielding H. *Contributions to the History of Medicine from the Bulletin of the New York Academy of Medicine 1925–1935*, New York: Hafner Publications, 1966.

Bibliography

George, M. Dorothy. *Catalogue of Political and Personal Satires*, London: British Museum, Department of Prints and Drawings, 1935.

'The Cartoon in the Eighteenth Century', *History Today*, 4 (September 1954), 591–7.

From Hogarth to Cruikshank: Social change in Graphic Satire, London: Allen Lane, 1967.

London Life in the Eighteenth Century, Harmondsworth: Penguin, 1985.

Gilman, Sander L. *Seeing the Insane*, New York: John Wiley & Sons, 1982.

Godby, M. 'The First Stage of Hogarth's *Harlot's Progress*', *Art History*, 10:1 (1987), 23–7.

Gombrich, E. H. *The Story of Art*, Oxford: Phaidon, 1984.

Gowing, Lawrence (ed.). *Hogarth*, London: Tate Gallery Publications, 1971.

Gray, Ernest (ed.). *Man Midwife, The Further Experience of John Knyveton M. D. . . . 1763–1809*, London: Robert Hales, 1946.

Grego, Joseph. *Rowlandson: The Caricaturist*, 2 vols, London: Chatto & Windus, 1880.

Gunnis, Rupert. *Dictionary of British Sculptors: 1660–1851*, London: Odhams Press, 1968.

Guthrie, Douglas. *A History of Medicine*, London: Nelson, 1945.

Gwyn, Norman B. 'An Interpretation of the Hogarth Print "The Arms of the Company of Undertakers"', *Bull. Hist. Med.*, 8 (1940), 115–27.

Haggard, Howard. *Devils, Drugs and Doctors*, London: Heinemann, n.d.

Halsband, Robert. *Lord Hervey, 18th Century Courtier*, Oxford: Clarendon Press, 1973.

Hayes, John. *Rowlandson: water colours and drawings*, London: Phaidon, 1972.

Thomas Gainsborough, London: Phaidon, 1975.

Helfand, William H. 'Medicine and Pharmacy in British Political Prints – the example of Lord Sidmouth', *Medical History*, 29 (1985), 375–85.

Hill, Draper. *Mr. Gillray: The Caricaturist, A Biography*, London: Phaidon, 1965.

Hogan, C.B. (ed.). *The London Stage*; Part 5: 1776–1800, Carbondale: Southern Illinois University Press, 1968.

Hopkinson, Martin. 'William Hunter, William Hogarth and the "Anatomy of the Human Gravid Uterus"', *Burlington Magazine*, cxxvi (March 1984), 156–9.

Hunt, Thomas (ed.). *The Medical Society of London: 1773–1973*, London: Heinemann, 1972.

Hunter, Richard & Macalpine, Ida. *Three Hundred Years of Psychiatry 1535–1860*, London: Oxford University Press, 1963.

Hutchinson, Sidney C. *The History of the Royal Academy 1768–1968*, London: Chapman & Hall, 1968.

Hutton, Laurence. *Portraits in Plaster*, New York: Harper & Bros, 1894.

Impey, O. & Macgregor, A. (eds). *The Origins of Museums: Cabinets of Curiosities in the Sixteenth and Seventeenth Century*, Oxford: Clarendon Press, 1985.

Jameson, Eric. *The Natural History of Quackery*, London: Michael Joseph, 1961.

Janson, H. W. *Apes and Ape-Lore in the Middle Ages and the Renaissance*, London: Warburg Institute, University of London, 1952.

Jarrett, Derek. *England in the Age of Hogarth*, St Albans: Paladin, 1974.

Jewson, N., 'Medical Knowledge and the Patronage System in Eighteenth Century England', *Sociology*, XIII (1974), 369–85.

Jordanova, Ludmilla. 'Gender, generation and science: William Hunter's obstetrical

atlas', in W. F. Bynum & Roy Porter (eds), *William Hunter and the eighteenth-century medical world*, Cambridge: Cambridge University Press, 1985.

Keevil, John. 'Coffee-house Cures', *Journal of the History of Medicine*, 9 (April 1954), 191–5.

Kemp, M. 'Vesalius Andreas. A Drawing for the Fabrica, and some thoughts upon the Vesalian Muscle-men' *Medical History*, XIV:3 (July 1970).

(ed.) *Dr. William Hunter at the Royal Academy of Arts*, Glasgow: University of Glasgow Press, 1975.

King, Lester S. *The Medical World of the Eighteenth Century*, London: Michael Joseph, 1961.

The Philosophy of Medicine: The Early Eighteenth Century, Cambridge, Mass.: Harvard University Press, 1978.

Kouskoukis, Constantine E. & Morris, Leider. 'Cupping, The Art and Value', *Am. J. Dermopath*, 15:3 (1983), 235–9.

Kromm, J. 'Studies in the Iconography of Madness. 1600–1900', Ph. D. dissertation, Emory University, 1984.

Lambert, S.W., Wiegand, W. & Ivins, W.H. *Three Vesalian Essays*, New York: Macmillan, 1952.

Lane, Joan. 'The role of apprenticeship in eighteenth-century medical education in England' in W.F. Bynum & Roy Porter (eds), *William Hunter and the eighteenth-century medical world*, Cambridge: Cambridge University Press, 1985, pp. 58–103.

LeFanu, William. 'Portraits' in *A Bibliography of Edward Jenner*, London: St Paul's Bibliographies, 1985.

(ed.) *A Catalogue of the Portraits . . . in the Royal College of Surgeons of England*, Edinburgh and London: Livingstone, 1960.

Leigh, Denis. *The Historical Development of British Psychiatry*, Vol. 1, Oxford: Pergamon Press, 1961.

Levey, Michael. *Marriage-à-la-Mode*, London: National Gallery Publications, 1970.

Lichtenberg, G.C. *Hogarth on High Life*, Commentaries trans. A. S. Wensinger & W. B. Coley, Connecticut: Wesleyan University Press, 1970.

Linebaugh, Peter. 'Albion's Fatal Tree' in Douglas Hay et al. (eds), *Crime and Society in Eighteenth Century England*, London: Allen Lane, 1975.

Llewellyn, Nigel. *The Art of Death: Visual Culture in The English Death Ritual c. 1500–c. 1800*, London: Reaktion Books in association with the Victoria and Albert Museum, 1991.

Loudon, Irvine S. 'The Nature of Provincial Medical Practice in Eighteenth-Century England', *Medical History*, 29 (1985), 1–32.

McClure, Ruth. *Coram's Children*, New Haven and London: Yale University Press, 1981.

McConaghay, R.M.S. 'The History of Rural Medical Practice in Britain' in F.N.L. Poynter (ed.), *The Evolution of Medical Practice in Britain*, London: Pitman, 1961.

Mackinnon, Charles. *The Observer's Book of Heraldry*, London: Warne & Co., 1966.

Macnalty, Sir Arthur Salusbury. 'The Prevention of Smallpox: From Edward Jenner to Monckton Copeman', *Medical History*, 12 (1968), 1–17.

Matthews, Leslie G. 'Day Book of the Court Apothecary in the time of William and Mary, 1691', *Medical History*, 22 (1978), 172.

Medvei, V.C. & Thornton, J.L. (eds). *The Royal Hospital of St. Bartholomew's 1123–1973*, Ipswich: Cowell Ltd, 1974.

Miller, John. *Religion in the Popular Prints 1600–1832*, ed. Michael Duffy, Cambridge: Chadwyck-Healey, 1986.

Morgan, Michael J. *Molyneux's Question: vision, touch and the philosophy of perception*, Cambridge: Cambridge University Press, 1977.

Munk's Roll, Royal College of Physicians, 1878.

Nicolson, Benedict & Kerslake, John. *The Treasures of the Foundling Hospital*, Oxford: Clarendon Press, 1972.

Open University, *Introduction to Art History*, A101.

Open University, *A204 Unit 3*, Supplementary Material, 1979.

Oppé, A.P. (ed.). *The Drawings of William Hogarth*, London: Phaidon, 1948.

Oxford Companion to the Theatre, Phyllis Hartnoll & Peter Found (eds), 4th edn, Oxford: Oxford University Press, 1992.

Page, Eugene R. *George Colman the Elder: Essayist, Dramatist, and Theatrical Manager. 1732–1794*, New York: Columbia University Press, 1935.

Paget, Stephen. 'John Hunter: Man of Science and Surgeon (1728–1793)' in *Masters of Medicine*, London: Fisher Unwin, 1897.

Paulson, Ronald. *Hogarth's Graphic Works*, New Haven and London: Yale University Press, 1965; revised edition, 1989.

 Hogarth. His Life, Art and Times, 2 vols, New Haven and London: Yale University Press, 1971.

 Rowlandson – A New Interpretation, London: Studio Vista, 1972.

 Emblem and Expression: Meaning in English Art of the Eighteenth Century, London: Thames & Hudson, 1975.

 Popular and Polite Art in the Age of Hogarth and Fielding, Chicago and London: University of Notre Dame Press, 1979.

 Representations of Revolution, 1789–1820, New Haven and London: Yale University Press, 1983.

 Hogarth, 3 vols, Cambridge: Lutterworth Press, 1991–3.

Pearlman, A. 'Wedgwood & Porcelain Dentures', in Geoffrey Wills (ed.), *Proceedings of the Wedgwood Society*, 3, London: Batsford, 1959.

Pears, Iain. *The Discovery of Painting: The Growth and Interest in the Arts in England, 1680–1768*, New Haven and London: Yale University Press, 1988.

Pelzer, John & Linda. 'The Coffee Houses of Augustan London', *History Today*, 32 (October 1982), 40–47.

Pevsner, N. *Academies of Art, Past and Present*, Cambridge: Cambridge University Press, 1940.

Piper, David. 'Take the face of a Physician', in Gordon Kerslake & John Wolstenholme (eds), *Royal College of Physicians Catalogue of Portraits*, vol. II, Amsterdam: Elsevier, 1977.

Plumb, J.H. *The First Four Georges*, London: Collins/Fontana, 1967.

Pointon, Marcia. 'Portrait-painting as a Business Enterprise in London in the 1780s', *Art History*, 7:2 (June 1984), 187–205.

Pollack, Kurt & Underwood, E. Ashworth. *The Healers*, London: Nelson, 1968.

Porter, Roy, *English Society in the Eighteenth Century*, Harmondsworth: Penguin, 1982; revised edn, 1990.

 'Lay Medical Knowledge in the Eighteenth Century: The Evidence of the Gentleman's Magazine', *Medical History*, 29 (April 1985), 138–68.

'Laymen, doctors and medical knowledge in the eighteenth century: the evidence of the "Gentleman's Magazine"' in Roy Porter (ed.), *Patients and Practitioners*, Cambridge: Cambridge University Press, 1985.

'William Hunter: a surgeon and a gentleman' in W.F. Bynum & Roy Porter (eds), *William Hunter and the eighteenth-century medical world*, Cambridge: Cambridge University Press, 1985.

'Before the Fringe: Quack medicine in Georgian England', *History Today* (November 1986).

'Disease, Medicine and Society in England 1550–1860', *Studies in Economic and Social History*, London: Macmillan, 1987.

Mind Forg'd Manacles: A History of Madness in England from the Restoration to the Regency, London: Athlone Press, 1987.

'I think ye Both Quacks' in W.F. Bynum & Roy Porter (eds), *Medical Fringe and Medical Orthodoxy, 1750–1850*, London: Croom Helm, 1987.

'Past and Present; Seeing the Past', *Journal of Historical Studies*, 118 (February 1988).

'A Touch of Danger: The man-midwife as sexual predator', in G. S. Rousseau & Roy Porter (eds), *Sexual Underworlds of the Enlightenment*, Manchester: Manchester University Press, 1988.

Health for Sale: Quackery in England 1660–1850, Manchester: Manchester University Press, 1989.

Posner, Donald. 'Watteau's Reclining Nude and the "Remedy" Theme', *Art Bulletin*, 54 (December 1972), 383–9.

Probyn, Clive T. 'Swift and the Physicians: Aspects of Satire and Status', *Med. Hist.*, 18 (1974), 249–60.

Purvis, J. S. *An Introduction to Ecclesiastical Records*, London: St Anthony's Press, 1953.

Rein, Michael. 'History of Syphilis', in King Holmes (ed.), *Sexually Transmitted Diseases*, New York: McGraw Hill, 1994.

Riely, John. 'Rowlandson's Early Drawings', *Apollo*, cxvii:251 (January 1983), 30–38.

Ring, Malvin E. *Dentistry: An Illustrated History*, New York: Harry N. Abrams Inc., 1985.

Rodin, Alvin E. 'Infants and Gin Mania in 18C. London', *Journal of the American Medical Association*, 245:12 (March 1981), 1237–9.

Rosenberg, Charles E. 'Medical Text and Social Content: Explaining William Buchan's "Domestic Medicine"', *Bull. Hist. Med.*, 57 (1983), 22–42.

Rosser, E. 'Hogarth and the Hospital Staircase', *Journal of St. Bartholomew's Hospital*, 77 (1973), 232–4.

Rousseau, G.S. and Porter, Roy (eds). *Sexual Underworlds of the Enlightenment*, Manchester: Manchester University Press, 1987.

Schultz, Bernard. *Art and Anatomy in Renaissance Italy*, Ann Arbor: UMI Research Press, 1985.

Schupbach, William. *The Paradox of Rembrandt's 'Anatomy of Dr. Tulp'*, Medical History, Supplement No. 2, London: Wellcome Institute, 1982.

Scouten, A.H. (ed.). *The London Stage*; Part 3: 1729–1747, Carbondale: Southern Illinois University Press, 1966.

Seligman, S.A. 'Mary Toft the Rabbit-Breeder', *Medical History*, 5 (1961), 349–60.

Sharpe, J.A. *Crime in Early Modern England: 1550–1750*, London: Longman, 1984.

Crime and the Law in English Satirical Prints. 1600–1832, Cambridge: Chadwyck-Healey, 1986.

Shesgreen, Sean, *Hogarth and the Times-of-the-Day Tradition*, London: Cornell University Press, 1983.

Singer, Charles. 'Historical Essay' in Ludwig Choulant, *History and Bibliography of Anatomic Illustration*, trans. Frank Mortimer, New York: Schuman, 1945.

& Underwood, E. Ashworth. *A Short History of Medicine*, 2nd edn, Oxford: Clarendon Press, 1962.

Smith, Maurice. *A Short History of Dentistry*, London: Allan Wingate, 1958.

Smith, Sir Rodney. 'The Hunters and the Arts', *Annals R.C.S. (Engl)*, 57 (1975), 117–32.

Solkin, David H. *Painting for Money: The Visual Arts and the Public Sphere in Eighteenth-Century England*, New Haven and London: Yale University Press, 1993.

Spencer, W.G. 'Vesalius: His delineation of the Framework of the Human Body in the "fabrica" and "Epitome" ', *British Journal of Surgery*, 10 (1923), 382–402.

Tait, James. 'William Hogarth and the Pictures He Painted in St. Bartholomew's Hospital', *Journal of St Bartholomew's Hospital*, 58 (April 1954), 89.

Thomas, Keith. *Man and the Natural World*, London: Allen Lane, 1983.

'Other modes of thought', *Times Literary Supplement* (4–10 December 1987), 1339.

Thomas, K. Bryn. *James Douglas of the Pouch and his pupil W. Hunter*, London: Pitman, 1964.

Thompson, Charles John Samuel. *The Quacks of Old London*, London: Brentano's, 1928.

Thompson, John D. & Goldin, Grace. *The Hospital: A Social and Architectural History*, New Haven and London: Yale University Press, 1975.

Thomson, Stuart Craig. 'The Great Windmill Street Schools', *Bull. Hist. Med.*, 12 (1942), 379–91.

Thornton, John L. & Want, Patricia C. 'William Hunter (1718–1783) and his contribution to obstetrics', *British Journal of Obstetrics and Gynaecology*, 90 (September 1983), 792–3.

Todd, Dennis. 'Three Characters in Hogarth's "Cunicularii" – and some implications', *Eighteenth Century Studies*, 16 (1982), 26–45.

Vandervelde, Denis. 'Anti-vaccination Art and Ephemera in the U.K.', monograph, privately printed for The Disinfected Mail Study Circle, London, 1991.

Waddington, Ivan. 'The Struggle to Reform the Royal College of Physicians 1767–1771', *Medical History*, 17 (April 1973), 107–25.

Wall, L. Lewis. 'The Strange Case of Mary Toft (who was Delivered of Sixteen Rabbits and a Tabby Cat in 1726)', *Medical Heritage*, 1:3 (May/June 1985), 199–211.

Wark, Robert. *Drawings of Thomas Rowlandson in the Huntington Collection*, San Marino, California: Huntington Library, 1975.

Warthin, Alfred Scott. 'The Physician of the Dance of Death', *Annals of Medical History* (March 1931), 134–65.

Watson, E.R. 'The Trial of Thurtell and Hunt', *Notable British Trial Series*, Edinburgh: Hodge, 1920.

Webster, Mary. *Hogarth*, London: Cassell, 1979.

West, Shearer. 'The Theatrical Portrait in Eighteenth Century London', Ph.D. Thesis, St Andrews University, 1986.

'W.J.' 'The Dissecting Room', *Annals of Surgery*, 4 (1949), 377.

Woodforde, John. *The Strange Story of False Teeth*, London: Routledge & Kegan Paul, 1968.

Wright, Thomas. *Caricature History of the Georges*, London: Chatto & Windus, 1904.

Young, Sidney. *Annals of the Barber-Surgeons of London*, London: East & Blades, 1890.

Index

Page numbers in italics refer to illustrations.

Index

[333]

Index